If you could change the world... would you?

EVERYDAY HEROES

50 AMERICANS CHANGING THE WORLD ONE NONPROFIT AT A TIME

Photographs by Paul Mobley Text by Katrina Fried

Foreword by Arianna Huffington Designed by Gregory Wakabayashi

WELCOME BOOKS NEW YORK

Contents

EVERYDAY HEROES: 50 Americans Changing the World One Nonprofit at a Time
Photographs by Paul Mobley Text by Katrina Fried

Published in 2012 by Welcome Books®
An imprint of Welcome Enterprises, Inc.
6 West 18th Street, New York, NY, 10011
(212) 989-3200; fax (212) 989-3205
www.welcomebooks.com

Publisher: Lena Tabori
President: H. Clark Wakabayashi
Associate Publisher and Editor: Katrina Fried
Art Director: Gregory Wakabayashi
Design Associate: Christopher Measom for Night & Day Design
Project Coordinator: Emily Green

If you notice an error, please check the website listed below where there will hopefully be
a posted correction. If not, please alert us by emailing info@welcomebooks.com and we will
post the corrections.

Library of Congress Cataloging-in-Publication Data on file

I S B N : 978-1-59962-112-8

First Edition
10 9 8 7 6 5 4 3 2 1

PRINTED IN CHINA

For further information about this book please visit online:
www.welcomebooks.com/everydayheroes

For further information about the photographer please visit online:
www.paulmobleystudio.com

Image processing and retouching by Richy Ferrell

Foreword Arianna Huffington

In March 2012, I spent a fascinating couple of days at the Skoll World Forum on Social Entrepreneurship in Oxford, England. It was exhilarating—and deeply moving—to hear example after example of social entrepreneurs making measurable improvements in lives all around the world. As Stephan Chambers, chairman of the Skoll Centre, put it: "I have cried every day this week. Remember as I tell you this, that I'm male. And British. And from Oxford." I actually cried every hour. But, remember, I'm female. And Greek. And from Cambridge.

It was a reminder that the innovation, passion, and empathy on display at Skoll transcend gender, politics, geography, and education. Service is in the zeitgeist. Now, "zeitgeist" is a German word almost untranslatable in English, but it does exist. And the evidence is all around us.

On the political level, we're polarized and paralyzed, as the media refuses to acknowledge that the crises we are facing go beyond the obsolete dichotomy of left versus right. Pushing back against the failures of our leaders and institutions—and the resulting lack of trust—is a growing movement of people and organizations taking the initiative to engage, connect, solve problems, share, and change their communities and the world. While we wait for our public leaders to act, thousands are looking at the leader in the mirror instead and taking action. By daring to take risks and to fail as many times as it's necessary before they succeed, they are re-making the world.

We see this in the people whose stories are featured in these pages. Some of them I've known and admired for a long time—like Geoffrey Canada, whose tireless work at the Harlem Children's Zone has transformed thousands of lives and an entire neighborhood. And DonorsChoose.org founder Charles Best, who has used technology to connect donors to classrooms and teachers around the country. Revisiting their stories was newly inspiring; in a world facing multiple crises, they are still hard at work offering solutions.

Others were new to me, and I was amazed at the boundless creativity, innovation, and empathy that drive their efforts to change the world. There's Dr. David Vanderpool, who started Mobile Medical Disaster

Relief, administering medical care in developing countries. And Abigail Falik, founder of Global Citizen Year, which recruits high school graduates for a year of service and leadership training in Africa, Latin America, and Asia. As she says, "Initiative plus optimism is the recipe."

I was particularly fascinated to see that so many of these organizations are rooted in their founders' personal experiences—and especially their past failures. Susan Burton drew on her own turbulent past, including prison time for drug-related crimes, to found A New Way of Life Reentry Project, offering housing and support to women being released from prison. And Anne Mahlum, a veteran marathoner, channeled her passion for running into Back on My Feet, helping homeless people build a sense of accomplishment and control.

There are many moments of wisdom and humor along the way, like Enid Borden's description of the path that led her to the presidency of Meals On Wheels Association of America: "I was a child of the sixties and back then we all wanted to change the world, but then we grew into the seventies and eighties and we thought, 'Eh, we're not gonna change the world too much after all.' When this opportunity presented itself out of the blue, I decided: I don't know if I can change the world, but I think I can make a difference in a small piece of that world."

"We are on the cusp of an epic shift," wrote Jeremy Rifkin in his 2010 book *The Empathic Civilization*. "The Age of Reason is being eclipsed by the Age of Empathy." He makes the case that as technology is increasingly connecting us to one another, we need to understand that the most important goal of all this connectivity is to allow us to see ourselves as an extended family living in an interconnected world with responsibilities to one another. The heroes of this book are the embodiment of this age of empathy.

So, if you've forgotten Physics 101, here's a quick refresher. To a physicist a critical mass is the amount of radioactive material that must be present for a nuclear reaction to become self-sustaining. For the service movement, a critical mass is when the service habit hits enough people so that it can begin to spread spontaneously around the county. Think of it as an outbreak of a positive infection. And everyone is a carrier. What we need to do is go out and carry this positive infection, so that together we can reach that critical mass. And we can start by reading, and sharing, the stories of the heroes celebrated here, who are changing the world, one small piece at a time.

Introduction Katrina Fried

The idea for this book began percolating about five years ago, just before Obama's election, as America was bearing down to weather the worst economic crisis we had seen in generations. With a mist of depression slowly blanketing and then blinding the country, amidst the salvo of doom and gloom headlines, it seemed imperative somehow to find focal points of light. Who were the heroes, the torchbearers of hope and humanity in this new era of darkness?

Many of us consider heroism a quality reserved for an exceptional few—Gandhi, King Jr., Mother Teresa. Such heroes are to be idealized and looked to for guidance, like the North Star—a moral compass, not a literal road map. But the more I read, learned, and listened, the more obvious it became. Like the canopy of stars that appear in a clear night sky, the heroes of today are anything but rare, they're everywhere.

They're standing beside you in the elevator and sitting across from you on the subway; they're your next-door neighbor and your college roommate; they're teachers, doctors, ex-cons, priests, lawyers, inventors, and orphans. There are quiet heroes among us who embody the power and promise of the American spirit—ordinary men and women who have devoted themselves to uplifting the lives of others. And it is precisely their ordinariness that makes them extraordinary. Unlike our idols of the past, these new revolutionaries are not wrangling to become the dominant voice of reform. Their power stems from the aggregate. Together they are raising a chorus for change. Listen closely, and you'll hear a growing battle cry: *If we don't take care of each other, who will?*

The process of selection for this book was equal parts pleasure and torture. There were thousands of worthy candidates who deserve to be recognized and celebrated—how to choose just fifty? Our criteria narrowed the field somewhat. The heroes we honor in these pages are not those, for instance, that personify physical bravery—such as veterans or fire fighters, though they are by no means less praise-worthy—rather, these are crusaders for social justice and equality. Their work is humanitarian in

nature. They are founders or leaders of successful nonprofits, representing a diverse range of causes and demographics. Offspring of the marriage of entrepreneurship and community service, nearly all self-identify as social entrepreneurs. They are all Americans.

Individually, each of these men and women has something exquisitely unique to teach us. Their personal paths to magnanimity are scattered with guideposts and universal lessons for achieving fulfillment. In their stories are actualizations of many of our own deep aspirations to live a just and generous life. By example, they demonstrate that the potential for heroism is innate to us all, if only we choose to activate it.

Collectively, these fifty heroes paint an electrifying portrait of contemporary philanthropy in America. The themes and qualities that emerge repeatedly in their profiles add up to a new and provocative re-imagining of charity, one that eschews tradition and embraces innovation, daring, and a global mindset. Today's tribe of changemakers is anything but cookie cutter, yet they share a number of governing principles. Here are the new rules of everyday heroism:

Out with charity, in with partnership. The most universally defining quality of philanthropy today is unquestionably the shift in the relationship between the giver and the receiver. Gone are the days of the traditional donor-beneficiary relationship. The handout has been replaced by the handshake. Today's nonprofit reformers are interested in creating meaningful equal partnerships to empower communities and individuals to raise themselves out of poverty. When Robert Egger founded D.C. Central Kitchen, he reinvented the model of feeding the hungry by training the homeless to prepare the food they were feeding to themselves and others like them. "So much of charity is still wrapped up in the redemption of the giver, not the liberation of the receiver," explains Egger. "You can't measure success by giving everybody free food. If you don't liberate them, you're just holding them down."

You're never too young. Rebecca Onie was a sophomore at

Harvard when she founded Health Leads, which connects low-income patients with the basic resources they need to be healthy. Lindsay Avner launched Bright Pink to educate young women about breast cancer prevention and early detection when she was barely twenty-three. The growing squad of Gen Next social entrepreneurs lays waste to the notion that experience is a prerequisite for leadership. As Onie says, "Being younger or just being newer to the sector often leads you to ask questions that aren't being asked."

You're never too old. Despite this infusion of young blood into the nonprofit sector, there are plenty of late bloomers and lifers doing deeply meaningful work. Mark Goldsmith didn't found Getting Out and Staying Out—a reentry program for convicts—until he'd retired as a corporate CEO. It took Wynona Ward, founder of Have Justice–Will Travel, almost fifty years to become a lawyer so that she could defend the rights of battered women in rural Vermont. Others, like Roy Prosterman of Landesa, have spent a lifetime fighting for the rights and dignity of the poor, and show no signs of slowing down. At seventy-seven, Prosterman remains as energized by his cause today as he was forty-five years ago. "I'm not tired at all," he told me matter-of-factly.

Crazy is good. In fact, if the world doesn't think your idea is nuts, you might want to rethink it. When Earl Shorris first told people he wanted to teach Plato to the poor, he couldn't raise a dime in funding. "Impossible," they said. Seventeen years later, his Clemente Course in the Humanities has had 10,000 graduates and operates sixty sites around the world. Linda Rottenberg was literally nicknamed *la chica loca* when she decided to start Endeavor, an organization dedicated to providing resources and support to high-impact entrepreneurs in emerging international economies. Today, she's considered a prescient pioneer. No one understood how Anne Mahlum, a petite blond from the Midwest, was going to rehabilitate the homeless by teaching them how to run, but that's exactly what she did.

Entrepreneurs are born, not made. I'd wager that every entrepreneur I interviewed would agree this is a truism. Most have walked to the beat of their own drum since they took their first uncertain steps as toddlers and have never been satisfied in a conventional professional setting. All cite the willingness to risk failure as fundamental. The stakes are even higher for entrepreneurs in the nonprofit sector. "If you don't succeed as a for-profit, someone doesn't get rich," says Jill Vialet of Playworks, an organization that provides safe and healthy playtime to low-income students. "If you fail as a nonprofit, someone gets sick; someone starves;

some child gets an inferior education." It takes a healthy dose of confidence, courage, and tenacity to shoulder the fate of others day in and day out.

You can't rely on the kindness of strangers. With an ever-increasing population of nonprofits, the growing competition for funding has forced today's social entrepreneurs to realize that the surest way to survival is self-sustainability. Many of these organizations have developed alternate sources of income through social enterprise. Wine to Water, the clean water charity founded by former bartender Doc Hendley, raises funds through selling their own wine label and holding ticketed wine events; Michael Weinstein of the AIDS Healthcare Foundation started a chain of pharmacies and thrift stores over a decade ago, which almost fully support the organization's 500-million-dollar annual budget.

Go big or go home. Scalability has become an oft-heard catchword among the nonprofit set. Scaling, simply put, is taking a small idea and making it huge. The potential for exponential growth is practically a requisite for the new wave of social entrepreneurs. Maximizing impact often entails reaching beyond the limitations of their own organizations to stimulate others to follow their lead. As Darell Hammond—whose organization KaBOOM! builds playgrounds in low-income communities—explains, "For us, it's not about scaling up the organization. It's about scaling up the cause."

True heroes never consider themselves heroes. If I had a dollar for every time one of these charitable leaders said to me, "You know, the true heroes are the [blank], not me," I'd be fifty bucks richer. They all possess a sense of humility and authenticity that I've come to realize is essential to the realization of their visions. The basic fact remains: none of these nonprofits would have soared without the profound sacrifices of their dedicated founders and CEOs. Geoffrey Canada of the world-famous Harlem Children's Zone sums it up this way: "Leaders do what needs to be done, whatever it is, and they do it for as long as necessary."

Having spent hundreds of hours interviewing today's most accomplished social entrepreneurs, and hundreds more researching their histories and causes, these are the earmarks of modern philanthropy. With each hero's story there is yet another entry point to this bounty of munificence that flows all around us. And here's the real take-away: There is no contribution too small or insignificant. Whether you choose to show kindness to a loved one or a neighbor, to volunteer, to donate, or to build your own movement—you are helping to grow a culture of giving, from which—to use a favored phrase among these entrepreneurs—a thousand flowers will bloom.

"I would say that People's Grocery's number-one asset and reason for its success, is the trust and reputation it has earned for being authentic about community leadership and engagement. We want to see social change take place, not just offer social services."

Brahm Ahmadi

Co-Founder, People's Grocery

Boasting more than thirty liquor stores and not one full-service supermarket, the inner-city neighborhood of West Oakland situated just across the bay from the foodie mecca of San Francisco, exemplifies what is commonly known as a food desert—an industrialized area in which there is little to no access to healthy affordable groceries. In 2002, Brahm Ahmadi and his partners set out to change this with the founding of People's Grocery—a community-based nonprofit committed to building a socially just and sustainable food system. Soon, their solar powered mobile market—a grocery store on wheels—could be seen zipping through the streets of West Oakland, offering healthy, often organic, produce and packaged foods at affordable prices. Urban gardens and nutritional education programs quickly followed. Through these and other inventive initiatives, People's Grocery planted the seeds for a new food landscape to grow in West Oakland. Today, they are both a trusted community fixture and a nationally recognized leader in the food justice movement.

Before we founded People's Grocery, my colleagues and I were community organizers, working mostly on environmental justice issues in low-income neighborhoods in the Bay Area. We focused on toxic sites and pollution and things that were having a negative health impact on these districts, and the environmental racism associated with that. The issue of food came to our attention through residents who were attending the community meetings we were holding in West Oakland about these inequalities. We were all living in the neighborhood but frankly we didn't realize how significant of a problem food really was. The lack of access to grocery stores just kept coming up over and over again. So, we decided to make a shift in our work.

Initially, we thought opening a grocery store was likely to be the best solution in terms of the convenience, selection, and regular availability that residents needed. But we just didn't have the experience and the know-how at that point to open a retail market. The stakes were too high to risk failure, because there was already such a stigma that businesses couldn't succeed in these kinds of neighborhoods. For us to just be another business that failed because we didn't know what we were doing

just wasn't acceptable to us. So we put that goal on a much longer term trajectory, and focused first on starting a nonprofit that would offer a mix of food-related programs addressing the local needs of the neighborhood using methods that perhaps had not been tried before.

We started by creating projects geared toward food production and distribution, which included developing urban gardens, the Grub Box (a CSA program) and the Mobile Market—which was the first traveling produce store of its kind in the country, now widely replicated. It was a great success, especially in regard to getting firsthand experience in marketing fresh foods and building community relationships.

Over the past ten years, People's Grocery has shifted its resources toward education, outreach, and community involvement. Too much emphasis, both in our work and in other organizations around the Bay Area, was actually going into creating the projects without a sufficient amount of engagement in the community. As a result, we were struggling to get residents involved—like volunteering at the gardens—and to get the food distributed. Even though the community wanted to be healthier, the connection between that desire and what we were offering wasn't

Brahm Ahmadi in one of People's Grocery's community gardens in West Oakland, CA.

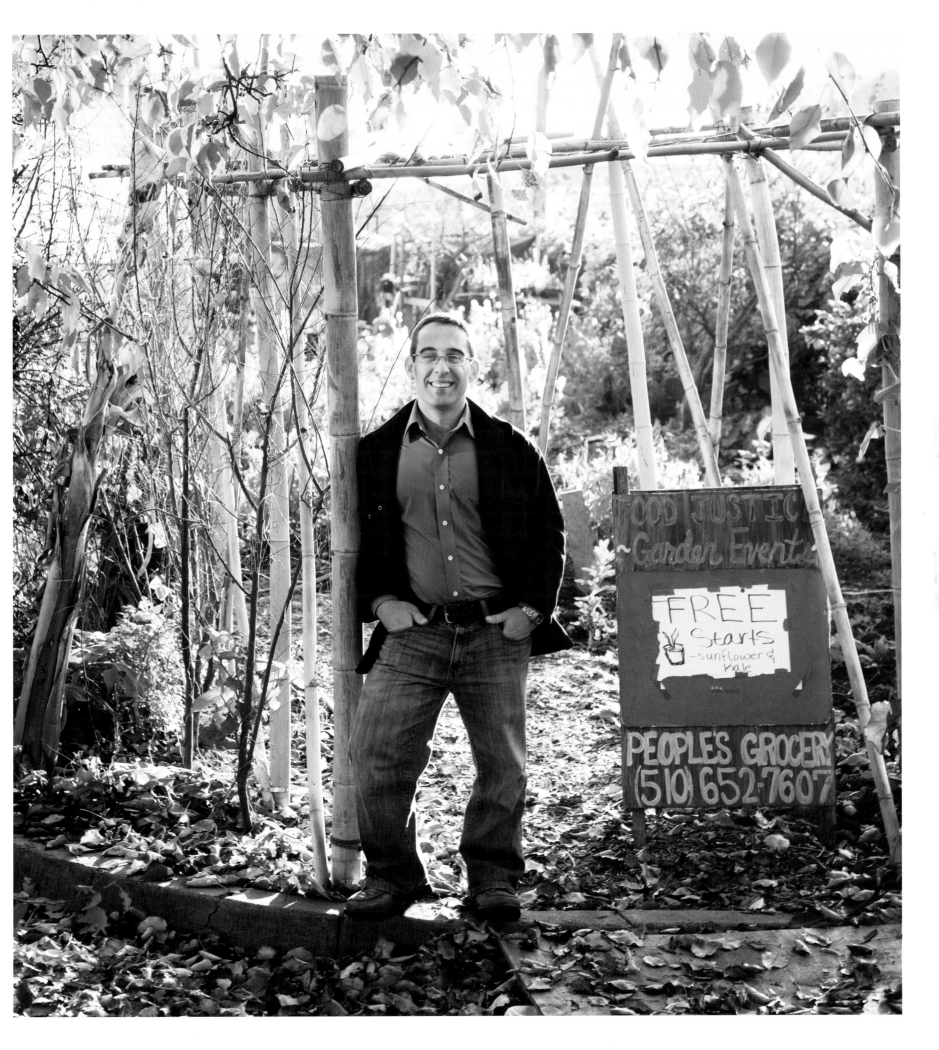

FOOD JUSTICE
~Garden Events~

FREE
Starts
-sunflower &
kale

PEOPLE'S GROCERY
(510) 652-7607

necessarily clear to them. We realized we were getting ahead of ourselves, and that we had to go back and rebuild the educational foundation in the community, so that the residents were really ripe and ready to participate in these programs.

For example, People's Grocery developed the Community Hands Project, which was really an outgrowth of our cooking class. We saw that the residents wanted to get more involved and take the lead in nutrition education. So there was an outreach capacity we hadn't been utilizing. In response, we created the Community Hands Project with a group of those students and offered a deeper level of training around nutrition, health, and culinary practices, as well as guidance in giving a cooking demonstration. Then we provided them with the resources they needed, so they could go out into the neighborhood and organize demos on their own.

Another form of outreach is the Growing Justice Institute, which is also resident-driven. Its purpose is to work with local community members to develop their own projects around food and health. They go through a one-year training intensive and the Institute helps connect them with resources. This contributes to building a community food system that's not just centered on what one organization does. You have to create all these different nodes of activity that need to be spawned by residents themselves; they have the most insight and they already have established relationships within the community they are serving.

I would say that People's Grocery's number-one asset, and reason for its success, is the trust and reputation it has earned for being authentic about community leadership and engagement. We want to see social change take place, not just offer social services. A lot of residents have seen nonprofits set up an operation and hire college grads from outside of the community to come in and deliver services to the poor. And they've seen those organizations fail to fundamentally create change over and over again. It's been more than half a century now that neighborhoods like West Oakland have been served by shelters and recovery programs. Even though they're still needed as a safety net, these programs tend not to address structural problems. Sixty years later, hunger and homelessness are worse than they've ever been. The residents look at that and say, "So why should I trust you? This stuff hasn't worked *and* you haven't

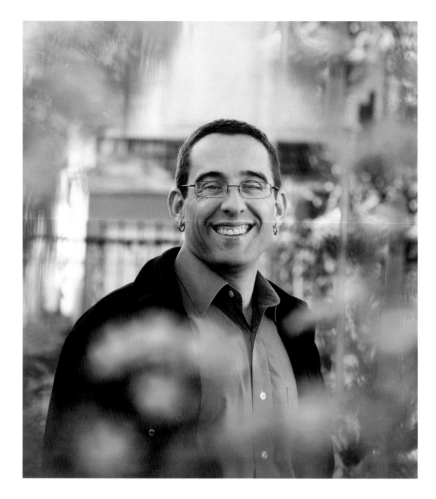

authentically brought the community in." When you look at the staffing and the leadership in a lot of organizations very few residents are involved because it's assumed that they're poor, they're uneducated, and they don't know. Yet they often bring so much insight, knowledge, and understanding of their communities—cultural assets—to the table, that if utilized well, can have a huge impact on being more effective. So we took that approach, not only to build trust, but to succeed in our mission. It's been a long ten-year journey for People's Grocery as an organization to build a strong and stable foundation of leadership in West Oakland.

I stepped down as the executive director of People's Grocery after eight years, in 2010, to re-engage the original mission of starting a grocery store in the neighborhood. The work of People's Grocery over the past decade created the right conditions in West Oakland for the retail idea to finally succeed, and I just felt the time had come. The People's Community Market will in many ways be a sister organization to the People's Grocery, but it's a totally independent and separate venture. Our focus is threefold: to provide what the community really wants and needs in the way of groceries—particularly in regard to fresh produce and perishable foods;

to fill the void in healthy prepared foods, which is the result of a lack of quality restaurants in the neighborhood; and to create a social meeting place for the local residents, which can foster community building and offer educational programs and resources. While access to good food is desperately needed here, the members of this community also want knowledge and information to support them in improving their health. And they want to be more connected with each other socially. We think that we can offer all those things in a way that's both good for the community and good for us as a business. We're playing with this tagline: "More than a grocery store." That's really the central premise.

In many ways, my interest in the intersection of food, social justice, and entrepreneurship can be traced back to my upbringing. My father is Iranian. My mother is from Iowa. We always joke that I'm the product of what happens when the Mideast and the Midwest get together. I was born in Iran and lived there until I was six. We left in 1981 because of the Islamist Revolution and moved to my grandparents' farm in Iowa for a year.

On both sides of the family, food is an important part of the culture. Persians love food. They have a very rich history and many longstanding traditions around food. On my mother's side, food was not only a passion, but it was also our livelihood. So there was an agrarian aspect to food, and a sense of its relationship to the land. I saw in my grandfather what a great and proud tradition farming is. From my childhood point of view, he was a giant, wearing overalls and driving a tractor. I was completely inspired by him.

My father comes from countless generations of merchants. My paternal grandfather was a businessman his entire life. He started and ran a number of small stores in the Bazaar in Tehran. The Bazaar is this giant underground market—it's literally like a city on its own. It's been there for centuries. My grandfather was very disciplined and over the course of his life he saved a lot of money. Eventually he started a chicken hatchery business—I believe it ended up becoming the largest in the Middle East. My father helped run the business until the revolution. So, there is also a strong entrepreneurial and business tradition in my heritage.

Moving from Iran to Iowa was very eye-opening for me. When we came to the States I spoke some English, but not very well. I was obviously Persian in my manner and outlook. I got picked on a lot by the kids, beaten up a few times, called terrible names—"towel head," "camel jockey," "terrorist." So, in my own experience, the farm was my sanctuary.

I understood very quickly that I was different by the way that I was treated. And when we moved from Iowa to LA, I saw that same thing happening to Latinos. After a while, I think I developed some degree of a race consciousness and an understanding about racism and equity in American society. All my friends were Latino, so I had a very close connection to their experience. A lot of them were first-generation Americans. Of course, I was an immigrant myself and I understood what it meant to be a minority in America. That definitely had a strong impact on the path I've taken as well.

> *"I've always wanted to reinvent the purpose of business to be more than just a money-making enterprise, but to create positive change in the world as well."*

There's also a strong history of justice in the Persian culture that's part of me too. It may not be showing up very well right now in the current regime, but Cyrus the Great, who founded the Persian Empire, created the first declaration of human rights 5,000 years ago. He said that we would treat everyone equally despite religion, despite their background. There is something intrinsic in the Persian culture that aspires to justice and respects human rights. I don't know how explicit that was in my upbringing, but it came through to some extent.

I think all of those early influences had a huge impact on me. A lot of my work at People's Grocery—and now People's Community Market—is tied to those childhood experiences with racial inequality, and to working around my grandfather's farm and being so close to the land, as well as having the examples of my father and my grandfather, as successful businessmen. I've always wanted to reinvent the purpose of business to be more than just a money-making enterprise, but to create positive change in the world as well.

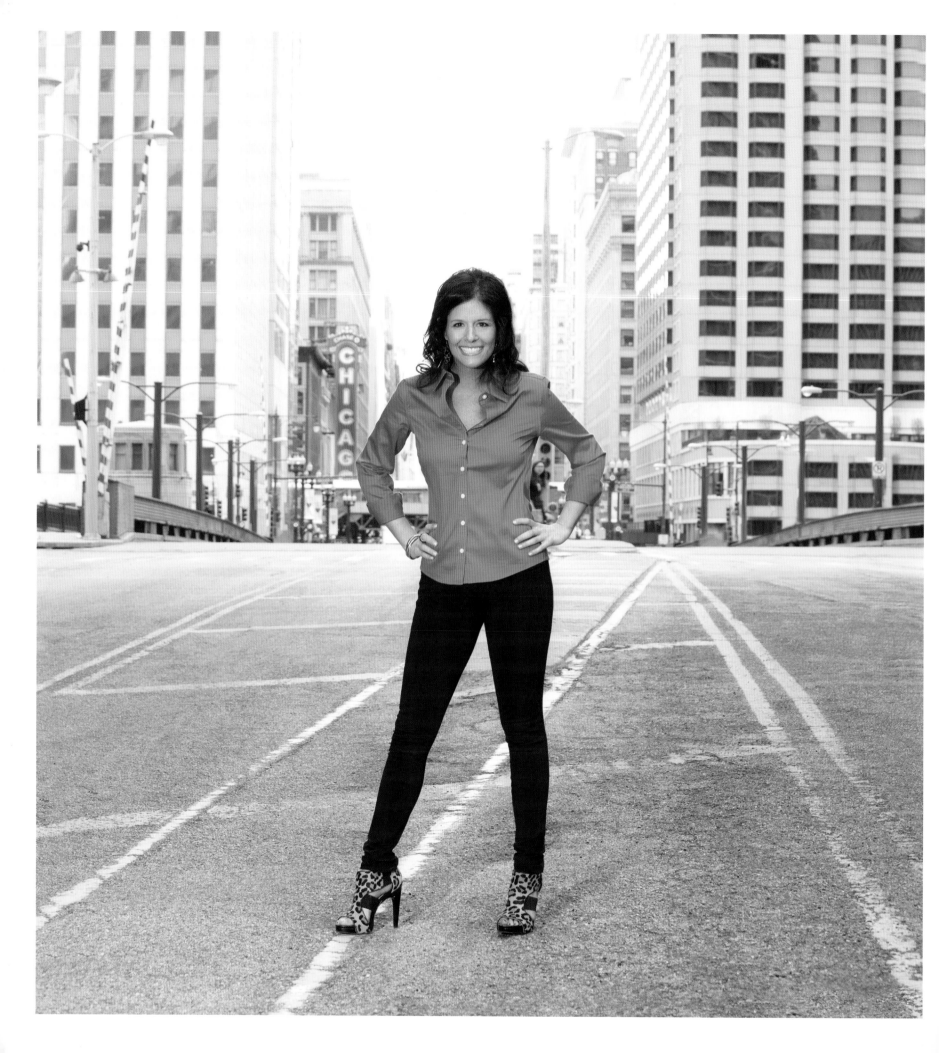

Lindsay Avner

Founder and CEO, Bright Pink

When Lindsay Avner founded Bright Pink (a nonprofit dedicated to the prevention and early detection of breast and ovarian cancer in young women) seven years ago at the age of twenty-three, she had just made headlines as the youngest woman in America to have a prophylactic bilateral mastectomy. Not exactly the way every girl dreams of becoming famous. But Avner isn't every girl. With three generations of breast cancer in her family history, Avner intimately understood the gravity of her decision, and was compelled to use her experience to help educate and support other women at risk. With ten Bright Pink chapters around the country, and more than 50,000 members nationwide, Avner is well on her way to realizing her vision.

B reast cancer is extremely pervasive in my family. My mom is a seventeen-year breast, sixteen-year ovarian cancer survivor. My grandma and my great-grandma died just a week apart, both from breast cancer. And eleven other women on her side of the family have died of the disease. Still—I decided to undergo genetic testing to find out if I carried a mutation on the BRCA gene, or breast cancer gene, which is associated with up to an 87 percent lifetime risk of breast cancer and 54 percent risk of ovarian cancer.

I went into it thinking I would test negative. After all, I am built more like my dad's side of the family and I therefore thought my genetic makeup would be more like his. I thought of the test as a chance to give me the relief of not having to worry about developing breast cancer like every woman on my mom's side of the family did. When I got my results and found out I had, in fact, tested positive and had such a high risk, I was devastated. It caused so much anxiety, I became physically ill. I was in and out of the hospital. While breast cancer was a part of my history, nothing can prepare you for the news that your own risk is as high as it is.

When I moved to Chicago after graduation, it was a very bittersweet time. I was embarking on this exciting new endeavor, a dream marketing job, but then also dealing with my own mortality at the same time.

Originally, I decided to enroll in an early detection screening program: every six months I was receiving a mammogram, MRI, clinical breast exam, transvaginal ultrasound, and blood tests. It was overwhelming to show up and be the youngest person in the waiting room by more than twenty years. Each time, I'd go into the appointments and hold my breath in anticipation of what they might find. After, I would walk out, breathe that sigh of relief, but know I had to turn around and do it all again in six months.

I started exploring the possibility of a double mastectomy. At first, it wasn't a consideration. The results of my mom's surgery from years before were pretty jarring, and I thought: I'm young and single. I am still dating. I can't make a decision like that now. Then, something clicked. I thought, "Wait, I have the power to change my destiny and take control of my life and the result will only be a couple of scars?"

Many of the doctors I saw wouldn't even contemplate it. One actually told me, "You know, I'd highly suggest you get married before you undergo a surgery like this." Then I went to my doctor in New York, Dr. Patrick Borgen— the same doctor who had performed my mom's mastectomy years earlier. He said, "I actually think we can get some amazing cosmetic results." He showed me the pictures and it was amazing. They were even able to keep a woman's nipples. I thought to myself, "I'm going to do this." At the time,

Lindsay Avner in Chicago, IL.

I was the youngest woman in the country to choose to have a prophylactic double mastectomy because of the gene. I had the surgery in 2006.

I was terrified going in. I knew I was making the right decision, but I didn't know how it would feel or look, or if I would ever feel beautiful or feminine again. During that journey—from finding out I tested positive to the surgery—I reached out to so many different cancer organizations to seek support and they didn't know what to do with me. I wasn't a survivor and yet I wasn't like my peers. I longed to connect with another young woman who had gone through the same surgery and come out okay. I couldn't find her. The women I found were all in their fifties and talking about how supportive their husbands had been by picking their kids up from soccer. I remember thinking, "That's your reality. Mine is: What happens the first time my shirt comes off after surgery with a new guy I'm dating?"

"The most beautiful part of this whole thing is that one day, when I have a daughter, she's going to be the first one, after generations of women in my family, to not have a mom who's sick with breast cancer."

I don't remember this, but my mom says that when I woke up in recovery my first words were, "It's finally going to be okay." Before going into surgery I was very quiet about my situation. Only three or four people in my life knew. I just wanted to go through it, move forward, and put this all behind me. But after the surgery, I actually felt so comfortable in my own skin, I had the option for a scar reduction technique, but I didn't want it. My scars felt like my battle wounds. They were profound reminders of the fact that I had taken my cancer risk down to 1 or 2 percent—which is dramatically less than that of a woman in the general population.

I started immediately dating a great guy, and I give him a lot of credit for helping me see myself as nothing but beautiful, scars and all.

And I decided I wanted to share my experience. The *Chicago Tribune* ran my story on the cover of a Sunday edition. The next day we were on the *Today* show and the cover of the *New York Post.* Then came CNN, and a whole news media storm kicked in.

The most amazing part was that there were more than a thousand women around the country who reached out and said, "I feel like a part of the story Lindsay was sharing is just like my own." They wanted to be proactive about their health, but society and their doctors were saying, "Oh, these are diseases you shouldn't be thinking about until you're forty or fifty." I remember at the time thinking, "Oh my gosh, there is no way I could ever e-mail all these people back. I'm just going to start a website to send them to." That was how it all began.

We launched the Bright Pink website in January 2007, but for a year and a half I continued to work full-time at my day job, and the organization was staffed by just a handful of volunteers in my apartment on weekends and after hours. The incredible thing was how quickly this community grew and how great the need was. It became clear that this idea was so much bigger than just a simple website for those at high risk. So, our mission quickly became focused on prevention and early detection of breast and ovarian cancer in young women, and support for those at high risk.

Of course, not everyone reacted positively. The critics are out there. There are people who were very, very disturbed that I chose to remove my breasts without actually having cancer. There were people who were very angry with my doctor for even engaging in this. Other people said, "You know, she's never going to feel like a woman again." But to me, that's just really an opportunity to engage in a conversation.

One of our first big growth steps as an organization was securing relationships early on with the Wrigley company and Orbit White Bubble-mint gum. They had us on jumbotrons in Times Square. Now, we've also signed a deal with the hair brand TRESemmé. And we're the official charity of Aerie, American Eagle's line of bras and panties. For us, these marketing relationships are so much more than the donations. They're how we reach young women.

I always tell people, "We don't need any more awareness." We all know what breast cancer is. What we need is action. We need women

taking control of their health and their bodies. When someone tells you to "look for a breast lump," what does that mean? But if you say, "It feels something like a frozen pea," all of a sudden that makes sense. When we break it down in these ways that are so easy and actionable for women, it's pretty remarkable how they're able to start changing their behavior.

Our education programs are very focused on prevention and early detection. One of our first was the Little Bright Book series, which is a collection of booklets for doctors to give their patients to help them understand how their families' cancer history impacts their own risk. More than 250,000 copies have been distributed to date. We also bring in experts to host educational teleconferences. We recently did one on sex and dating. We answer questions like: What happens when the guy gets scared off because he thinks you have too much baggage? We're actually working now on some rapid-fire Twitter chats, where we have experts answer questions about breast and ovarian cancer in real time. The neat thing is that, for example, a young woman in South Dakota can hear from a premier doctor at Sloan-Kettering. We're trying to even the playing field.

We host Breast/Ovarian Health 101 educational workshops, and we'll go everywhere, from churches to the Junior League. We even held educational burlesque shows for the lesbian community. In our PinkPal program, we pair up young women who are considering genetic testing with women who have already been through it. And we organize outreach groups, which are our version of support groups, but they're fun activities: cardio strip tease, yoga, self-defense, cancer-fighting workshops—along with a facilitated, supportive conversation.

We started hearing that after attending our sessions, young women were going to their doctors and saying, "I learned that I have a family history that could mean something." And some of their doctors were giving them strange advice. So, we realized the need to change that. We just launched the pilot for our Emerging Medical Professional Workshops, where we go into ob-gyn and internal medicine residency programs and teach doctors how to talk to young women about their breast and ovarian health and to create urgency around prevention. We just piloted the program at Northwestern and soon we're going to have these workshops all around the country.

Bright Pink turned five this year and I'm turning thirty. I feel blessed that every day I wake up and I have this profound sense of meaning, this impact on people's lives that I never in my wildest dreams thought I would have. But I also need to start pulling back and recognize that I'm not going to be able to keep up this pace forever. I'm on that search for Mr. Right. I want to find him. I want to have a family. I want there to be a point in my life where that's my number one priority, and Bright Pink is my number two.

I think the most beautiful part of this whole thing is that, God willing, one day, when I have a daughter, she's going to be the first one, after generations and generations of women in my family, to not have a mom who's sick with breast cancer. Pretty incredible!

"I figured there were people out there who wanted to support public-school classrooms but were skeptical about writing a big check to a large institution and feeling like their gift was going off into a black hole."

Charles Best

Founder and CEO, DonorsChoose.org

When Charles Best started DonorsChoose.org, an online charity that raises money to fund public-school classroom projects through small donations by concerned citizens, he was a recent Yale grad, surviving on a starting teacher's salary, still living at home with his parents in New York City. Twelve years later, DonorsChoose.org has received more than 1.5 million contributions subsidizing 250,000 teacher requests from all over America, ranging from violins for a music recital to a class outing to the zoo. DonorsChoose.org vets every project before posting it on the site and donors can search almost any keyword imaginable to find a project that suits their interest or passion. It's a brilliant model, one that is helping to redefine the future of charitable giving.

I had a wrestling coach in high school who was an amazing guy and I really looked up to him; I figured that if anybody looked up to me the way I looked up to him, I would have done my share. So, I already knew when I went off to college that I wanted to be a teacher. My parents were totally supportive; they really encouraged me not to feel pressured to take a job that would make a lot of money.

The spring of 2000 was my first year teaching social studies at a public high school in the Bronx. My colleagues and I would talk all the time in the staff lunchroom about books we wanted our students to read or a field trip that we wished to take them on. We'd spend a lot of our own money on supplies like copy paper and pencils—really basic stuff, but we couldn't provide our students with all the materials and experiences they needed to have a great education out of our own pockets.

We felt this major constraint on us as teachers and we saw clearly this inequity that our students were experiencing. We knew that added resources would make a huge difference for them, but we'd found both the school bureaucracy and the traditional private grant-making apparatus forbidding and overly complex. I figured that there must be individuals out there who wanted to support public-school classrooms but were getting more and more skeptical about writing a big check to a large institution

and feeling like their gift was going off into a black hole. I believed that if we could give people like that a way to pick a project that spoke to them personally, and they could see where their money was going, then my colleagues and I would be able to get our students those books and take them on that field trip.

So I came up with the idea of DonorsChoose.org, and had this very basic website built. I drew each web page with a pencil and paper and wrote out how I wanted it to function. Then I paid $2,200 to a programmer who had recently arrived from Poland to implement my ideas. Suffice to say, the result was very rudimentary, but it was functional.

To get my colleagues to try out the site, I asked my mom to make this dessert she makes, which is really good—it's a roasted pear dessert. I put it in the teachers' lunchroom and said, "All right, whoever eats this has to go to this newly created site and propose the project you've most wanted to do with your students." Eleven of my colleagues ate the dessert, and they posted the first eleven project requests.

My aunt funded the first of those project requests, and I anonymously funded the other ten myself, because I didn't know any other donors. Funding them anonymously had this unintended effect of my colleagues thinking that the website actually worked, that there were all these donors

Charles Best, surrounded by student thank-you letters, at the DonorsChoose.org headquarters in New York City.

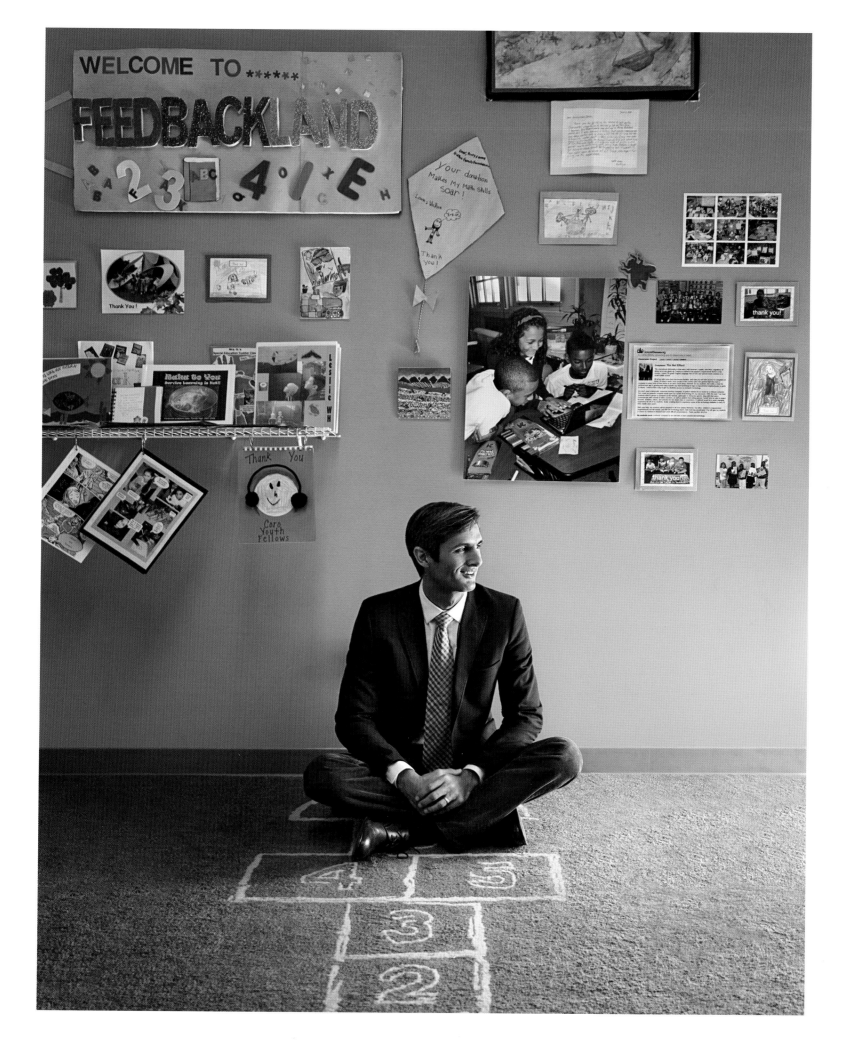

on the site just waiting to fulfill teachers' classroom dreams. So, that started a rumor, which spread across the Bronx, that there was this website where educators could go and get funding for special projects and supplies. Very soon, teachers all over the borough had posted hundreds of projects on our site, which I obviously could not subsidize myself.

But my students saw the potential of this website to change their academic lives, and they volunteered after school every day for a few months to put together letters—by hand—to about two thousand people across the country, telling them about this website where somebody with ten dollars could be a classroom hero. And we got the addresses out of the alumni directory of the boarding school and college I had gone to, and sent those letters out, and it generated the first $30,000 in donations to projects on our site.

From day one, our model included the teacher photographing the project taking place, and the teacher writing an initial thank-you note, then an impact letter a couple months into the project, and the students writing their donors thank-you letters. I didn't know how teachers and students would respond to that responsibility—especially the students. But the thank-you letters were just incredible, so that was a proof point that the model itself could really work.

In 2003, Oprah Winfrey caught wind of our little philanthropic experiment, and she did a very nice segment on us. The onslaught of traffic afterward crashed the website for an excruciating ninety minutes. It was a big growth point. Two years later, we won the Amazon Nonprofit Innovation Award, which was billed as the award that was going to identify the most innovative charity in America. And in 2007, we went national, and opened our website to all the public schools in the country. That year we posted more than 100 percent year-over-year growth.

Today, half the public schools in America have at least one teacher who's posted a classroom project request on our site. So, that's about 200,000 teachers who have posted about 300,000 projects, which have inspired more than $100 million in donations from citizen philanthropists and partners.

I continued teaching for about five years before I gave it up to run DonorsChoose full-time. It's not exactly the path I expected to be on, but I don't see teaching and entrepreneurship as necessarily being as different as you might assume. I was teaching during a time and under a principal where I had a lot of freedom. At the same time, I didn't really know what I was doing my first year in the classroom and had to figure it out as I went. I think that's not dissimilar from being an entrepreneur and launching a new project when you don't have an MBA or the experience of having done it before. With teaching, I was able to write my own history textbook and come up with a customized curriculum. It was a pretty entrepreneurial experience, as teaching assignments go. And there were points of connection. I taught a class called Virtual Enterprise, where students would create their own virtual web-based businesses. I can remember the day approaching when I had to teach my students how to write a business plan—and I didn't know how to write a business plan, so I certainly didn't know how to teach someone else how to do it. So the night before—and I'm embarrassed to admit this—I crammed on how the heck you write a business plan. I taught what I'd learned to my students the following morning, and the next day I was able to write the first business plan for DonorsChoose.

> *"Oprah Winfrey caught wind of our little philanthropic experiment, and she did a very nice segment on us. The onslaught of traffic afterward crashed the website for an excruciating ninety minutes."*

About half the classroom projects on our site request materials that the system ought to be providing: dictionaries, fundamental art supplies, fundamental science equipment, paper, etc. And honestly, we would like nothing more to be put out of business in terms of those requests. And we think we're contributing to that eventually happening, because when people come to our site and support those projects, they do not then think that they've solved the problem and the government can stand down. Quite

the opposite. They come out of that donation experience newly aware of what's going on in public-school classrooms on the other side of the tracks. They come out politically energized to demand change, and they come away feeling like they now have a personal relationship with a particular group of students about whom they are thinking the next time they walk into the voting booth. And we have captured this in surveys, where 70 percent of our donors say they've never before contributed financially to a public school, and 60 percent of our donors say their experience on our site has made them more interested in systemic reform because it was their first vivid encounter with the unmet needs of students in disadvantaged neighborhoods.

But then, the other half of the projects on our site go beyond what you'd expect the taxpayer to provide—a field trip to Washington, D.C., to see the Supreme Court consider a case, butterfly cocoons for a really special science experiment—which are pretty darn impactful, but I don't think you'd consider it an injustice if your local school district were not underwriting such projects. And we see an ongoing role for ourselves in supporting this kind of enrichment and experimentation, for which private philanthropy is really appropriate.

Looking toward the future, there are three main growth areas for us. One is continuing to increase the number of teachers and schools using our site and the dollar value of resources delivered to students in need. We have the audacious goal of seeing a million people give a $100 million to classroom projects in 100 percent of our country's high-poverty public schools, all in one school year. We're a little over a third of the way there. We certainly don't feel like we've cracked the nut yet on citizen philanthropy on a vast scale. We drive hundreds of thousands of people to support classroom projects on our site every year—we want to be driving millions.

The second growth dimension involves opening up our data and inviting web developers and data crunchers to build applications and analyses that can engage the public with schools and provide information that could change the education system itself. So, for example, right now people have the ability to see that high-school teachers in Louisiana are posting 30 percent more requests for math technology than they were one year ago—perhaps that should inform the next state school budget. Or you might learn that middle-school math teachers are requesting a lot

"We certainly don't feel like we've cracked the nut yet on citizen philanthropy on a vast scale. We drive hundreds of thousands of people to support projects on our site every year—we want to be driving millions."

of cooking equipment because they've concluded that doing recipes is the most effective way to teach basic algebra. Maybe that should affect the curricula of teacher-training programs. DonorsChoose.org is often knocked as strictly a direct-service charity, but we think that all the acts of immediate relief that are taking place on our site are generating data that can be used to influence education reform and help point out areas of need.

The third growth area involves enabling our donors to engage with public school classrooms in ways that go beyond simply opening their wallets. We just completed a successful experiment in offering donors the option of giving time as well as money, specifically by volunteering online to help a public school classroom that uses DonorsChoose.org. We have a mission belief that a donation to a classroom project on our site should not be an end unto itself, but should be the first step on a path leading to full-fledged engagement with public schools in low-income neighborhoods. We also have another—you might call it strategic—objective, and that's thinking that if we ask our donors to give their time, they'll end up giving more money to classroom projects as well.

Today, we are completely self-sustaining, financially. From day one we've always encouraged, but not required, our donors to allocate 15 percent of their donation toward our overhead. Three-quarters of our donors choose to do that, and the other quarter either reduce that percentage or eliminate it. It took us about nine and a half years, but the income generated from classroom-project donors voluntarily giving us that allocation now pays 100 percent of our operating expenses. So, we're a break-even organization and we do not need to seek operating support from foundations, big donors, or corporate sponsors. We feel really lucky. We're liberated from going hat in hand, asking for help with the rent payment.

"... when I went on my first home delivery and brought a meal to someone's house ... I said to myself, 'This is where I belong. I'm home ...'"

Enid Borden

President and CEO, Meals On Wheels Association of America

Enid Borden might just be made of finer stuff than the rest of us. In the twenty-plus years she has been at the helm of the Meals On Wheels Association of America, the country's largest hunger relief organization for senior citizens, she has sacrificed all semblance of a personal life to fight relentlessly and successfully for her cause. Her devotion appears nearly too good to be real, yet her actions stand behind every irrepressibly optimistic word that tumbles from her mouth. In just over two decades, Meals On Wheels has amassed a volunteer army of 2 million who feed more than 1 million of our elderly every day, but Borden isn't stopping there. She has recently committed her organization to ending senior hunger by the year 2020. Coming from anyone else, this might sound like a pipe dream; coming from Borden, it seems utterly plausible.

When I was offered the job running the National Association of Meal Programs (that's what Meals On Wheels used to be called) I had never thought about the nonprofit world. I was a child of the sixties, and back then we all wanted to change the world, but then we grew into the seventies and eighties and we thought, "Eh, we're not gonna change the world too much after all." When this opportunity presented itself out of the blue, I decided: I don't know if I can change the world, but I think I can really make a difference in one small piece of it. When I went on my first home delivery and brought a meal to someone's house, and when I knocked on that door and saw what was behind it, it was very powerful. I said to myself, "This is where I belong. I'm home, I have to do this." I've been at this job for over twenty-two years now.

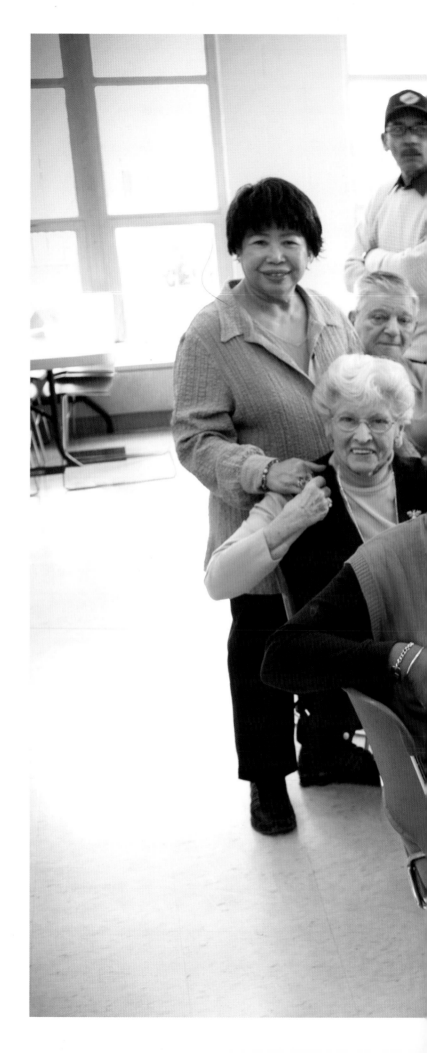

Enid Borden with members of the Stanley M. Isaacs Neighborhood Center in New York City.

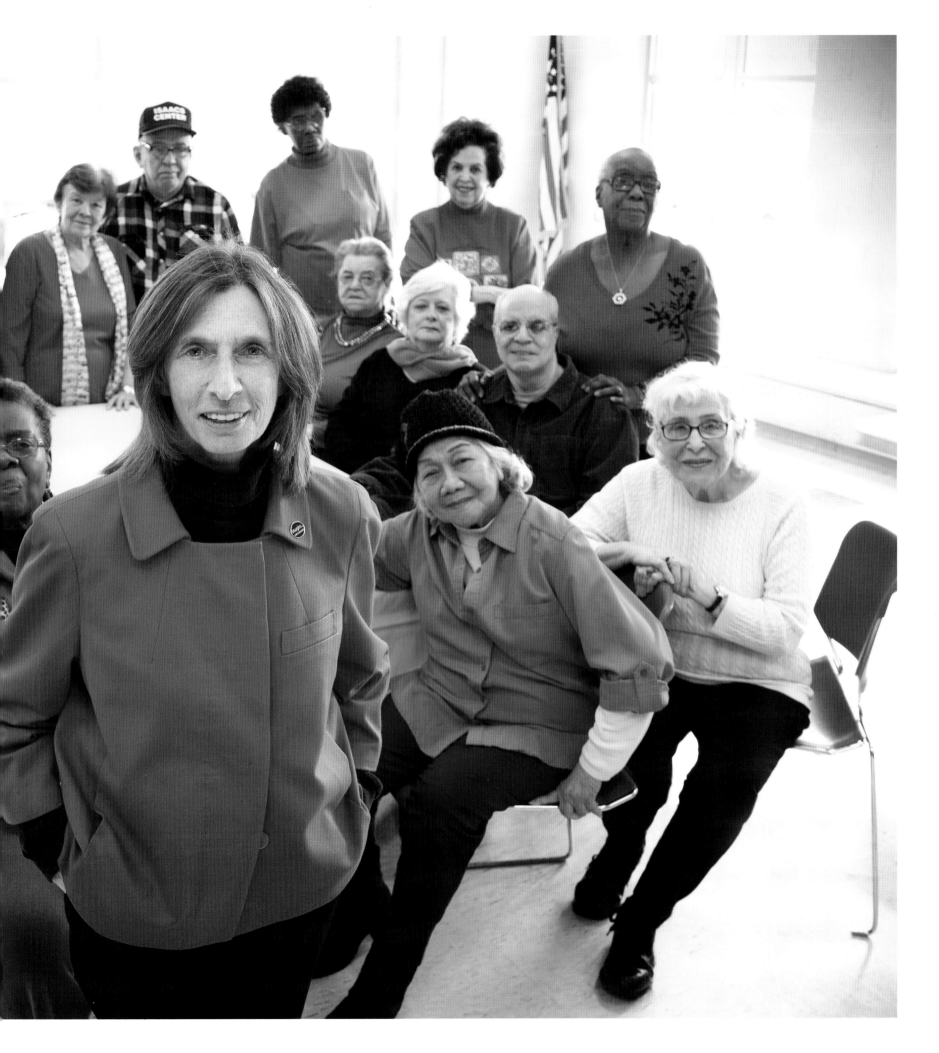

When I took over the organization the budget was less than $100,000, which I thought was huge. It's now almost $20 million. I've got a great staff, and I'm proud of how young they are. I want to get young people to understand that they need to care about old people, that one day they too will be old. When I took this job I talked about old people as if they were a distant group somewhere out there. Now I'm one of them. I'm eligible for my own programs. You realize, there but for the grace of God. Will I ever know true hunger? Probably not. But while I won't experience it, I need to end it; I think it's a moral obligation. There are certain things in life that we have to do, and one of them is not to allow anyone to go hungry in this great country of ours.

> *"The terrible truth is that we can't get to everyone. We have waiting lists, people who are literally waiting for meals. I mean, if you're eighty-five years old, how long can you wait?"*

My mission, from the time I started, was to raise funds in order to raise awareness—because awareness is the first thing you need to end senior hunger. There is a great anti-hunger movement in the United States, and for many years seniors were never a part of it. It's taken a long time for us to even get a seat at the table. Because people look at us and they think, "Old people get Social Security and they get Medicare, so what else do they want?" But what they want is dignity, they want to live in their own homes, and they want to be nourished. So we had to get the message out that there were those living among us who were too proud to tell anybody else that they were hungry. When Americans think about hunger in this country, we think about people standing in line at a food bank or begging on the street, but those aren't my people—my people can't get to the food bank, they don't vote, and they don't kvetch. They're not raising a ruckus; they're not marching on Washington; they're not marching anywhere.

They're hidden, and they're hungry and they're alone and they don't have a voice. I realized we had to be their voice.

Fundraising is probably 90 percent of what I do. It's me going out and speaking—and I'll speak to anybody, I mean, I'll open up the refrigerator, see the light go on, and I'll give a speech. I'll speak to anybody because I believe in what I'm asking for, completely. The biggest problem we have is that there are many charities—so which one is more valuable than another? The answer is they're all valuable, they're all worthy, they all need help, and so I have to figure out, what do I say that makes my organization and my cause any different than anybody else's? I've been known to go out and give a speech and tell people, "I don't care if you give to my organization or someplace else." My message is, *Just give*. I always tell people: once you give something back, whether it's a meal or something else, you're hooked. It doesn't pay monetarily, but it pays spiritually.

Our funding is the definition of grassroots. We get some money from the government, but it's minimal. The majority comes from individuals and small groups—people who are having bake sales, car washes, and the old spaghetti dinners. Those ideas are still there, they are alive and well in every community in America, and the monies that they generate add up. My folks get excited when they've done a huge event and they've raised $2,000: think about how many people we can feed with that money.

When I shut off the light and go to bed tonight, I know that there are at likely 8.3 million seniors in America who didn't eat today. That keeps me up at night. I'll tell you one of my "Aha!" moments. I met a guy named Al a couple of years ago while I was delivering meals one summer day at a trailer camp in Appalachia. It was like nothing you've ever seen in your life—there were stray dogs and cats everywhere, it was brutally hot, almost 100 degrees, and Al lived in a trailer that was really a sardine can. He had dragged his mattress outside because it was too hot to sleep inside. I handed him his meal and I looked at his arm and I could see right through to his bones, and I asked him if he was going to go to the doctor, and he said, "Doctor? I don't go to a doctor." And he said the only thing he had was his Meals On Wheels. Here's the problem with that story: Al only got fed Monday, Wednesday, and Friday, because the program doesn't have enough to feed him five days a week, so what happens to Al on Tuesday, Thursday,

Saturday, and Sunday? And even on the days we did serve him, he only got one meal a day. One meal. I mean I could eat twenty-one meals this week if I choose, because that's the situation I'm in, but we're saying to these folks, unfortunately, we can only give you three. We have five thousand programs in the United States that do this and we're serving in excess of 1 million meals a day, and it's just not enough. The terrible truth is that we can't get to everyone. We have waiting lists, people who are literally waiting for meals. I mean, if you're eighty-five years old, how long can you wait?

To be candid, most of the time I feel like a failure. I want to end senior hunger, period. But I haven't yet, and I ask myself all the time, "What am I doing wrong?" The reality is that I'm getting older too, and it may not happen while I'm at the helm. But it will happen. If I accomplish nothing more than letting people know that there's hunger right in their backyard and there's something they can do about it, then at least I've done something.

"I always tell people: once you give some-thing back, whether it's a meal or something else, you're hooked. It doesn't pay monetarily, but it pays spiritually."

My parents were both deeply affected by the Holocaust, and being Jewish has affected me in every aspect of my life. During WWII, my father served in Europe with the army. He never wanted to talk about it: it never crossed his lips because he couldn't bear it, it was too sacred a thing for him. But I have right here in my desk drawer some pictures that they took of the death camps and the crematorium. I have them because I never want to forget that there are people in this world who suffer, and it is my moral obligation to make sure that in my own way I can end some part of suffering.

My mother was a very special woman. I still miss her every day. She was always volunteering—it was just part of her fabric. She taught us that we needed to give back, but to be honest with you, I never fully understood the meaning of that until I took this job. How wrong I was, and how right I am now, and thankfully, it's been over twenty years that I'm doing the right thing. I don't know if she was proud of me, but I sure was proud of her, and I don't think I ever told her that. I wish I had. I guess that what I do every day is to make sure I give back the way she did, and I believe that somewhere up there she's looking down on me, and I hope she's proud.

I don't see myself as a hero—not remotely. I'm just a kid from Brooklyn who wanted to be a folk singer in Greenwich Village, that was my greatest aspiration. My heroes are all the volunteers who go out there, rain or shine, and deliver meals. They have taught me more than my graduate degree ever did. This has been my college, and these people have been my teachers. There was a couple in New Jersey—true story: one was blind and one was deaf, and they had a route together. The deaf one drove and the blind one delivered the meals. In Alaska, they deliver meals on sleds, believe it or not. I went to deliver a meal once in Dallas, Texas—I thought it was so hot I was gonna die. And the elderly woman I was delivering to was sitting in her living room with a heater on, wearing a sweater, because she was so cold—she weighed about eighty-two pounds. These volunteers go and they sit and they talk to these people—it's amazing.

I have this nutty thing that I do—I handwrite thank-yous to everybody who donates to us. I had a consultant come in once and ask me, "Why do you do that?" And my answer was, "How can I not?!" I have to admit, this job really is my life. What do I do for fun? Meals On Wheels. What do I do for work? Meals On Wheels. Maybe it's crazy and every psychiatrist would probably say, "What the hell are you doing?" I just have to do it. It just feels right. And you know what? I have the luxury to bring my dog to work with me—he's a little Maltese. So, what could be bad?

I'll be honest, I've probably stayed too long in this position. I worry about it just becoming "Enid's vision," and it shouldn't be that. I should probably let some young people take it over, but I can't let it go, I just can't. It means too much. And this is going to sound Pollyannaish, but it's all coming from the heart: I just really think when the time is right, I'll know it—and I'll know that I'm putting it in good hands. But we're just not quite there yet.

Adam Braun

Founder and Executive Director, Pencils of Promise

Adam Braun launched Pencils of Promise four years ago on his twenty-fifth birthday with a modest 25-dollar bank deposit. That simple act of giving became the catalyst for a movement that has raised more than $3 million to build schools for the poor in developing countries, while simultaneously empowering America's youth to create social good. Having Desmond Tutu's stamp of approval and Justin Bieber as a spokesman certainly adds some muscle to the nonprofit's cause, but it's Braun's social-media savvy and progressive for-profit approach that separates Pencils of Promise from the rest of the philanthropic crowd.

Our very first in-country coordinator was a woman named Lanoy, who I met when I was backpacking through Laos, trying to identify a community in which to build the very first school. I stayed at this one guesthouse and Lanoy was changing the sheets, doing the dishes, and cooking soup for the guests. She just had an incredible light about her. She was very positive and intelligent and spoke English beautifully. But no one had ever given her a chance to pursue anything other than being a housemaid. So I asked her to become our first coordinator and promised her that I would dedicate myself to mentoring and training her to become a great business leader one day. She was very surprised by the idea that someone would show such an interest in her. And now, she leads a staff of forty and oversees all the schools built in Laos. This year the Southeast Asian games were hosted in Laos. Lanoy was the final torchbearer. To watch somebody go from being a housemaid to lighting the Olympic torch for her entire nation is the epitome of what we seek to enable at Pencils of Promise.

I got some really great advice some time ago, which was to make little decisions with your head and big ones with your heart. It's really guided all of the hiring I've done and important decisions I've faced, personally or professionally. Lanoy is our very first coordinator and that was a decision of the heart, but it's been validated time and time again through her contribution.

I was born in New York City but I grew up in Greenwich, Connecticut. In deciding where to move our family, my parents actually put a list together of towns with access to the very best public education and Greenwich was at the top of that list. I was a very good student, straight As for years, Salutatorian of my graduating class—I prided myself on my academics.

There was a definite culture of giving back in my family. I'm Jewish, and every Chanukah, when most kids got eight gifts, we got four. Every other night, we selected charities and, in lieu of a gift, my parents donated to that charity in our name. I usually picked charities around other children. It might have been homeless youth or education in the developing world. I was always, as a child, affected by the idea that other children lived in deep poverty. I think learning at a very young age what it meant to sacrifice the pursuit of personal possessions in the interest of a greater good had a large impact on what I've chosen to do with my life.

Until I was twenty-one, I wanted to work in finance. My whole adolescence centered on that professional goal. I interned at hedge funds and banks and studied Wall Street. Then, when I was at Brown University, I went away on a "semester at sea," which is an around-the-world trip with 650 other students and forty college professors. It's essentially a floating campus, and it really opened my eyes to life in the developing world.

Adam Braun at Pencils of Promise's office in New York City.

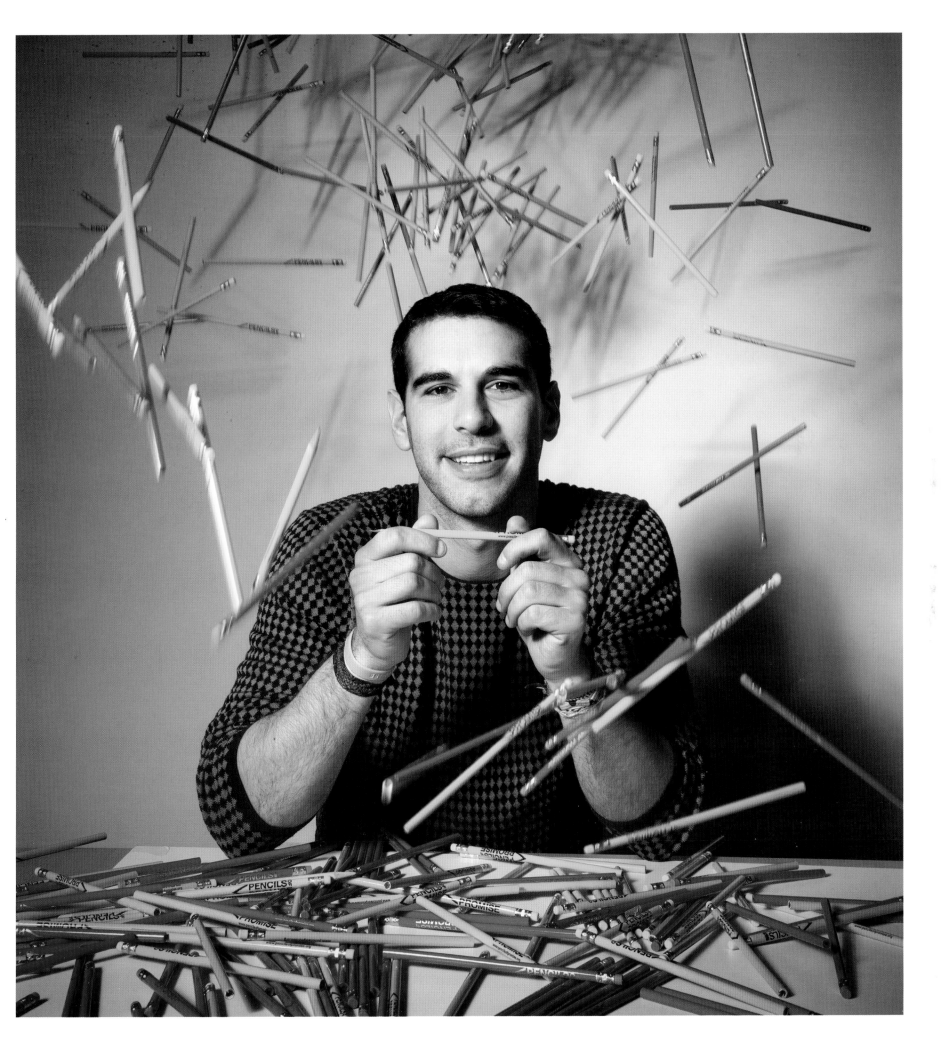

We visited ten different countries along the way, and I have this habit of asking one kid per country what they wanted most. I asked a boy on the street in India what he would want, if he could have anything in the world, and he said, a pencil. I gave him my pencil and he just lit up. It was a very powerful moment for me. So, I started passing out pencils through my travels and it always led back to conversations around the value of education and that so many children in extreme poverty don't even have access to basic schooling. Something as small as a pencil can be revolutionary for them.

I came back to the States and decided I wanted to pursue a very different path, and start a nonprofit that focused on building schools for children in extreme poverty. From that moment on, anyone who knew me knew that I was totally committed to this vision. I did a few independent studies on what it would be like to start a business. I also spent a lot of time studying nonprofit, for-profit, and governmental organizations, as well as the keys to accepting leadership and entrepreneurship.

> *"That was a key motivation in wanting to start Pencils of Promise: not just to do quality educational work on the ground, but also to train and inspire young people, in particular, to get involved in social action."*

A lot has changed in the field of social enterprise because of digital media. I was in Mark Zuckerberg's year in college. I was at Brown and he was at Harvard. He started Facebook his sophomore year and then it trickled over to our sophomore class. I was one of the first five thousand Facebook users. Suddenly, we had this emerging tool through which you could create a movement. Even amongst those without the capital, if they donated their time or energy or abilities, that could be really valuable. There was no organization working in international education taking that approach. That was a key motivation in wanting to start Pencils of Promise: not just to do quality educational work on the ground, but also to train

and inspire young people, in particular, to get involved in social action.

I'm pretty analytical by nature, so first I looked at what it would take to create the organization I had envisaged. It was clear that you need two capabilities. The first is real, practical knowledge of how to work with communities on the ground to help them achieve educational self-attainment. In order to gain that, I've spent half of the last six years traveling through the developing world. I've backpacked to more than fifty countries, living with and learning from the best communities and organizations working on international education.

The second capability is that the organization needed to be run like the greatest for-profits. I had to gain a strong business acumen. It was very clear that know-how and passion wasn't enough. Given that I had been on a path toward finance, I realized that working in management consulting at a top-tier firm would give me solid professional experience. I worked at Bain & Company for a couple years. I approached the job as a paid business school and sponged as much knowledge as I could.

In 2008, about two years into my time at Bain, I founded Pencils of Promise. I put $25 into a bank account on my twenty-fifth birthday and threw a party. I asked my friends to give $20 at the door or match my $25. Four hundred people came. We had our initial start-up capital. I threw a few more parties. On New Year's and Valentine's Day alone, we raised $35,000, which was more than enough to build the first school. In 2008 and 2009, 98 percent of the donations were in amounts of $100 or less.

With every new school, the first step is meeting with the Education Ministry. They provide us with a list of the fifty villages with the greatest need. Then we visit and vet each of those communities with really rigorous metrics. Once we create a score card of all the communities that we've assessed, we go back to those that we believe are most in need and that we feel most confident will do a great job of helping to build and sustain their own school.

We have architects on staff who put together a budget proposal, which we bring to the village leaders, elders, and educators. Every school has to provide 10 to 20 percent of the funding. Oftentimes, they can't come up with cash, so they make it up in materials and labor. They build their own school with help from our staff, which includes builders and contractors.

"We promote something just like for-profit companies do. You would never call them a 'non-purpose.' I think the vernacular should change and we should be calling nonprofits 'for-purpose' organizations instead."

Once it's open, the Education Ministry agrees to provide trained teachers. We also have a program called SHINE, which is an acronym for Sanitation, Health, Identity, Nutrition, Environment. Our SHINE coordinators are primarily local women. They work as educators in each of these villages, to teach community development and to monitor and evaluate the success of the school. It's always trial and error. One of our core beliefs is that innovation is incredibly essential to the success of Pencils of Promise.

We have a twofold program. There is the international side and then there are separate domestic programs. In the United States, we focus on training and inspiring a new generation of young people to incorporate social action into their personal and professional lives. A lot centers on digital advocacy and training. We have the largest social-media following of any nonprofit started in the last four years. One hundred interns go through our training program every year. They're not here photocopying and getting coffee. They're actually helping to build and lead the organization. Some of them, for instance, handle on-campus engagement at high schools and colleges, organizing events or outreach. There is an activation on behalf of Pencils of Promise every single day somewhere in this country. The highest-performing interns then have an opportunity to transition into the fellowship program, in which they participate in the planning and execution of building schools in other parts of the world.

Today, we have sixty full-time staff members in the field in the three countries in which we work: Laos, Nicaragua, and Guatemala. In the New York office, there are usually about thirty bodies, including interns.

Much of our funding is still very grassroots. Our community of individual donors expanded very rapidly past friends and family. We have thousands of supporters today, and I can assure you, I don't have that many friends. We also receive a lot of corporate capital—a great many companies are interested in promoting and creating good in the world. And we're starting to get major institutional support from grants and foundations. We're growing rapidly and building more schools than ever before. Our goal is to construct our hundredth school by the end of 2012.

There are enormous challenges in running a nonprofit. Oftentimes, they surface much more prominently in the media. For example, as a nonprofit, you're expected to operate with all of your funds going to programs rather than toward the ultimate goal of your mission, whereas a for-profit company doesn't have that expectation. For example, Apple's ultimate mission is to get great technology that changes people's lives into their hands. In order to do that, they spend a ton of money on marketing so their products can get out there. If they had to spend 90 percent of their dollars on producing computers, they wouldn't be successful. So, it can be very challenging. People want to know their donations are going straight to programs but there are a lot of costs that indirectly enable those programs.

Additionally, there's an expectation of transparency. The great for-profits don't have to share any of their private data or financials, whereas, with nonprofits, it's all public. Rather than shy away from that, we decided very early on that we were going to run at it headfirst. We promote the idea of radical transparency, because we really have nothing to hide.

There is fierce competition between nonprofits in the same space for funding. Rather than being competitive, we're as collaborative as possible. We celebrate the accomplishments and victories of our peers. That's why I'm very good friends with a lot of the great nonprofit directors out there. We have a mutual respect and affinity for one another.

I think it would be very difficult to take a hard-line approach to externally structuring a nonprofit the same way you would a for-profit. But certainly, mimicking the internal operations of how a great for-profit is run can be very valuable in a nonprofit. My big belief is that the term *nonprofit* doesn't actually make a great deal of sense. That's not what we do. We promote something just like for-profit companies do. You would never call them a "non-purpose." I think the vernacular should change and we should be calling nonprofits "for-purpose" organizations instead. That's really why we exist and what we focus on.

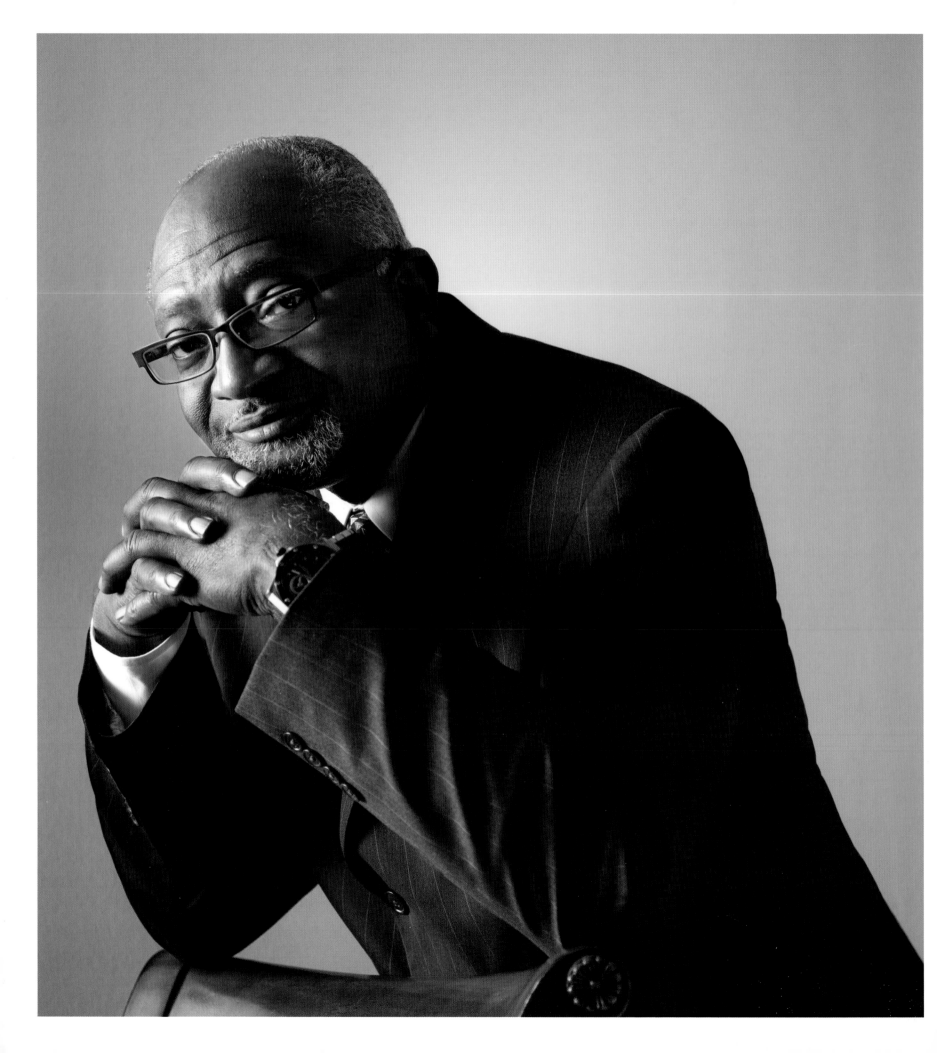

"It seems like common sense that you would not put a landfill next to a school or a petrochemical plant next to a park. But we found that this was systemic, and it was happening all across the United States in poor communities, and communities of color."

Dr. Robert D. Bullard

Dean, Barbara Jordan-Mickey Leland School of Public Affairs, Texas Southern University

Widely acknowledged as the "father of environmental justice," Dr. Robert D. Bullard has spent the last forty years crusading against ecoracism. Over the course of his professional life, Bullard has published prolifically, penning dozens of articles and seventeen books exposing the environmental disparities in low-income and minority communities, ranging from the glut of toxic waste dumps and pollution to the deficit of public green spaces and healthy food resources. When Bullard started in this field of work in 1978, not one American state had legislation concerning environmental justice. Today, all fifty states and the District of Columbia have passed some type of law, policy, or executive order. Yet the inequalities persist. African Americans are 79 percent more likely than whites to live in neighborhoods where industrial pollution is thought to cause the greatest health risks. "People may think I am racializing this, but how can you not?" wonders Bullard.

I was born in 1946 and I grew up in Alabama, in a small town called Elba, which was an all-black community. We did not have paved streets, sidewalks, sewer lines—all the things that were present in the white communities. No library, no swimming pool. I learned how to swim in a river that was very dangerous. I grew up during the time of Jim Crow. When I graduated high school in 1964, it was ten years after Brown v. Board of Education. The signs had come down, but it was still very segregated.

We were a blue collar, working class family. Both my mom and dad finished high school. They didn't go to college, but they believed in education, that education is the key to success. That was always drilled into us. I have three brothers and one sister, and my parents paid for all of us to get our advanced degrees. We didn't have any loans. It was tough, we were very stretched out, but they managed, somehow. In my high school, there were only three possible tracks: college, army, or Dorsey Trailers—which was the local industry in Elba. The idea of not going to college was not an option in my family.

I always knew that I wanted to be a college professor. It seemed to me that professors had a really cool job. I loved the idea of an occupation

that was about the sharing of ideas. Looking back now on thirty years of teaching and what I'm most proud of—it's the impact I've had on other people's lives. I've taught hundreds of students, and the biggest compliment that a teacher can get is when a student gives you a call or a shout-out, and says, "You know, Dr. Bullard, I'm an environmental attorney, or I'm a toxicologist, or I'm a law professor." Because you never know who's listening, and you never know how you've touched someone's life.

I'm at Texas Southern University now. It's actually a return to the place that gave me my start. I was fresh out of graduate school in 1976, after finishing Iowa State University, and my first job was at Texas Southern University. I was here until 1987. I was an assistant professor of sociology. And I did urban sociology—housing, residential patterns, segregation. That was twenty-five years ago, so it has come full circle. When the opportunity became available to be dean here in the policy school, it was very enticing. It feels wonderful to be back, because I know much more now.

Just two years out of graduate school, I was asked by my wife, who was a practicing attorney, to collect data for a lawsuit that she had filed here in Houston. Bean v. Southwestern Waste Management Corporation

Dr. Robert D. Bullard in his office at Texas Southern University in Houston, TX.

was the first lawsuit that used the civil rights law to challenge environmental discrimination. The suit claimed that the siting of one particular landfill in Northeast Houston fit a pattern that was racially motivated, and was a form of racial discrimination, and that black neighborhoods were systematically selected for the location of disposing of garbage. It was a landmark case.

I did a study to map the solid-waste landfills in Houston. I had ten graduate students in my research methods class, and we set out to examine the locations of landfills, garbage dumps, and waste incinerators, which did not have zoning back then and still do not have zoning. So we had this puzzle to put together—and this was before computers. We were able to get base maps, and we color-coded exactly where the landfills were with Magic Markers and stickpins.

What we found is that Houston sited 100 percent of its landfills in predominantly black neighborhoods. And six out of the eight incinerators and three out of the four privately owned landfills were located in predominantly black neighborhoods. Black people only made up 25 percent of the population in the city, but they got 82 percent of the waste. This was the first study done of its kind.

We didn't win the case, because this was 1985, and in many ways the rules were not fair as they related to meting out equal justice. The elderly white judge kept calling the plaintiffs (residents of the neighborhoods) "Nigrahs," which is not a term of endearment. It's just short of calling someone the "N" word.

Even though we lost the legal battle, I expanded the studies to look at Dallas, Louisiana, and Alabama. That's what sociologists do: we carry out studies. And once I started looking, I saw this pattern. As a researcher and a social scientist, it became an area that was really attractive to me because I was uncovering another form of discrimination.

So I started to recruit others to help me. We began writing together and collaborating. There was no established methodology for doing this type of research. We invented a strategy for plotting these facilities on maps, and color-coding, overlaying, and looking at the demographics and the proximity of waste facilities to public facilities, such as parks, schools, and recreation centers. It seems like common sense that you would not put a landfill next to a school or a petrochemical plant next to a park. But we found that this was systemic, and it was happening all across the United States in poor communities, and communities of color.

One of my heroes is W.E.B. Du Bois. He was an excellent scholar, researcher, policy analyst, political critic, and an activist. I tried to model my career after his. Du Bois's approach became my approach: gather the facts, document everything, and put your findings in the hands of someone who can make change; and educate and inform those individuals and communities that are in the impacted areas—get them information so that they can start to speak for themselves.

I knew that if I could document it, I could have an impact on policy. Once I had the research, I gave it to people who could use it and take it to the next level—like the city council or a county commissioner meeting or a Congressional hearing. These issues may be invisible to the larger society, but that does not mean that people aren't getting hurt. Awareness is the key. Legal action is important, but it has to go hand in hand with education, training, organizing, and mobilization. That has always been the case. That was true in the civil rights movement and it's still true today.

The turning point that really brought the issue of environmental justice to national attention was in 1983, in Warren County, North Carolina. PCB-contaminated oil had been illegally dumped on the roads in 1978 and the governor needed someplace to move the dirt. He chose Warren County, which is very poor and predominantly African American. A national protest broke out. It was the first time anyone in the United States had been arrested for protesting a toxic-waste landfill. That's when the term "environmental racism" was first coined by Reverend Ben Chavis, who was leading the demonstrations.

I had no direct involvement with what was happening in North Carolina, but I knew it was very similar to the placement of waste facilities in Houston. It quickly became clear that this issue of waste and race was a national phenomenon. A group of us sociologists began sharing and comparing information and ideas via phone and fax—this was before the age of e-mail—from all around the country. An then two environmental justice professors and leaders, Bunyan Bryant and Paul Mohai, held a conference that brought a number of us together. That's when we

pooled our research to create the first real picture of what environmental inequality looked like in America.

We started planning the first National People of Color Environmental Leadership Summit to be held in Washington, D.C., in 1991. We invited community groups, professors, environmental justice groups, lawyers, and policy makers from around the country who had all been working in isolation up to that point. The intention was to connect all these separate factions into a single army, if you will, and create a strategy for change. We expected five hundred people to attend, and more than fourteen hundred people showed up. Together, we developed the seventeen principles of environmental justice. Those principles stand as relevant today as they did then.

I've never seen myself as an organizer, but it has taken a high level of dexterity to mobilize not just communities but also lawyers, toxicologists, epidemiologists, hydrologists, economists—to work with all these various disciplines and with people who have different worldviews. The glue that holds us all together is the idea of justice.

The early days of the movement were focused mainly on anti-toxics—fighting landfills, incinerators, pollution, and poisoning. Over the years, groups started to expand to all kinds of issues, including transportation, housing, food security, and climate change. Because when we talk about overlaying race and class with space or place, you can see how the communities that are most likely to get environmentally dumped on are the same ones that are most likely not to have a green space, or a full-service grocery store. Even all transit is not created equal—some communities get light-rail and clean transit, and others get dirty diesel buses that are dilapidated, or have very little public transit at all. Think about what happens without adequate or safe public transportation: it cuts people off from jobs, from parks and recreation facilities, from hospitals. It is all intertwined.

At the center of all these disparities dwells the question: Why is it that some communities get benefits, while others have to pay the cost? That's the equity analysis that has now been adopted across the board. The results of that analysis are being used to challenge the way that tax dollars are spent, and to challenge the disparate allocation of resources that is starving some communities for parks, transit, full-service supermarkets, banks, and other services.

At the same time that we've been focusing on all these inequities domestically, we've also expanded our sights beyond U.S. borders to examine global environmental justice issues. Years ago, we started to engage the U.N. process and attend U.N. summits, where we presented our seventeen principles of environmental justice. By 1992, those principles had been translated into at least a dozen languages and environmental justice was becoming an international movement. Our framework has been adopted at every U.N. summit, and it's being adopted in a number of countries around the world. These issues resonate globally, whether we're talking about human rights, climate justice, land rights, or sovereignty.

The environmental justice movement has redefined *environment* to mean both the natural world and the places where we live, work, play, learn, and worship. We can't leave people out of our concept of the environment. And once we start to talk about people, we have to talk about justice and equality. Our society is still very segregated along class and race lines, and the poor and minorities suffer more adverse effects. Too many Americans don't have a clue what happens outside their own neighborhood. They assume that everybody shares equally the effects of pollution or degradation, but that's simply not true.

Susan Burton

Founder and Executive Director, A New Way of Life Reentry Project

Growing up in the projects of South Central Los Angeles, Susan Burton had a childhood filled with poverty and brutality. After a series of traumas, including the tragic death of her young son in 1981, she began a decade-long battle with alcohol and drug abuse, serving multiple prison sentences for drug-related crimes. In 1997, she finally got clean and turned her life around. One year later, she founded A New Way of Life Reentry Project, an organization that offers housing and support to women being released from prison. In the past thirteen years, A New Way of Life has sheltered and rehabilitated hundreds of formerly incarcerated women, less than 20 percent of whom have returned to prison since leaving the program.

South Central was a dangerous place to be a girl. I had five brothers, some of who abused me. I remember one of my brothers putting a spoon in the fire on the stove and burning my arm with it. There was a lot of violence in the house. My father drank excessively, and he beat my mother. She finally divorced my dad when I was eight. So my mother became a single parent with six children, and my father became a scorned black man, you know?

The first time I went to prison, when I was about thirty, was for being under the influence of a controlled substance. I had started drinking excessively and using drugs a few years before that, when my five-year-old son was killed in a police-car accident. Over the next decade I was in and out of the justice system more than six times. Every time I'd leave prison, I'd get off a bus in downtown skid row, no ID, no social security card, no place to go because my family's home was not a safe place for me. I vowed not to return to jail, but I would always end up back in a world of underground drug use and criminal activity. I remember one time I was released and the person who picked me up from the prison had drugs in the car.

Finally, they put me in a rehabilitation program and I went through this weekly counseling class, which really helped me look at myself. I stayed there a little over three months, and in that time I realized that just about my entire life had been filled with excruciating trauma, and that I had learned to endure it and survive it, and that it wasn't normal. That was the first time I recognized that something was really wrong and needed to change. That place was really magical for me, there was this degree of genuine concern, love, understanding, and structure, and I think it sort of infiltrated my hard exterior.

One of the steps I had to go through in rehab was something called doing inventory. It's the process of looking at all the people you've harmed, and all the resentments you still have, and making peace with all those parts of your past. I forgave a lot of abuse that had happened to me, forgave myself for some of the abuses that I had delivered, forgave the policeman who killed my son.

I never used again after that. One of my brothers—my sponsor calls him the "good brother"—he helped me to get sober. He paid for my first month in the recovery center and helped me find a good job as a home health aid. I moved in with the lady I worked for, so I saved all my money and tried to go to nursing school. But the school said with my criminal history they wouldn't even let me enroll. I was furious about that. So I had this idea that I could use the money I'd put away to help other women like me. During that period I had gotten really involved in my community and began

Susan Burton in front of Southern California Library of Social Justice with two participants in A New Way of Life Reentry Project in Los Angeles, CA.

to understand the massive rate of incarceration for women with substance abuse histories. I also saw that in other more affluent communities, people weren't going to jail for substance abuse, they were being referred to treatment instead. And I just thought, why isn't that happening in South LA? I bought a lil' house and opened it up to women who'd just gotten out of prison, and I called it A New Way of Life. It was ten of us living together, poolin' our money to pay the bills, supporting each other and creating an environment of healing and recovery.

Obviously, I didn't know anything about running a nonprofit back then. I basically taught myself what I had to do as the need arose. For instance, I incorporated about a year after I started A New Way of Life mainly because I'd asked to join the transportation program of this local church and they told me I'd have to become a nonprofit to participate. So I said, "Okay," and I went and filed for nonprofit status. Then I was nominated and selected for a California Wellness Violence Prevention fellowship and through that I really learned how to run an organization. One thing just built off the other.

> *"The state of California has built thirty-three prisons in the last thirty years and just one university. It is really troubling that we can put so much energy into punishment and incarceration and so little into education, prevention, and supporting poor communities."*

It's been thirteen years since our founding, and today we have a full-time staff of ten who oversee five homes, which house fifty to sixty women and ten kids. They come to us with a sort of fear in their eyes, with walls around them. We give them a community to belong to and the support they've never had before. We offer them classes and we also have a legal department, made up of three lawyers, that helps them expunge their criminal records and get occupational licensing like nursing or CNA. Because if you have a criminal record, licensing boards automatically reject your application without even reviewing it, so we file appeals for them and we have a 100-percent success rate. It just goes to show you how the cards are so stacked against you when you have a criminal history.

When a person first comes out, for the first thirty days we want her to get acquainted with the house; get accustomed to the services that we offer; get her ID; get her connected to public benefits. I try to use that time to evaluate who they are, what their strengths are, what their weaknesses are, and I do this by observing them, not by asking them some long list of questions—I think that's impersonal and it doesn't tell you who the person really is. Then I begin to gauge what their needs are and how we can support and help them. One of the things we ask the women to do is really look inside themselves to answer the question, What do I want to do? What makes me happy? I don't want to tell them what to do. I want them to figure out what they want to do with their lives. That's a big part of this process.

There are a few things we require for participation in the program—you have to stay sober, and I won't tolerate any physical aggression. We teach the women how to communicate in other ways through our Peace over Violence class. They also have to commit to engaging in school, work, or volunteerism—something that is bettering their lives, which will ultimately better the lives of others. If they need it, we will help place them in rehab. We do also require that everyone attend some type of support group or 12-step program. Every morning in the houses starts off at 8 A.M. with what we call Morning Meditation, where the women read from a positive book called the *Recovery Book for Women*, and they set goals for themselves for that day or the week or the month. Between 8 A.M. and 10 A.M. chores are done, and then we ask for a weekly schedule of activities. We just try to provide a real structure that will help them down the road when they're back on their own.

It becomes a family community, and people play different roles. Sometimes the older women treat the younger women like their daughters and help guide them; some of the women have cars and some don't, so

I see them gathering to go on outings and to meetings together. It's a community in which each person is reaching back to help the next person along, sharing their experiences, sharing their resources, sharing their chores, and supporting each other.

In time, you can see these women really start to change. They learn that life does have ups and downs, and though they're down today, they can be up tomorrow—they'll survive this. I see that *resolve* happen within them. A light starts to come on in their eyes, they take on a new kind of determination, and you begin to hear laughter in the house.

"In time, you can see the women really start to change. They learn that life does have ups and downs, and though they're down today, they can be up tomorrow—they'll survive this. I see that resolve *happen within them. A light starts to come on in their eyes."*

I remember one young woman, Tiffany, came to us after serving a sixteen-year sentence. She was convicted of shooting her childhood molester who was also beginning to molest her sister, and she was protecting her. She wrote to us and said that she had been incarcerated for a long time, and she asked for our help when she got out. The morning after her first night in the house, I came by at 9 A.M. and found her sitting in the chair next to the door rocking, crying, and clutching the Bible. I asked her, "What's wrong?" and she said, "I was upstairs and I heard all the other women downstairs, but when I came down no one was there. I went back upstairs and I wanted to take a shower, but I didn't know how to turn the shower on. I'm all alone and I don't think I can do this. I don't even have a coat." And I said, "I'll give you one of my coats, and I'll teach you how to turn on the shower, and all the other things that have been updated and created since you've been gone, you'll learn how to do them one by one,

and you're gonna be okay, you don't have to do this alone." This was about a year and a half ago, and today, Tiffany's employed, she lives in her own place, she has a car, and she's doing really well.

It's been a long journey, and I feel very blessed, but there are definitely still challenges. The economic landscape is really bad. California wants to just keep building prisons instead of schools. The state has built thirty-three prisons in the last thirty years and just one university. It is really troubling that we can put so much energy and so many resources into punishment and incarceration and so little into education, prevention, and stimulating and supporting poor communities. It's very heartbreaking to see that that's the way the world works.

When I started A New Way of Life I never imagined that I would be doing development work, I just thought that if women had a place to come they would be all right, and I could pay the bills if we all pitched in together. So it was a really simple concept of providing and creating a household, a family not related by blood but by a shared mission to get their lives together, and I think that it's really scalable. That's the next phase of my own development—to encourage and create ways that people can duplicate these reentry homes in communities throughout the country. I've actually mentored three other women who have started their own homes so far, and now the goal is to develop a training manual to get people started, and then encourage them to implement their own ideas and design.

I started this organization—not because I wanted any fame or recognition, but because I wanted to see something different happen for people who had the potential to make a valuable contribution to the world if given the opportunity. You look at these women's lives, and I look back at my life, and I just say, "Hey, I got a real dirty deal here in this life, and I have a right to be mad." But I don't have a right to be angry to the level that it's destructive. Things just happened like they happened, they were unfortunate, but someone helped me to see that. And now my job is to help others to see that and move beyond it. I don't know what the effect of this will be ten, twenty, fifty years from now, but I feel like I'm on the right track. I think I'm showing California, the United States, the World, that there is an alternative: we can treat people differently and have more positive outcomes.

"We created HCZ because we needed a more powerful way of intervening in poor children's lives."

Geoffrey Canada

President and CEO, Harlem Children's Zone

Geoffrey Canada started the now famous Harlem Children's Zone (HCZ) fourteen years ago with the goal of providing every necessary support service to the children living on one block in New York City's poorest neighborhood. Today, the Harlem Children's Zone serves the needs of eleven thousand children, from birth through college, and their families, within a nearly one-hundred-block area. Canada's recognition that to truly provide a good education you must attend the health of an entire community is at the very heart of HCZ's philosophy. In the face of a chorus of detractors, he has refused to compromise his vision every step of the way. His one-foot-in-front-of-the-other approach and steely determination has turned what began as a small social experiment into a program that has set the bar for educational reform in this country, and people have taken notice, all the way to the Oval Office. In 2009, President Obama vowed to replicate HCZ's model in twenty cities across the United States. "If it were going to be easy, it would have been done before," says Canada. "But is it doable? Absolutely."

Geoffrey Canada with a group of students at The Promise Academy in Harlem, NY.

I was the kind of student who was easily distracted. I had a wonderful teacher in the first grade who saw my potential and was intent on getting me to focus. She tried everything—painting, poetry, nothing worked. One day, she started reading to the class. It was a book about this guy who had these eggs and the eggs were green. He didn't eat them on the house and he didn't eat them with a mouse and he didn't eat them here or there. I had never heard of Dr. Seuss before. I said, "Excuse me, could you read that book again?" So she read it again to the class. Then she suggested I take it home. So I did, and had my mother read it. The next day my hand flew up first thing and I asked, "Teacher, can you read that book again?" She said no, but she sent me to the back of room and told me to read it to myself. I didn't know how to read yet. But I learned, because this wonderful teacher just kept trying to connect until she opened up a whole new universe.

People sometimes say, "All children can learn," but they don't really mean it. I know absolutely all children can learn. It's about whether or not you've found the right key to unlock that great potential that we all have inside of us. This teacher changed my life. By the end of the first grade, I had read every single Dr. Seuss book in the school—every one. When I finished, I was absolutely convinced that my life was over. I went crying to my mother, "I'm only in the first grade and I've already read all the great literature in America."

My mother always told us the key to life was reading. She just kept saying it, "The key to this is reading. No matter what happens, you just have to read." And she allowed me to read all kinds of stuff. I was reading adult books when I was still in elementary school. She didn't care. The books had curse words in them. It didn't matter: "The key is reading." Now, we were very poor, and we couldn't afford things like haircuts. The other kids would laugh and tease me. My mother would say, "It's not what's on your head. It's what's in your head. That's what matters." I'd be like, "That's not what I wanted to hear." But you know what? Years of those kinds of messages began to really seep in and suddenly I started saying that to myself.

Reading also taught me that the way we lived in the South Bronx wasn't the way everybody lived. There was a whole different world out there, where you didn't grow up with roaches and rats and having to worry about people shooting and robbing you. Even fifteen blocks away, people were growing up with a totally different view of what childhood looked like. I just thought to myself, "Why did this happen to us?"

I used to read comic books and I believed Superman was real. I remember one of my friends telling me one day, "You know, there's really no Superman." So I asked my mother and she had no idea what I was talking about. She thought I was asking, "Is this cartoon real?" But what I was really asking her was, "Isn't there somebody who will come in and save us?" She said, "No, no, Superman is not real." And I thought, "There's no one coming?" They're going to just let us live like this?" And it made me realize, there needs to be someone coming into these communities and saying to kids, "No, I'm here. I'm going to make sure the monsters don't get you. I'm going to make sure that this system works for you." At eleven or twelve I decided that's what I was going to do with my life.

From sixth grade to high school I lived through one of the most turbulent times in this country's history. We had not only the assassinations taking place—Kennedy, King, Malcolm X—but also cities burning in the summertime. We had these long, hot summers where there were riots in the street. By the time Martin Luther King was killed, I remember thinking that African Americans would never see anything that looked like equality in my lifetime. We believed it was one big conspiracy, and that if you said certain things in this country, you would get killed. So we figured we would smash through every door they'd let us without killing us. How far could you go? Well, you'd never get to be the president, so leave that one alone. But could you run a Fortune 500 company? Maybe. Work for a major law firm? Maybe. We didn't know exactly how far we could go. We just thought we had to open as many of these doors as wide as possible to advance the corps another couple of steps. That's the best we hoped for.

I certainly never imagined I'd get the opportunity to do what I've done at the Harlem Children's Zone (HCZ). This year we'll spend about $95 million in Harlem. If you asked me back in 1976, when I first began teaching, "Is anybody ever going to trust you with that kind of money?" I'd have said, "Are you kidding? Don't you know where I come from?" At the time I began this work I wanted to be a teacher and I wanted to save

twenty kids. And when I had done that, I thought, "Wow, maybe I can save two classrooms." Then I said, "Well, maybe I'll run the school and I can save all two hundred kids." So, it started from there and I slowly opened up to the possibility that I could do much more.

> *"In some communities if you're not lucky, you don't get into Harvard. In others, you end up dead. The challenge for us is to level the playing field."*

We created HCZ because we needed a more powerful way of intervening in poor children's lives. So we carved out an area of Central Harlem that now comprises ninety-seven blocks. We wanted to start with children from birth and stay with those children until they graduated. We tried to figure out how we could do everything: housing, health, education, child care. We had to solve each one of those areas. They're absolutely all interconnected. We had to really bite off tiny bits and be successful at doing a small thing first. I think that in the end, if you really want to have an impact that is large, it is about going one step at a time.

Basically it gets back to education. It gets back to: Are we making sure these young people have an education that's competitive? It's not just whether or not the schools are equitably funded or integrated. You've got all of these other barriers that have to be removed before these young people can get an education. This is the part that bothers me—people come in to HCZ and they ask, "Do you provide health care?" And we say, "We have a health clinic." And then they ask, "Do you have mental health services?" "Yes, we have psychologists, social workers." "Do you provide education?" "Yes, we run our own schools." "Do you offer recreation?" "Yes, we have terrific recreation, culture, arts." They're like, "Isn't that great?" And I think, "No, it is simply average." That's what the average middle-class kid gets in America. There's nothing great about that. I haven't figured out some terrific new revolutionary way of educating. No one should think that it's some special thing that we're providing because that should be every child's right as an American. It just should be average.

I think that one of the great shames of this country is that my success isn't based on whether or not I had the potential. If I hadn't gotten lucky, my life would be over. I wouldn't have graduated college. I'd probably have ended up in jail or on drugs. That's what happened to all the rest of the kids in my neighborhood who didn't make it out. See, in some communities if you're not lucky, you don't get into Harvard. "I can't go to Harvard. I have to go to a state school." Oh boy, you weren't lucky. In other communities if you're not lucky, you end up in jail. You end up dead. Part of the challenge is for us to level the playing field.

Young people often ask me, "Can you tell me how to get where you are and what the secret sauce is in doing that?" I remind them that I've been here nearly thirty years. That's the first thing. I say, "You know, fifteen of those years you didn't know who I was." There never was any map for how to get from there to here. We saw something that we cared passionately about. We said that we're going to try and figure out how to solve this. We were prepared to work on this issue until we died. We thought it was that important. No one ever expected we were going to make any money or get famous.

There are some people who think studying leadership development is the way to become a leader. That's a path that I am doubtful of. When young people in the organization ask about leadership, we say, "The leader is usually the one who works the hardest, the one who works holidays and weekends. They can do that year after year after year." Leaders do what needs to be done, whatever it is, and they do it for as long as necessary. And they never lose touch with what the mission is.

I hope my greatest contribution as an African American leader is going to be that we have proven without a doubt that we can take large numbers of poor, disadvantaged students and get them through college and on the path to success. I want to prove it so convincingly that there won't be a question of whether or not it can be done anymore. It will only be a question of whether or not we have the will to do it. I want to end that whole conversation and just get it down to: Do we or don't we care enough?

Eugene Cho

Founder and President, One Day's Wages

The idea for One Day's Wages came to pastor Eugene Cho as the literal answer to his prayers. Cho listened, and was able to summon the courage, strength, and faith required to make a sacrificial decision in the face of his responsibilities and expectations: to abdicate his salary and all financial security for one year in the name of service. That selfless act has since encouraged thousands of people to donate one day's worth of their income to aid the poor. "You don't have to be a celebrity, rock star, or millionaire to help change the world," says Cho. In just over two years, One Day's Wages has raised more than a million dollars, which supports myriad projects around the world to improve education, deliver clean water, and end poverty.

In my desire to be a better storyteller, I've learned that the best way is to live a better story. So, that's what I am trying to do. My parents are really the beginning of my story. We came here as a family from South Korea in 1977 with very little. At six, I was the youngest. My brothers were nine and twelve. For my parents, it was the pursuit of the American Dream. The opportunity to come to the United States and have their three sons educated here and go to college was very much part of that, so there was a lot of pressure placed upon us.

It was only as an adult that I realized their expression of love was to have these very high expectations of us. I can't say enough about how much respect I have for my parents. It's hard to imagine what it must have been like for them, as late-thirtysomethings, not knowing a single word of English, leaving everything behind to come here for the sole purpose of creating a better life for their children.

Eugene Cho at the Olympic Sculpture Park in Seattle, WA.

One of the three times in my life that I have seen my father weep was when I graduated college. He said he could die in peace now that his youngest—like his brothers—was completing his college degree.

I really struggled with fitting in when I was growing up. Kids would often ridicule me because my English was horrible. I wet my pants every week in first grade because I was too afraid to ask permission to go to the restroom. In junior high school I was voted the shyest person in my class. I struggled with stuttering. People would say, "Why don't you go back home?" After the seventh grade, I spent a summer in Korea. But my Korean wasn't fluent, and there, too, they would tell me, "Why don't you go back home?" It only exasperated this identity issue I had.

But over time, I think I just became more comfortable in my own skin. I began to realize that when people believe in you, love you, care for you, and advocate for you, you can be yourself. Though I struggled, I had a couple friends who really supported me. So, it was a series of things that helped me to find my own voice.

The Church wasn't a big part of my adolescence, but when I became a Christian at the age of eighteen, that became a pivotal part of how I saw issues of injustice and compassion. In college, I double-majored in psychology and theater. I wanted to pursue theater. It had become a way for me to confront my shyness and stuttering. But my parents ordained that I would be a doctor. So, I added the second major to appease them. Then, in my third year in college, I decided I wanted to be a minister. It would be inaccurate to say it was last on my list because until then, it wasn't even on my list. But it felt like a calling.

When I shared this with my parents they were incredibly disappointed. They had grown up in extreme poverty. To them, ministers were people who weren't able to succeed in other areas and lived off the generosity of others. But now, they are so proud of me. It's pretty emotional for me to say that, because pleasing my parents has been a lifelong pursuit.

I went to Princeton Theological Seminary but I took a couple years off to work as a pastor in Korea. I wanted to reconnect with my roots. That was a very important part of my journey. Also, I met my wife in Korea. After I finished seminary, I came to Seattle to be pastor of a church in the suburbs. I was there for three years. Then I moved into the city to a much

more multicultural context to start my own church. I wanted to be investing in things I really cared about. I had been at a homogenous Korean-American church. I'm a very proud Korean American, but I also grew up in the diversity of San Francisco, and I wanted to see multiculturalism and different ages and backgrounds coming together. I wanted to be mindful about art, justice, and engaging the larger city, not just the affairs of a particular church.

Regardless of your religious background or if you even have one, every single human being is on a quest. We're searching for meaning or worth. And I wanted to communicate as graciously as I could that God is also on a quest for His creation, that God is searching and courting people to be in a relationship. So we named the church Quest.

We started from scratch. We had seven people come to our living room the first time we congregated. It was humbling, but at least it was five more people than my wife and me. There wasn't a guarantee this church would get off the ground; but one thing I've learned about myself is that I'm pretty passionate and very tenacious. Slowly but surely, people came. We didn't want to be about organized religion. We wanted to be a church that was committed to relationships and to serving our neighbors. That began to resonate and grow.

Eventually we began meeting at a café—very Seattle-esque. As we outgrew that, we started renting out a church. Five years ago, that church did an incredible thing and chose to close down and give us all of their land and assets. Several of their congregants decided to join our church.

I had developed a reputation in my community for caring about social justice. When you start writing and preaching about things, it's possible to end up liking the idea more than the action. It was a painful revelation to me that I had grown to be in love with the idea of compassion, but when there was a cost to me or my family or a sacrifice involved, I was no longer comfortable with it. That was how One Day's Wage came about.

I trekked into Burma to do some research on the Karen people, who were victims of genocide. We visited a makeshift school. There were posters with pictures of men, women, and children, bleeding, with missing limbs and oozing body parts. This awkwardly taped collage was their way of teaching the kids to avoid land mines. Later, I discovered the

yearly salary for their teachers was $40. It was humbling and shocking, but I also felt inspired. Walking through the jungle, I was reminded of a quote from Mother Teresa, "If you can't feed one hundred people, then just feed one."

I thought, "I might not be able to change the whole world, but I can start doing my part." Processing this trip with my wife, we knew we wanted to go beyond loving the ideas of compassion and justice and start investing our lives into them. Being people of faith, we prayed. As we prayed, we received an idea to give up a year of our wages. I was thirty-seven years old with a mortgage payment. I had three kids with piano lessons. We're your average middle-class folks, struggling to pay our bills. I was not initially thrilled about this idea.

But I also realize how blessed we are. My yearly salary is $68,000. So, it meant coming up with $68,000. We were hoping that if we gave a year's wages it would inspire people around the world to consider donating one day's wages. That comes out to 0.4 percent of one's annual income. Our initial aspiration was that One Day's Wages could change the world. But I've learned that the most important change that happened was the change in us, in my family, in me.

I'm really grateful for that experience. But having said that, it was extremely difficult. We gave up everything beyond necessities. It's hard for me to say this, but if I knew now how difficult that journey would be, I don't think I would have done it. For a couple months we had to leave our home and sublet it. We stayed on our friends' couches. Our loved ones really questioned our wisdom.

During that time, I got into a major accident and ruptured my Achilles tendon. We couldn't afford to pursue surgery. It's part of the wonderful story of our lives. It's not perfect. It's very broken, very blemished. I think part of the reason why it's resonating with people is because of the fact that we're your average people. I'm not a celebrity. I'm not a rock star. I'm not a billionaire. I'm just your everyday person trying to speak the language of others to say, "Hey, we really are blessed and there are people living in this world who are living in extreme poverty."

One Day's Wages is incredibly grassroots. I have one full-time staff member. Our headquarters is a spacious 250 square feet. But we've had

more than seven thousand people around the world give. We've raised over $1.2 million and 100 percent of those donations (minus credit card fees) goes to projects around the world.

Internationally, we work on education, water, and food-security issues. And as much as I care about the 1.4 billion people who are living on five quarters a day, my hope is also to start a domestic version of One Day's Wages to focus on lack of equity and access in education here in America. My church has a homeless advocacy center. Every day I'm reminded that these men and women who are living in our streets also need our encouragement and support.

> *"Walking through the jungle, I was reminded of a quote from Mother Teresa, 'If you can't feed one hundred people, then just feed one.'"*

My posture has always been to be a peacemaker, even if I have to speak directly about difficult topics. Ultimately I have to be about people, to live with kindness and grace. I have congregants at my church who are very different from me and who see the world differently, and I think that's what makes life beautiful and challenging. Good leaders take a posture of humility and listening. I continue to grow in that pursuit.

I often joke that my children may need counseling later on because we really underestimated how difficult starting One Day's Wages was going to be. My oldest daughter, Jubilee, prayed every single day because she was scared about what might happen to our family. But they're also really proud of what our family has done. They're the ones who are eager to share the story of One Day's Wages with their friends and in their classes at school.

My children live with the kind of privilege my parents struggled to provide for us. I don't have to worry about that for them. But, I think you fail as a parent when you cease to have expectations and wishes for your children. My wife and I hope they will live to bless and empower other people, that they are agents of hope and change in the world.

Taryn Davis

Founder and Executive Director, American Widow Project

Taryn Davis was just twenty-one years old when her husband Michael was killed in Iraq by multiple roadside bombs. Theirs was a young love story that's tragic abbreviation shattered Davis' life. As she searched for a way to survive her grief, Davis reached out to other military widows across the country and asked them to share their experiences. In the details of their personal stories of love, loss, and survival, Davis began to find her footing for the first time since Michael died. Through her own journey of healing, Davis discovered her true purpose: to connect and unite the disparate community of America's military widows, and provide them with opportunities to exchange memories, form friendships, and support one another. Since 2001, more than 6,500 U.S. service members have been killed in Iraq and Afghanistan. Around half of these service members were married, leaving behind an estimated 3,200 military widows. The American Widow Project provides a virtual gathering place for these women on its website, as well as a twenty-four-hour hotline and monthly newsletter. Davis also travels the country bringing small groups of military widows together for unique adventures, like skydiving and camping.

I was almost sixteen when I met Michael. He had just moved to our town of San Marcos, Texas, and of course I liked him right away: he was a total nerd like me, but a very good looking nerd who liked video games and *Star Trek* and all these crazy awkward kinds of things. Michael was a simple person, but very, very smart. He was a guy of few words, but when he spoke it was very poignant. The first time he brought me flowers, all he wrote on the card was "You Make Me Happy." We always thought that was really perfect, it defined our whole relationship. We dated through high school and the beginning of college, and that's when I noticed Michael really struggling to find his path. One evening he even expressed to me the fact that he felt that the journey he was on was one he couldn't envision in the future. He wanted to make a difference. He wanted to feel challenged. He knew that what he was doing was not where his life was meant to go. In his apprehension, I found myself doubting our relationship and abruptly asked that we part ways.

I knew Michael was devastated, but I needed to work on myself, by myself. Months later, I wrote Michael a letter and I said: "I just need

you to know where I am and I still love you because so much of who I am is because of you." Three months later—nearly a year since we had last spoken—he called and said, "Taryn, I'm joining the army, and I'd like to see you if I can."

I was taken aback. Michael had never expressed any interest in the military before. I said, "Of course." We were able to meet up a week before he swore in. We spoke about our lives and what his plans for the future were. More than anything, I wanted to know what made him decide to join the military. He said, "I feel like I have to do this to see that I can be challenged and make a difference, and I just need to know others will support me." I told him I would write him during his training. Well, I wrote him two or three letters a day for five months straight and it was during that time I saw Michael become the man I knew he could be: someone who was passionate about something and excited about his future.

When he called to say he was going to be stationed in Alaska, without a doubt, I said I'd finish my senior year of college up there. "If you get deployed," I told him, "I don't want to think that I didn't spend every

Taryn Davis holding her husband Michael's boots near her home in Driftwood, TX.

single day leading up to that deployment being by your side." He called me back ten minutes later and said, "Let's get married. I know how finite life is, and if we have what we want in front of us, why wait? I know I want to spend my life with you, and I know I want you to be my wife and if you're okay with that, let's just do this." So three months later—four days before my twentieth birthday, on December 23, 2005—I got married to Michael in Austin, Texas.

After he was deployed, I moved back to Texas and went back to college. We live in a society where the visual and the physical are such big priorities in relationships, but in our case those things didn't matter; our love would endure all things. If anything, that time apart just strengthened and solidified our relationship. When we talked, Michael never told me what he was doing and I never asked, because I knew if he wanted to tell me he would, and if he didn't, it was probably because he didn't want to worry me.

> *"He would always look down at me and ask: 'Baby, why do we fit so well together?' And I would say, 'Because we were made for each other.'"*

Eight months into his deployment Michael completely surprised me and just showed up at our home one morning in April 2007. I opened the door and just jumped up on him. He had two weeks of R and R, and we sat on the porch and talked about starting a family and how he wanted to finish school once he got out. We spent a lot of time together at the river with my family—he loved swimming—it was simple and it was perfect.

When I took him back to the airport I promised I would not cry. So when his group was called he stood up and said, "All right, babe, it's time for me to go." I'm five feet four and he was six feet two, so I could literally put my hands in front of me and walk forward and they would just fit perfectly around his waist. He would always look down at me and ask: "Baby, why

do we fit so well together?" And I would say, "Because we were made for each other." So I remember I did that then and he looked down at me and said, "I love you and I'm so in love with you," and I said, "*Just come back.*" He said "All right babe, I will," and he kissed me. Then I said, "Now give me a real kiss." I had that real kiss and then we were walking in opposite directions and I knew that if at any point I turned around, I would run to him sobbing and want to put him in a car and take him to Mexico or Canada. So, I made it over to the next gate and I fell down and cried.

After he returned to Baghdad, I got back into the groove again, working, going to school, talking with him through instant messages. Six weeks went by and one morning I woke up to the little *ding ding* of an IM. I ran over and there he was on Skype. We were talking about the simple and mundane, when all of a sudden his demeanor changed. Then he said, "I have to go," and if he had to get off that abruptly, I knew it was most likely because they were being called out on a mission. I said, "Okay, baby, I know this sounds really cheesy, but I love you more than life itself and I can't wait till I can see you again." And he said, "Baby, that's so sweet of you. I love you and I'll try to get back on later tonight if I can."

I went on with my day, and that night I was at my parents' house for dinner when the phone rang and my neighbor Danny said, "You need to get home, Taryn." His voice sounded really weird: "I can't tell you why, you just need to come home right now. There are some people here that you need to talk to right away." Panic took over. I ran upstairs screaming for my mom, but I couldn't even make it down the hallway, and she just said, "Taryn, you don't even know what's going on." We stopped the car down the street from my house so I could look, and that's when I saw my neighbor standing with two men in class A uniforms—the same as the one Michael wore when we got married. I went up to the house and sat on our patio chair. One of the men was shaking when he told me, and I remember thinking, "I can't wait to tell Michael about this soldier who can't compose himself enough to notify this wife." It really hadn't sunk in yet that Michael was the one who was dead. I started dry heaving and screaming, I had to lie on the ground and everybody in the neighborhood was standing in the street watching.

There were a couple of military wives I had been close to, but after

Michael died, it was like I had become a physical example of their worst nightmare, so they dropped off the earth. I had my family and friends, but none of them had ever gone through what I was going through—not even my parents. I felt like I was the only twenty-one-year-old widow in the world. For three months I slept on my couch and watched TV. I read all the letters Michael had written to me and thought about how he'd handle this if our roles had been reversed. I knew more than anything he would have wanted to be able to stand here with me and pursue all of those dreams that he had. I knew that I needed to try to live for him until I could hopefully find a reason to live for myself. It eventually became apparent to me that I was not going to die of a broken heart and that the world, in some cruel way, was going to continue spinning without Michael on it, and I was going to continue breathing. One evening I went on my computer and Googled "widow." When it came back with "Did you mean *window*?" that was kind of the catalyst. I thought, "Screw you, Google, I'm going to come up with a better response."

The next day, I called Jessica Ardron whose husband Brian was killed sitting behind Michael. I had only met her a couple of times. I knew they'd had a newborn baby who Brian had just met on his R and R. I told her, "I want to ask you all the things people have stopped asking me that make me not want to continue living. Questions about the life I had with Michael, how we met, how we fell in love . . . I want to know all about you and Brian . . . how he proposed to you, how it was when you found out he was getting deployed, how you were notified, how you hope to keep his memory alive. And most importantly, because it's the one answer that I'm really looking for: What makes you get up every day and want to keep on living? And I want to film it and I want to put it on a medium such as a DVD, so that another young widow, or widows, who have gone through the same thing can see that they're not alone." I definitely didn't expect her to say, "OK, when are we going to do this?" But she did. I met with an editor I knew and told him, "I don't know anything about doing any of this, but I have this money that my husband left me and I want to buy the best camera equipment and hire you to come with me. Will you do it?"

Two weeks later, we flew out to meet Jessica. It was one of the most difficult things I've ever done. As one widow put it to me, meeting another widow is like looking in the mirror for the first time; you are finally seeing what you are and coming face to face with the fact that you are a widow. But also, it was difficult because her husband had died in the same incident. I'd never wanted to know all the details of what happened, so I was afraid of what Jessica might tell me. The interview was so raw and so candid that even our producer told me he cried for two days afterward.

> *"I went on my computer and Googled 'widow.' When it came back with 'Did you mean* window?' *that was kind of the catalyst. I thought, 'Screw you, Google, I'm going to come up with a better response.'"*

I got more depressed after that because I thought, there's no way I'm going to find other women who want to do this. It was healing, but also really, really painful. It was during that time that Glenda Carter responded to one of my posts and said, "Taryn. Hi, I'm a Vietnam widow." I didn't answer her because I couldn't imagine what this sixty-something lady knew about my experience. But she kept writing and said, "Taryn, I just need you to know my story and I want you to know that I'm here for you. I was nineteen when my husband was killed in Vietnam. Our society and my family and everybody around me did not accept the war or those who participated in it so I had to pretend that he never existed and our love never existed. Thirty years later, when I finally met another Vietnam widow, I went to his grave and I begged his forgiveness for what I had done, not only to myself, but also for not being proud of the sacrifice that he had made and not being proud to share it. If there's anything that you should know, Taryn—share your story. Share it and be proud of it." That email put me back on track.

In December I met Nina, and she became the next widow in the documentary. In May 2008, we got our 501-c3 status approved just as

we were wrapping up the film, and in July, we launched the organization itself. The military gives us a lot of resources, but as a young widow, I needed something else: I wanted to create an organization that would help me and other young widows to live again. So I planned a zip-lining trip; a tubing trip down the Guadalupe; a screening of our documentary at the Alamo Draft House, and lots of time for the women simply to connect and discover their similarities. I remember when we were tubing, I found myself laughing with these ladies, and I stopped myself because even though Michael had been dead a year, I thought if I laughed in front of anybody, they would think, "Okay, she's over him." But then I looked around and saw all of these amazing women who had gone through the same thing, and they were smiling and laughing too. And I realized, they might be like me and they might finally be allowing themselves to do this for the first time, and it might be scary for them, too, but they have faith in me and what I'm trying to do. It was everything I wanted our organization to be.

> *"I had passion for Michael, but I never had passion for something outside of our love. It wasn't until I started AWP that I finally understood: Michael had given me the ability to pursue something I'm passionate about and be among people I would give my life for as well."*

In the first year we had maybe two hundred widows, and our toll-free number came directly to my cell phone. Now, we have more than 1,300 widows and we're coming up on twenty-five national events. And now that we've really mastered the art of allowing women to see that they can survive and be proud military widows, we'll be taking it a step further with a new program that will give them the tools and hands-on experience to pursue careers, get back on track with their health, or simply overcome the day-to-day obstacles that can make them feel like they've walked a million steps and fallen two million behind.

It's been a difficult journey for me to share, but I think it's our duty as this generation's military widows to make it a little bit easier for the ones who, unfortunately, may follow. We want these women to embrace the title "military widow." That title represents Michael's sacrifice and it represents my sacrifice, and most importantly, it represents my survival, to be here and able to share our story and continue on with his legacy and my own life. So I am as proud to be called a military widow as I was when Michael would introduce me as his wife, back when he was alive. I feel blessed that I have this passion to pursue.

A gift that Michael left me is the knowledge that when he was killed, he was doing what he was passionate about with people he cared about. I had passion for Michael, but I never had passion for something outside of our love. And I never understood how he could possibly sacrifice his life to save a stranger—someone he had only known a couple of months. It wasn't until I started the American Widow Project (AWP) that I finally understood: Michael had given me the ability to pursue something I'm passionate about and be among people I would give my life for as well. These women gave me my life back. I don't like to say that I'm saving their lives, I just allow them to see that they can do it on their own, that they have the power within them and just need someone to show them it's possible.

I don't know if you've ever read C. S. Lewis, but after he lost his wife, he published a journal of his life. There's one part along the lines of: *I can't help but think this loss is like losing a limb and over time that stump will heal over and, who knows, with enough perseverance maybe I'll even get a wooden peg leg and I'll walk somewhat normally, and with enough time, people might not even know what happened to me. But at random moments, sharp pains will shoot up that stump, and I'll look down at it and I'll remember what happened.* Starting this organization, it makes me feel like I'm looking down at that stump, but I'm really glad I have that peg leg, and I know I can walk. I see what I'm doing for other people and what they've done for me, and it makes it all worth it, and I kind of forget about the pain.

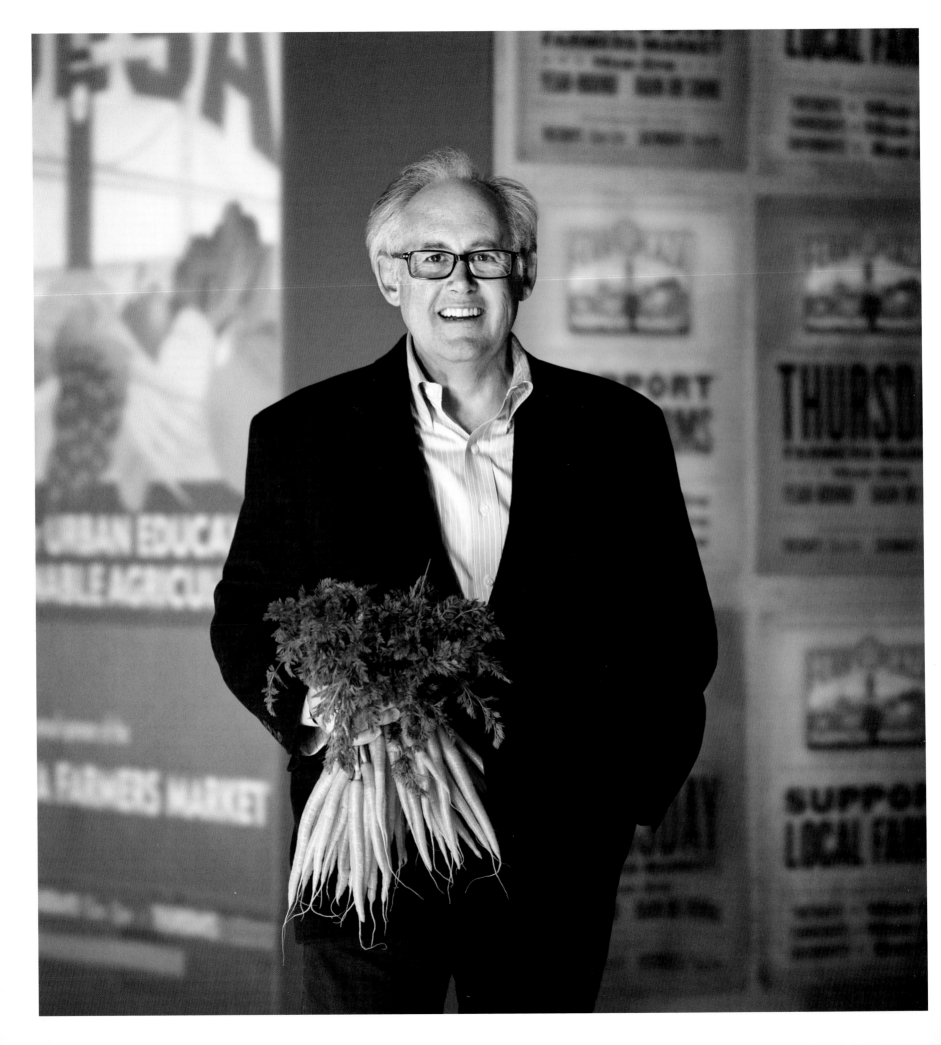

Michael Dimock

President, Roots of Change

Michael Dimock's goal is simple: to create a sustainable food system in the state of California by the year 2030 that can be used as a model for the rest of the country, if not the world. Ambitious, definitely. But Dimock's track record for changing the unchangeable is hard to argue with. Long before words like "sustainable" and "locavore" became headline favorites, Dimock was using his grassroots approach and business acumen to convince community members to set aside differences and join forces around the common objective of preserving the future of local agriculture. Part diplomat, part activist, he seems to understand what so few others in the new food revolution do: lasting transformation only happens from the inside out. And the stakes couldn't be higher—with America's skyrocketing obesity rates and rapidly diminishing natural resources, our lives literally depend on the radical reformation of how we eat . . . perhaps our lives literally depend on Michael Dimock.

Right before I took my job at Roots of Change (ROC), I asked myself, "Am I a reformer? Is that what I am?" Because if you look at the lives of reformers, they're often painful and short. But I've realized this is what I was meant to do, and it's deeply satisfying.

I grew up in San Jose, California, in a house surrounded by walnut and cherry orchards. In the background was the sound of tractors knocking down the trees as they developed Santa Clara County. I remember lying in my bed, hearing that squeaky tread and the engine, and then the tree falling. I often think that memory is part of why I do this work.

After a graduate program at Columbia in Soviet studies, I went to work for an international agribusiness company that supplied ingredients to the big food manufacturers like McDonald's—they bought 25 million dollars' worth of tomato paste from us every year. I was based in Europe and I lived in Holland and Spain, traveling all over. I also saw regional, sustainable agricultural systems, both in development and long existing. That was the beginning of my true food consciousness. I was getting a taste of all models of agriculture.

When the First Gulf War happened, a huge recession hit and the company got in big trouble. So, I came back to California and I spent a year in Sonoma County thinking about what I was going to do next. I realized one day, as I was looking over this beautiful area, that I wanted to live here, first and foremost. And second, I wanted to continue working in food and agriculture.

There's a saying, "Once you decide, all things line up." I was sitting in a coffee shop one day reading an article about agriculture when a woman sitting at the table next to me leaned over and said, "Are you interested in agriculture?" She was on the board of Select Sonoma County, which was the first nonprofit in the United States focused on promoting a county-based identity for its farming products. Soon after, I was hired as the first director of marketing because of her and that chance meeting. I then took the county-based model to other areas of Northern California. The impact of industrial agriculture was really starting to hit, and the regional food producers were going downhill fast. I was getting a lot of work advising communities on how to save the local agricultural economies. Eventually, I started my own consulting firm in 1992, to promote food and farming sustainability in California, which later became known as Ag Innovations Network.

That's when I became really interested in community consensus

Michael Dimock at the Ferry Plaza Farmers Market in San Francisco, CA.

building around regional identities for food systems. Community Alliance with Family Farmers (CAFF) invited me to join its board and I got into statewide policy work. In 1996, a friend introduced me to Slow Food, which was really the first consumer-based component of the food movement. I'd been working with government agencies and industry-oriented nonprofits up to that point, but there were very few organizations out there connecting producers and consumers, and I knew that was going to be a critically important component in protecting local food systems. I founded a Slow Food chapter in Sonoma, and that eventually led to my being asked to become chairman of Slow Food U.S.A., which I did for many years. Part of my work as chairman entailed traveling all over the United States, meeting farmers and producers who were doing cutting-edge things, and that was really a privilege and an education.

It was all an evolution. I saw the linkage between the environment, communities, and food systems. I saw the food system as an engine for change because it is really the base of all systems. If you want to change the face of culture and of the planet, the food system is the way that humans have the most impact. It is at the root of transformation. I think another reason that I'm drawn to agriculture is that I see it as an extension of the feminist movement. A lot of the leaders of this movement are really powerful women. I do feel that there is a need for the rebalancing of the masculine and feminine forces in the world. The food system is a place where that's really happening.

In 2000, my company Ag Innovations helped form this entity made up of community leaders in Ventura county—environmentalists, labor activists, farmers, and government officials—that came together around the common cause of saving the area's agricultural future, which was at risk because of development and changes in environmental regulations, etc. These groups had been at war for years on the front pages and in the ballot box until we pulled them together into this consensus-building body. We launched and within three years, we changed a state law, key local ordinances, and how people thought about agriculture and food. We transformed the community.

By this time—2002—ROC had already been formed, and they had started providing grants in 2004. One of the people I was working with in

Ventura suggested I apply to take the Ventura model statewide through ROC funding. So I did, and with their support I developed locally based consensus-building policy bodies around the state. After two years, ROC started to really develop, and they needed a full-time executive. I got the job in the summer of 2006. There are now twenty-five food policy groups statewide. Almost half of them have been funded by ROC or are supported by Ag Innovations, which I turned over to a wonderful colleague when I moved to ROC.

"Right before I took my job at Roots of Change, I asked myself, 'Am I a reformer? Is that what I am?' Because if you look at the lives of reformers, they're often painful and short."

We are now in the next phase of Roots of Change. We completed our first five-year plan, which created a context for major change. In the next three years, ROC is going to support California's first statewide Food Policy Council, and we're going to pull all of these regional groups together into one body, to share what they've learned in their own communities and to collaborate regionally. The most important thing is that together, they're going to become a voice to the governor and the legislature about what's needed to unleash the entrepreneurship required to create regional, sustainable food systems in California.

We have met huge benchmarks. When groups like Slow Food and Roots of Change started really pressing, farmers got nervous and realized that they had to be responsive. Sixteen to twenty of the largest cropping systems in California are now developing sustainability standards. And the most important crop system to change grew out of the statewide roundtable, the California Roundtable on Agriculture and the Environment (CRAE). That group developed this idea called the Stewardship Index for Specialty Crops, which is a way for growers of vegetables, fruits, and

nuts, to measure how they're impacting the environment, so that they can then create more sustainable systems. That model is now being tested all over the United States. And that's going to fundamentally change farming systems, because farmers are going to get real-time feedback about their impact on the environment and energy. That was the first benchmark.

The second benchmark is that the idea of proper nutrition and access to healthy food has completely taken off, in large measure because of the national health crisis and the nonprofit health world really taking on the issue of obesity. Now that we folks in sustainable agriculture have joined it, it's going to become unstoppable.

One of the things that I feel great about is that ROC is one of the reasons that the State of California developed a strategic plan for sustainability by the year 2030 for food systems, run by the California Department of Food and Ag. And that's exactly what ROC's mission is—the creation of a sustainable, mainstream food system in California by 2030. We took our DNA and got it planted in the state.

New Mexico, Michigan, and Vermont are all moving toward getting their states to sanction their strategic plans as well. It's happening. Because we're a little bit further ahead of everyone, people are interested in what we've learned. We're providing a model of what's possible, and it's almost our responsibility to educate and share what we've discovered.

One of the most important things we're planning over the next two years is a communications campaign focused on eliminating the undermining message that industrial food systems are the only way to feed a planet of 9 billion. We will shed light on the fact that the industrial food system, as it's currently designed, simply cannot sustain itself because of 1) its dependence on oil and 2) its negative impact on our environment and our health. Its demise is inevitable because civilization simply will not survive without an alternative.

The economics are the hardest part of this campaign. I have some really incredible folks on my board and in our network, true capitalists and economic thinkers, who understand that the problem is that the marketplace does not price food properly. Every consumer is paying the full price of food, but they're paying it in different places. They're paying it through their taxes and through their medical costs. So, the question is,

how do you actually price food properly, and therefore, save people money in other areas? And then also, how do you scale sustainable food systems to bring down prices? Because one of the reasons they're so expensive is there's less scale. So there are two things that have to happen. The first thing is that unsustainable food has to be priced higher in order to clarify its true cost; and second, currently expensive sustainable food has to drop in price, based on greater availability and production. And then if people still can't afford food, we're going to have to find ways to ensure they get fed, because we're going to pay for it later if we don't.

Our core model for change is to change how people think because the way we think leads to the way we act. If we don't think systemically about food, we won't make the changes we need. Two big revolutions need to be underway. One is the way we think about systems and their linkage to everything else, and the other is how we economically structure food systems.

"California is considered the epicenter of the sustainable food movement, so one of the fundamental principles behind ROC is that if we can change it here, we will impact the whole world."

This will be my life's work. We've got to change it in my lifetime, or we're in deep, deep trouble as a nation and a world. The United States is the leader in most areas of agricultural innovation. We have a huge infrastructure of universities and research dollars committed, and we have a great number of farmers who are very pioneering and entrepreneurial. We also have the strictest environmental regulations in the world. People look to the United States as the leader, and within the country, California is considered the epicenter of the sustainable food movement. So one of the fundamental principles behind ROC is that if we can change it here, we will impact the whole world.

"My attitude is that food isn't just gasoline for the body, food is community."

Robert Egger

Founder and President, D.C. Central Kitchen

Through job training, meal distribution, and supporting local food systems, D.C. Central Kitchen uses healthy food as a tool to strengthen community and build long-term solutions to the interconnected problems of poverty, hunger, poor health, and homelessness. Their multi-million-dollar annual operation hauls in two-tons-worth of excess food from various hospitality businesses and farms each day, and converts those leftovers into 4,500 meals, which are delivered to partner agencies that serve the needy throughout the D.C. metro area. To date, the organization has served 25 million meals, helped 1,000 men and women gain full-time employment, and empowers 5,000 student volunteers every year to implement the D.C. Central Kitchen model in thirty communities around the country. The force of nature behind it all is Robert Egger—whose *I can do good and have a good time doing it!* philosophy has become the mantra for a new generation of social entrepreneurs.

I watched *Casablanca* when I was thirteen years old and saw a nightclub become a doorway to freedom. On the one hand, it provided the immediate liberation of being a refugee from the grind. And then, below the surface, everybody was whispering about escaping to the metaphorical freedom of America. That night I decided I wanted to open the greatest music club in the world. I started sneaking out to clubs in Washington, D.C., and later I got into the business and ran a number of different music venues. It was never about sex, drugs, and rock 'n' roll for me, I truly believed music could change the world.

My wife, Claudia, came into this notorious dive where I was working, ordered a drink and stole my heart. I thought, "All I want to do is marry this

Robert Egger with a group of students, staff, and volunteers in D.C. Central Kitchen's headquarters in Washington, D.C.

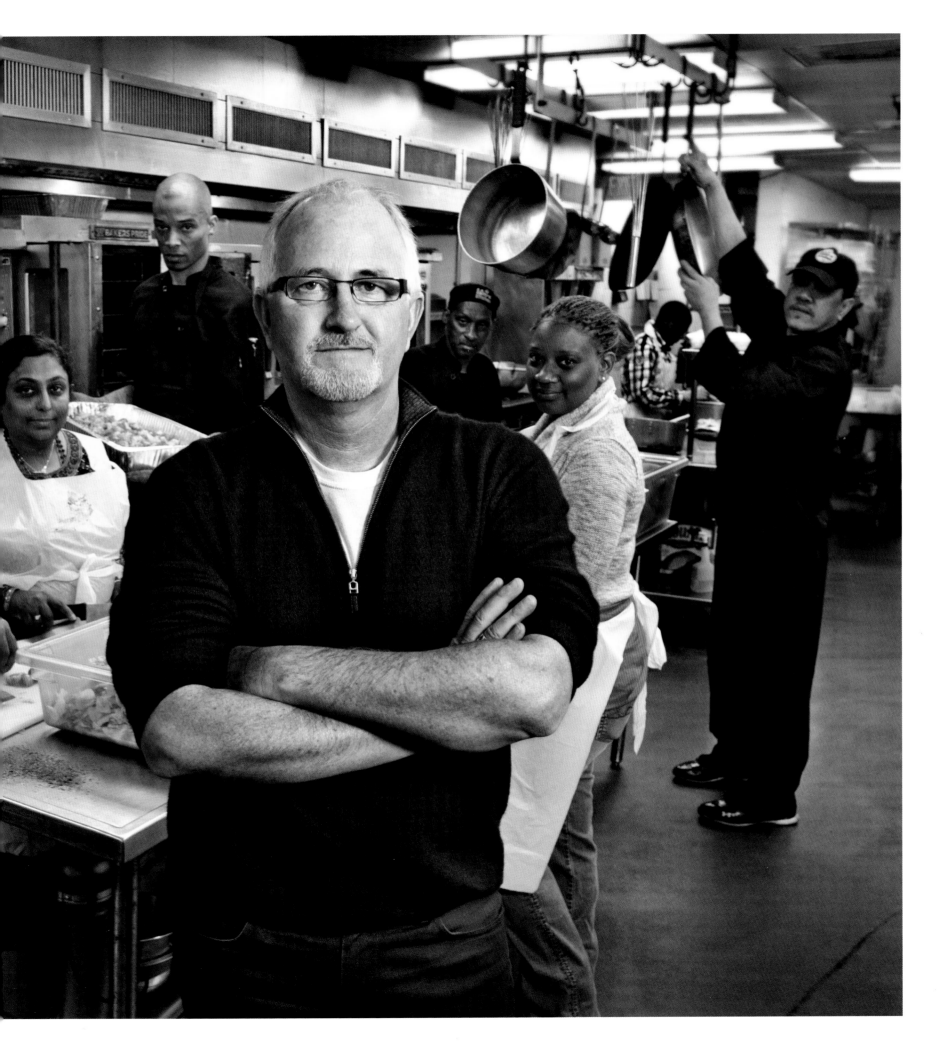

woman." We didn't have any money and most of the local churches wanted at least a $500 wedding rental fee, but this great Episcopal priest said they'd only charge us $100. We developed a very nice relationship with this priest and discovered that the church had a program providing meals to the homeless. I had spent all of this time talking about how music could heal the world, yet when somebody said, "Do you want to go on this truck and serve food on the streets of D.C.?" I looked for every way to get out of it. Homeless people scared me.

I worked tirelessly to avoid the steely grasp of the church's volunteer coordinator, but I ended up on the truck eventually. We pulled up to Virginia Avenue and there was a long line in the drizzle. My fears were instantly mitigated. Just the humanity of the conversations taking place, the decency of both the volunteers and the people being served meals. At the end of service, everybody was saying, "See you tomorrow night!" And I'm wondering, "Tomorrow night? What happens to these people now?"

I started thinking about inventory control, how the club I was working at threw away food every night, as did every other restaurant, hotel, and caterer in the city. While they're chucking legs of lamb and filet mignon into the garbage, these people, with love in their hearts, are serving chili. I thought, "What if we created a model where restaurants, hotels, hospitals, and caterers could donate to a central kitchen that would turn out meals for those in need?" The breakthrough idea, though, was to bring these people lined up at the truck in out of the rain and allow them to be part of the process, by teaching them how to cook the food that's donated. You could feed more mouths better food for less money and shorten the line by employing the very people you're serving. This was the "eureka" moment.

Many people ask me, "How did you make this leap from nightclubs to serving homeless people?" It's the same business. I've been in service all of my life and it's what I love. Nightclubs, catering, D.C. Central Kitchen—it's just the audience that's different.

I put together a little business plan and I asked if I could present my idea to all the local parishes that were already serving the homeless. The day arrived and I was all earnest, standing up there making my pitch. I finished my big speech and waited for the applause. And waited.

It never came. I was ready for doubters, for questions about sourcing and the legalities. There's a very pervasive myth that the health department won't allow restaurants to donate food, when in fact there's a law in every state that allows it. So, I'd brought that documentation with me, and I had already signed up ten restaurants. Nothing hurts a restaurateur's soul more than throwing away food. I explained that if you can give them a tax deduction for it, they'd be thrilled. So I was prepared to address a number of concerns, but not the final one they threw at me. What they said was that I couldn't possibly train the homeless. That just floored me. It became one of those moments where the road splits. I could have retreated but I really believed in the idea, and I knew it could work. I'm one of the first people who came into this field with any food-service background. Back then, a program like this was considered a "calling," not a career. It took time and patience, but I finally got a grant for $25,000, which to a twenty-nine-year-old in 1988 was an enormous sum.

George H. W. Bush had just been elected president. I called up the Republican National Committee, and after three days of "hold, please," I got to the person in charge of catering for the inauguration. I took a deep breath and said, "Hi, my name is Robert Egger and I have a refrigerated truck and I've opened a nonprofit called D.C. Central Kitchen, and I'd love to talk to you about donating the surplus food or the leftovers from the inauguration to shelters in D.C. This is the kind of publicity that will be tremendous for you and a great way to launch this new organization." And they immediately simply said, "Yes." So, Bush was the first donor to D.C. Central Kitchen and, as I'd anticipated, the donation was covered by media all over the world. That's how we got our start.

I've been lucky now; I've met six presidents. Clinton and Obama have both visited the program, and they are two of the most intellectual presidents we've had, but you put them in a kitchen to cook for five thousand people and they're all thumbs. Picture it: you've got someone who two years ago might have been out on the streets, just hustling to get high, chopping vegetables next to the president of the United States. "No, Mr. President, you hold your knife this way." That's the power of what we do.

We go through a lot of steps to make sure the students are

physically and emotionally prepared for the program. The outreach workers helped to get people off the street, to get them birth certificates, drug treatment, reunions with family. We also have front-line shelters, drug treatment centers, and transitional homes we work with, so we can say, "Hey, come in out of the cold." The first step is getting people off the street, into a shelter, into a program. Then they're primed for the kitchen.

On average, students stay in the kitchen for twelve weeks before they graduate. We also offer a life skills class. And if you come to the first day of any new class, you see a room full of hard-core-looking people, but that's a mask. They're terrified. We just graduated our eighty-sixth group, so I've done this a few times. For the vast majority of men and women who succeed in our program, it's because from Day One they realized they had a valuable role to play in the healing of their community, and an opportunity to make right what they did wrong.

> *"So much of charity is still wrapped up in the redemption of the giver, not the liberation of the receiver. You can't measure success by giving everybody free food. If you don't liberate them, you're just holding them down. You can love people to death."*

There are 90 million people under the age of twenty-five in this country who have been raised with a value system that includes doing service. They're itching for a way to do good. Everyone will tell you that you have to choose between making money and doing good. You don't. There's a new generation of backers who want to be intimately involved and aren't hoodwinked by good deeds—they want real stats. The actions themselves aren't enough—it's not enough to feed people, it's how you feed them and what you reveal during the process, that's the goal. My attitude is that food isn't just gasoline for the body, food is community. We

wanted to start to explore what the power of food in a community could be, so we developed different metrics. Instead of giving a little to a lot, we wanted to give a lot to a little. So, we've never supplied meals to more than a hundred agencies. By picking these agencies very deliberately, we're saving them millions of dollars that they can reinvest, again amplifying or reinforcing the work we do. For example, by giving meals to drug treatment programs, they can focus on getting people sober. Then they can send the clean and sober people to us.

I went to India to study the Indian National Congress because I was mesmerized by the fact that the British never had more than three thousand officers stationed in India, yet they were able to dominate 350 million people through dividing by race, caste, geography, and language. If they could keep them fighting each other, it was easy. That's the nonprofit sector in America. Economically, we're almost as big as India, yet all we do is squabble and fight each other. So, I co-founded the first ever nonprofit congress. There are 14 million of us and we need to move into an era where we elect people who understand that we are a significant part of the American economy. At D.C. Central Kitchen, we added fifty jobs this year, plus there are eighty people who graduate annually and they'll earn $2 million in new salaries, versus going back to prison, and they'll pay $200,000 in taxes, and provide 1.5 million meals for the city for next to nothing. And those are healthy meals, which means people aren't going to have as many health-care costs down the road.

The future of philanthropy is how you spend your money every day. So much of charity is still wrapped up in the redemption of the giver, not the liberation of the receiver. You can't measure success by giving every-body free food. If you don't liberate them, you're just holding them down. You can love people to death. We need to get every able-bodied person out of the system ASAP. You could give me a million dollars a day to feed people, but that's not the same thing as solving hunger. I can't solve hunger. We are trying to do something else. A great nonprofit doesn't try to solve the problem, it tries to reveal the power we have as a community to solve the problem. If I were just Robert Egger, Feeder of the Poor, I could make quite a good living and win awards, but unfortunately, I'm dedicated to doing more.

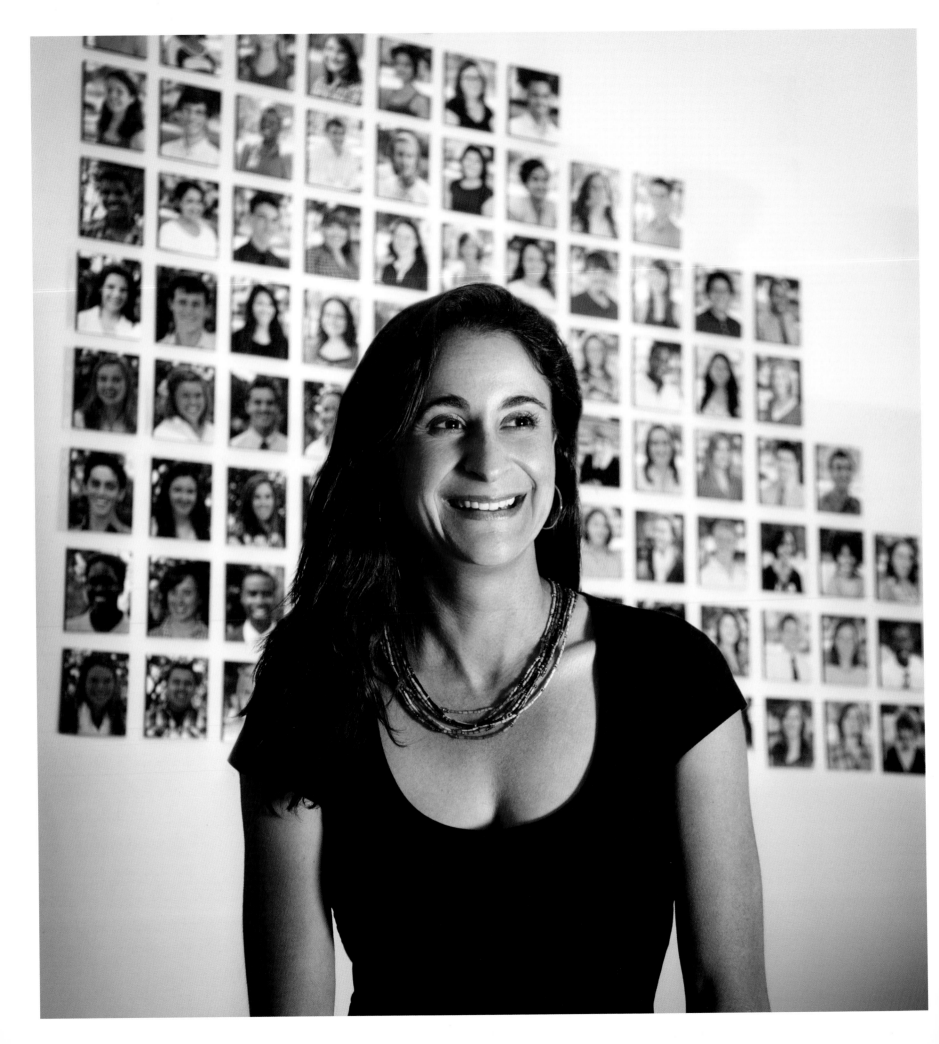

Abigail Falik

Founder and CEO, Global Citizen Year

When Abigail Falik first conceived of Global Citizen Year—an organization that facilitates a bridge year for youths between high school and college, immersing them in the culture of a developing country—she was a scant eighteen years old. Exhibiting a maturity far beyond her years, she then did what so many of us would not have the patience to do—she waited, allowing the idea to crystalize for more than a decade, during which time she earned two Ivy League master's, sought out established social entrepreneurs as mentors, and collected real world experience in the international and nonprofit sectors. In other words, she did it the hard way—she worked for it. Perhaps even more importantly, she recognized that the success of any great idea is deeply indebted to timing. When Falik finally launched Global Citizen Year in 2009, America was ripe for the concept. As we stared through the doorway to a new global age, our unpreparedness was and continues to be shocking. Consider this: to date, 50 percent of our congressional leaders do not even hold a passport, only 9 percent of English speaking U.S. citizens know a second language, and just 1 percent of us will ever meet someone living in extreme poverty. Falik envisions a not-too-distant future where these statistics will seem archaic and a year of social service abroad before college will be the norm. High profile partners, such as the Nike Foundation, and an invitation to speak at the Clinton Global Initiative, are just a couple indications that Falik's gospel already has a devout audience. And according to her, she's just getting started.

I grew up in the Bay Area, with wonderful, intrepid parents who thought travel was the highest-value education they could imagine for their kids, and they made mighty sacrifices to insure that we had opportunities to do so. Those early experiences following them to far-off locales woke something in me, and gave me a sense of who I was and what it meant to be American in the world.

After high school, I was set to head off to Stanford, but before school I was itching to do something meaningful in the "real world"—something that would push me outside my comfort zone. So I called the Peace Corps. And the Peace Corps said, "Little girl, see you in four years." I knew that I did not have a lot to give in terms of skills, but I wanted to cut my hands on real work and I had much to learn about why I was going to college in the first place. It was really the frustration of that rejection that set me on this path, which has been about trying to create a rite of passage during the transition from high school to college. That period is an opportunity to prepare kids for higher education, life, and success in a global world.

I eventually took a year off and went to work in Brazil and Nicaragua. Those experiences grounded my studies when I returned for college, and gave me a sense of purpose. The seed for Global Citizen Year was already planted when I got back from South America. By the time I started grad school at Stanford, I was studying the question, "What's going on in the international exchange space?" Most kids take a junior year abroad and come back with one year left to cram it all in. They regret that it took until their senior year to really figure out what they were doing there. The trend is for two-thirds of the kids who study abroad to go to Western Europe, studying in English with other Americans. But I felt there was really something missing without full immersion in a new context, which really helps you understand what life is like for very different people. I finally

Abigail Falik at the Global Citizen Year U.S. headquarters in San Francisco, CA, pictured with photographs of the program's early alumni on the wall behind her.

wrote a thesis that became the blueprint. I can look back now and see the concept was very much there then, but 1) I was not ready to build an organization and 2) the world was not ready for the idea.

Fast-forward ten years: I apprenticed myself to other social entrepreneurs, I learned from private-sector travel experience. Then I ended up at Harvard Business School, where I really incubated the idea and developed a business plan. I finished school in the fall of 2008, when the economy was crashing and there was a heightened sense in this country that we'd crossed a threshold and were not living in a unipolar world. It was no longer enough for us to learn only about American history and speak only English. We needed to be fluent in how others see us and speak the languages that will help us communicate, collaborate, and compete internationally. That was the convergence of events and time when the idea really ripened.

I was lucky at Harvard to win first place in Pitch for Change, which is a business pitch competition. It was this moment of feeling, "Whoa, maybe I'm onto something that actually has broader resonance." I had no resources, no staff, and no clue how it was going to get off the ground. But I had grit. I moved back to the Bay Area because I felt it was the right place to ground the organization. I spent about six months asking for funding, being told no, and building a board, all of the classic, early steps that you go through. It was exhausting but left me much more committed. I eventually broke through and started raising early seed money. I hired a couple teammates, and about six months after that, we were launching our first program.

I think there's a concept that entrepreneurial insights come in a flash or an epiphany. For me it was very much a slow cook. There was a long period when I kept a file on my computer called My Master Plan. I didn't even really know what that meant, but it was where I would put everything that somehow felt relevant to what I was trying to do. There are definitely moments when I have felt deflated, but those are fleeting. This vision has been compelling me for so long and I have committed so much of my life force to it. I know so much about this narrow field that I'm a part of, that I am absolutely, utterly convinced that what I'm imagining, in its most ambitious expression, can happen. I know it can.

Anybody can apply to Global Citizen Year as long as they are at a U.S. high school and intending to go to an American college. Ours is a selective program, so it's not remedial training or a catchall. Our Fellows come through a fairly extensive selection process, where we're looking for kids who have that kernel of leadership potential. That potential may or may not have been expressed in traditional ways in high school: we have kids who were former gang members from rough urban schools, who might not originally have been on a college track; and then we've got kids who grew up in Greenwich, Connecticut, and are heading to Harvard. What's common among them is that they are able to take initiative, they are persuasive among their peers, and they're optimists and role models. Initiative plus optimism is the recipe.

Once they're accepted into the program, they can give us their preferences about where they want to go, but similar to a Peace Corps process, we're less about choosing a country from the catalog and more about placing kids where their skills are needed. We're in Ecuador, Brazil, and Senegal, and we're looking to bring China, India, and eventually the Middle East into the mix in the next few years. If this is going to be a new type of American education, we should expose young people to big emerging economies so they experience what life feels like in parts of the world that have a significant relation to our country.

"There was a long period when I kept a file on my computer called My Master Plan. I didn't even really know what that meant, but it was where I would put everything that felt relevant to what I was trying to do."

The arc of the experience follows the school year. Fellows have to raise $2,500 and have a hundred people signed on to their social-media blogs before they leave. Then they come together for a boot-camp training

session at Stanford, which focuses on entrepreneurial leadership and global development. Once they get to their countries, there's a month of immersion in local language and culture before they move out to their placements in rural communities. They live with a host family and they work on a local project: teaching English, coaching and mentoring young people, or working on technology projects. Relatively speaking, any eighteen-year-old in this country is pretty tech savvy. Effective storytelling is a strong emphasis for us, especially how they can use their experiences to inform and influence others at home, who may not have opportunities to travel. Whether they're monitoring or evaluating or providing technical training, it's really about figuring out what skills are needed and how to focus them in a way that's impactful. The students come together every month for a training seminar while they are in-country and then the whole crew comes back together at the end for a reentry program. Once they're home, they make presentations at schools, join our alumni ranks, and get ready for college.

All but one of our Fellows have gone straight into college, so we like to use the term *bridge year* instead of *gap year*. Our training is very much around helping kids transition more effectively from high school to college, and not fall into a "gap" or hole. Most of our kids were admitted to college before they joined us. Schools are delighted to grant that deferral because if they want you now, they'll want you even more after this experience. Our kids get to college with a road map and an intention for their studies. They've formed a set of questions they're trying to answer over the next four years, as opposed to just getting requirements out of the way. It's a total reversal of how most kids approach school now.

We're really, really committed to rigorous evaluation. From the moment kids apply, we're already entering information into a database. Our sample set is very small right now; our kids are only two years out, at the most. But what we have learned is that 100 percent of our kids feel much better prepared than their peers in school; 94 percent speak a second language proficiently; and 66 percent are designing their own majors. They get to school with a clear idea of what they want to do and if it doesn't fit into something that exists, they design it themselves.

We have a large number of kids in international development studies, and everybody's continuing to take the language they studied or a new language, which is key in working effectively internationally. Many are interested in international relations and emerging economies. I suspect most of them will travel again during college because they feel that's a foundational part of their education. Our hope is that over time they'll all engage internationally in working toward social improvements, and that they will have an entrepreneurial and global approach to leadership.

It's about awakening potential, but it's really about helping kids see their own limits through an experience that tests everything they've got. They emerge confident, resilient, and fired up about what is possible. When they come back and ask what they can possibly do to stay a part of what we're building, that's my food.

"I imagine a day when employers will look at job applications and say, 'What do you mean, you went straight from high school to college?'"

My role has evolved from doing everything to becoming the external face of Global Citizen Year. I'm most energized by talking to press, working on partnerships, raising money, and building the board. I still work crazy hours, but I do now have an extraordinary team of sixteen, and will be adding about ten people in the next six months, between our San Francisco and international offices.

By the end of this academic year, we'll have a hundred alums from our first three years, fifty-six of whom are in the field right now. Our target is to double that number next year and continue doubling from there with ten thousand Fellows ten years from now. I don't see any reason why a year of public service can't become the new norm for how kids are prepared for college and a career. The endgame is that our program would be one piece of a broader cultural shift toward that requirement. I imagine a day when employers will look at job applications and say, "What do you mean, you went straight from high school to college?"

"My mission is to make sure everybody can benefit from all of the impressive cancer research and available therapies, not just those who can afford it. In the end, it's a moral issue. People should not die because they're poor."

Harold P. Freeman, M.D.

Founder and President, The Harold P. Freeman Patient Navigation Institute

Dr. Harold P. Freeman has devoted his entire career to providing equal care and patient advocacy for the poor. As a preeminent cancer surgeon, he has tended to the underserved and voiceless in his Harlem community for more than forty years. His list of achievements is expansive and substantive, but the contribution he remains proudest of is the introduction of his patient navigation system, in which trained volunteers guide low-income patients through the health-care process. The program has been widely adopted by hundreds of American medical institutions. Based primarily on the model developed by Dr. Freeman, President George W. Bush signed the Patient Navigator Outreach and Chronic Disease Prevention Act of 2005. Through this legislation, funds have been made available to support a number of patient navigation programs throughout the country. Dr. Freeman speaks of his purpose with a clarity and decency that is humbling and direct: "No person with cancer should have to spend more time fighting their way through the cancer care system than fighting their disease."

My great-great-grandfather was a slave in Raleigh, North Carolina. He bought his freedom in 1838 and took the surname "Freeman." Four years later, he bought his wife and six children. Legally, that made them his slaves, so he had to emancipate his own family in writing. They moved to Washington, D.C. and their next son born became the first African American dentist in the United States, after he finished Harvard, in 1869. I picked up *Time* magazine once in 1966 and on the front page was a man named Robert Weaver. I knew he was my cousin but I had never met him, and Lyndon Johnson had just appointed him to be the first Secretary of Housing and Urban Development. He was also the first African American Cabinet member. I read about his ancestry in *Time*, and that's how I learned about my family background and the history of my name.

I was born in Washington, D.C., which was segregated when I was a boy. My father died of cancer when I was thirteen years old, and my mother drove me to focus on my education. I attended an all-black high school, but it was a very good school, it took the best students. We had excellent, highly educated teachers, as well—some even had Ph.D.s

from Harvard—because they were black and couldn't get jobs elsewhere. So, ironically, the negative circumstance of segregation made this school extremely competitive.

I went to medical school in Washington, D.C. and I met my wife during that time. We have two boys, and they're both doctors now as well. I came to New York to train for four years at Memorial Sloan-Kettering Cancer Center to be a cancer surgeon after doing my general surgery residency. And I stayed.

I decided to start working in Harlem when I finished that training. I was a surgeon at Harlem Hospital beginning in 1967 and I've worked in that community ever since. When I came to Harlem, I was enthusiastic and ready to work, but in the late sixties and early seventies, the population I was serving was poor and black, and I was seeing many patients who were coming in with very late stage cancer. My skills were not what those people needed, because they were past the point of surgery. I began trying to understand why this impoverished minority community delayed seeking cancer treatment. Ultimately, I became an authority on the relationship between race, poverty, and cancer.

Harold P. Freeman, M.D., at the Ralph Lauren Cancer Center in New York City.

By 1979, I had established two free screening clinics in Harlem for mammography because I realized part of the problem was simply that they couldn't afford an examination. That did help, but it opened up another can of worms. Patients were getting the test they needed for a diagnosis, but there was no clear avenue to pay for biopsy or necessary treatment after that. Mammography doesn't cure cancer.

When I was appointed as the National President of the American Cancer Society in 1988, I held hearings on cancer in the poor populations. I solicited testimony from people of all races and from all fifty states. I found that what I had seen in Harlem was happening in poor communities all over the country.

That experience drove me to the concept of what I now call "patient navigation," which is a system for guiding the poor and uninsured through our very complex and often fragmented health-care system. I started with Harlem and I trained people from the community to come into the clinics and accompany patients from the initial examination through diagnosis and treatment. I called them patient navigators. They would observe and hear the doctor's recommendations, and then the navigator would take the patient into another room and find out if there were any barriers to doing what the doctor recommended. Barriers were typically financial, but there were also communication barriers, when people didn't understand what the doctor had said or spoke a different language. There were barriers related to the complexity of the health-care system—for instance, sometimes patients didn't understand where they had to go to get a particular test or procedure. The most frequent barrier was fear and mistrust. Many people, particularly in poor communities, don't trust the medical system. There could also be transportation barriers, or babies at home that couldn't be left. It is the navigator's job to resolve whatever the obstacles are rapidly and get the patient to the point of resolution.

Let's say a typical patient has no insurance. Some of the patients might still be eligible for coverage through low-income assistance programs. There's one, for instance, called Emergency Medicaid, and it's designed for people who are undocumented and who have cancer. So, navigators have to be versed in all the financial support options that are available. There's almost always a way to get the uninsured through the system.

"Ultimately, I became an authority on the relationship between race, poverty, and cancer."

Later I expanded the initial navigation model, which covered screening through treatment, to cover the whole health-care continuum. We expanded to testing for diseases other than cancer, and we are working on the survivorship phase of navigation, so the patient navigation continuum now covers outreach, detection, diagnosis, treatment, and survivorship.

Our patient navigation program has now been instituted at more than two thousand medical facilities throughout the United States. Recently, the American College of Surgeons, which is the most important surgical organization in the country, determined that for cancer centers to be approved by them they must have a patient navigation program in place. Established medicine has now adopted the model, and it all came out of that early experience in Harlem.

About five years ago, I founded the Harold P. Freeman Patient Navigation Institute, where I've established a three-day training course. We saw the need for creating an institute that could define patient navigation and create standards and a certification process. We've now taught that curriculum to approximately six hundred people, from forty-one states in America and six other countries. We've recently also launched an online training system. The name is out there now and we're reaching a wider and wider audience.

I'd like to see patient navigation universally incorporated into the health-care system, especially for poor people. Perhaps not everybody should have navigation, but I certainly believe that the poorest of our population would greatly benefit from it, and it's cost effective, as well. In a particular hospital in New York, they had a colonoscopy clinic that had a 65 percent no-show rate. That represents a huge loss of income. Navigation was put into the clinic and they reduced the rate to 10 percent. In other words, not only is this personal attention helpful to the patient, but also to the system. Now all eleven public hospitals in New York City have patient navigators that are paid for by the city, because they realize the advantage.

For something to be adopted by the health-care system you need to prove public benefit and you need to prove that it's saving money.

There is a growing national movement toward an acceptance of the importance of disease prevention. The two kinds of prevention are primary prevention, where you promote awareness so a person never develops the disease, such as illuminating the dangers of smoking; and secondary prevention, which is about getting the recommended test, like a mammogram or a colonoscopy. Secondary prevention requires bringing people into the health-care system, which is the concentration of navigation, as opposed to public education, which is mainly concerned with primary prevention. But if you manage to get people in for examinations, like mammography, then they have to be paid for.

If you are talking to people who deal with budgets and money and are economically inclined, you can make an argument that it makes logical sense to pay for early diagnosis through screening and treating people as early as is possible. That is when it costs the least to treat people with cancer. Instead we put them through an obstacle course before they finally receive treatment and they receive it when it is least effective and costs society the most money.

Right now, only half of poor people in America are poor enough to be on Medicaid, and a study showed that people who are on Medicaid have no better outcome, when the measure is mortality, compared to people who have no insurance. I point that out because to have universal health insurance would certainly be a good thing, but if you give health insurance to a very poor person who also has inadequate housing, social support, and education, and perhaps has a risk-promoting lifestyle, then other things need to be done to help that person. If you add navigation to Medicaid, then you've solved that problem. Public education is also very important: half of cancers could be prevented by certain lifestyle changes, such as stopping smoking and having the right diet and exercise. Those are the big-picture answers.

Patient navigation is certainly not a total solution to the disparities that exist in the American health-care system. It doesn't change the system itself, it just acknowledges that there's a best that you can do under any circumstances. The way the world is, it doesn't look as if there's going to be a revolutionary overhaul of health care anytime soon; and so we have to do what we can do for people who don't have knowledge, or insurance, or who are culturally different.

Our biggest issue now is that there is a wide gap between what we know and what we do. Between the discovery and the treatment. I have spent my life focused on the treatment side. This is where more progress is still needed. My mission is to make sure everybody can benefit from all of the impressive cancer research and available therapies, not just those who can afford it. In the end, it's a moral issue. People should not die because they're poor.

"My family went from slavery to living in a segregated system to becoming highly educated. That set the stage for me to do the work I have done, so I don't feel I deserve any credit for it. It's something I had to do."

I believe we are all morally required as members of humanity to do what we can do to help other people. My energy to continue this springs from my personal belief system and my cultural history. My family went from slavery to living in a segregated system to becoming highly educated. That set the stage for me to do the work I have done, so I don't feel I deserve any credit for it. It's something I had to do. I think we're all directed in various ways in life to follow a certain path, based on our background and the environment we grew up in. The world is constantly changing and my sons have very different challenges from mine. I think someone like me, who lived before the Brown v. Board of Ed. decision, and through segregation and the civil rights movement, has a very particular perspective on both inequality and the potential for change. My life has overlapped with some epic shifts in this country and that has deeply informed my career decisions and my commitment to achieving justice.

"I go back to the prison sometimes just to share some hope and tell folks, 'Man, it's better on this side.'"

Raymond Gant

Co-Founder and President, The Ray of Hope Project

Born and raised in the inner city of Philadelphia, Raymond Gant has lived a life of extremes. He's seen both the darkest and kindest sides of humanity, in others and in himself. After serving a twelve-year prison sentence for dealing drugs, Gant defied the odds and used his second chance to make a valuable contribution to the community he'd wronged. In 2002, he founded The Ray of Hope Project—a green nonprofit that's mission is to rehabilitate the homes of low-income residents using only recycled materials and a volunteer work force made up of former convicts, college students, and skilled contractors. Gant has also spearheaded a neighborhood cleanup initiative and often performs needed services for seniors such as lawn mowing and minor home repairs. Every so often, Gant returns to the prison where he once spent two years in solitary confinement to share his redemptive story with the inmates there, and let them know—it's never too late to change the ending of your story.

I was born in 1956 in North Philadelphia. I'm the fourth of eight children in a blue-collar family. I came up in a rough neighborhood. People teased us when we were growing up because we wore hand-me-down clothes. Sometimes we had to wash and bathe in the same water together because we didn't have gas to boil our water. One day when I was a kid, I said to myself, "If I ever come through this and get myself up on my feet, people are never going to laugh at me again."

There was a lot of killing and bloodshed in my community. When that's all you see around you, you don't know some other way exists. Your role models are the drug dealers, the prostitutes, the pimps, the hustlers.

Raymond Gant in a Ray of Hope Project house in Philadelphia, PA.

So no matter how much my grandmother preached to us about Jesus Christ and going to school and getting an education, all that was self-defeated once we got out in the streets with that peer pressure. My brothers and I all belonged to a gang.

I started drinking when my mom and pop would have their little weekend fiascos and leave all the half-empty bottles lying around. The first kind of trouble I got myself into was when I stole some money from my grandmother's pocketbook. I got a beating. Back then, the kind of whippings we endured would be considered child abuse today. My pop was a hard-core guy, and the harder he got, the harder we got. So, that punishment didn't help. It just made me want to be tougher.

I found out early stealing wasn't really my forte. I didn't like it. I'd rather go out and do people's backyards or run to the store for the neighbors. I created little jobs for myself throughout the neighborhood. I'd get ten cents to do an errand, and in those days that was a lot of money. With a quarter you were a millionaire.

> *"I'm the guy that goes into all the areas of the city that other people are scared to go into—the threatening, high-crime, drug-infested neighborhoods. People often ask me why I do it. I say, 'Because somebody has to.'"*

When I started working, I could buy my brothers a pair of pants or a new shirt. Things begin to change for us as a family. My mom could rely on me. A lot of mornings we would get up and she didn't have the proper food to send us to school with. Some mornings it was just a hot glass of tea and some toast. When I was helping, we would have some bologna on that bread instead of just mayonnaise.

I dropped out of high school in eleventh grade. I got my girl pregnant,

so it was time for me to step up. I became a troubleshooter and then a manager for BP Oil. They wanted to send me back to school, to finish getting my education so they could put me in a supervisor position. In the late seventies, I was making $20,000 a year. That was great money. It was just that I wanted more. Opportunity came when cocaine hit the street. I was off and running. I saw poor folks become millionaires overnight. I met this other young lady and we had a son, so then I had two families. I was already using cocaine casually—I was a weekend warrior. I started selling a little and then I became one of my best customers. Everything was going in my nose or in the pipe. The mother of my son left and my wife eventually kicked me to the curb.

Before I left BP, I robbed them and used some of the money to put myself in a rehab for three months. When I came out I took what I had left and I started to build my empire. I became a major drug dealer. I went right back to using. I had about an eight-year run before I finally got busted in 1987. I did twelve years. I couldn't adapt to authority in prison, so, the first two years of my incarceration I spun a hole in solitary confinement.

Through all my drug dealings, I brought my family in and they got involved with my business as well. I'd especially taken my little brother underneath my wing because he was having problems with my pop, and I knew what that was like. So he'd been living with me and working for me. He ended up turning state's evidence and testified against me. I wanted to kill my brother because in street law the worst thing you can do is rat out your flesh and blood.

When I finally got released they sent me to a halfway house. I was older; I had some health issues. I didn't want to come back out because I didn't think that I was going to make it. I went right up to my counselor's office after getting off the bus and said, "I'd like to go back." She told me if I continued to stand there, she was going to accommodate me with that. One of the monitors put his hands on my shoulder and said, "Mr. Gant, come on out here." He said, "Look, there are some folks around the corner. Go take a walk." So I did and there was this guy sitting there that had this expression on his face like a shining star. Right away I became attracted to that look. They had a program called End Violence and this gentleman was holding conversations with the residents of the halfway house to teach

them how to make conscious decisions about what they do, instead of always getting into trouble. I started going to this group and learning about how to make healthier choices in my life.

Eventually, I got up and spoke about the situation with my brother. That was a breakthrough because I was so focused on trying to forgive him for what he'd done to me when the truth of the matter was that I should have been asking him to forgive me for what I'd done to him. Everything he was about, I taught it to him. I realized that instead of pointing the finger, I had to take responsibility for what I'd done. It opened my eyes to see life differently. So I wrote my brother a long letter expressing my apology to him.

Another gentleman in the group heard my story and he was moved. We became friends. One day he asked me, "Raymond, what would you like to see done to improve your community that we can make happen?" I said, "Man, I come home and I see some of the elderly folks still living in these horrible conditions. Before I went to prison I used to fix up people's houses for them so that they could have a better quality of life." So we became partners and started helping out low-income families and senior citizens who couldn't afford the high cost of repairing structural home

damage. If they met our criteria, we would provide the labor and material free of charge to do repairs, like fixing a leaking ceiling or a burst pipe. That's how The Ray of Hope Project started, in 2002. We've done more than eighty homes since.

I'm the guy that goes into all the areas of the city that other people are scared to go into—the threatening, high-crime, drug-infested neighborhoods. People often ask me why I do it. I say, "Because somebody has to."

This is our tenth year and they say every good organization takes at least that long to hit its stride. We'd like to start expanding our mission and rehab vacant houses so that we can create more housing for low-income families and the homeless. Right now we're trying to get somebody at the counsel district to grant us a pilot project so we can demonstrate what is possible. They know our track record. In all the houses we've worked on, we haven't had a screw fall out of the wall. We haven't had a single complaint. All we want to do is create jobs and affordable housing. These vacant houses are the answer.

My daughter just turned thirty-nine this year. We're pretty good. My son is incarcerated. His mother walked away with him when he was just a baby. The next time I heard from him he was a grown man. I tried to bring him on board with us at The Ray of Hope Project, but he chose to stay with what he was doing. All I can do now is pray for him. The thing is, sometimes we just have to meet people where they're at. We can't love them for who we want them to be. We just have to love them for who they are.

I am trying not to see the inside of anybody's prison ever again in my life. We have to do for ourselves in the end. We can't expect the world to do for us. I go back to the prison sometimes just to share some hope and tell folks, "Man, it's better on this side." I give seminars and workshops about change and what it takes. It's not a whole lot of work, but it's all up to you. There aren't no magic wands or voodoo. It's just about what you want to make of your life and what you want to be responsible for. This work has put me in a space where I really belong. I've always been pretty fearless, even when it comes to death. The only thing that's ever scared me was when they told me that I could change. But I did it, and I'll never know that kind of fear again.

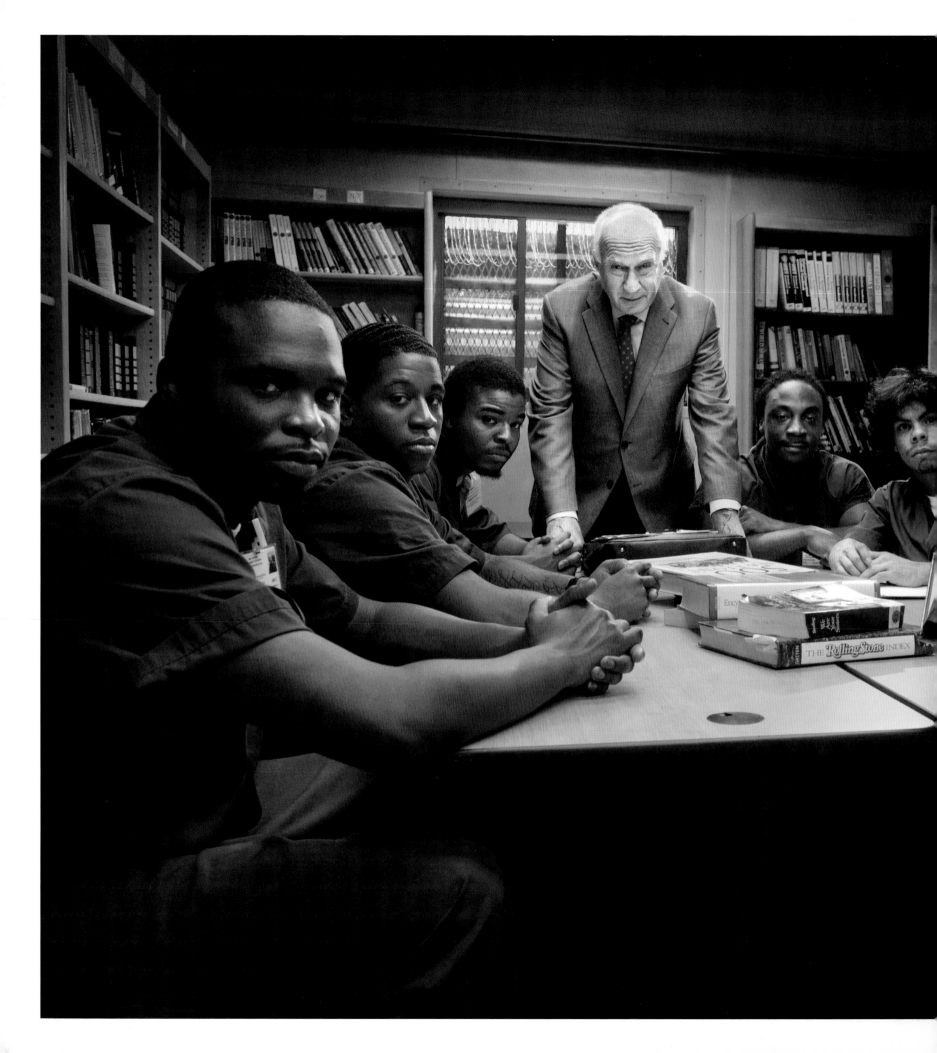

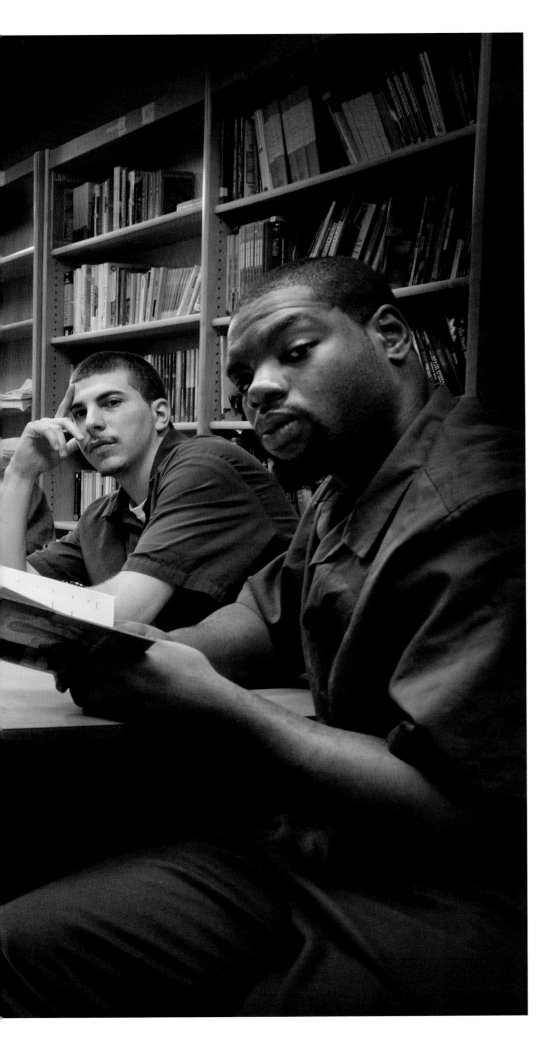

"When we talk about our success rate, it's not what we do—it's what they do."

Mark Goldsmith

President and CEO, Getting Out and Staying Out

Mark Goldsmith enjoyed a long and lucrative career as a business executive. When it came time to retire, he could have just donated his suits to charity, settled back in a deck chair, and enjoyed the rewards of his hard work. He could have done that, but he didn't. That's just not who Goldsmith is. When serendipity landed Goldsmith at Rikers Island for a day (as a volunteer, not an inmate) he saw that some assistance and education for convicts reentering society could change lives and futures. So he called upon his lifetime of profit-making skills to build a robust nonprofit called Getting Out and Staying Out in 2004. Through a combination of psychological, educational, and vocational support, Goldsmith's organization has since successfully guided hundreds of men through their transition from the inside to the outside. The numbers speak for themselves: the recidivism rate nationwide for young men is about 60 percent; for members of Getting Out and Staying Out, it's 20 percent.

Mark Goldsmith with incarcerated members of Getting Out and Staying Out at Rikers Island in New York City.

I grew up in the coal-mining town of Johnstown, Pennsylvania. I went to a very small high school—twenty-four kids in my class. Sports really ruled the roost. So I played basketball and enjoyed life as it was, growing up in a small town—I wouldn't give it up for the world. I wasn't a bad kid but a bit of a wise guy. I wasn't much of a student either and I dropped out of Penn State after two years to join the navy. When I got out of the service, I met my wife, got my undergraduate from NYU, my MBA from Baruch City College, and embarked on a forty-year career in the cosmetics industry.

I've had conversations with other people from Johnstown, and we've always talked about why we were all relatively successful and we determined it had a lot to do with the work ethic we grew up with. In fact, when my kids came back after their freshman year they sat down to dinner and looked at me and my wife and asked, "How come we're the only kids in high school who worked?" And we said, "Because that's the way it is in our family, you know—you work!"

I had heard about an interesting program in New York called Principal for the Day where professionals can go into New York City schools and talk to the principals and the kids and try to get them to appreciate that society really does care about schools and teachers and students. In 2003, I decided to volunteer.

I'm still a bit of a wise guy, so I asked for a tough school thinking they might send me to the South Bronx, but instead they asked me if I would go to jail. And I said, "Excuse me?" They wanted me to go to two high schools on Rikers Island. So off to Rikers I went.

I had an incredible first day there, met the principal, talked to a bunch of the guys, and something clicked. I did an analogy for them that they thought was pretty clever. I set up side-by-side models of a drug cartel and General Motors. I showed them how the chairman of the board of General Motors wasn't much different than the kingpin of a drug cartel. The kingpin has a hierarchy of lieutenants and generals all the way down to the punks who hustle drugs on the street, and the GM has executive VPs, VPs, marketing guys, and sales guys who basically hustle cars, and there's no difference between selling cars and selling pot. I told them, "The bottom line is that you don't sell drugs because you're bad guys, you sell drugs because you want to make money—it's the same thing as a car salesman."

The next time I went back, a lawyer also showed up and I wondered why we needed two principals for the day, but then I said to myself, "Wait a minute, he's talking about them getting out of prison, and I'm talking about them *staying* out." I went home and trademarked the name Getting Out and Staying Out.

The rest is history. I got my 501c3 in 2004. I couldn't afford an office yet and it was just me, so I'd work with the guys on the inside, and then when they got out, I'd meet them at the Starbucks on 39th and Madison. I did that for about a year—I drank an awful lot of caffe lattes. Now we have an office, six paid employees, and a board of directors, many of whom serve as mentors and coaches. We're kind of lean and mean.

There are three parts to the program. At Rikers Island, we start mentoring the minute they get in. Applicants have to write an essay telling me a little bit about themselves and how we can help them when they get out. Then we assist them with their court cases. Rikers is not a turnstile: 14,000 people sleep there every night: 2,000 women we do not work with; 2,000 people who have been sentenced to less than a year for misdemeanors; and another 10,000 awaiting adjudication of their trial. Of those, an awful lot are going Upstate to do time, so I opened an Upstate correspondence program that keeps them in the loop while they're incarcerated. When they get out they come to my office in East Harlem.

It's strictly men that we work with. We started with eighteen- to twenty-four-year-olds, but we moved it down over the years to sixteen-year-olds. The program is 100 percent voluntary. I would say, maybe 50 to 60 percent of the guys we see on the inside show up at the office. And of the 60 percent who show up, 60 percent stick with the program.

The way it works once they're out is pretty straightforward. They come to the office on the very first day they're released. We do intake, they get a psycho/social done by a licensed social worker or a social-work intern, and we start to talk about what they really want to do for the rest of their lives, the types of careers they want. Educationally, do they have their GED or high-school diploma? Do they want to go to college? They leave with a

brand new résumé that day. That's part of our tool kit—they get a résumé; an electric alarm clock; as many condoms as they need to keep themselves safe; a pad, pencils, maybe a little briefcase; and then perhaps the most important thing is a monthly MetroCard. If you go to school and work full-time, we give you a card: it costs us $105 and it's our pleasure.

We also give them shirts, ties, and pants for interviewing, and a new pair of shoes. Over the first month or so, they embark upon a series of seminars that involve interview skills, how to get a job and keep a job, financial planning, time and priority management, etc. We get them interviews. Before the training, they are woefully unprepared—they think they're ready, but they're not. Not by a long shot. We make sure that when we send them out, they really have a chance at getting a job. Also, with respect to school, we teach them what a bursar is, what a registrar is, what the difference is between college and high school, because they usually don't have a clue. We have thirty to forty guys in college at any given time, and often they are the first generation in their families to ever go to college.

"We try to get these guys to understand that they're not totally forgotten, that people do care—but at the same time the overriding principle is that you must pay your dues, you must step up and you must be accountable."

The unfortunate part is that their families remain dysfunctional. They are still living in lousy neighborhoods; there are still very few male role models for them, which is very sad; and many of the problems that caused them to take the wrong path in the first place are still there. So the objective is for them to move on as quickly as possible, get a job, be able to afford a house, an apartment, and get on with their lives.

We try to get these guys to understand that they're not totally forgotten, that people do care—but at the same time the overriding principle is that you must pay your dues, you must step up and you must be accountable. If they're screwing up, they have to meet with me, they have to face Goldsmith, and I say, "This is it—we've put up with your antics long enough, you've got to shape up or you just can't be part of the program." It's all about them, it's not about us. When we talk about our success rate, it's not what we do—it's what *they* do. What we're doing is counseling, mentoring, coaching, giving them every support that they never had. They've been dealt a very bad deck, a *very* bad deck. It's a wonder they can walk and talk, it really is. It's amazing how they have survived up to the point that we get our hands on them . . . incredible endurance, you just don't know how they do it, you really don't.

And when they come to us, they don't really get it, they don't understand that by going to work early every day, and not taking a bunch of sick days, and working really hard—you can get ahead; because they've never had a role model who did it. Everybody's been on welfare, everybody's been on SSI, everybody has all these checks coming in for not doing anything. It's horrible.

For all the frustration, there are countless success stories that have really impacted me over the years. We have one guy I met at Rikers: this young man wanted to be in health care. He got out, he went to Queens College, he got a job at Mount Sinai Hospital as an orderly, saw a job posting for a lab tech, got the job, and he quickly went from making 12 to 14 dollars an hour to 18 to 20 an hour. He's graduating Queens College this year with a three-something average, and he's going to be a professional nurse. He's married now, too, with a child, and living happily ever after.

There's another guy, who wanted to go into physical therapy—went to college, graduated with a 3.5, and is successfully working in that field. Another guy graduated Columbia University with a 3.75, no less. We put him on our board, and he's very active in the Muslim community, trying to instill peace and civility and understanding between the Muslims and non-Muslims. So a lot of them, they get out, they move on, they succeed, and they have really productive lives.

Roshi Joan Halifax

Founder and Abbot, Upaya Zen Center

In a culture where death is often denied or hidden away, Roshi Joan Halifax has spent much of her lifetime teaching others how to be with dying. She has sat with dying people and caregivers, listened to them, comforted them, eased their suffering, and borne witness to the final failing breaths of those who were meeting death. Her commitment to end-of-life care has spanned more than forty years. She is a Buddhist teacher, Zen priest, anthropologist, social activist, author, and teacher of health-care professionals about the dying process. As the spiritual leader of her community at the Upaya Zen Center, which she opened in 1990 after founding and leading the Ojai Foundation in California for eleven years, Halifax focuses on socially engaged Buddhism, which aims to alleviate suffering through meditation, interfaith cooperation, and social service. She describes what her daily schedule at Upaya was for many years this way, "I sat in the *zendo*, I taught, I sat with dying people, I wrote. I did the chores of daily life. It was kind of a regular life. And I'm very fortunate to live in a beautiful place, yet we were and are surrounded by suffering, so I have had to ask, how can I bring the gifts of my life forward to really help other beings?"

My field is dying. How we die and how we live can't be separated because factors and policies surrounding death affect the well-being of us all. You could say I've been on a death trip for the past forty years.

I've done the most simple things for and with dying people and people concerned with the issues of suffering and death. I've worked with family members and professional caregivers. I am defined in various ways: a Buddhist priest doing pastoral work; a medical anthropologist; a caregiver; a friend. I prefer the latter definition because I do not want to be distanced by roles and titles. I am simply a person in the community who brings a certain quality of presence to those who are suffering and those who want to learn to be with dying.

Working with dying people was inspired by my grandmother. When I was a young girl, we would spend summers with her. My father told me that she made tombstones for local people in Savannah, Georgia. She was a remarkable woman who, in her elder years, often served her community as someone comfortable around illness, who would sit with and care for dying friends. My grandmother was intimate with both the challenges of dying and the truth of death. For her, dying was very much a natural part of life. She was a "village woman" like many women of the South who took care of their own and their neighbors. Hers was a skill that has been mostly lost in our communities.

When my grandmother had a stroke, her own family could not offer her the same compassionate presence she had offered others. She was put in a nursing home and then left largely alone. Her death was long and hard. I remember visiting her and sitting beside her as she lay in a criblike bed, begging my father to help her die. It was a situation I couldn't bear to see. When she finally died, I felt ambivalence, both sorrow and relief. As I stood there looking at her gentle, peaceful face at the funeral home, I promised I would do everything I could for the rest of my life to make dying better for others.

Years later, when my father lay dying, he did not seem to be afraid. He had included old age, sickness, and death in his life, even as he let go of it. He held the memory of my mother together with the presence of

Roshi Joan Halifax at the Upaya Zen Center in Santa Fe, NM.

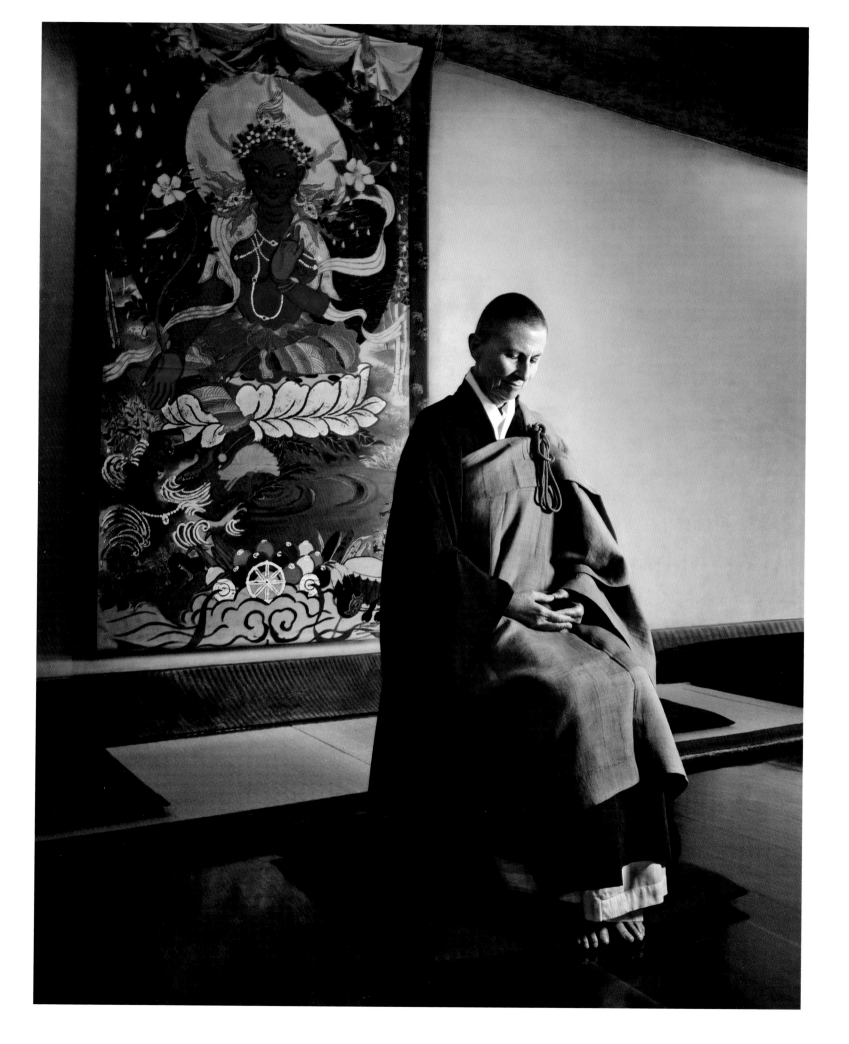

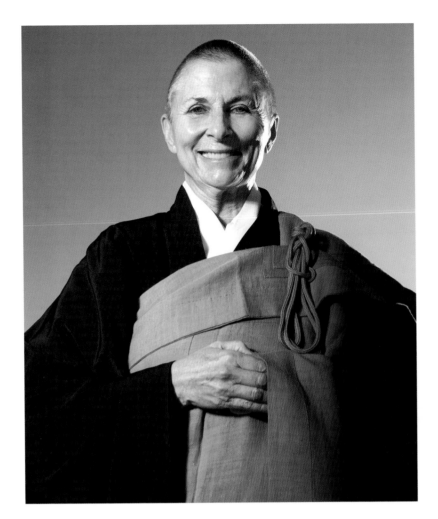

his new wife: his children, grandchildren, and great-grandchild, together with nurses, doctors, and aides; and his discomfort alongside his sense of humor. Nothing was left out. As he gave away his life, his wisdom and kindness grew even deeper. He let go of opinions, concepts, and ideas. He let go of us. His true nature shone through his dissolving body as boundless love, completely free of clinging, for everyone around him.

As a young anthropologist I studied rites of passage, especially the function of initiation in indigenous cultures. I looked at the psychosocial absence of rites of maturation in Western culture. I knew very clearly there was a great absence in our culture. I was working with the University of Miami School of Medicine, which is located in a very culturally complex area. There were people in communities around the hospital from all over this hemisphere. These folks had very different belief systems than our prevailing one. Several of us served as bridges for the healers in those communities to allow them to come into the hospital system.

One of the things that really disturbed me about the hospital setting was that dying people were marginalized. The thought was that dying people represented a failure on the part of medical technology and skills, which focuses on curing. As a social scientist in a medical setting, I was looking not just at how people were marginalized for the failure of medicine to save their lives, but also at how medical education rarely, if ever, addressed the psychosocial, existential, and spiritual issues related to dying and death.

In the early 1970s, I married a psychiatrist and we worked together at the Maryland Psychiatric Research Center using LSD as an adjunct to psychotherapy with people dying of cancer. This project began in the late 1960s. The caregivers at the Research Center provided an incredible amount of attention to each dying person and their family. I felt very privileged to sit for many hours with a person dying of cancer, and share his or her psyche in the most intimate way–aspects of which were, in general, not normally accessible in a non-altered state of consciousness.

My husband and I parted ways, but this work with dying people had touched me. I had been practicing meditation since the sixties. I realized that death was the most intimate experience of our life—more intimate than sex and birth. I wanted to continue working with dying people. So I studied and practiced and got ordained and became a pastoral person. This gave me as an anthropologist the ability to study a person as an individual and not turn them into a research project. Life and death became the project. For many years I worked individually with dying people, realizing that death itself—the dying process itself—is a huge transformation in a person's consciousness. Death is a phase shift between living and afterlife. In that phase shift, everything is up for grabs.

We should remember that only 10 percent of people die quickly and painlessly. For the rest of us, whether we are on a conscious death trip or not, we will share this process with the people we love and with strangers. The simple truth is that we cannot know death except by dying. This is the mystery that lies beneath the skin of life. But we can feel something from those who are close to it. In being with the dying, we arrive at a natural crucible of what it means to love and be loved. And we can ask ourselves this: Knowing that death is inevitable, what is most precious today?

If death is looked on, for example, as a defeat or as something just

awful, then we will approach death with a very deep sense of failure. And we'll do anything, at any cost, to avoid it. This is not to say that human life isn't precious. On the contrary, what an extraordinary experience it is to be born and to have a life, and so efforts to prolong life, to me, seem quite sane and correct. On the other hand, to let life go is also quite sane and quite correct. So when we get into sectarian complexity around issues in relation to the prolongation of life or the ending of life, it behooves us to understand what conditioning we are addressing, but we often don't see what shapes our behaviors. Plato said the very bedrock of our spiritual lives is the contemplation of death. And this is true in many religions, that understanding the truth of our mortality—really coming to grips with it and, in fact, preparing for it moment by moment—brings us into a profound sense of immediacy and a deep value for things as they are, for our lives and for this world as it is.

> *"The simple truth is that we cannot know death except by dying. This is the mystery that lies beneath the skin of life. But we can feel something from those who are close to it. And we can ask ourselves this: Knowing that death is inevitable, what is most precious today?"*

My whole practice has been about opening yourself to a basic not knowing, to being with the inconceivable and not trying to figure it all out. And that is, in essence, what the practice of being with dying is all about for me. You don't know, you bear witness to each moment as it arises. We need to learn to bear witness. And "to bear witness" is not to be separate from what is going on, but rather to be open to whatever is occurring. How to do this? Meditate. Pay attention to whatever is going on in your own mind. Start with your own experience because the ability to be present is

often hard-won. The image of riding the waves of birth and death shows that you are in a continuum of constant change, constant groundlessness. And instead of drowning in the waters you are surfing, you are riding it. And every time you fixate, you start to drown. The struggle can be very profound. I have sat with many dying people, bearing witness to the experience of dying and recognizing that most individuals do not die alone. They die within a community comprised of not only family and friends, but also caregivers and compassionate strangers.

My own work in the field of death and dying now, and for sometime, has been in the training of clinicians and caregivers in bringing more presence, more compassion, and more wisdom in their care of dying people. We, at Upaya, work in four transformational areas: transforming the experience of the clinician, transforming the experience of the patient, transforming the community around the patient, and transforming the institutions that serve dying people. We train clinicians in our approach to care of the dying not only at Upaya but also at major medical centers around the country, in Europe, Asia, and Canada. In addition, we train contemplative caregivers to sit with dying people. We also have a weekly meeting for those who are facing life-threatening illness; and offer, to those who need it, refuge at Upaya.

I think the most important thing I've learned from working with dying patients and death-row prisoners is that the gift, really, is to be present completely. Out of being present you're able to see that even in situations that seem absolutely helpless, there's always some deep invitation to come into a miraculous presence.

I'm very comfortable around the truth of dying. I'm around a lot of suffering. Does it bring me down? No. Does it bring me up? No. It's as it is. There's a kind of frankness to this way that I approach life. I feel so lucky that I've had so many years sitting with dying people. And I still feel that I am in the presence of a mystery, and it's a deep privilege, and it also gives me so much to appreciate in my life.

I don't know what my death will be. I have seen so many people die. Held so many people as they let go—or struggled and fought and tried to hold on. I hope it will be a good death, a gentle passage, but I can't know that before. Death will be my final teaching, that's all I can know.

"The real heart of the organization and the model to be replicated is still ten supportive women paired with ten high-risk pregnant women."

Kathryn Hall-Trujillo

Founder and Director, Birthing Project USA–The Underground Railroad for New Life

In America, which has the highest infant mortality rate of any industrialized nation in the world, African American babies are twice as likely to die as Caucasian babies before they reach their first birthday. That statistic is the driving force behind the Birthing Project USA, a nonprofit that promotes a peer support system for disadvantaged, pregnant African American women. The model is simple: one woman helping guide another woman through a healthy birth and her child's first year of life. The program is the invention of Kathryn Hall-Trujillo, who has spent twenty-five years crusading for the safety and well-being of African American infants and their mothers. Hall-Trujillo's methods may be more based in the spiritual, but the results are pure science: babies born through the Birthing Project have longer gestation periods and higher birth weights than those in the general target population. Her heroic efforts have saved thousands of lives but not without a significant personal cost: "I can't tell you how many times I had to refinance my own house to make payroll, and to this day I still haven't taken a real vacation since starting the project," says Hall-Trujillo, who is familiarly known as "Mama Kat." She regrets nothing. The gift of knowing she has "midwifed" thousands of healthy newborns into this world eclipses every sacrifice.

I worked for the State of California for fourteen years, from 1976 to 1991 as a public health advisor. A lot of our funding was used up treating drug babies. At the time, it cost the state about $300,000 to care for one of these infants for the first ninety days of their life. There was hardly any money left over for public health. It was clear to us that it would be a lot better—and cheaper—to have these babies born healthy.

I had the idea to match volunteers from the community of Sacramento with high-risk pregnant women. I found ten local women mentors who were not social workers, but who were willing to provide direction and support and keep pushing these expectant mothers forward, as opposed to making them dependent. If their babies could be born healthy and live to age one, it would reduce the burden on the state tremendously. I wish I could say that I came up with something so scientific it took a blackboard to explain it. But it was that simple.

In 1988, I wrote a proposal for the Birthing Project and sent it through channels. The state never said no. They just never said yes. So, I applied to the Sierra Health Foundation. And lo and behold, they funded us. So here I was, a state employee with a funded project from a foundation, which was unheard of. That's like your parents sending you to your room as punishment, and you call out for pizza. There was no other organization in California at that time, that I know of, that provided services specifically to women of color.

I matched the women up and myself up with a woman as well—and her baby died. It was horrible. I knew that the State of California and I had failed the mother: she was receiving medication from two doctors, and one didn't know what the other was doing. That could have been avoided. After that, I knew I had to continue with this.

The organization grew as we became more aware of the needs of the women that we served. And one day, I just never went back to work again. My boss called and asked if I had forgotten my job. And I really had. He gave me a leave of absence. The next morning I said, "Thank you, I quit." I drew down my retirement and I bought a house. It was the only

Kathryn Hall-Trujillo holding a baby picture of herself, in her home in Albuquerque, NM.

"We want our kids to feel like it is special to have been born into a Birthing Project, into an intentional community that waited for them, prayed for them, loved them, and supported them when they came into the world."

house I could find under $100,000 in Sacramento where I was not afraid to get out of the car to look at it.

That little house was known as Dorothy House, and it became the base for the project. There were times I lived there, times when women lived there who were escaping a violent environment. Sometimes it was a substance abuse rehab. We used Dorothy House for everything that we needed it to be. My poor neighbors. All these women coming and going. They couldn't figure out if we were a house of ill repute or what.

Funding was a challenge. When you seek outside capital, you have to meet certain goals and objectives. And half the women I worked with, I buried. That really limited our funding opportunities. We chose to think out of the box because we wanted to have the flexibility to do what needed to be done and to take chances with people who might not become success stories. So we had to learn to earn money ourselves. We decided to open a clinic, which we called the Center for Community Health and Well-Being.

We became an economic development project through the Ms. Foundation's Women's Economic Development Institute. They found us early on and helped us see ourselves not just as a charity, but as a business that put local women to work doing something that needed to be done in the community. The nurse-practitioners and midwives who worked in the clinic definitely earned less money than they would have someplace else, but that meant that the people who worked at the bottom never earned less than $10 an hour. We split the money differently than you normally would. To this day, I still earn just $50,000 a year. My parents don't understand that, because I have a degree from UCLA, so they wonder how come I don't have a real job and why I don't have some money saved for retirement. But the organization has always been about finding people who have a shared vision and the willingness to give up something so that someone else can be involved. That's how we can really make a difference in the community.

The clinic is just one example of what a Birthing Project can do. The real heart of the organization and the model to be replicated is still ten supportive women paired with ten high-risk pregnant women. We provide an amazing resource and model for individuals and organizations to duplicate and sustain. Once they get together, they can decide if they want to build a clinic, start a day care center—whatever the need is. All of that has happened in the different kinds of Birthing Projects around the country and the world. They are all based on the idea of one woman supporting another woman within a small group that collectively figures out the systemic problems and deals with them. Since 1988, we have spawned more than a hundred community chapters in seven countries.

I know we've helped at least ten thousand women. After that I stopped counting.

The first Birthing Project outside the U.S. was in Canada, with a group of Jamaican women who read about us in *Essence* magazine. We didn't know how to replicate it then, so we just talked them through it. Then, in 2000, I had the opportunity to visit Cuba. When I arrived, I realized their infant mortality rate was better than ours. I absolutely could not understand why a blockaded, underdeveloped country had healthier babies than we did. At the same time, the United States had started sending students to Cuban medical schools in exchange for their commitment to come back and work in underserved areas here. They have students there from almost forty countries now. The students from Honduras asked if I would help them put together their women's program. How could I say no? The project became a replicable model and we were invited to go to Malawi. One thing kept leading to another and it just grew from there. Just today, someone e-mailed me and said, "I want to do a project in Atlanta." I wrote back, "Can you put together a group of ten women that you trust to be sister-friends to ten other women?" Because if she can convince me she can do that, we have something to work with.

I really see the connection between my childhood and the work that I do now. Even though I came from a family that was poor, I came from a very good family; we loved one another and were part of a larger community. Still, I made decisions to do things my parents told me not to do. Some people say, "I never did anything bad when I was growing up. I don't understand these young people." Well, I did everything, so I do understand. My grandmother was my mentor. She loved me. It is so important to have someone who loves you unconditionally, who is pulling for you no matter what. When I dropped out of high school and ended up in an abusive marriage, I was embarrassed because I knew that's not what my family expected of me. I even lived in the bus station with my children for a time because I was ashamed to go home. But other women in the community said, "Oh, no, we're not going to have this." Those were the women who modeled caring for me.

I remember one day I needed to take a test at Los Angeles City College in order to complete my studies and move on to UCLA, where I had already been accepted. And that was the day—because this is how domestic violence works—that my husband beat me until I looked like I had been mugged. I went to a woman who ran a community center, with my babies, crying. She said, "Here's bus fare. I will hold your babies. Go take that test." I got on the bus, all ragged and bleeding. But I ended up at UCLA because of her. Those little things are so much more important than somebody referring me to some program. She did the basic human thing. She said, "I'll take care of the babies, you go down there and make this happen." That's what the Birthing Project does: it's one woman saying that to another woman.

We want our kids to feel like it is special to have been born into a Birthing Project, into an intentional community that waited for them, prayed for them, loved them, and supported them when they came into the world. We're raising kids now in New Orleans that were born after Hurricane Katrina. We call them our Rainbow Babies. They're starting school this year. They're growing up in a community that's not going to let them fall through the cracks.

Until I met my current husband, I was pretty much consumed by the Birthing Project. My house was full of pregnant women and babies. It was my whole life. And when I started going to Cuba twelve years ago to research why their birth outcomes are better than ours, I also started getting more balance in my life. I actually met my husband there. He was the videographer for our trip. It was the right time and he was the right person. We ended up getting married the next year in Cuba. He documents my work and helps other people see what we're doing. It's quite amazing to finally have a true partner.

The Birthing Project feels like my child who's growing up, and I am ready to be a grandparent. I want to live long enough to see the next generation take it over. All these other chapters are headed up by women who I consider to be my sisters. The Brooklyn Perinatal Network Birthing Project, in New York, is totally different from the Northeast Mississippi Birthing Project, in Tupelo—but when we get together and support each other, we get through the hard times. It's almost like a quilting circle, and I think how lucky I am to see the world in sisterhood with women. I just love it.

Darell Hammond

Founder and CEO, KaBOOM!

Darell Hammond has built a philanthropic empire around the simplest of mottos, "Have playground, will travel." Under Hammond's sixteen-year leadership, KaBOOM! (even the name sounds FUN) has orchestrated the construction of more than 2,100 playgrounds in neighborhoods in need across America. Along the way, Hammond has amassed a trove of awards and honors, including the prestigious Schwab Social Entrepreneur of the Year Award and the Jefferson Award for Public Service. Yet for Hammond, few of his many profound achievements compare to being the first nonprofit to have a Ben & Jerry's ice cream named after them (Kaberry KaBOOM!—a blueberry, strawberry ice cream with white-fudge-covered pop rocks).

I do what I do today because I'm a product of philanthropy and charity. When I was two years old, my father—who was a cross-country truck driver—went to unload a shipment one day, and unfortunately, never came back. My mother was left to care for me and my seven brothers and sisters. For two years she did as much and as best as she could. But when I was four, we became wards of the court and were shipped off from Idaho to a twelve-hundred-acre group home called Mooseheart, outside of Chicago. The reality is that what was probably the hardest decision my mom ever had to make was certainly the best decision for us.

For the next fourteen years, we were raised at Mooseheart with over three hundred other kids in similar circumstances from all across the country. It was much like a Boys Town. You lived and went to school on a campus. You participated in athletic programs. Every June, each class relocated to a new residence hall. So you never acquired a lot of possessions because you didn't want to have to move more than what could fit in your footlocker.

If there is any tragedy to our story, it's that although all my siblings and I went to the same institution, we didn't necessarily stay close. We all lived in different halls based on our ages, and we took on lives of our own.

To this day I'm only still in touch with four of them. So it kept the family in one place, but it didn't necessarily keep the family together. I'm not sure I feel that's a criticism. The story just didn't write itself that way, you know—it wasn't a fairy-tale ending.

Knowing what I know now about Mooseheart, and thinking about the other schools that were around us, that we played sports against or participated in bands or other cultural and athletic activities with—when those other schools were consolidating or cutting programs (one year they'd be around and next year they wouldn't), that didn't happen at our school. The men and women of the Moose Lodges across the country continued to provide what was best for us as whole children and gave us a good education, but also a well-rounded, enriching environment that included arts, culture, and vocational training. That became my upbringing. It was a very formative experience to be raised through the generosity of strangers, and it gave me the life that I now have. I'm compelled to give back in the same way.

After I graduated, I went to a community college and then a four-year college. I learned that I had dyslexia in college, but developed very good coping skills. I didn't have money for the course books, but during and after class I was keen on conversation. I'd interview all my classmates

Darell Hammond sitting amidst the mobile Imagination Playground at the KaBOOM! offices in Washington, D.C.

about the subject matter, find out what their contrary points of view were, and would tease out information as if I was reading the material, but in a much more well-rounded way. I did well from that perspective, but I didn't have the money to continue, so I dropped out and joined a program in Chicago called the Urban Studies Fellowship. I was paired with Dr. Jody Kretzmann, who ran the Asset-Based Community Development Institute at Northwestern, and that gave me a whole new vantage point on the difficulties that families and communities face when they're on the lowest rungs of society and life. The whole idea behind asset-based development is to focus on what a community *has*, not what they *don't* have, and build on that. Then I started to work for City Year, which was part of President Clinton's wave of AmeriCorps programs, and I had the opportunity to build a playground in Columbus, Ohio.

> *"The playground became a powerful means to accomplish what I thought was my life's work, which was building communities from the inside, focusing on people's gifts and strengths, not their weaknesses and deficiencies."*

I saw that the playground could almost be used as a Trojan horse to work on a definable project with a definable timeline for the community. Not to try to solve all their problems at once, but essentially to come around a common cause—the well-being of kids, and have achievable wins through the building of a playground that potentially could lead to greater cascading steps of confidence and courage once the community saw themselves as part of the solution. The playground became a powerful means to accomplish what I thought was my life's work, which was building communities from the inside, focusing on people's gifts and strengths, not their weaknesses and deficiencies.

Shortly after, I moved to Washington, D.C., and read an article in the *Washington Post* headlined, "No Place to Play." It described a reporter who had seen a story in the *Post*'s Metro section about two local kids dying. She went down to the community and wrote a front-page article about how they had crawled into an abandoned car to play during the heat wave that year, and had suffocated. For several weeks, she went in widening concentric circles around the housing development and couldn't find a playground, a skate park, a swimming pool, or even green grass. At the same time, she saw apathy and people pointing fingers. I identified with these two kids. They were around the same age I was when my father left us, and whereas I went to a group home where people surrounded and helped us, this event continued to divide the community, and nobody was surrounding anyone to make it better.

This made me think, "How do you turn this into Community Building 101 and use the playground as a vehicle to bring the community together and create something that is unifying and attainable?" In 1996, the first KaBOOM! playground was built, in honor of those two kids. Since then we've built more than two thousand playgrounds and raised over $200 million.

KaBOOM! has a complicated model. We get the majority of our funding from corporations who not only put up hundreds of thousands of dollars, they also dedicate their employees' time to be part of the planning committee for each community playground and they provide 50 percent of the labor force to actually construct it. So the first piece of the KaBOOM! recipe is engaged corporate partners. The second piece is having a community that not only needs a playground, but will also go through the three-month process of putting together a planning committee, holding an assets-based walk in their neighborhood to look at their community differently, and having a design day where the kids talk about their dreams and desires and actually become the architects of the playground they will go on to enjoy. Instead of telling people about what we do, we show them. We show them our playgrounds. We let them bear witness. They see vacant lots transformed in mere hours. They see diverse groups of people from both the corporate realm and the community blending together, so that you don't know where one stops and the other begins. Then they want to participate. I think that's the beauty of this movement. It's self-directed.

There is definitely higher demand than we can fulfill. So we have

to look at different ways for us to have greater and deeper impact. For instance, we have an online replication strategy that uses mobile technology encouraging people to map out where every play opportunity exists in their community. If they do that, we can create a comprehensive map of play, and overlay that against demographics of race, income, population, high-school graduation rates, obesity rates—and start to contextualize, and determine the communities in which the opportunities are better, and make a more compelling case from a funding perspective. At the same time, how do we enable people, through open-source material, to independently adopt what we've learned through our sixteen years of experience, so that they can organize and fund-raise without us?

"We believe that every child should have a great place to play within walking distance of where they live."

One way we're trying to bring more play opportunities to children is through the development of the Imagination Playground, which is essentially a portable playground made up of different parts and pieces that can be configured in an endless number of ways. It fills in the gap in places where a permanent park is not necessarily affordable or there just isn't the space to do it. It can be pulled out into a street during a fair or it can be set up at a day care center or at a school. The second purpose of the Imagination Playground is that it helps us change the narrative of what the best type of play is for kids, which we would say is all types of play. But the part that we don't think they're getting enough of is self-directed, self-motivated play. Imagination Playground puts the kids at the center of control versus the equipment or space dictating what kind of play they should have.

KaBOOM! doesn't do anything alone. We do everything in partnerships. And, we're really trying to answer this question, "How do you get 100,000 flowers to bloom at once?" I think part of my role as leader of KaBOOM! is to help shine a spotlight on all the other organizations that are advocating playtime and play space, so that we can use our platform to give them more visibility. That visibility creates interest and enthusiasm in people everywhere to potentially duplicate these programs and projects in their own communities. Our objective is that the movement grows stronger, faster. That's what we're really in it for.

I think good leaders go through phases in their development. In sixteen years, I've gone from a project manager to managing project managers to managing people who manage project managers. My highest and best use today is to enroll other people in the art of what's possible and to help them realize that all communities are worth investing in. I don't manage the day to day anymore. I manage the strategy. I'm involved in major key relationships, and I see my role as being the chief advocate for our cause, introducing our mission, our movement, and our tools to the largest possible audience. For us, it's not about scaling up the organization. It's about scaling up the cause, getting a lot of people to care about it and then unleashing them, but at the same time making sure that they are connected to one another so that information and experiences can be shared.

We believe simply that every child should have a great place to play within walking distance of where they live. That place needs to be imaginative, creative, and fun. It should also be a community and social hub for all members of the community, from the very young to the very old. So how do we achieve this? It has to happen through multiple avenues. We need federal policy makers to understand their role in making sure that day care centers and schools and places where kids spend time have playgrounds. We also need communities and parents to understand that outdoor, child-directed play is just as important as organized sports, and that they have a role in ensuring that their kids have the time and opportunities to explore and play.

People assume that I started out with the intention of building what KaBOOM! has become. That's just not the case. That single playground I first helped construct turned into a couple dozen playgrounds, and then it just kept growing. The momentum builds on itself, and what we're able to accomplish today is the result of a variety of extremely skilled and talented people and resources over the past sixteen years. Maybe in another sixteen years it will be completely different. It's always a constantly evolving journey; it's never about reaching a destination.

Scott Harrison

Founder and CEO, charity: water

Scott Harrison's journey from celebrity party promoter to third-world missionary is so inherently dramatic it almost seems magical. After living a life of apathy and excess for nearly a decade, Harrison experienced a moment of spiritual reckoning. He vowed to return to the faith of his childhood and re-direct his energy towards helping those in need. In 2006, he founded charity: water to bring clean and safe drinking water to the 800 million people around the world who live without it. Much of the money raised so far is through small online donations from individuals that log on and chip in. "We're not offering grand solutions and billion dollar schemes," says the organization's website. "For about $20 a person, we know how to help millions."

In 1979, when I was four years old, my family relocated from Philadelphia to South Jersey. We moved into a new house, and within a few months my mom got really sick. She just collapsed one day. It took almost six months of testing before they realized she had carbon monoxide poisoning. It turned out the furnace had pinholes in it, and carbon monoxide had been leaking into our house. My dad and I were out all day at work and school, so we weren't seriously affected. But my mom was home all day and it just destroyed her immune system. From then on she had to wear charcoal masks and was connected to oxygen and had to live in a tile bathroom in our home, where the door and walls were covered in tinfoil. She was so sensitive, we had to bake her books to get out the smell of ink. My dad decided not to sue the gas company. We believed that one day, my mom would be healed through prayer. It was a pretty bizarre childhood.

At eighteen, like so many bad clichés, I rebelled—grew my hair down to my shoulders and moved to New York City with my band to give everybody the middle finger. Our band immediately broke up, but I learned there was this job in the city called a "nightclub promoter," where you could actually get paid to drink.

I climbed up the social ladder of nightlife. By the time I was twenty-eight, I was getting paid $2,000 a month by a few liquor companies just to be seen in public drinking their brands. I worked behind the velvet rope, selling $500 bottles of vodka to bankers. From the outside, my life looked great—dating models and driving a BMW, everything I thought I wanted. But, of course, I was the most miserable, selfish, sycophantic human being that I knew. I came to my senses on a trip to South America. I flew down with all the beautiful people on a private plane. We spent our nights partying and our days hung over.

I started reading the New Testament while I was there, and I rediscovered a lost Christian faith, in a much more significant way as an adult, since it wasn't being forced down my throat. I remember reading a verse in the Book of James that said, "True religion is this, to look after widows and orphans in their distress and to keep yourself from being polluted by the world." I had looked after zero widows and orphans and I actually was a purveyor of pollution. I wasn't just personally polluted; I went out and spread it.

I made a deal with God, there and then, that I would give a year to serve the poor, in exchange for the ten I had wasted. I hadn't had any interest in doing charity work before; in fact, I don't know that I even wrote a single check in a decade. But I started applying to humanitarian organizations. To my great surprise, they all turned me down. No one had any idea what a nightclub promoter even was—much less what one could do for their

Scott Harrison in New York City.

water.

cause. Thankfully, one organization, called Mercy Ships, said, "We'll take you if you pay us $500 a month for the pleasure of volunteering." I said yes.

The next thing I knew, I was sailing to Liberia on this giant hospital ship, with facial surgeons who specialized in operating on monstrous tumors. They brought me along as their photojournalist. I came face to face with hundreds of people who had horrible deformities—the most terrible, gut-wrenching stuff you can imagine. I had about fifteen thousand people on my e-mail list and I sent pictures back to my whole community.

I remember weeping and weeping, seeing extreme poverty for the first time—but also watching how these doctors were bringing hope to Liberia, which had just one physician for every fifty thousand people. By comparison, here in the States we have a doctor for every 180 people. I signed up for another year.

On my second tour, I learned about the link between lack of access to clean water and disease. I followed a guy who was digging wells out into the villages. Even though we're a medical organization, they allocated a little bit of money to fund clean water projects. I remember seeing these algae-filled ponds and rivers that people were drinking out of and thinking, "No wonder people are sick. I can't imagine letting my dog drink out of this water." I later came across a statistic from the World Health Organization, lack of access to clean water and sanitation is responsible for 80 percent of the disease on the planet.

"I made a deal with God, there and then, that I would give a year to serve the poor, in exchange for the ten I had wasted."

The minute I walked up the gangway of that ship, I never really looked back. I had quit smoking and drinking and every other vice in my life, of which there were many. I stepped into this whole new story. I felt blessed. I knew I was going to dedicate the rest of my life to service. Of all of the issues I had seen concerning poverty, water just leaped off the page. There were a billion people living without access to something I'd taken for granted my whole life. There was no awareness and there was very little being done about it, certainly nothing at scale.

When I came back from Liberia, having just had this transformational experience, I found my mom had been healed after twenty-eight years. My family's not sure why it took God so long, but we believe it happened in answer to prayer. It was just miraculous and deepened my commitment to follow my calling to start charity: water and inspire people toward generosity and compassion. I wanted to reinvent charity for my generation and bring a pretty disenchanted group of people back to the table of giving. Offer them a brand new model they could trust.

Step One was a party. That was the only thing I really knew how to do, so I threw an event in a nightclub and gave my friends open bar for an hour. Seven hundred people came. I charged them $20 at the door and used that $15,000 to build three wells and fix three other wells at a refugee camp in Uganda. I sent the photos and GPS back to every single person who'd attended the party. People were blown away that a charity had bothered to report to them for $20 so they could see what had happened with their donation. I promised to use 100 percent of public donations for direct project costs, so I was scraping to find friends who would cover the tiny staff budget.

We did a lot of events in the beginning. After the first party, we did an exhibition where I put dirty water from our ponds and rivers into these plexiglass tanks and built a giant water tower made of empty water bottles. The exhibition traveled from park to park in New York City. It showed people what it would look like if we had to drink from our ponds and rivers. That raised about $20,000. Then we went to Sundance and took over a gallery and did a "water walk," where people would carry forty pounds of water, like millions of people do around the world every day.

It quickly went online. Our creative director, who is now my wife, started building a web presence, where we sold $20 e-cards and found innovative ways for people to give monthly. I didn't want to throw another party. For my birthday I asked every single person I knew to donate my age in dollars, which was $32. We used 100 percent of the money to provide clean water to hostels in Kenya. We wound up raising $59,000 through my virtual non-birthday.

"My faith is the most important thing in my life, personally. But I actually didn't start a faith-based organization—charity: waters' mission is about getting clean water to everyone on the planet, which is fine with my theology. I don't think in heaven any woman is walking eight hours a day for dirty water."

And then a seven-year-old kid in Austin raised $22,000 on his seventh birthday and I realized we'd stumbled onto a very powerful idea. Everybody in the world has a birthday, and most of us don't need another handbag or tie, when a billion people lack access to clean water. We could track donors' birthday funds and show them exactly where the money went. Well over $10 million of the $60 million we've raised is through the birthday donation program.

I found that the people who were best at implementing clean water, sanitation, and hygiene solutions were some of the worst fund-raisers and marketers. I wasn't a hydrologist, so I built a movement around the lack of access to clean water. We would raise millions of dollars and use it to grow our partner organizations, so they could do what they're good at. Our portfolio has twenty-five implementing partners in nineteen countries. They work in thousands of villages, which are selected based on greatest need.

We've taken no government money and very little foundation money; 300,000 donors have given us money, mostly through modest online donations. People giving up birthdays, running marathons, holding car washes, skydiving, walking across America, sailing, going on crazy diets, shaving their heads—we've seen an army of passionate fund-raisers take our simple story and just run with it. Of the people who have given to charity: water, a large percentage of them weren't "givers." We restored their faith. At one of our early events, this guy who sold weed for a living dropped $500 and said, "I've never donated to a charity before." We sent 100 percent of that money to northern Uganda and people got clean water. And he got to see that.

Some new data just came out saying that the number of people without access to clean water is about 800 million now, down from 1.1 billion when we started. We were a part of that. While we've only directly helped 2.5 million people through six thousand water projects, I think we've really helped bring the issue to the forefront of awareness.

Last year we got clean water to 725,000 people, which translates to about 1,900 people a day. It's pretty cool to wake up knowing more than 600 people got clean water while you were sleeping because of the generosity of people around the world.

There are probably a dozen other organizations that do what we do in America. There's plenty of space for all of us. Some water nonprofits are out speaking in churches and others are out speaking in synagogues. We're trying to cast a very broad net, primarily using social media. The more the merrier. I don't have a poverty mentality at all when it comes to fund-raising. I think there's all the money in the world, especially for a cause like this. A lot of people ask me if I'm surprised we raised $60 million in the first few years. I'm mainly surprised we've raised so little.

I'll probably do 80 to 100 flights this year and get to spend a lot of time with our projects. Those are the real highlights—when a woman who was walking for six hours a day is now walking fifteen minutes and has tears streaming down her face saying that we were sent by God. Even secular people get incredibly spiritual when clean water is brought in.

My faith is the most important thing in my life, personally. But I actually didn't start a faith-based organization—charity: waters' mission is about getting clean water to everyone on the planet, which is fine with my theology. I don't think in heaven any woman is walking eight hours a day for dirty water.

Outside of the power of faith, a more universal message in my story would be that it's never too late. You can redeem the time. Because of my past, I'm almost uniquely qualified to do what I'm doing now, which is storytelling. I'm telling the stories of amazing humanitarians and drillers who have sacrificed their lives to get people clean water, instead of selling the story of Bacardi.

Doc Hendley

Founder and President, Wine to Water

Doc Hendley's journey into the nonprofit sector can only be described as refreshingly atypical. In 2004, within the span of a few months, Hendley went from slinging cocktails for rowdy crowds of undergrads to digging wells for the needy in one of the world's most volatile and impoverished countries. Not long before that, his search for a meaningful path in life led him to discover that the lack of access to clean drinking water and sanitation was the leading cause of childhood death in world. His confrontation with that statistical reality triggered a chain of events that ended in the founding of Wine to Water, an international nonprofit that aims to alleviate the water crisis in the developing world. Sustainability has been part of Wine to Water's core mission from the start, and Hendley believes emphatically that empowerment and assistance go hand in hand. Wine to Water always works with a local team on the ground to rebuild a water system and returns periodically once a project is completed to provide ongoing support and maintenance.

My father was a preacher man when I was growing up. The black sheep is probably the nicest way to put what I was in my family. I was quite rebellious and a bit of a loner. But my parents never boxed me in; they gave me the freedom to be who I was. I bought my first Harley when I was seventeen and dropped out of college after my first semester. The road was calling my name. So, I embraced the biker lifestyle for a while. I worked on different horse ranches around the country. I even lived overseas for a bit for a change of scenery. I finally came back to North Carolina after a few years and enrolled at NC State University and that's when I picked up some bartending skills. There's no other place that's felt more like home than the mountains of North Carolina.

In December 2003, I'd been bartending and playing music to make ends meet in Raleigh, and struggling my way through school. I had one semester left and I decided to go home and visit my parents in Boone for a week or two, and really think about what it was I wanted to do. I loved bartending. I loved the service industry. But I also knew I probably wasn't going to bartend for the rest of my life.

One night I woke up and I was still half asleep when I heard this phrase repeating over and over in my head: "wine to water." It was a little freaky. At first I thought, "This might be a good idea for a song." Obviously, it's the reverse of the story that I heard my dad tell, growing up. I pulled out a pad and pen. I wrote down *wine to water* and when I looked at the words on the page I just had a feeling deep down that it was supposed to be more than a lyric. I had recently started learning to use the computer a bit, so I got up and Googled "water issues" and "water problems."

The very first figure I saw was that 1.1 billion people at that time didn't have access to clean drinking water. I was shocked. I thought, "There's no way that can be right." The next thing I read was that dirty water kills more children in our world than anything else. I'd heard about HIV and malaria, which were the number two and three killers. But water killed more than both of those combined, yet apparently received much less funding. I stayed up that entire night, researching and studying. Instead of an idea for a cheesy country song, Wine to Water ended up becoming the concept for this organization. I saw it as the way to fight what seemed to be the worst crisis facing our world.

Doc Hendley in Boone, NC.

It took me about a month and a half to throw the very first Wine to Water event. I'd never been to a fund-raiser before, much less put one on. But I just looked at the resources I had around me as a bartender and musician. I had access to wine, music, a great crowd, food, and space. So, I put together an event for free, and the very first night we raised around $5,000.

We had another big wine tasting a month later and it just began to snowball from there. I opened a bank account. People began to send in checks. I was just happy to continue raising money and playing my music and bartending. When the donations reached a certain amount, I realized I had to start figuring out how to actually get it to the people in need. I found a local group that was based in Boone that had a huge water program. They still do. It's a group called Samaritan's Purse. I was sold when I read that over 92 percent of their money went directly to projects in the field.

> *"The very first figure I saw was that 1.1 billion people at that time didn't have access to clean drinking water. I was shocked. I thought, 'There's no way that can be right.'"*

I had a meeting there with the person running their international outreach and asked if I could donate the money I'd raised to their water program. He started grilling me: Why would you do that? Why are you so passionate about water? I told him that I really felt like this was what I was supposed to be doing. He ended up spinning it around on me and said, "I'll tell you what, it looks like you only have a month left before you graduate. Why don't you finish your degree and then come work for me? I'll send you into the field. We'll teach and train you. You can learn by getting your hands dirty. And you can bring the funding that you've raised and support the programs that you want to while you're there, doing the work yourself."

I was shocked that the meeting turned into a job interview. Especially

because I was pretty rough around the edges, a biker/bartender kind of guy. But I jumped at the opportunity. He asked me where I wanted to go. I said, "Send me to the worst area that you can think of." My crazy logic was that if I went to about the worst place in the world, I would still make a positive impact, even if I didn't really know what I was doing. I'd held the first Wine to Water event in February 2004, and six months later, I was on a plane to Darfur, Sudan.

It turned out to be the most life-changing experience I've ever had. I came from a traditional Southern family, and suddenly I was in a tribal sub-Saharan African community that's 95 percent Muslim. But when I got there, I fell in love with the culture and the people. I found it very easy to focus on the things that we had in common.

I had a half-Christian, half-Muslim team, and it was very cool to see everybody working together toward this common goal of providing clean water. But there was genocide going on there, and toward the very end of the project, one of the men I worked with was killed. I don't know if the government saw us as some sort of threat, but they attempted to kill my whole team. They ambushed us and shot up our vehicle. We almost didn't make it through.

I had a lot of problems coming back home and realizing that no one will ever understand the things I'd seen over there. I didn't feel like I could relate to anybody anymore. I probably wouldn't have had the strength to continue with Wine to Water had I not met my wife just a week or two after I got back from Darfur. She was monumental in helping me pull through.

I took me a long time to recover from that experience, and in the interim, my father-in-law offered me a job selling insurance. My wife saw me put on a tie every day and one night she just told me, "I didn't marry an insurance salesman. I married a man who had the weight of the world on his shoulders, and wanted to bring children around the world clean water. Where is that man?" So, I told my father-in-law I was very grateful for the opportunity but I needed to do what I was called to do.

I went out and looked for an office that same day. I was fortunate to have some space donated to me and I hired a guy I had grown close to in Darfur. He came over for a few months to help me get Wine to Water

"I'd never been to a fund-raiser before, much less put one on. But I just looked at the resources I had around me—I had access to wine, music, a great crowd, food, and space. So, I put together an event for free and the very first night we raised around $5,000."

restarted. Our first project, in 2006, was to install a water system in a leper colony in India. After that, we began work in Ethiopia and Uganda. By 2008, we had added on a major drilling program in Cambodia. We've worked in thirteen different countries, and we're reaching 100,000 people around the world with clean water.

It's always easy for me to go out in the field because life is simple there and people are happy with practically nothing. But when I return to the States, people are so much more dissatisfied with what they have. It's difficult to navigate back and forth between two very, very different worlds. So, it's hard to come home, but my family is what really helps me. When I came back from Haiti after the earthquake, for instance, we had a newborn baby that we needed to take care of. I didn't have the time to be sad. So, I've tried to learn how to shut it off. It's not easy.

I want to grow through more alliances overseas rather than build a bigger staff here. The whole concept of the organization is about sustainability. We always partner with locals on the ground. Instead of just giving money to another water organization, we go in ourselves and train the community to do the work. It's cheaper, and more importantly, we're empowering people to fix their own issues instead of relying on the

West. On top of that, water systems break. Instead of having to wait for an outside organization to come in and save them, they have people right there who can fix it with local materials.

In the beginning, our capital was only through wine events, but now there's much more variety. We have younger folks who hold parties and drives at their schools to raise awareness and money for our programs. There are church groups that do fund-raisers. We also have great partnerships with wine companies around the country that support us with their own labels. They'll make a special bottle of wine and donate a percentage of what they sell it for. And we actually have our own wine label now. I wanted Wine to Water to be self-sustaining, so that we're not totally reliant on outside funding, and that's been a big success.

My wife and I definitely want to go in the field together one day when the kids get older. I want my children to experience life in the developing world. It's a powerful thing. It makes you appreciate what we have here. We have a four-year-old and a two-year-old. I don't know if we'll have more kids. I think the playing field is pretty even right now. It's two against two. We can play man on man, but if we have one more we'll have to switch to a zone defense. So, we'll have to see.

My goal from the beginning was to be able to do this work for free. So, as soon as I had the opportunity to give up my salary, I did. I support my family with motivational and public speaking, and I just had my first book published. My mom's always taught us, there's no sacrifice too great when you're right in the middle of what your calling is.

Sarah Elizabeth Ippel

Founder and Executive Director, Academy for Global Citizenship

When Sarah Elizabeth Ippel rode her bike down to the board of education in 2005 to first propose a revolutionary public charter school for Chicago's south side, she was all of twenty-three years old and just two years out of graduate school. What she lacked in experience, she made up for in confidence and zeal. The Academy for Global Citizenship (AGC) offers a new future-oriented model for education, one that aims to prepare its students to be socially and environmentally responsible members of their local and global communities. AGC was the second school in the nation to receive the Gold with Distinction Award from Michelle Obama and welcomes the thousands of educators from around the world who come to study the AGC model in the little barrel factory the Academy calls home. For Ippel, it's a dream come to life: "It's a beautiful thing when you're in love with what you do. I still grow jittery with excitement when I'm en route to school every morning."

My favorite moments are those when a child comes bounding into my office in the middle of the school day with enthusiasm. How beautiful to be writing a tedious grant application and have a bright, inquiring child asking me about solar panels or endangered species. Our five-year-olds beautifully articulate what it means to be a global citizen. The results are tangible. In addition to unprecedented academic outcomes, we have countless stories of parents reporting that their young child is asking them to buy more vegetables or wishing for a compost bin for their birthday. These might sound like cute little anecdotes, but it is profound to see how, at such an early age, they can already ignite such incredible change.

Sarah Elizabeth Ippel with a group of students at the Academy for Global Citizenship in Chicago, IL.

AGC is an authorized International Baccalaureate (IB) World School, which is a framework for teaching and learning. Students learn by asking questions and the teacher's role is to facilitate critical thinking and reflection. In the IB Primary Years Programme, children learn through transdisciplinary themes, which they study in six-week blocks. In our case, they are often environmentally relevant and health-based themes, like local and global food systems, sustainable design, the future of transportation, or renewable energy. Their core subjects and learning standards, like math, science, and literacy are incorporated into these units. So if, for instance the first-grade class is studying food systems, math exercises might involve counting seeds in the garden and calculating food miles, while science subjects could include photosynthesis and what plants need to grow. We also emphasize outdoor and experiential learning that uses our city as a classroom, so the students might embark on local expeditions to meet the baker that makes our whole-grain bread, or visit the creamery that produces the organic milk for our school.

An interesting component of our assessment philosophy is that students are evaluated in part based on the self-initiated action they take as a result of their learning. So in addition to standardized tests, we also maintain students' portfolios, which exhibit what actions they've taken based on what they've been taught in their classes.

> *"Our vision is to build a prototype that models what education and environmental sustainability look like in the 21st century."*

On a typical day of school, our students arrive in the morning and come together for breakfast. We serve 100 percent organic food that's made from scratch. Among the children, 83 percent are low-income, so many of our families wouldn't be able to send them to school with such positive food in their bellies. Ensuring that our students' bodies are nourished so they are able to learn is integral to our philosophy of serving the whole child. After breakfast we practice yoga, which really gets the blood flowing to their brains and awakens their minds so they can begin focusing on their academic work. Throughout the day, students learn in two languages and also have a daily sustainability and wellness class, which integrates physical and nutritional education with environmental studies. That might include things like cardiovascular work, or learning about antioxidants or renewable energy. They have a class and recess outside every day, in the wind, snow, rain, or sunshine, where students care for our chickens, dig in the garden, or use their imaginations under the solar-energy learning lab. These activities are common in a day in the life of our students.

I came to the field of education rather organically. I moved to Chicago after I finished my master's of philosophy at Cambridge University in England. The time I spent studying abroad was a very formative experience. I was surrounded by people with a variety of perspectives, histories, and backgrounds, and I became inspired to learn about different educational systems and beliefs around the world. I began traveling with the intention of visiting schools, and found it was a very illuminating way to learn about a foreign place. Throughout the past ten years, I have visited about eighty countries, and through those experiences I witnessed firsthand what was happening in the world regarding education, health, and the environment.

On one hand, I saw that malaria, AIDS, and malnutrition are among the greatest health epidemics facing children internationally, while obesity is one of the greatest challenges among young Americans. I also witnessed how our individual choices directly impact the state of our planet. I began to feel a sense of urgency to identify and invent solutions that would address the global issues of environmental impact and human health. I started to see how education could address those two challenges, but then realized that education itself was a third challenge. Children around the world lack access to quality schools, and I suddenly realized that these disparities exist even in my own backyard.

As I canvassed the globe for effective models of education, I was struck by the implementation of the International Baccalaureate program in so many different cultural contexts. The IB program exists in about 140 countries and integrates the notion of global citizenship into its framework. I felt it best represented an educational structure in which these universal issues we face could be addressed within a rigorous academic approach.

It was a convergence of insights into these three areas—health, environment, and education—that led me to pursue the idea of opening a new kind of public school. One of the most important pieces to the puzzle was literally identifying all of the necessary skills and expertise required. I formed a 501c3 nonprofit organization, developed a board of directors, and then assembled a team of people who collaborated on our proposal to the board of education. It took us three proposals and three years to get approved. I was twenty-three when I prepared the first proposal and the board of ed looked at me rather wide-eyed. I had no background in education, just a strong determination and belief that we needed to be thinking differently about public schooling.

In 2007, the board finally gave the green light for the school, and the Academy for Global Citizenship opened months later in 2008 with kindergarten and first-grade students. The model is to add a grade every year, so by 2020 we'll graduate our first class of 12th grade students. After our first year, we moved to a former barrel factory where we currently reside. On the 13,000 square feet of asphalt outside, we've created a solar-energy learning laboratory, a greenhouse, raised-bed organic garden boxes, and a home for our rescued chickens. We also have a demonstration wind turbine, rain barrels, and a composting area integrated into our playground.

We've already outgrown the barrel factory, so we are developing the first net-positive-energy campus on an eleven-acre urban farm down the street. Our vision is to build a prototype that models what education and environmental sustainability look like in the 21st century. We're incorporating wind turbines and geothermal and solar panels not simply to lessen our impact on the environment, but also as a means of providing an experiential education. The campus will include seven acres of restorative urban agriculture, including vertical farms, greenhouses, and learning gardens; renewable energy generating playgrounds; and a solar power plug-in carport.

In conjunction with the campus, we are focused on creating an institute, a complementary organization that will focus strategically on "scaling" the innovation happening at the school. So, our school prototype will continue to provide an incredible education for our students, and the institute will focus on policy and research to be used in a broader implementation of the work that's happening here.

Admission to AGC is lottery based, so we have no selection criteria. We intentionally opened the school in one of the most underserved neighborhoods here in Chicago: Garfield Ridge. Our students are 90 percent minority, a third English language learners. Before opening the school, we engaged prospective families by going door to door or holding events to answer their questions and learn about their vision for their children's education. Now our families are our biggest ambassadors. We have an active PTA; we hold family education events and parent after-school programs to connect our students' learning between home and school.

The three key elements of international mindedness, environmental sustainability, and serving the whole child, are all at the core of our mission, every minute of the day. At our school, we not only want to empower our students to create a life of possibility, but also to impact the 7 billion people who live on this planet. We take that external mission very seriously: we believe that revolutionizing the role of schools in communities is essential to the health of our planet, humanity, and our future.

Jessica Jackley

Co-Founder, Kiva.org

The power of story to connect us, both to one another and to ourselves, is at the very heart of Jessica Jackley's personal and professional path. The Bible stories Jackley was told as a child helped propel her into a life dedicated to social service; and later, the personal accounts of third-world entrepreneurs inspired her to create one of the most successful nonprofits in recent history. Kiva.org's pioneering microlending model matches individual investors with small-business owners in the developing world, for whom just a tiny influx of capital might mean the difference between surviving and thriving. By replacing the traditional donor-beneficiary relationship with a partnership based on mutual respect and personal connection, Kiva is rewriting the story of the poor and blurring the lines between the haves and have-nots. Though Jackley has moved on from her day-to-day involvement in the organization to focus on new projects, as co-founder she continues to champion Kiva's mission like a proud mother. Those maternal instincts now extend to her latest entrepreneurial endeavor: twins.

I grew up in the Presbyterian Church. Our church was really the hub of our community just outside of Pittsburgh. I was taught the Bible from a very young age. In the Christian tradition, there are some beautiful values that are very much about service to the poor in particular. I was six years old when I first heard stories about the poor from my Sunday-school teacher. I remember learning that people who were poor needed something material—food, clothing, shelter—that they didn't have. And I also was taught that it was my job to help give them these things. This is what Jesus asked of us. I was very eager to be useful in the world—I think we all have that feeling. But I also learned very soon thereafter that Jesus also said that the poor would always be with us. This frustrated and confused me, because I was excited to help, but I felt like I had been told no matter how hard I tried, the problem of poverty would never go away.

Those early teachings were very relevant to me, and they were a real, practical part of my life. Not only did I learn about these things in Sunday school, but my family also did service activities all throughout my adolescence. In high school I volunteered—I worked in soup kitchens, I helped fix up local homes for people who couldn't afford repairs. I continued to give of my time and my money, but it grew to be more out of guilt than generosity—more to relieve my own suffering than someone else's.

In my senior year of high school I went on a service trip to Haiti with my church group. That was the first time I was exposed to abject poverty outside of the United States. It was shocking and heartbreaking to me. It really spun my world around. The week after I came home, it was my senior prom. It was the strangest juxtaposition of experiences: I'd just met kids my age who struggled every day to eat, and then came back to my middle-class American community, where kids were spending hundreds of dollars on one night of fun. I didn't know how to make sense of it. I actually broke down a few times in the following weeks. I'd be in a fully stocked grocery store and think about the starving kids I'd met and feel overwhelmed. I felt somehow like I had to live with that discomfort and tension. I wanted to keep volunteering but really didn't feel like what I was doing was having a lasting impact.

I studied philosophy and poetry and political science in college. I was in love with language and ideas. It sounds random, but philosophy helped me hone in on the right questions and challenge the deep underlying assumptions I had about the world. Poetry taught me how to distill and focus my language—to really articulate and express myself. And political

Jessica Jackley on the beach in Santa Monica, CA, with her twins.

science was, truthfully, my way of trying to figure out how to address the world's problems. The issues I saw in Haiti seemed structural, and I thought, "If we just change the system and what the government is doing, then won't everything else shift?" That was my very basic understanding of how I might be able to have some impact at that point.

When I look back at that time in my life, I can see that my approach to service was very scattered. I basically just signed up for whatever was presented to me; it was not very strategic. I sought out some opportunities, but they were really ready-made experiences that were handed to me by my church or my school. After college I tried to step it up in different ways. I joined nonprofit boards. I kept feeling like, "Okay, it's one thing to just show up every day and serve food in the soup kitchen, but what's going to change the actual circumstances of the people who are here?" I was more interested in being involved in development versus relief work.

After college, I knew I wanted to work in the nonprofit sector. But that's all I really knew. I didn't know how to go from being the friendly, passionate volunteer to somebody who was creating organizations. For a time, I lived as a house mom in a home for teen moms in East Palo Alto. At one point it was the murder capital of the country. I would wake up every day, drop off the babies at daycare and the moms (just young girls themselves) at their high school. Then I would go to work at my job at the Stanford Graduate School of Business. I'd be there all day learning about applying business thinking to social problems and then I'd go home at night to this houseful of disadvantaged girls. I was just juggling the reality of theory versus practice. There still seemed to be a big gap between what I saw happening every day with these local nonprofits that were trying to do good things for the community and these big institutional ideas about organizational efficiency and scalability, etc. They just felt very disconnected.

Things finally shifted for me when I saw Dr. Muhammad Yunus speak at Stanford. Dr. Yunus won the Nobel Peace Prize a few years ago for his work as a pioneer in modern microfinance. I had heard little things about microfinance before, but he explained it in a very accessible, easy-to-grasp way. I remember sitting near the back of the auditorium because I didn't know if it was going to be boring and I wanted to make sure I could duck out if I needed to. It was, of course, the opposite of boring. It was amazing to hear that this little bit of money could change the trajectory of somebody's life. Dr. Yunus was speaking about the poor in a way that I had never heard before. He wasn't telling stories of sadness and desperation and suffering. He was talking about strong, smart, hardworking entrepreneurs who were doing everything right. All they needed was access to a little bit of capital.

I was so moved by what I heard that night, I decided I wanted to get involved in anything even remotely related to microfinance. I wanted to see for myself how this process actually worked and meet the people it was supposed to be helping. So I basically started to stalk people in that field. I developed a great mentor relationship with the founder of an organization called Village Enterprise Fund, which provided micro grants to entrepreneurs in developing countries. Having been a philosophy and poetry student, I didn't really know what skills I had to offer, but I knew I could talk and, hopefully, be a good listener, so we shaped a project where I could do impact surveys and interviews with hundreds of the recipients of these $100 grants. A few weeks later, I quit my job at Stanford and flew to East Africa.

"I didn't even know the difference between profit and revenue when I went to Africa, but I learned it from these unexpected entrepreneurs—from goat herders and fisherman and seamstresses."

I traveled through Kenya, Uganda, and Caledonia, interviewing these entrepreneurs, and I was galvanized by what I heard. Microfinance really worked. There can be true business successes with this tiny infusion of capital at the right time. Over and over, I heard stories of how this money had transformed people's lives. I saw people slowly lifting themselves out of poverty and improving life for their families. There were all these beautiful details, unique to each business owner that I just couldn't get enough of. Even if I talked to twenty different farmers in a row, no two had the same story: one used the profits from their business to send their daughters to

school, another obtained medicine for someone who was sick, still another improved nutrition for their family, so they could eat protein more than twice a year or have three meals a day instead of two. All these details were surprising and special. There was something so moving about every single individual's journey. I felt there was a real power in their stories.

So this was my introduction to business. I was able to understand what $100 could do for an entrepreneur. I didn't even know the difference between profit and revenue when I went to Africa, but I learned it from these unexpected entrepreneurs—from goat herders and fisherman and seamstresses.

When I came back home three months later, I had already begun to formulate these questions: What would happen if I shared these stories with friends and family? What would happen if they could lend a little bit of money to individuals like the ones I'd met, on a website that would tell their stories honestly? Most of what I had seen in the nonprofit world was about sad people who needed me to give them a handout, not about empowered entrepreneurs who were looking for investment. This was a very different message we wanted to share and therefore the reaction needed to be equally different. Instead of asking people to just throw change in a jar, what if we offered them the opportunity to lend to these entrepreneurs? Those were the seeds of the idea for Kiva.

My co-founder Matt and I started to ask anyone that would talk to us what they thought about the idea and the limitations we might face. We had a ton of people give us negative feedback, thinking we might have to do crazy things like audit the goat herder we wanted to lend to, but we didn't see it being complicated. We thought, "Why can't it just be like loaning money to a friend? We don't even have to charge interest." For the small amounts we were talking about, we didn't think a tax deduction would be the priority to potential lenders. That's not the motivation. It's a social return, an experience.

We were overwhelmed by the initial success. The pilot round was a little over three thousand bucks. It was a handful of friends and family that loaned to seven entrepreneurs. Then, in 2005, we officially launched, and by the end of that year we'd managed to facilitate $500,000 in loans. The next year, we totaled out at $15 million. The next was around $40 million. The next was $100 million. This year, we are over $325 million.

One thing I think we did really well was bring people onto the staff very organically, in ways that fit them and fit the organization. It's been a very co-creative process. We've always looked at this as more of a movement, and we've tried to empower people to create their own priorities and goals.

Though many people may think of the money as a donation, it's not, and a loan provides a very different interaction than a donation. It's one of dignity and equity and partnership. It's a very simple model really. Lenders can visit the site and read the stories of potential borrowers and choose who they want to lend to. Loan terms can be six or nine months and 99 percent of the loans are repaid. In my utopia this is as good for the lender as it is for the borrower. Interacting with Kiva and hearing these stories changes the way people see the world and themselves.

"In 2005, we officially launched, and by the end of that year, we'd managed to facilitate $500,000 in loans. This year, we are over $325 million."

I learned through starting Kiva, and by the example of all these amazing entrepreneurs, how to become an entrepreneur myself. I've realized that what's most important to me is finding ways to enable entrepreneurs and make sure that they have the support they need. It's funny: I'm actually pretty agnostic about organizational structure—profit versus nonprofit. It's a tax code, not a religion. I feel like whatever gets the job done and brings in the capital needed to do the project and creates the appropriate roles for people to participate is what matters. So it's not as if I feel I have to always work in nonprofits. Why? Who cares? There are nonprofits screwing things up in the world and there are for-profits doing great stuff and vice versa. I think finance will probably always be a part of my focus because money is a really interesting and sticky tool for connectivity. That's the piece that I care about—how to connect the most people to one another, to participate in each other's stories.

> *"I've gone to places and interviewed people who have so little in terms of material wealth, and I've discovered so much wisdom there by listening. If there's one thing I want to do with 100 People, it's to really show how much richness there is in the world that's different from what we have."*

Carolyn Jones

Founder and President, 100 People Foundation

It all began with an email that landed in Carolyn Jones' inbox, asking the simple question: What would the world look like if it were 100 people? The statistics that followed were fascinating: 50 would be men and 50 women; 60 would be Asians, 15 Africans, 11 Europeans, 14 people from the Americas; 33 Christians, 22 Muslims, 14 Hindus, 7 Buddhists; 17 would be unable to read and write, 13 would have no safe water to drink, 21 would be overweight, 15 would be undernourished, and only 7 would have a college education. Jones immediately saw this factual snapshot of the world's population as an opportunity to tell a deeper story about our global community. She wondered: Who were those people? Where and how did they live? How were they different or similar to us and to each other? Known for her socially proactive photographs and documentary films, Jones set out to use her gifts to tell the story of 100 people who exemplified all of the almost 7 billion of us sharing the planet. Her vision was to create visual and educational tools that "facilitate face-to-face introductions among the people of the world in ways that cultivate respect, create dialogue, and inspire global citizenship." So she has asked 500 schools from 100 countries to nominate 10,000 people to help her find the 100 people that best represent the world population. "We are," she says, "asking the children of the world to introduce us to the people of the world."

I started out as a fashion photographer. I did some work with *Italian Vogue* and *Interview* magazine that I loved. But I was just a beginner, and there were lots of hills to climb, and fashion wasn't a perfect fit for me.

I had a very, very good friend, named B. W. Honeycutt, who started *Spy* magazine. I shot many of their covers with B. W., and we worked very closely together for two years and had a great time; he became such a dear friend of mine. So when B. W. told me that he had AIDS, it knocked my socks off. There was no drug cocktail then, so it was a death sentence. I didn't know how to help. I remember when he told me and I sat down on a street corner with him and cried. Only later did I realize that that was about the worst help I could have given him.

The whole reason that I got into photography to begin with was so I could better understand things. So at the time, the answer to me was to really dig into that world and find out as much as I could. A friend came to me with the idea to photograph people living with AIDS positively, to offer role models celebrating the time they had rather than dreading it. We created a series of portraits called *Living Proof*, and we had a show at the World Trade Center with four-feet-square prints portraying fifty people with AIDS.

I come from a conservative community in Lancaster, Pennsylvania. I remember saying to people, "I'm going to do this book about AIDS," and I was asked, "Why? What does that have to do with you?" I thought, that's really the problem. So instead of hollering at people, I decided to use photography and stories to try to change their minds about things that were going on in the world. *Living Proof* did help change minds. It was a turning point. There was no going back.

I did a couple of other books, and then my husband—who is French—and I moved to Paris, and that's where 100 People was born. I was taking French classes in Paris. I was the only American in a very

Carolyn Jones at the 100 People Foundation headquarters in New York City.

diverse group of students. September 11 hit, and I felt completely helpless. I couldn't get home or get through to anyone on the phone. On September 12, I woke up and I didn't know what to do with myself. At the last minute, I decided to go to my class. And when I arrived—late—a woman from Iran walked over and gave me a hug in front of everyone. And it was just the most powerful moment. What went through my head was, "How did you know that was the right thing to do?" I don't have that tool. I wouldn't have known that that was the perfect gesture. But it was, and it was so generous. And it put me in this head frame of wanting to do something that would foster understanding between cultures.

Soon after, my friend Isabel Sadurni sent me an email titled, "If the World Were 100 People." It offered an accurate description of the world population proportionally represented by 100 individuals (1:62.5 million), based on criteria such as age, nationality, gender, religion, and language. When I saw it, I thought, I want to meet these people. The statistics are great, but I really want to attach a face to each one of them. It was one of the most powerful ways of looking at the world that I had encountered, and a really simple and beautiful way to get away from the quagmire of problems and issues that weigh us down so deeply we often can't get anything done.

I started thinking about how the world's diversity could be represented if there were just 100 people. Then my daughter came in and looked at it, and commented on how many people wouldn't be able to read or write. And I thought, you know, she gets it. At her young age—I think she was in the third grade—she could understand it. She grasped precisely what was important about it.

Statistically, you can't exactly represent the entire global population with 100 people, so it was always meant to be an artistic interpretation. The idea was to find 100 people that could provide us with a better understanding of the world and who we share the planet with. I would photograph them standing in the doorways of their homes, like crossing the thresholds into their worlds. It was never meant to tell the whole story, but it's meant to tell the beginning of the story—and introduce the world's population.

Isabel and I connected with our third partner, Michal Chrisman, and we decided if we're going to find 100 people to represent the world's

population, we should make it a school project so that children all around the globe could participate. The kids could nominate someone in their community that they really thought best represented their corner of the world. It would get the students out in the community, armed with their cameras and their notebooks, to gather the information and find out who best represents them. We thought by doing that, we could get away from politics in every way.

The original idea was and still is that the students send us photographs and stories and we sift through those submissions, select 100 people, and I photograph each one in the doorway of their home. What I envision is a traveling exhibition of life-size portraits all in a circle with a huge map on the ground. You can walk among them and stand on the map and see a red line from the person to the place, and then hear the audio of their interview.

But the student nominations have been even richer than we imagined, and it turned out that following the students into their communi-

ties and meeting the nominees was much more significant than we'd originally expected. Some schools have even created their own community of 100 people, and uploaded those videos to our site. So 100 People really became more about creating tools—including the videos of some of those meetings—to help teach global understanding at schools. The exhibition will still happen at some point, but it will be just one more tool; it's not the entire goal anymore. The value has become much bigger than any one thing—now the State Department has even recommended us as a program that helps students to understand different parts of the world.

After three years, Lisa Frank came on board and helped focus things by saying, "Let's concentrate our attention on global issues, and get people talking about the same things, but in different parts of the world." I love that. So now we have zeroed in on ten issues that we all share and feel strongly about: water, food, transportation, health, economy, education, energy, shelter, war, and waste. Our goal is to create media that illustrate each of these topics; the media can then be used by teachers and students as educational tools. So we asked ten very bright students to interview ten leaders in fields relating to those issues. I'm always interested in looking at things from space, if you will. If you put two scientists together, and they start talking, I'm lost. But if you pair up people from different disciplines or different age groups, you get a layperson's explanation. Plus it's irreverent and funny, and those young students ask fearless questions.

Our perspective as Americans has been to go out and fix things. That's what we do. We think we've got it all figured out—that the way we live is great—and people should be able to live like we do. But I've gone to places and I've interviewed people who have so little in terms of material wealth, and I've discovered so much wisdom there by listening. We have to be really good listeners. If there's one thing I want to do with 100 People, it's to really show how much richness there is in the world that's different from what we have.

I like to stay really light on my feet when I travel, and I usually just have one cameraperson with me, and one producer. That way we're able to get into small corners, which is always my dream. You simply encounter people and follow your nose. For instance, we met a young man once in Africa who suggested we go meet this healer. So we arrived at this village outside of Niger to an enormous amount of fanfare and were finally able to meet him. He had no shoes—nothing, materially. But I will never forget how he spoke to me about the need for world peace. I barely said anything. He spoke so beautifully about humankind. He said we had to all speak with the same mouth, and care about the same things.

"If this is what the next generation looks like, we are going to be okay. We are in very good hands."

I have also had some incredible experiences watching teachers teach. We went with a school from Wake County, North Carolina, to visit their sister school in Hiroshima. They pick an annual project, and they had chosen 100 People that year. We filmed the American students teaching about 100 People to their Japanese peers. To see them so proudly represent those they had selected from their community, and show their artwork and essays and answer questions from the students from Hiroshima, was so simple and beautiful. It opened the lines of communication: they found simple commonalities—"You nominated your bus driver—we have a bus driver here"—that were conversation starters that led somewhere.

It's like our organization has been building a house all this time, and we made the bricks ourselves, and then the mortar, and then the structure. We've got the best foundation I could have ever imagined. When you look at the website and all those red dots on the map, you can see a really broad scope of schools and students participating in the project. Next we are going to India to bring a lot more schools into the project. I'm still in "building" mode, but if all the stars align, I could be shooting the exhibition soon.

If I don't do anything else but this for the rest of my life, I will be thrilled. Having a chance to help students teach one another, that's where it's really golden. If this is what the next generation looks like, we are going to be okay. We are in very good hands.

"Let's allow kids to feel what it's like to take their own abstract idea and turn it into a physical reality that does what they want it to do. They're not really building robots, they're building self-confidence."

Dean Kamen

Founder, FIRST (For Inspiration and Recognition of Science and Technology)

Inducted into the National Inventors Hall of Fame in May 2005, and holder of more than 440 patents, many of them for revolutionary medical devices, Dean Kamen is often referred to as the modern day Thomas Edison. Kamen's primary ambition is "to transform our culture by creating a world where young people dream of becoming science and technology leaders." This objective is the cornerstone of *FIRST*, Kamen's nonprofit vehicle for inspiring kids to become the inventors of tomorrow. Fueled by 100,000 volunteers, *FIRST* engages young people (from ages six to eighteen) in mentor-based programs and competitions that build science and technology skills, breed innovation, and foster self-assurance, collaboration, and leadership.

It's not like I got up one morning and put together my plan for the day and it said, 9 A.M.—breakfast, 10:30 A.M.—have brilliant idea. My life hasn't been a straight line; it's a spaghetti ball. I climbed up and down every strand before I ever got around the ball. That's what life is, and in my case it's even worse because I'm not a structured, organized guy. I never had a long-term business strategy and I wouldn't have predicted any of this. Like *FIRST*—it just seemed like a good idea the day I started it, and as it turned out, it was.

I have an older brother who's an M.D., Ph.D., brilliant professor at a medical school and pediatric oncologist and hematologist. I have a younger brother who's a gifted musician. We always joke that among the three of us, we make one Renaissance man: my father.

I'm a physicist. A mathematician. An engineer. My father spent his life creating incredible art; twenty years ago, I would've said we're nothing

Dean Kamen in the *FIRST* headquarters lab with a group of participating students in Manchester, NH.

alike. I can't even draw a straight line! At one point, a Ph.D. in industrial psychology called because she was writing a book about why people do what they do and she wanted to interview me. When I told her about my family background, she said, "Ah, I see, you're an entrepreneur because of your father." To which I said, "No, no. You don't understand. He's an *artist*." She looked at me as if I had two heads. "Dean, do you know how few people work for themselves, produce something and hope that the world will pay them for what they created? It's extremely rare. That's what your father does and that's what you do."

My father said to me when I was little: "Figure out something that you really love to do and get so good at it that you can make a living. Then you'll be the happiest guy around." I didn't like sitting in a classroom or doing homework. I liked solving problems. I liked trying to invent things. In the end, I am not only like my father but I took his advice, maybe to an extreme.

I was a terrible student. I'm a very slow reader and I'd look at a three-page test and know I'd never finish. The teachers would go too fast, they'd talk about too much stuff superficially. So, I gave up on school and I would just go get books that I could read at my own pace. If they seemed too simple I would skip ahead; if they seemed hard I would read it five times and I didn't have the pressure of somebody watching me or testing me or thinking I was dumb. I learned how to teach myself the things I needed to know.

Even in junior high school, I started taking apart electronic equipment and putting it back together again to make something else. At the time, GE had just started making these *thyristors*, which are big power transistors. I still think we can blame that industry for the horrible age of disco, because once you could run things much bigger than a speaker, like the entire lighting system of a room, through the output of your amplifier and have lights beating to the music, you could make a disco.

So, I could get these power electronics in small quantities at places like Radio Shack and use them to build small-scale thyristors. You couldn't buy them anywhere commercially, so I started this little business in my father's basement, selling them to kids. It was fun and I made more money than cutting lawns. I reinvested my earnings to buy oscilloscopes and more equipment to make other things. By then, my older brother was coming home from med school complaining about the lack of equipment for medi-

"My father said to me when I was little: 'Figure out something that you really love to do and get so good at it that you can make a living. Then you'll be the happiest guy around.'"

cal research. So I would invent devices for him. They worked, and it made me feel good because he was helping people with them.

My first substantial success was a drug delivery pump for my brother that I invented in my twenties. Some of the doctors he worked with said, "Something like this could help millions of people with diabetes." So I built a small, wearable pump that allowed people to self-administer small amounts of drugs throughout the day, which is much more natural than a shot in the morning and a shot at night. The next thing I knew I had a business making the world's first insulin pumps.

Most of the products we create to this day at my company DEKA

are in the realm of medical equipment. We also work on power, water, and transportation, and frankly, they're not all as different as you might think. It's not as if we sit down with a blank sheet of paper and try to invent something that's never existed before. One thing tends to lead to another. You work on a diabetes pump but in the process you're learning how to make precision valves and systems to move sterile fluids. Then somebody says, "Can you make that move a lot more fluid? We need that for dialysis." These things always have a thread that brings you from one solution to another.

We don't work on a project unless we believe that if we succeed it will have significant impact. If we're going to work hard and spend the most valuable resource we have—time—the result has to really matter; it can't be trivial. It also has to be an interesting technical challenge that we feel more uniquely qualified to solve than anybody else.

FIRST is a microcosm of DEKA. We have a real problem in this country; we have a whole generation growing up that doesn't understand how fun, exciting, and rewarding technology is. Let's immerse them in it the same way we get immersed in the projects we do, with the same kinds of constraints. We never have enough time or enough resources. We never know what the competitor is going to do. We have to come up with a technical solution, conceive it, design it, develop it, build it, and test it—fast.

If kids can taste that, they'll get the bug. Let's allow them to feel what it's like to take their own abstract idea and turn it into a physical reality that does what they want it to do. They're not really building robots, they're building self-confidence.

We founded *FIRST* in 1989. The idea was to sponsor teams of high-school kids from across the country to design their own robot, and then come together in friendly rivalry. Since then we've added many other competitions and age groups. Every *FIRST* team has its own instigator—it might be an accountant of twenty years who loved to tune-up his old car on the weekends and decides to mentor some high-school kids; or one of the hundreds of scientists and engineers that Fortune 500 companies send us as mentors because they know they have to help inspire this generation in order to have a future workforce; or the dedicated, passionate teacher who recognizes some kids don't learn well sitting in a classroom and says to their principal, "We've got to get involved." Every team has come together because

of some unique passion that intersected with the opportunity to be in *FIRST*.

Competitions have always been the backbone of *FIRST*. We have a culture that's obsessed with sports and entertainment. We want the instant gratification of winning. You have teenagers thinking they're going to make millions as NBA players or movie stars when that's not realistic for even 1 percent of them. Whereas there is an unbounded set of opportunities for any kid to become a scientist or engineer. So, we said, since we've got so much evidence that kids are obsessed with the world of sports and entertainment, why don't we take that model of instant gratification and put content in it which isn't bouncing a ball; it's thinking, it's problem solving, it's innovating. And it worked.

Giving somebody a completely unbounded universe with no structure and no discipline doesn't work. If there were no rules, you couldn't play basketball. We created a sport, much like basketball, where there are specific rules, a specific playing field, and a specific object to the game. There are assigned components the kids are allowed to use when they build their solution. But we leave it so open-ended that if you go to a competition and look at the radical diversity of solutions that all grew out of the same set of parts, it'll amaze you.

We give them the ability to work in an environment where it's okay to fail as long as you learn and move on. Sometimes the spectacular failures turn out to be more fun and educational than the successes. A failure often points you in the direction of how to solve a different or new problem, one that's even more meaningful than the problem you started out trying to tackle.

There's a study that was done by Brandeis University, funded by the Ford Foundation, that showed the longitudinal impact of *FIRST*, particularly on women and minorities, and it was astounding. It changed their career choices, it kept them in school, it caused them to take the "tough courses" because they needed the tools. There are loads of very compelling data on the impact of *FIRST*.

I'm never satisfied. That's who I am. I always want to do more. But I'm not so jaded that I don't recognize that I've had a great life and I've gotten to do a lot of things that most people never get to do. What invention am I proudest of? That's easy—it would have to be *FIRST*.

Patrick Lawler

CEO, Youth Villages

Patrick Lawler wants nothing less than to reform the childhood welfare system in America. His pioneering model to rehabilitate and care for at-risk youth is predicated on the belief that to heal a child, you must heal their family too. Over the decades, he and his team at Youth Villages have developed a program that aims to keep kids and families together through intensive counseling and ongoing support services. Their long-term success rate is twice that of traditional services and costs one-third as much. The organization now serves nearly 20,000 kids and families a year in eleven states, and they're growing by the minute. Their revolutionary approach has led Youth Villages to be recognized by Harvard Business School, *U.S. News & World Report*, and the White House as one of the nation's most promising results-oriented nonprofits.

We moved to Memphis in 1958, when I was just three years old. Dad got a very low level job opportunity in a power plant here. He had spent five years in an orphanage as a child, in the thirties, and they weren't pleasant years. He never graduated from high school. He was definitely working class. I look at how I live now and I'm amazed we got by. But that's how everybody we knew lived back then. I don't remember wanting for anything. We were aware that there were people poorer than us because we had a maid sometimes who we would take home, and I saw how her family lived. But I never knew how rich folks lived. I wasn't ever around people who had money. I mean, there were a few buddies of mine who lived in two-story houses; we thought they were rich.

I went straight from high school to the University of Memphis. I was the first in my family to graduate college. I paid my own way by working in a residential program for delinquent, unruly boys called Tall Trees Youth Guidance School. I was responsible for thirty-one boys, and I had to live there as well. Half the kids were African American, half the kids were white, but they were all rough and tough, and had emotional and behavioral problems. I had never been around youth like that before. I initially didn't like it, but I grew to love the kids and love the work.

After that, I took a job at the Juvenile Court of Memphis and Shelby County. I had the midnight shift for four years while I finished undergraduate school. I worked two years in boys' detention and two years in central intake. Then I became a probation counselor for about a year and a half after I graduated. I really loved that.

I got a master's degree in counseling. I also got married while in graduate school, in the summer of 1978, and about a year later, we got pregnant with our first child. We didn't exactly plan for it to happen, but I guess you could say we knew it was a possibility. I had almost finished my degree. I had one class left when the juvenile court judge asked me to be the interim director of a residential program called Dogwood Village. I was just a kid, twenty-four years old, with a seven-months-pregnant wife. He actually wanted me to close the program down quietly, because it had become an embarrassment to him and the court. They'd spent fifteen years getting the place started and it fell apart after being open for less than a year. It had been all over the newspapers and television.

I went out to Dogwood Village and spent a day or two observing. Then I came back and I asked if the judge would give me an opportunity to keep it going. And he told me: there's no money left, the facility is broke, most of the board members have resigned; the place is being torn up;

Patrick Lawler with a group of children at one of Youth Villages' campuses in Memphis, TN.

the state is about to take its license away. But, he said, I could try.

I had never seen a budget. I didn't know what a license was. I had never supervised anybody. There were a lot of problems. We had six girls and nineteen boys in our care when I started. I had to replace a lot of the people and really learn on the fly. I ended up with nine staff members and we all just rolled up our sleeves and said we're going to do whatever it takes to do the best job we can to take care of these kids. Fortunately, I had a very supportive wife who didn't mind my working seven days a week, sixteen hours a day. And somehow, we hung on that first year, and we grew to serve forty kids.

Nobody wanted to take the really tough kids. The ones with psychiatric issues, drug or alcohol addictions, or who were aggressive or acted out sexually. I was always drawn to the most troubled kids. I felt like they needed help more than the rest did. So, we took the hardest-of-the-hard cases.

In those days—I'm embarrassed to tell you—the state paid us just $15 a day per child. You couldn't care for a child on that. But if a child was released or if they ran away, say, in March, the state would often keep paying you through the month of April. We were so broke, I would just pay the bills with that surplus, and I'd get this letter every few months saying we owed them that money. I'd write back and say we didn't have the money because it went to cover the basic needs of the kids. So, eventually, we had this meeting about it in Nashville and they said that if we couldn't pay our debt we were going to have to close.

At the end of the meeting, they asked for a list of all the young people in our program. I knew there was no other place that would take those kids—they had already been turned down by other programs in our community and across the state. Sure enough, the next morning they called and thanked me for the meeting and said we would receive a new contract for $22 a day. Honestly, if you had come out and seen how we lived in those days, you'd have been shocked. But we just had as much as I had when I was growing up, so I honestly thought we were doing okay. And as the years went on, we were able to start negotiating higher rates with the state because we kept serving the toughest kids. Our budget was about $150,000 in 1980, and by the mid eighties, it had grown to about $1 million.

There was another local residential program called Memphis Boys Town, which had been around about forty years. They had a great reputation and a long history, but they had developed serious financial problems. In 1986, they were about to lose their license with the state because the program had gotten so bad. The juvenile court judge said to them, "Call Pat." The chair of the board asked if I would run their program. We decided we could merge the two programs and develop an entirely new organization with two campuses. We called it Youth Villages. We never really dreamed it could be more than what it was then.

By the late eighties, I wanted to know whether we were really making a difference in these kids' lives after they'd left the program. There was never any talk about outcome studies in those days, but that's exactly what we started to do. We had a staff person call all the kids who had left the year before, and we learned that only half the kids were doing well. The other half had terrible outcomes. They were on drugs, homeless, in jail, pregnant, or worse—dead. Based on that, we improved our counseling program. We developed a recreational program. We built our own school on campus. With all these changes, you'd have expected to see a noticeable difference. But year after year, the same results came back. I just couldn't understand it. I began seriously questioning myself as a leader.

On the one hand, all these children were on a waiting list for our program, and we felt like we were really succeeding. On the other hand, we quietly knew that our outcomes were not very good. Because we had no other studies to compare ourselves to, we didn't know if 50 percent was high or low, but we knew that we wanted to do better than that.

We hired a recent MBA graduate from Vanderbilt University to do research assessing kids from a twenty-county area in Tennessee to see what services they were receiving, where they had been placed, their outcomes, and their needs. Over the course of his research, he interviewed 126 people, every key official in that area of the state—mental health specialists, educational leaders, all the juvenile court judges. At the end of this study, the number-one recommendation was that we should be providing a program in the community to work intensely with the families.

There was no such service on this earth that would work with the whole family instead of removing the abused or neglected child; but we

learned about a model called Multisystemic Therapy, or MST, which is an intensive in-home approach that had recently been developed at the University of South Carolina Medical School. Their model was based on the notion that when you moved the child to a residential setting, you just created a make-believe world that was nothing like the real-world environment they were going to return to.

We developed this in-home program with tremendous success. The kids that were in our residential programs were going home or into foster care and then a counselor worked with them and their families. The lengths of stay in our residential programs became shorter because we were working with the families so intensively. Kids had been staying a year or two, and now they were staying six months. We could serve four times as many kids in the course of a year. And we also used family therapy as an alternative to bringing a child into the residential treatment program in some cases. So not only were we serving a lot more kids, but we were also making it unnecessary for some kids to be placed in our facility altogether. We went from being in the business of raising other people's children to really helping families be responsible for raising their own children.

We'd gone to the state when we started the in-home program. They thought this idea was just crazy. They saw the families as irresponsible and dangerous and they wanted these troubled kids off the streets. We had to go to a local foundation for a grant to start the program because the state wouldn't give us any money. It turned out that not only was our way better for the kids, but it was much, much less expensive. We're talking 75 percent cheaper. Finally, the state had to give this a little more attention because they were having financial problems, and we were able to develop a contract with them.

Foster kids are the group most likely to go to jail, get pregnant, have a minimum-wage job, spend time in psychiatric facilities, be homeless, or abuse drugs and alcohol. These are the most vulnerable kids in our country. So, we found a philanthropist in our community to give us some seed money, and we built a model that helps kids who have aged out of the foster system to transition into adulthood. Each transitional living specialist has a caseload of about eight young people and is responsible for helping them complete their education, find housing, manage their health,

and find a place to live. We have helped more than four thousand young people through this program.

Today, Youth Villages helps more than 20,000 youth a year and provides services in four core areas. We serve around six hundred or more children a day in residential facilities and about two thousand kids a day in intensive in-home services. We serve five hundred kids in therapeutic foster care, and about seven hundred fifty young people in transitional living. Our success rates have gone up to well over 80 percent now in terms of one year post discharge—even two years post discharge. That means more than eight out of ten of our kids are now living at home with their families and going to school or working—and are not in trouble with the law.

What we're ultimately trying to do is transform the child welfare system in this country and persuade policy makers who have the authority to make decisions about how resources are distributed to recognize the real value of restoring families. There's only so much money, and there are a lot of people out there who need help. We are convinced that to have the greatest positive impact with limited means, we must focus on strengthening families and communities.

In the old days, I would spend my time providing counseling and therapy to kids, cooking, cleaning, cutting the grass, and helping kids with their homework. But with 2,600 employees and more than sixty locations across eleven states, I travel a lot now. I spend much of my time with policy makers, the board of directors, raising money, building a stronger and more sustainable organization, working with our leadership team, and advocating for states to put more money toward rehabilitating families and removing kids from placement institutions and foster care.

I took two days off the first year I worked, and that was for my son's birth. And even when I was with my wife while she was going through labor, I was on the phone half the time. I didn't take vacations. I didn't take weekends off. I'm not sure what my kids would say about it if you asked them now. I took them with me to work all the time. I think they understood that what I was doing was important. I've always loved my work. I have the greatest job in the world. I've got at least another fifteen or twenty years left in me—I've never even thought about retiring. I'm just not a lying-on-the-beach kind of guy.

> *"The Trevor Project is not about gay rights. It's about human rights. It's about providing the same kind of support and acceptance for everybody, regardless of who they are."*

James Lecesne

Co-Founder, The Trevor Project

When James Lecesne created the character of Trevor—a gay thirteen-year-old boy who attempts to take his life after being rejected by friends because of his sexuality—for his one-man show *Word of Mouth* in 1993, he had no idea it would spark a national movement. Co-founded by Lecesne in 1998 after the story of Trevor was adapted as a short film, The Trevor Project was the first 24-hour suicide-prevention hotline for lesbian, gay, bisexual, transgendered, and questioning teens in America. In the decade and a half since then, the organization has grown to include an active online community, and offers lifesaving guidance and resources for educators, parents, and young people.

I grew up in a little bedroom community in New Jersey. If you just stood on the roof of our house, you could see the glow of Manhattan. As soon as I was old enough, I got on a bus and hightailed it into New York City. When I think about the things that I wore and what I was doing back then, it's amazing that I'm still here. People didn't really come out in 1970, but I knew that I was *something*. I had a boyfriend in the city when I was in high school, and I'd sneak in to see him as often as I could. I was so happy to have found other people who accepted me. That's what drew me into New York. It wasn't so much about being gay. It was really about being free to be who I was, which wasn't the case in my hometown.

My parents were older than most when they had my siblings and I. They came from a very different world. I knew from their attitudes about things, they would never approve of me being gay. It wasn't even a question. When I did eventually come out to them in my twenties, they did their best

James Lecesne near Times Square in New York City.

to continue to love me, but it was very hard for them to accept it. Very hard. It made me forever understand what it's like not to have a place to turn to.

In high school, I was successful at staying under the radar and not drawing too much attention to myself. The other kids just thought I was kind of peculiar or a sissy. I think it's harder in some ways for lesbian or gay teens today because they can be more easily identified. There are more behavioral markers now that are commonly associated with homosexuality than there were then.

I was always oriented toward the arts. When I was fifteen, I ran away from home to join this theater company on the Jersey Shore for the summer. My parents had forbidden me to go but I remember thinking, "Oh, my God! It's the *theater*. I have to do this." I worked there for two summers and I met these amazing people. It was all over after that. I was hooked.

In 1976, I finally moved to New York City. It was a struggle starting out in the business. I couldn't figure out how to be myself. It's hard enough to be an artist in the world that we live in, but it was even more complicated to be gay. You were supposed to hide it—that was made very clear to me in an oblique way—and I was never any good at that. For better or worse, that's just who I was and who I am. So I was never going to play leading men, because you'd never be cast unless you passed yourself off as straight.

My first professional job in New York was in a play called *Cloud 9*, which was a seminal piece of theater at the time, dealing with sexual identity in a very frank way. I played a black African manservant and a five-year-old girl. I was only in my twenties and I was already labeled as a character actor. So, rather than running around New York chasing after roles, I spent my time writing. I would get the occasional acting job, but in the meantime I began writing these short performance pieces about characters. I would perform them anywhere I could. Eventually, I put together a musical called *One Man Band* based on these characters, and it was fairly successful. I traveled it around the country, performing wherever I could get a gig.

AIDS was just starting to show up in New York around that time but it didn't directly affect my life until the early nineties, when my friends started dying. In 1993, I took a year off to work for this amazing grassroots organization called Friends In Deed, and twenty years later they are still providing the much-needed emotional, physical, and spiritual support for people with HIV/AIDS and cancer.

Around that time, I met Eve Ensler, who, years later, wrote *The Vagina Monologues*. We became friends and she wrote this piece for me called *Extraordinary Measures*. It was a very beautiful one-man show telling the story of Paul Walker, a man who is being kept alive by all these machines and medical interventions during the last five days of his life. I played him and all the people who come to say good-bye in the hospital. It was a very cathartic experience, which allowed me to process my feelings about what was happening with my friends and the men I worked with.

At the same time, I was developing another multi-character one-person show called *Word of Mouth*. I performed it at La MaMa E.T.C., and Eve directed it. We were very intertwined in each other's work and it was a fertile and exciting time. Mike Nichols came to see it because he was chairman of the board of Friends In Deed, and he took me out to dinner afterward and said that he wanted to produce it. That allowed me to bring the show to an uptown audience. We ended up winning the Drama Desk Award and the Outer Critics Circle Award for Best Solo Performance.

One of the characters I played in *Word of Mouth* was a thirteen-year old boy named Trevor, who, through a series of diary entries, begins to realize that he has feelings for his best friend, or someone he perceives as his best friend. And in exposing those feelings, he's ostracized. He can't really go to his parents. So, he tries to commit suicide. After he doesn't succeed, he goes on to figure out how to be himself.

I had gotten the idea for *Trevor* after listening to a report on NPR that said about one-third of all suicides between the ages of thirteen and twenty-four were attributable to homosexuality. I thought, "And those are just the ones they know about." Because many young people would rather die than come out to their families. It just struck me that here was this epidemic that nobody was addressing, that nobody was talking about. It made me furious that anyone would take their own life because of something that's just part of who they are. So I began to think about what it was like for me growing up in New Jersey and I pulled out my journals from when I was fourteen and fifteen years old and reread them. I tried to recall how isolating it had felt, and then I interviewed a lot of guys who were ten years younger than I was, to see the difference. And that's how I created the character of Trevor.

The first time I performed it, I was terrified, because it was so revealing.

Two producers, Randy Stone and Peggy Rajski, approached me about making a short film based on the story of Trevor. They asked if I would adapt it as a screenplay. They raised the money and made the movie pretty quickly. We always had this idea that the film would have an educational component. So, we applied for a 501c3, just to be ready. *Trevor* went on to win a bunch of awards, including an Academy Award, which was just unbelievable. Then we sold the film to HBO in 1998 and we thought it would be a great idea if we added a telephone number for a help line at the end, in case there were kids out there who recognized themselves in Trevor and needed someone to talk to. But it turned out that there was only one suicide prevention help line for lesbian and gay teens in the country. And when we called it, there was never an answer. So, we decided to start our own.

"We didn't start out to be activists. Just by doing what we loved to do, it took us in this direction. But we're not unique. Everybody has that ability to make some difference even if they're not even aware of what it could be."

The night the film premiered on HBO we got more than fifteen hundred calls from young people around the country. It was overwhelming to say the least. It made us realize just how great a need there was. And that was really the beginning of The Trevor Project.

We trained our own staff and ran the help line—or the "lifeline," as we call it—out of other call centers until we became a little more financially secure, and then we opened up our own. In 2011, we opened our third call center in the Harvey Milk Camera Store in the Castro in San Francisco, which was one of the most incredible moments of my life. Now we can take calls twenty-four hours a day. Somehow, that was Harvey's legacy to us.

The volunteers who answer the phone are the true superheroes.

They have the patience, kindness, and tools to handle incredible circumstances. Not all the calls are rescue calls, but their ability to listen can change the course of someone's life. All young people are in a period of experimentation and questioning, and what we do at The Trevor Project is say to them, "You're perfect just the way you are." Because none of us gets through it alone. We all need one another. We all need that voice-to-voice, life-to-life connection.

We get about thirty thousand calls a year. The majority of calls come from the South and the Midwest, where there are fewer resources for young people. We don't have the arms and legs to reach in there, but we have our voices and teachers, counselors, parents, educators, and in some cases the government, to make young people aware that they have options.

What's amazing to me is that the statistics haven't really changed in the now fourteen years that we've been doing this: 33 percent of suicides between the ages of thirteen and twenty-four are still attributable to LGBT issues. I think that everyone knows how hard it is to live in a society in which you're perceived as different or freakish. The past few years have shone a spotlight on the issue of bullying and targeting young kids for being gay, even if they're not. These unforgiving viewpoints about homosexuality that happen in politics and churches and schools harm our young people. And, not just lesbian and gay teens, but all teens who are questioning the value of their own love.

The Trevor Project is not about gay rights. It's about human rights. It's about providing the same kind of support and acceptance for everybody, regardless of who they are. We didn't start out to be activists. I work in the theater; Peggy is a filmmaker; Randy was a television producer. But, we tapped into something at a particular time that needed to be said. Just by doing what we loved to do, it took us in this direction. But we're not unique. Everybody has that ability to make some difference even if they're not even aware of what it could be. That, to me, is a very exciting thought.

I meet people, now in their late twenties and early thirties, who saw the film on HBO when they were younger, and whose lives were saved by the help line. That's greater than any work of art you could ever hope to create. This whole thing started from a story. I'm a big, big believer in the power of story to change the world.

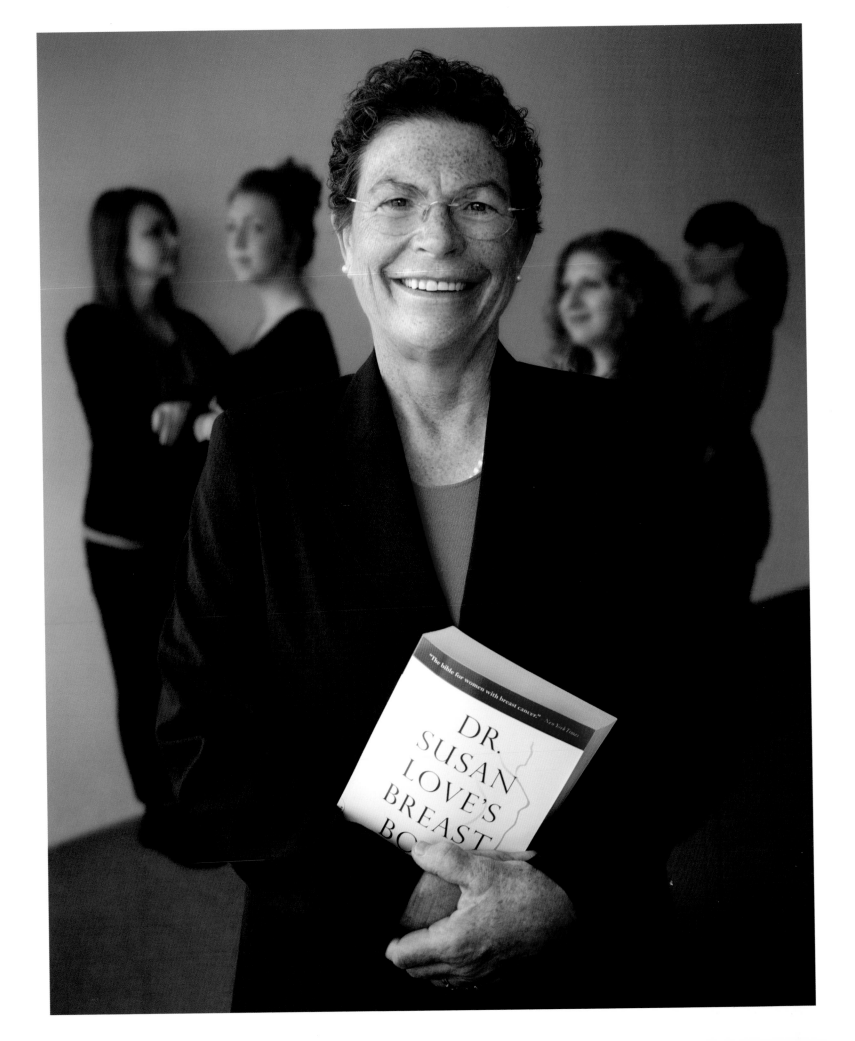

The bible for women with breast cancer." *New York Times*

DR.
SUSAN
LOVE'S
BREAST
BOOK

"It's hard to be an iconoclast. You need a pretty strong ego. But I come from a big band of optimists. You don't get discouraged, you just keep on plugging."

Dr. Susan Love

President, Dr. Susan Love Research Foundation

Dr. Susan Love, the "face of breast cancer," has been advocating for women on Capitol Hill and all around the world for almost four decades. Her groundbreaking book, *Dr. Susan Love's Breast Book*, has sold more than a million copies since its first publication in 1990, and continues to be regarded as the bible of breast-care. Love's ideas have not always been popular. She was among the first to link hormone replacement therapy with breast cancer and at times was sharply criticized for thinking outside the box. By 2008 she was convinced that it was time to shift her focus. "We can't afford to sit around and twiddle our thumbs anymore," she said. "We have done much better in our treatments and certainly reduced the death rate. But the time has come to get rid of breast cancer. We can be the generation that stops it." With a grant from Avon, her foundation set out to create an army of women—one million strong—to avail themselves to researchers all over the country in the hope that their shared experiences will lead experts to the cause and the cure for breast cancer. More than thirty years later, Love is still leading the charge.

I set out on the path to become a doctor at a pretty early age. I did research, operated on frogs and spiders, and even won my high-school science fair. At the time, I didn't fully realize that it might be hard for me to become a doctor because it was pre-women's lib. But when I went to college, it was right after Vatican II, and I ended up deciding to become a nun—fleetingly. For about six months in my junior year, I went to classes every day in a habit, and finally realized that wasn't the way I wanted to go. I mean, it was the sixties; we were all trying to be relevant one way or another.

So, I finished up at Fordham and went to apply to medical schools. They all had quotas on how many women they would accept and said, "Sorry, we already took our five percent." At the same time my advisor told me, "If you go to medical school, you'll kill some boy, because you'll take his place and he won't get a deferment from Vietnam." Eventually I managed to get into SUNY Downstate in Brooklyn, which had a 10 percent quota for women. I did well and then applied for surgical residencies in 1974. Again, there weren't very many women and I ended up at Beth Israel hospital in Boston, where I was the second woman in the general surgery

training program, and then became chief resident. Usually when you're chief resident, you get job offers at the end of your six-year residency, but nobody wanted a woman surgeon. They were afraid men wouldn't go to see women surgeons. So I opened my own practice.

I remember saying before I went into practice, I will not let them turn me into a breast surgeon, because in those days, the only doctors that did breast surgery were the ones that couldn't really handle the macho operations. Lo and behold, my first ten referrals were women with breast problems and it became clear very quickly that they weren't being treated well. At the time, we had data from Italy, in big randomized controlled trials, that lumpectomy and radiation was just as good as mastectomy, and yet the American surgeons were saying, "No, that's just Italian women, with Italian breast cancer, that's not true in this country, here we need to do radical mastectomies and blah-blah-blah." I mean, there were surgeons in Boston in those days that were saying very crude things, like: "There's no breast that's so good it should stay on," and, "If you have cancer it belongs in a jar."

My grandmother died of breast cancer when my mother was in college, and my mother was so afraid that she would get cancer too, that

Dr. Susan Love at the Dr. Susan Love Research Foundation in Santa Monica, CA.

she had a mastectomy when I was in college. People are always looking for that to be the reason I went into the field, but it actually isn't. It was really sexism. I was thrust into the specialty because breast patients were the only cases male doctors would refer to me. And then I realized I could make a much bigger difference taking care of women with breast problems then I could, say, taking gallbladders out.

"I began over thirty years ago, and it's still slash, burn, and poison; we're still cutting off normal body parts to prevent a disease. It's barbaric, and we need to be able to fix it."

I soon had a thriving practice, and the trick really was that I actually talked to the women like they were intelligent human beings—God forbid! It was still the age of the "Don't worry dear, we'll take care of you" approach, and you didn't know if you were going to wake up from surgery with a breast or not, so to have someone sit down and explain to you what was going on, and what your choices were, made a huge difference. People still said to me, "You'll never make a living as a breast surgeon," but before I knew it, I had a staff of five women surgeons, and a couple of medical oncologists and radiation therapists. We had a completely female-driven practice.

So I took all this information and experience and I wrote *Dr. Susan Love's Breast Book*. It took me about five years, and the first edition was published in 1990 (it's now in its fifth edition). It was clear to me that the time was ripe to politicize breast cancer. There was the whole example of AIDS—for the first time, you had people with a disease actually doing the fund-raising and deciding where the research money should go. Prior to that, all the advocacy and disease organizations were founded by doctors— never by patients. And now there were all these women, who had been part of the feminist movement, getting diagnosed with breast cancer in their late thirties, forties, and fifties, and they were asking, "Where's the political

action around breast cancer?" There wasn't any. The funding for breast-cancer research was miniscule, around $40 million at the time. So, like spontaneous combustion, a number of research and activist groups started popping up all over the country. The most telling moment was during my book tour in Salt Lake City, Utah. It was the middle of a weekday, and I was talking to a group of women. I think they had me scheduled for three hours of speaking, so at a certain point I was looking for a laugh. George Bush Senior was in office, and I said, "I don't know what it's going to take to change breast cancer and get enough funding—maybe we should all march topless to the White House." The image of George Bush Senior with all these topless women showing up, not to mention what Barbara would have said, made everybody hysterical. Afterwards they came up and asked, "So, when do we leave?" That's when I realized that this was the moment, and I came back to Boston and pulled together a lot of these groups around the country, and we started the National Breast Cancer Coalition, which within one year increased the funding for breast-cancer research from $40 million to $300 million.

In 1992, I was recruited by UCLA. One gray February day they called me in Boston, and I looked out the window and said yes, I was moveable. So my then girlfriend, now wife, Helen, and I packed up and moved to Los Angeles with our four-year-old daughter Katie. I was at UCLA for four years, and when I left in 1996 I stopped operating on patients. I went and got an MBA, started a few companies based on breast-cancer devices, and then settled down with my nonprofit foundation. Mostly it was my frustration that we were still doing the same old thing. I began over thirty years ago, and we're still today doing combinations of surgeries, radiation, chemotherapy, hormone therapy—we never subtract anything; we only add. It's still slash, burn, and poison, we're still cutting off normal body parts to prevent a disease. If you are a survivor, you don't want to complain because you think, *I have my life; I shouldn't complain*, but actually, you should complain. It's barbaric that you had to go through all that to save your life. It's stupid. We need to be able to fix it.

I felt that I had to redirect my focus and figure out how we could end this once and for all—and that's still my goal. It's not just about finding a cure. All of the treatments have significant side effects and collateral damage, so

even if you do cure somebody, there can still be very harmful long-term effects. Chemotherapy causes heart disease and leukemia; radiation can cause second cancers, surgery can cause complications—the targeted therapies all have substantial consequences. During that same thirty years that I've been in this field, in cancer of the cervix, we've gone from an abnormal pap smear resulting in a total hysterectomy and loss of fertility, to having a vaccine. So, when's the last time you saw a march or a run for cancer of the cervix? And yet, they have the answer and we don't. So, why?

A big part of the problem is that we're victims of our own success—we've raised a huge amount of money for breast cancer but we haven't done a good job at directing where it goes. The scientists do what they think is interesting but may not, in fact, have an impact on people's lives, at least not directly. Too much research is done on rats and mice and they don't naturally get breast cancer, so we have to give it to them in order to study them. If you ask the researchers, they say women are too messy, but rats and mice they can completely control, and it's nice, pretty science. And then you realize—that's their goal: their goal is not necessarily to cure disease; it's nice, pretty science. And then they say, "Well, we don't know how to find women." So that's one of our current big initiatives. It's what we call the Love Avon Army of Women. We have 360,000 women who are willing to be in studies, and researchers come to us with different projects. We vet them and we e-blast them out to everyone in the Army of Women, and very often we get a huge response. We did a webinar today for a researcher, and we got her 230 people in a week. We're trying to accelerate more focused studies that will make a real difference in women's lives.

The Army of Women has been around now for about three years, and we've recruited 60,000 women for sixty studies, so it's really become a model that people around the country who are working in other diseases are looking at. We've found that it's been easier to get the women to participate than to wean the scientists off the rats and mice and laboratory animals. The biggest complaint that we get from the women is that there aren't enough research studies that they can participate in, so we're about to launch our own, the Health of Women study, in which we're going to track women both with and without cancer over time, and try to look for some new risk factors, because the majority of women who get breast cancer have no known risk factors. They did everything right and they still get it. So we're obviously missing something big, but we keep looking for variances of the same thing as opposed to looking for totally new things. We're trying to democratize research.

Another question we are researching right now at the foundation is: Could breast cancer be infectious? Could it be a virus or a bacteria? And the answer is, of course, it could—nobody's looked before. Cancer of the cervix is a virus, cancer of the liver is a virus, cancer of the stomach is a bacteria, so it would not be at all surprising to find the same is true for breast cancer. So we're looking for that, and we're looking at breast fluid to see what's there.

You need two things to have cancer: you need mutated cells and they need to be in an environment that's egging them on. They have done studies that show that 30 percent of women who die of something else in their fifties have breast cancer if you look for it, so essentially, most of us are walking around with breast cancer cells if we live long enough. Then the question is: Why does it show up in some people and not in others?

We focus a lot of our research on the breast, whereas everyone else focuses on the cancer, but, in fact, we're one of the only animals that gets breast cancer. Why? And what exactly does the breast do? For all the molecular biology, we're still arguing about how many holes there are in the nipple.

I'm not discouraged; I keep plugging along and trying to come up with new ways to solve the mystery of breast cancer. One of my mentors described me once as being the one who always says, "You know, I don't think the emperor has any clothes on." And I take that outsider position as a woman, and as a lesbian surgeon. When I started out, none of those things was very acceptable. I was never going to be chief of surgery at Mass General. In a way, I think that's my strength—it really freed me up to take unpopular stances or ask questions that nobody else asked because I had nothing to lose.

It's hard to be an iconoclast. You need a pretty strong ego. But I come from a big band of optimists. You don't get discouraged, you just keep on plugging. That's really the role that I've carved out for myself. It is a very comfortable place for me, actually.

"This all started as a small idea with my family's company, and now there are so many other movers involved, and they're taking ownership of it."

Adam Lowy

Founder, Move For Hunger

While many think of hunger as a third-world problem, the statistics in our country are devastating. One in six Americans is struggling to find their next meal. Equally relevant to New Jersey native Adam Lowy, whose family is in the moving business, is that one in seven Americans relocate to a new home each year. In 2009, Lowy put those two statistics together and had an idea: What if he could deliver the food that people throw away on moving day to those in need instead of it going to waste? Shortly after, he founded Move For Hunger, a nonprofit that mobilizes movers across the country to rescue and transport discarded non-perishable foods to shelters and food banks. With a network of relocation companies that expands daily, Lowy's local humanitarian experiment is quickly becoming a national campaign to stop hunger.

My great-grandfather started a moving company about ninety years ago, and my dad took it over from his dad. I worked on the trucks when I was a kid, but was never interested in running the business myself. I graduated from Arizona State University with a degree in marketing. I loved it out there.

After college, I landed my dream job at a boutique event marketing company. I worked for a luxury brand and found myself renting out mansions, flying to Hawaii, driving around rock stars. All my friends thought I was crazy for quitting all of that to start a nonprofit. My dad was incredibly supportive of me leaving to start Move For Hunger. In fact, we came up with the idea together. We were getting sick about how much food my dad's customers left behind in their homes when they moved. So, in March 2009, we started asking them if they would be willing to put their food aside on moving day so that we could bring it to a food bank.

Adam Lowy outside the Move For Hunger headquarters in Neptune, NJ.

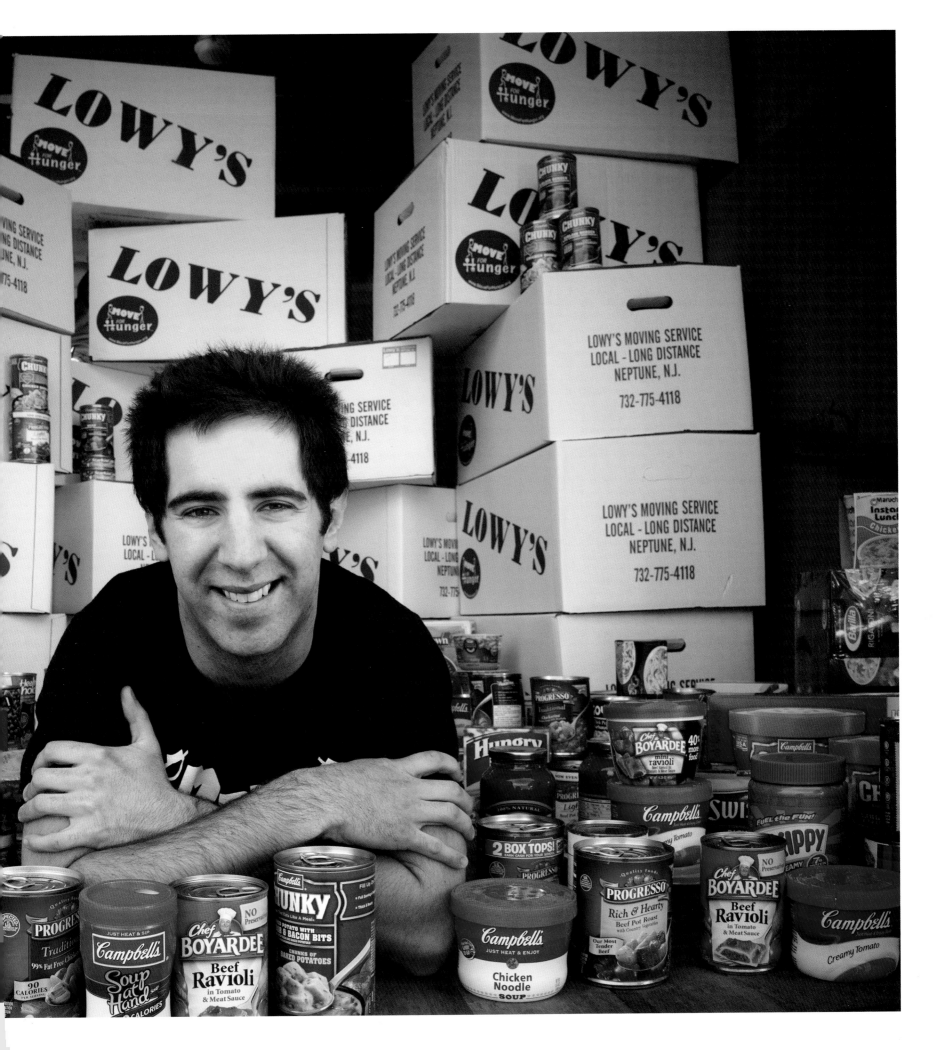

"I was twenty-three years old when we launched, I didn't know anything about hunger or nonprofits."

Nearly everyone said yes! We realized that people want to give, they just don't always know how. If you can provide them with an easy way to contribute, they're going to.

In the first month, we collected three hundred pounds of food, just by asking—no website, no marketing materials, no organization. I could see right away how big the idea could become. If one moving company could collect that much in a month—and there are thousands of movers in this country—we knew we could really create some positive change.

I was twenty-three years old when we launched, I didn't know anything about hunger or nonprofits. People always thought I was an expert, and I had to tell them that they were wrong. When we brought in that first donation to our local food bank, they told me there were 125,000 people who were hungry in my county. That actually stopped me in my tracks. All I kept thinking was, "Where are all these people?" I'd never seen food lines or the homeless where I lived. But once I became aware, I was compelled to act. So a big piece of what we do is try to educate the public.

On every single estimate that our movers go out on, they provide a local hunger statistic: "This is the number of people in your community who do not have enough to eat." The average mover gives maybe five estimates a day. Multiply that by three hundred days a year, then multiply again by the number of movers, and that equals a lot of awareness. These people had no idea about hunger or food banks, but now we are able to educate them and give them a simple way to get involved.

For the individual moving company, we ask for a commitment to the cause. We think it's important for them to have at least a little skin in the game. They have to make a tax-deductible donation to Move For Hunger and commit to collect at least three hundred pounds of food per year, which is ridiculously feasible. In fact, many of our movers collect thousands of pounds of food each year. They're already in the home at the time when people are throwing away all of their belongings, and they have to drive their truck back to their warehouse at some point anyway. Then once a month, or whenever it's convenient, they drop off what they've collected at their local food bank, which is usually just a few miles away from their office. They fax us a weight receipt each time they make a donation, and that's how we track the amount of food collected.

Currently, we have 330 moving companies in forty-two states working with us to fight hunger in their communities. Together, they've collected more than 675,000 pounds of food—enough to provide over 500,000 meals to those in need. Last week a mover sent us a note that said, "We held a big food drive over the weekend. We forgot to tell you." They collected six thousand pounds of food at their local baseball game, and the entire community got behind it. Those things make you proud because this all started as a small idea with my family's company, and now there are so many other movers involved, and they're taking ownership of it. We are the liaison; we give them the opportunity and the tools to make it easier to give back, and to make it a core part of the way they do business. Then it's not something extra. It's not corporate philanthropy. This is a program that happens every single day. We don't waste time cold-calling movers to get involved. All the moving companies come to us. They're proud to do it because it's a great for them to be able to say, "We collected ten thousand pounds of food for the hungry this year." We also understand that this is a valuable marketing tool, and we want them to use it to their competitive advantage. Doing good is good for business!

We just rolled out a real-estate agent program as well. Realtors who join our efforts also receive educational materials and are added to a list of socially responsible relocation professionals. We're trying to encourage these companies to incorporate philanthropy into the way they do business. If we can get 1 percent of the realtor market, we'll be in really good shape. Prudential Properties of Arizona, one of our newest partners, has a thousand agents. That adds up really quickly, and that's just one group. By the end of this year, we should have three to five thousand agents working with us.

Another cool partnership is with Victory Packaging. They're the largest box distributor in North America. They sell us their boxes at cost and we resell them to food banks. Food banks save money and we make

money, which goes right back into supporting the food banks.

It's a different approach than just, "Hey, can I have a dollar?" We want to find ways to bring value to all the companies working with us. I approach it in a very marketing-minded way. We've also created all these fun programs and events to get people more engaged. We planned seventy food drives last year, and we're aiming for two hundred this year. And our events are not just "put the can here." We're about to launch College CanFest, to get university students organizing food drives on their campuses. Instead of just telling them to hold a drive, we're sending them posters, fliers, and collection boxes. We'll even have our local mover pick it all up and deliver it to the food bank. Then we're going to put a leaderboard up online, so the universities can compete. As we bring more sponsors on, we'll be able to give out actual coupons and prizes to students who donate. Eventually, we can even work with college bowl games. We love competition! We love young people working with us, because they're much more likely to continue to give back later in life.

"In the first month, we collected three hundred pounds of food, just by asking— no website, no marketing materials, no organization. I could see right away how big the idea could become."

The years 2010 and 2011 were huge for us in terms of awards and visibility. In 2010, I won an essay competition with Jet Blue. They gave us a thirty-day all-you-can-fly pass. We planned a three-week trip in twenty-four hours. We visited moving companies and food banks, and learned about hunger all over the country. A few months later, Ford had a contest where you had to answer the question: "Why do you want to test drive the all new Ford Focuses?" The prize was $10,000. So we filled a Focus with food, drove to the food bank, and made a fun two-minute video, complete with a slow-mo high five at the end, of course. We won. In addition to the money,

we got a Focus to drive for a month, so we took a twenty-eight-day, nine-thousand mile road trip across America and continued our education on hunger at the local level. We did one-on-one interviews with the directors of food banks, and talked to people about hunger in their communities. We filmed the whole thing and did a daily video blog of our journey.

Food banks themselves actually don't deliver straight to recipients. They'll deliver to agencies and pantries. So, we also visited pantries, met the people they're serving, and listened to their stories. It's tough, because we're usually a bit separated from the people we're actually helping. As a team, we've decided to start volunteering at local pantries once a month, just so we don't lose sight of our ultimate mission.

It was huge when we got Bruce Springsteen's endorsement. Hunger is a cause he cares deeply about. If you've been to a Springsteen concert in the last twenty years, you've seen the food banks collecting outside the door. He's in our backyard, too. I could walk to the Stone Pony from my office. We reached out to him, but didn't get a response. Then one day, I started getting phone calls: "Do you know that Bruce just plugged you on his Facebook page?" All of a sudden, we had 5,000 "comments." It legitimized what we were doing within the nonprofit world. We were able to start reaching out to some of the other big hunger organizations. I just met with Why Hunger last month and they said, "We saw that Bruce endorses you, so we knew you were the real deal."

I'd be naïve to think that we could end hunger. But I do believe that, in this country, we can realistically eliminate hunger for children and the elderly. There are always going to be people who fall on hard times. There's nothing that we can do about that, except try to lend a helping hand and give those people the support they need to get themselves back up on their feet. This job really is my life. Despite what some of my friends might say, though, I do still make time for myself. I shut off every once in a while. I try to leave work by six every day. I rarely wear a suit, which is one of the benefits of being young and being your own boss. I play the piano to keep myself sane. I perform out in clubs every once in a while. And with all the traveling I do, I've made some incredible friends all over the country. But the truth is, I'm always thinking about Move For Hunger, and what I can do to make an even greater impact for those in need.

> *"We believe teens have a ton of power they can use to make the world a better place. . . . We don't preach. We don't judge."*

Nancy Lublin

CEO and Chief Old Person, DoSomething.org

In 1996, when Nancy Lublin started her first nonprofit, Dress for Success—which provides low-income women with interview suits and career development services—she was barely out of her teenage years. Today, she runs the largest organization devoted to teenagers and social change in America. Her title at DoSomething.org may be CEO and Chief Old Person, but don't let her fool you—Lublin's approach to business is as fresh and youthful as ever. Under her leadership, DoSomething.org's internet-based model and it's-hip-to-help-the-world vibe have succeeded in making the words "charitable" and "cool" synonymous—a charmed achievement in the domain of nonprofits.

My mom was a homemaker and a volunteer. My dad's a lawyer. I took the yellow school bus every day and my parents are still married. I've never had an eating disorder. I don't think there's an alcoholic anywhere in my family. I grew up eating Wonder bread, bologna, and American cheese sandwiches. On Saturday and Sunday, my father could be found in front of the television watching football, eating Fritos. And we stopped everything on two nights a week—one to watch *The Cosby Show* together, and the other to watch *Dallas*. Those were major family activities. It could not have been more suburban America.

The only people I knew were Jewish dentists, doctors, and lawyers. I thought those were the only career options I had. I wasn't wild about blood, so my whole young life, I thought I was going to be a lawyer. By the time I'd graduated Brown, I'd spent most of my time taking feminist theory and doing all kinds of pro-choice work. After that, I deferred law school for two years and went to Oxford on a political theory scholarship. I was so

Nancy Lublin riding her Hello Kitty bike to work in New York City.

sheltered that when someone put an artichoke in front of me at Oxford I looked at him and said, "Why did you just give me the top of a pineapple? What am I supposed to do with that?"

When I came back to the States I went right to NYU Law, but very quickly hated it. Then, at the beginning of my second semester of law school, out of the blue, I got this envelope in my mailbox with a check made out to me for $5,000 from the estate of my great-grandfather, who had died years earlier. He was that person in my family, who came to America with nothing and really made something of himself. It felt really strange to receive a windfall from his death—I hadn't earned this. I literally got the idea to use the money to start Dress for Success while I was in the elevator, with the check in my hand, on the way back to my apartment. It just came to me.

So, I went to school the next day and found the one professor I really liked and asked him, "What do you think?" And he said, "You need to go talk to Sister Mary Nerney." Now, my only experience with nuns prior to this point was playing Sister Berthe in The Sound of Music in the sixth grade. But I did it; I met with three nuns in Spanish Harlem and told them my idea, and they said, "We love it." They each ran a different social service program locally. So, I asked them, "Will you be my board of directors?" And they said, "Go get a rich white guy from a bank." And I was like, "No, no, no. I want you and I have five thousand dollars. I'm rich." They became my original board, and I made the critical mistake of following the financial advice of people who had taken an oath of poverty. They told me to put the $5,000 in a CD in the bank, which I did. Which means we started the organization with no money. I really didn't know what I was doing. In fact, I met with a pro bono attorney to set up the organization and she said, "First, we need to form a corporation." And I was like, "No—this isn't a corporation. This is a nonprofit." And, she said, "Nancy, that's a legal term." Then she asked me, "So, who's going to be your secretary?" And, I said, "Okay. Stop right there. That is so bourgeois. I am not going to have a secretary. I don't even drink coffee!"

Frankly, I was learning more from building Dress for Success than I was sitting in classes, and I couldn't keep doing both. So, after a year and a half, I dropped out of law school and focused on the nonprofit full-time.

Seven years later, we had created a subsidiary clothing line and we were operating in seventy-six cities in four countries. I've been to lots of fancy-schmancy schools, but those years were truly the best education of my life.

Then I left. Quite simply, I got bored. I turned thirty, I got my first straight flush, 9/11 happened, I met my future husband, and a couple months later I gave my notice. It was early 2002 and it felt like I was stepping off the flat earth. I knew I didn't want to be a typical founder, lurking in the shadows, calling all the time and asking, "Hey, how's it going?" so I went to Australia. I had absolutely no idea what I was going to do next.

I've always had an angel and a devil on my shoulders. I'm not sure which is which. One Nancy is that girl from the insurance capital of the world who goes to a fancy restaurant and orders the salmon, right? And then the other Nancy is like, "Let's go eat Ethiopian tonight." She gets bored and doesn't sit still well. It's almost like I was born into the wrong community. I have these definite intrinsic entrepreneurial itches, but growing up I was socialized to not respond to them. And that's the struggle of my life. So, when everybody else would have stayed at Dress for Success and just enjoyed it, I was like, "You know what? Anybody can run this now. It doesn't need me anymore." It's grown since I left, but it's really the same organization it was, which is terrific.

> "I turned thirty, I got my first straight flush, 9/11 happened, I met my future husband, and a couple months later I gave my notice at Dress for Success. It was early 2002 and it felt like I was stepping off the flat Earth."

About a year later I got a call out of the blue from Andrew Shue, who had cofounded an organization called Do Something in 1993, when he was on the TV series Melrose Place. Do Something's mission was to encourage leadership and good citizenship in young people by engaging them in community and social causes. The organization had fallen on hard

times. They were looking for someone to turn it around, and they asked Wendy Kopp, who founded Teach for America, if she knew anybody. She said, "I think Nancy's trying to figure out what's next." Do Something had just laid off twenty-one out of twenty-two employees. There was $75,000 left in the bank. They had lost their free office space and everything was in boxes in storage in Queens—and incidentally, nobody knew who had the key. It was really a mess. And I thought, "That's exciting."

I loved the name and I loved the potential. I didn't see another organization for young people out there that was truly *fun*. I felt that their model was messed up, but that I could fix it. I kind of describe it as a ficus plant. I'm always killing ficus plants—but people with a good green thumb can see that the roots are still alive and know how to bring them back. So, in real life, I'm a ficus killer. But apparently, I've got a green thumb for nonprofits.

When I got here, the organization was defining young people as anyone under the age of thirty—that was their target market, and it was just way too broad. It took me several years to narrow them down to only teenagers. In 2011, we worked with 2.4 million kids, and in 2012, we'll run more than twenty-five campaigns—these are contributions that kids can make that don't require money, an adult, or a car, but that have a positive impact on something outside themselves. It's now one of the largest organizations for teenagers in America. We believe in teens, and we think they are awesome and that they have a ton of power that they can use to make the world a better place. And there's nothing condescending about it. We don't preach. We don't judge. I like to describe it as: "This is the not the organization that's ever going to try to take away their tater tots." We have no political agenda whatsoever. We just believe that young people have the creativity and the passion to affect every social issue out there. *And* we don't take sides on anything.

Our focus on leveraging web and mobile technology is because that's where the kids are. If they were somewhere else, we'd go there instead. We're so focused on our target market, and on loving, respecting, and believing in them, that instead of saying, "Hey, you come to us," we go to them. We're one of the only organizations who use mobile communication for uses other than fundraising. Teens don't have a lot of money to give, and that's okay with us. We just want their time, their passion, their creativity. So, we are almost entirely corporate-supported. Government funding is a waste of time. It's slow. And there's nothing about us that's slow.

When I started, I was the lone employee. Now I have almost fifty full-time staff, and another twenty-five part-time. We're big, but we're just starting to realize our potential. We should have 5 million teens in the next three years. And to be able to have their attention on a minute's notice, to be able to text out to them, "Hey, this tornado just hit this area," or—I don't know—"We need blood donors badly." It's like a silent army that's out there waiting to be activated on all kinds of issues.

One piece of advice I give to many social entrepreneurs is that they don't have to explain every aspect of what they do. Better to keep the message clear and simple. I describe this as the "FedEx Principle." What is Federal Express? They're the company that gets stuff there overnight, right? That's all you need to know. Meanwhile, FedEx is one of the most complicated start-ups in history. Think about that proposition, "We're going to get your package anywhere overnight." Before they even opened their doors, they had to be capable of delivering packages overnight everywhere. And, they have to do it with planes. You think it's a pain to take off your shoes at the airport? Try shipping only other people's packages—every one of them is a terrorism hazard. And their costs fluctuate based on the season, on weather patterns, on gas and oil prices. It's a very complicated brand and company to run. It has one of the largest fleets of planes in the world. But at the end of the day, we know it as "the company that gets stuff there overnight." Nonprofits are typically not very good at this. So one of my goals when I work with social entrepreneurs is to help them figure out who they are. You can't be something to everyone.

I have two kids now—they're five and seven. Being a mother has made me a better CEO. I used to pull all-nighters in the office. I used to be very unbalanced. I love getting home on a Friday night now and spending the weekend with my family. And I also love going to work on Monday morning. I finally feel whole and complete—and calmer and happier.

I loved being pregnant. It makes you feel really powerful, you know. I mean, I made a human being and that's the ultimate entrepreneurial project. It's pretty cool. I made a person.

"I knew that homeless or not, running makes you feel like you can fly. It doesn't discriminate, it doesn't matter if you're white, black, rich, or poor."

Anne Mahlum

Founder and CEO, Back on My Feet

In 2007, then twenty-seven-year-old Anne Mahlum left behind a promising corporate job to start Back on My Feet, a nonprofit that uses the discipline of running to inspire confidence and self-sufficiency among the homeless. A veteran marathoner, Anne started running when she was sixteen, as an escape from turbulence in her family life. A decade later, she began a running club with a group of men in a local shelter. She believed that running could give them back the sense of control and accomplishment they needed to rebuild their lives. The program was so successful in its first few weeks, Anne knew her intuitions were right. In the five years since, Back on My Feet has grown exponentially, adding programs that provide educational support and job placement, and helping hundreds of members through chapters in nine states.

I grew up in Bismarck, North Dakota. I had a really idyllic childhood— by the age of twelve I had my whole world figured out; I thought I knew exactly what kind of life I was going to have. Then when I was sixteen I discovered that my dad had a gambling addiction. I didn't understand addiction at the time, obviously, but my mom kicked my dad out the same day he told her, me, and my brother and sister about it. Unfortunately, this wasn't her introduction to my dad's addictive behavior; he'd gone through drug and alcohol recovery when I was really young and they'd kept that hidden from us kids. So when the gambling surfaced, she was just like, "I'm not going through this again." It was really a huge shock, especially for me—I loved my dad more than anything. Suddenly my mom didn't want him to live with us anymore and I didn't understand any of it. I spent the next three years not having a relationship with my mom, but also trying to fix my dad, which of course didn't work, because

Anne Mahlum with three Members of Back on My Feet near the U.S. Capitol Building in Washington, D.C.

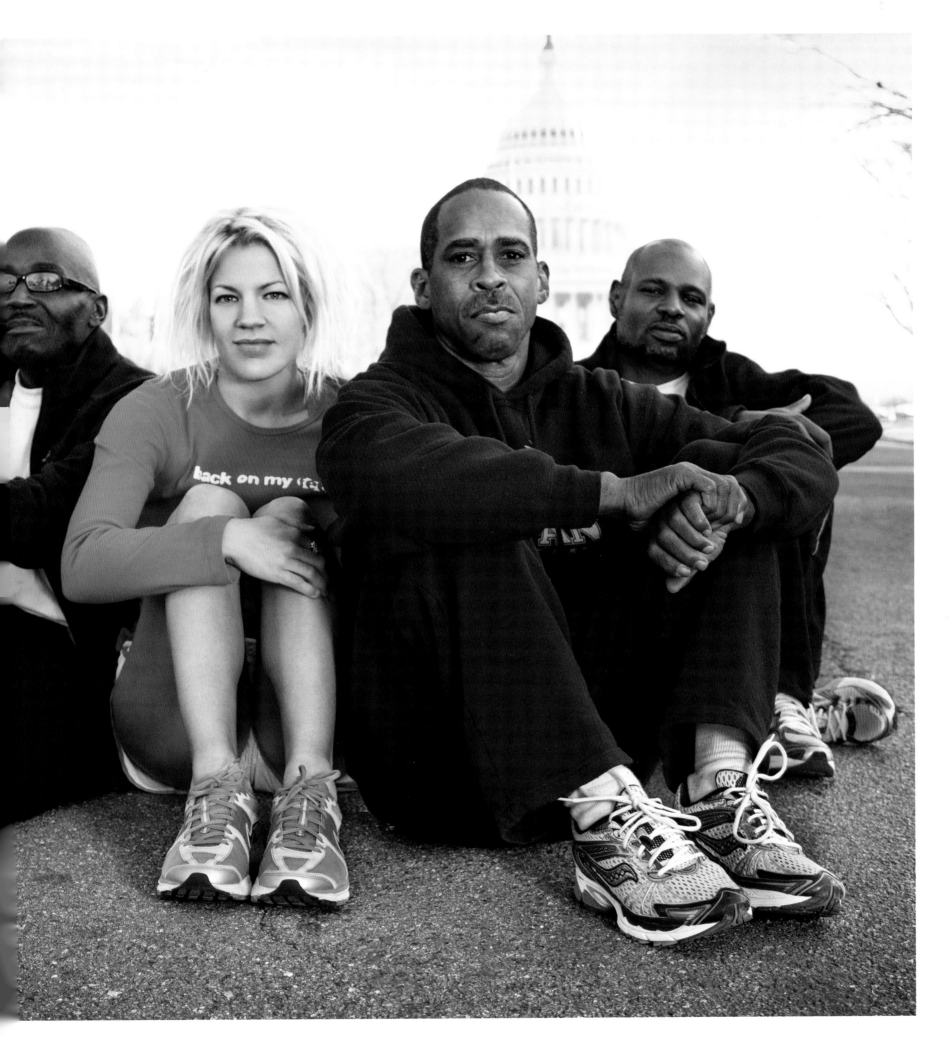

you can't fix somebody who's not ready to be fixed. I had to deal with all those emotions and it's a small town, people talked. I didn't know anybody whose folks got divorced when they were teenagers. So running became my outlet, it was really my saving grace. It gave me an escape, but it also gave me a lot of clarity and strength, and helped me discover things that I liked about myself. It just taught me so many lessons—beautiful lessons.

Ten years later I was living in Philadelphia where I'd moved after grad school, and I found myself running by this homeless shelter every day. There was a bunch of guys who were always standing out there on the corner and I started to develop a really fun, sarcastic relationship with them. Knowing the power that running holds, I got the idea to start a running group with them. It took a little convincing to get the shelter to agree—they didn't think people experiencing homelessness would have enough discipline or interest, but I knew that homeless or not, running makes you feel like you can fly. It doesn't discriminate, it doesn't matter if you're white, black, rich, or poor.

"When I was sixteen I discovered that my dad had a gambling addiction. It was really a huge shock—I loved my dad more than anything. Running became my outlet, it was my saving grace. It gave me an escape, but it also gave me a lot of clarity and strength."

At the time, I was just about to start this great new job with Comcast, and I asked them if they would give me a month deferral so I could get the running group started and stabilized. Those four weeks changed my life. I began to see how powerful this structure could be, how it could help these men see themselves completely differently. It was all on a voluntary basis, and they kept showing up, three days a week. They were genuinely excited about being part of a team, and I could see their self-confidence growing with every run. I thought to myself, "If these guys at this one shelter are

benefiting and enjoying this so much, then imagine how many other people we could help." I realized we could build a real program behind this theory and this model, which was to use running to restore the confidence and emotional well-being of people experiencing homelessness, so that we could then focus on moving their lives forward through education, job training, employment, and housing.

I turned down the Comcast job and thanked them for the time they gave me, because I felt like I had finally figured out what I was supposed to do with my life. Obviously a big part of that was understanding my dad better and what he went through with his addictions. If my dad wasn't who he was, I might not have felt so compelled to help those guys. I really saw my dad in them.

When you look at our Members and then you look at me or the other volunteers, we don't necessarily have a lot in common on the surface: our educations are different, our backgrounds are usually different, many of them have been incarcerated, many of them have tried drugs, a big chunk of them have addiction issues. But through running, we've built a common ground, a foundation that we can build upon to then form friendships, and you quickly realize how similar we all are as human beings, regardless of our experiences. Through running we've also created a shared language, so we can say things like, "Remember when you ran your first mile, and you never thought you'd be able to run a marathon? You've run two of 'em so far. There's going to be a first day for other stuff, too, and now you know that there are no shortcuts—there are no shortcuts to running ten miles, you have to do every single mile from one to ten to get there." So you're using this new language and experience to teach them a whole new way of thinking and change their mindset.

To participate in the program, members have to run three days a week, at 5:45 in the morning. They have to be on time, they have to come with a good attitude and the willingness to be open-minded, and they have to respect their teammates. Those are the foundational principles of the organization, that's where it all starts. You have to make a commitment to want to move your life forward. You have to want to get out of this dependent state of homelessness. If you do the work, we'll do our part and help build the road map for the life that you want. We really teach self-

sufficiency and individual responsibility—we're saying to them, "We know you need some help, and we're here to help you, but we're not doing all of it," and that's an important lesson.

After they've met these requirements consistently for a month, they sit down with our staff and go over what's going on in their lives so that we can get a snapshot of where they are and then where they want to be. We offer a variety of types of assistance depending on their needs—financial, educational, employment, rehabilitation. Everybody's different—we don't stereotype and we don't put people into boxes. We might have somebody who doesn't have any addictive or emotional issues to overcome, who simply lost their job and couldn't pay their rent so they ended up in a shelter. They're not fitting the typical demographic of a homeless person. We can probably help that person a little more quickly than someone who has been homeless for five years, or can't get through their addictions. So the average length of time in our program is four-to-six months. From September 2008 through May 2012, we've helped 500 Residential Members obtain employment, 327 obtain housing, and 480 enroll in job training or re-education.

What's been true from day one, and is still true, is the simplicity of the theory—that if you give people an environment where they can be successful and feel appreciated, valued, and cared for, they will respond. We're five years old now, we have hundreds of Members involved, thousands of volunteers and forty staff members—so it's a stable and strong organization.

In terms of future growth, it's like that old adage, You can't change the world all at once, but you can change the world one person at a time. So, patience is the key. So much depends on what kind of impact you want to make: Are you looking for quality or quantity? Obviously we're looking for both. But if you want to help, say, ten thousand people, you have to start somewhere, right? I wasn't planning for any of this to happen, but I've felt all along that I was being guided or directed down a certain path, and all I had to do was listen. Listen to that voice inside of me that said, "This is what you were meant to do." Because when something is really right, things fall into place.

On the face of it, almost everything about Back on My Feet didn't

"I see all these people out there who hate their jobs and I think, 'Man, am I blessed.'"

seem like it should work—I didn't have any experience in this field, I was very young, I don't look like these guys, the idea of putting running and homelessness together seemed crazy to most people. It was almost like this combination of random elements that turned out to be perfect. I get a response from the members because at first they are curious about me—then they hear my story and they understand the genuineness of why I'm doing this. And from a corporate or fund-raising perspective, I just have an unusual sense of confidence, which I learned through my dad at a really young age. I can remember once when we were kids in North Dakota—it was the middle of the winter and it was freezing. We complained that there was nothing to do. And my dad finally said, "Go get your swimsuits." So we put on our suits, pile into the car, my dad takes us to this hotel, we pull in, and we're all looking at him. And I say, "Dad, we can't swim here. We don't have a hotel room." He told me to walk in like I own the place and ask where the pool is—and people will tell you. I've taken that approach with this organization. I know that it works, I see it every single day. When I walk into a meeting where I'm the keynote speaker and people often ask, "Are you the intern?" that's okay, because I'm certain about the message I'm delivering and this program that we've built. I think that kind of thing works to my advantage.

Everybody thinks what I've chosen to do with my life is some big sacrifice, but I'm having a blast. I'm an entrepreneur and I don't consider what I do work. There is never a day that I'm bored. I see all these people out there who hate their jobs and I think, "Man, am I blessed." I honestly never used that word before, because I didn't know what it truly meant, but I get it now.

This whole experience has also brought me much closer to my mom and my dad. It feels like I have two really great friends now who just happen to be my parents. My dad has really opened up a lot more to me about himself and he's doing so much better. He's addicted to fishing now, but that's okay, that's an addiction I can deal with!

"No matter how frustrated I am with someone or they are with themselves, I always tell them, 'I'm never giving up on you.'"

Brother Bob Malloy

Director of Pastoral Care, Capuchin Soup Kitchen

If angels walk this earth, then Brother Bob Malloy is surely one of them. For forty years this priest of the Capuchin order has been serving the mentally ill and disabled, and ministering to the poor. Raised in the Detroit area, a decade ago he returned to his childhood neighborhood to run the Capuchin Soup Kitchen (founded in 1929), which includes the oversight of multiple programs for the disenfranchised. Day in and day out, Brother Bob, as he is familiarly known, sees to the persistent needs of the thousands of men and women that pass through his doors. In the noisy wake of a new generation of entrepreneurial nonprofit leaders, Brother Bob quietly reminds us that we will always need foot soldiers in the fight against poverty.

I'm what you'd call a lifer. My third-grade teacher would ask what I wanted to be when I grew up, and I'd always say, "A priest." When I was eleven, we moved to Milwaukee and I went to a Catholic grade school and then straight into a Capuchin high-school seminary. I'm the first of my family to join the priesthood.

Capuchins are an order of the Franciscans, who are known for working with the poor and disenfranchised. St. Francis of Assisi himself worked among the

Brother Bob Malloy (left) and Brother Vincent Reyes, with patrons of the Capuchin Soup Kitchen in Detroit, MI.

lepers. I followed the normal procedure, went into an officiate after my senior year, and was invested in the Capuchin habit. Then I went to a Capuchin college followed by graduate studies in theology. We were ordained at the beginning of our fourth year and given our assignments. I also received a master's in special education; I wanted to work with children who are developmentally disabled.

In a time previous, a priest just went where he was sent. By the time I came through, it was more of a negotiation between one's preference and where there was need; so, I was allowed to go into the field of special ed. I went to Washington to be the executive director of a national organization for catechesis and religious development for people with developmental disabilities. At that time it was called the National Apostolate for the Mentally Retarded. I worked there for three years and then came back to the archdiocese in Detroit to work in their ministry with people who were disabled. From there I did a short stint on Guam in the summer of 1980 and was then sent to work in a parish in Wisconsin, where I remained for seven years.

In 1988, I requested a sabbatical to get retooled in my area of special education. There was an approach to catechizing people with developmental disabilities in Chicago that I wanted to get into my bones. At the end of that year, I spent three months in Europe visiting churches that had implemented this approach and had set up facilities for people with profound disabilities. When I returned to the States, I was sent to a Capuchin retreat center in Saginaw, Michigan, where I remained for nine years and became the director. While I was there, I worked weekly with a group of people in a nearby town who were mentally ill. When I was done at Saginaw in 1999, I was urged by the order to focus my next phase of work on the marginalized and the poor. There had been a good deal of advancement in the field of developmental disability since I'd started out, but much less so in the field of mental illness. So I decided the greatest need was in ministering to the mentally ill. To learn more about it, I went to Washington, D.C., where I completed a two-year program at a large hospital.

The only places where the Capuchins directly served people with mental illness were the two soup kitchens, in Milwaukee and Detroit. In 2002, I decided to go to Detroit. I'm the chaplain at the center, which has five different sites, two of which are soup kitchens, where we serve about 2,000 meals a day. I'm also the pastoral director for the whole operation. So, my job description is really whatever doesn't fall to anybody else. Whatever needs doing, I do. I drive people to doctor's appointments, take them to the emergency room, deliver food, get them a clean pair of socks if their feet are wet—I'm just caring for people all day long. I come in at about 8:30 in the morning and then I often stay until 9:30 at night.

"At mealtime, I like to sit on the edge of the dining room and look at the variety of people at the tables, eating. I think, what a cast of characters. Every one of them has a unique story. It really is a moment of gratitude."

The mental health system is not able to meet the needs of people who have been released from institutions. Government funds have been cut, so we work with local agencies and we do the best we can to get people the services that they need, but part of the difficulty is the nature of the illness. A person can't be forced to accept treatment unless they're a danger to themselves or someone else. If we "petition someone in" —in the old days we would say "commit"—they can only be kept for seventy-two hours. Then they're back on the street without any place to go and will inevitably stop taking their medication. It's a vicious cycle and it's very frustrating. We try to get them housing, provide stability, get them into the mental health system, and onto medication. But it's a big job in a city where resources are dwindling. We just don't have as much as we used to.

One program we have is called Faith and Fellowship. We have volunteers who go pick up a group of people in the area who are mentally ill—they live in what are called adult foster-care homes—and they bring them to the soup kitchen on Monday evenings. We share a meal together,

we put out glassware, cloth napkins, real flowers, and candles. We speak to their dignity. It's amazing how people begin to share over time. Many are intimidated or paranoid that large groups may sneer or stare at them, but in this group they're welcome and they eventually share more, and the hope is that somebody will be able to help them into their own faith community.

It's very gratifying to watch people as they gain more confidence. With the mentally ill, it takes a long time to win their trust. I had one woman in particular who would ignore me if I went to sit next to her—she would get up and move to another table, and it took me a whole year to get to the point where she would stay seated. Then eventually, she started to come to the Wednesday-morning prayer service. She finally warmed up to me and told me about her past, and even showed me a picture of her as a bridesmaid at a wedding when she was healthy.

I believe there are some biological and inherited traits that contribute to mental illness, but for many of the people that come here, there is also a significant history of trauma. As you get to know them, and you begin to realize what they went through in their youth, how they may have been abused, you begin to put the pieces together and understand why they are where they are. Just this morning I talked with a woman who's an alcoholic. She told me that three years ago, her daughter was shot and killed in the street. I said to her, well no wonder you drink. She admits she's very much addicted to alcohol, and she's homeless, living in a shelter that has no heat, no electricity. There's one gentleman who has been coming for years and I didn't know until the other day that he was a medical doctor—I had no idea that he had that kind of professional background. He lives in an adult foster-care home now, and he is a very broken man.

Nothing really shocks me anymore, though there are some great disappointments. For instance, we just had a forty-three-year-old severe alcoholic that we finally got to go into treatment. He was given the opportunity to stay for as long as ninety days and go into transitional housing and then permanent housing, and he chose to leave. I'm sure that he's going to be a drunk on the street again and that's very saddening and disillusioning. But I told him, "You're welcome to come back, we still love you no matter what you do. We will offer to you what we offer to anybody."

There are some success stories, too. We have an urban farming program, and we have some people from the soup kitchen who have gone through a nine-month agricultural training program and have become entrepreneurs. One is raising worms now, and another person is raising seedlings. There's a woman growing herbs and she's making tea to sell. That's a wonderful program. You watch people who are staying off of drugs and getting their focus and self-confidence back. We also have a bakery where we bring people who are coming out of treatment or out of prison, and they live together for a year and develop good work habits. We teach them how to bake and they operate the bakery and sell the goods. They can move on with that experience on their résumé. We have a small rehabilitation center for men, and that's been very successful too. They stay in residence for six to nine months and we help them get back on their feet and find a job and a home.

I've been a Capuchin for fifty years now. I'm becoming more aware of my own mortality. I feel good that I'm healthy and able to continue doing what I'm doing. We used to say that we could be semi-retired at sixty-five and retired at seventy, but because of our dwindling numbers, we are being encouraged to work as long as we can. In one sense we don't ever really retire fully.

I have my own key to our local cemetery so, even if they're closed, I walk in there for forty minutes every day. I have a period of solitude. It's just good to be away from everybody, where nobody can find me because I'm locked in. I walk for my own mental health and I say a prayer for people who need it. I've been doing that every day for the ten years I've been here.

At mealtime, I like to sit on the edge of the dining room so I can see if anything erupts. If I'm not being pulled away, I often enjoy looking at the variety of people at the tables, eating. And I think, what a cast of characters. Every one of them has a unique story. It really is a moment of gratitude. Their individuality always warms my heart and gives me motivation to continue on.

My one principle of operation is to not ever give up on anybody no matter how frustrated I am with them or they are with themselves. I always tell them, "I'm not giving up on you, I won't always do what you want me to do, but I'm never giving up on you."

"Kids are seven times more likely to go to college if they've got a college savings account in their name. That is an unbelievable statement about how when tangible expectations are set, behaviors change."

Ben Mangan

Co-Founder, President, and CEO, EARN

The concept behind EARN—an acronym for Earned Assets Resource Network—is brilliantly simple: saving for future goals is the foundation of wealth in America and the first step on the path out of poverty. Ben Mangan didn't just learn this in graduate school or through the study of economics, he knows this from personal experience. Mangan grew up poor and understands intimately the entrenched obstacles facing low-income families in this country. In fact, if an organization such as EARN—which offers the disadvantaged matched savings accounts earmarked for higher education, homeownership, or small business expansion—had been available to his family when he was young, it might have profoundly improved their lives. The real beauty of EARN is its message of empowerment—by helping people lift themselves out of poverty, they become designers of their own prosperity instead of dependents on the prosperity of others.

I teach a class at UC Berkeley at the business school on leading and managing social enterprises and nonprofits. It's a real hands-on, hardworking class, because I want to disabuse young people of the notion that nonprofit work is easier than work in the private sector. A lot of the class is how you successfully apply business principles to the nonprofit and social venture space. It's an enormous amount of work, teaching, but I am one of those people who get their energy from being around others who are fired up about meaningful things. So I always feel super-energized by the students. It is also a good way for me to stop and reflect on EARN, and how the things I'm teaching these kids apply to my own business, and the leadership challenges that I need to tackle to get EARN to the next level.

I've learned from experience that if you want to be a leader in the social sector, to do it authentically, it takes time. There's this mythology around the "Aha!" moment where a nonprofit gets huge fast and within three years they're achieving their goals. For most of us, it takes a lot longer than that—it takes relentlessness to be successful. Especially now, where there is this weird lionization of social entrepreneurs in a way that can be counterproductive. It's very important for young people to get that. There are some kids in my class who will say they want to be social

entrepreneurs, but they can't name a cause they feel passionate about.

I came to San Francisco the first time in 1990, for a summer during college. I knew even then that I wanted my life's work to be highly focused on social justice and opportunity. I did an internship in the DA's office. I just instantly fell in love with it here. There is an energy that is so entrepreneurial here, so willing to reward dreamers. You don't need to come from the right family, or have the right pedigree to achieve.

It took me ten years to get back to Northern California. Early in my career, I worked in education. And then I went to graduate school for public policy. While I was there, I focused on finance and strategy. I went to work in management consulting at first, which was mostly financially related. I ran a small consulting practice at Ernst and Young for about two years. It was a tremendous experience.

The next area I felt I needed to learn about was technology. So I moved to San Francisco in 2000 and for a year, I worked for a company that was focused on micro-payments online. That's when the economy totally shifted. I got an e-mail from a good friend telling me about this interesting project called EARN that some people were trying to get off the ground, and she thought it would be perfect for me. I read about what they wanted to do, and it was just the thing I had been waiting for.

Ben Mangan in San Francisco's Financial District, near the EARN office.

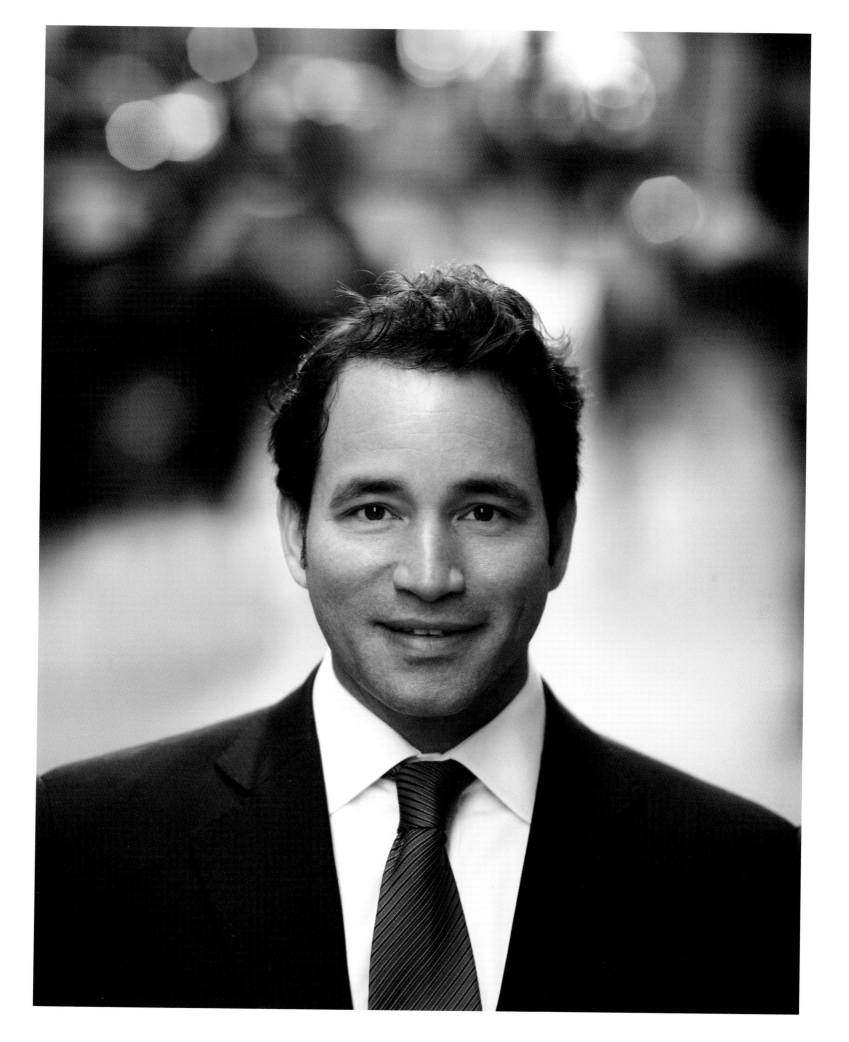

The traditional approach to fighting poverty has always been about helping people get more income, a roof over their heads, and a job. Those things all matter. But that doesn't necessarily get people closer to prosperity. This country is actually phenomenally good at creating wealth. So at EARN, we looked at the root of wealth creation to find a way to apply that to low-income people. And what we found was that the path to prosperity was really tied to being able to save and invest in assets that were iconic to the American Dream. That was the magical discovery.

We started working on EARN in 2001, and it took a full year just to get the ball rolling because the dot-com bust had such a powerful effect on the Bay Area. It took us another couple years to get to the point where we were finally able to start growing on the right trajectory. We did have some powerful champions for our cause and they opened a lot of doors. The idea was compelling and relevant. But it took us time to get over the initial stumbles. We had to adjust our model. The original guiding star was always in sight. We just had to alter our course a few times.

The original idea was to open ten thousand matched savings accounts ($4,000 apiece plus administrative costs) in San Francisco. But it would have cost $50 million, and during that recession, people were literally laughing in my face. So we had to scale back those goals. But that idea solidified our four core values, which are prosperity, dignity, innovation, and scale.

We've opened about four thousand matched accounts since then, and what we've learned is that the assets that people use the accounts for—like college degrees, small businesses, home ownership—are very important. There's also something transformational about the simple act of saving. The Pew Research Center has a study that shows that one of the greatest predictors of people leaving the bottom of the economy is whether they save or not. It's a totally future-oriented action. And it's an act of optimism.

A big part of what we'll be experimenting with in the years to come is just how much value you get from that. There's a very compelling statistic that has driven a lot of how we're orienting our future work. It says that kids are seven times more likely to go to college if they've got a college savings account in their name. That is an unbelievable statement about how when tangible expectations are set, behaviors change.

As we learned and grew, EARN evolved into a three-part organization. The first part is dedicated to service, where we provide savings accounts, training, and other resources directly to people. We are just introducing a new type of matched account that has been redesigned to be much more scalable, and can reach potentially hundreds of thousands—even millions—of people. Those are for low-income families, specifically to help their kids with educational expenses. If they save at least $500, they get a three-to-one match, so they come away with two thousand dollars. But what's important to remember is that the money is just the spark for a shift in perspective. There's a huge body of research about what it takes to build self-efficacy for people. A big part of it is giving people what's called perceived control. So many social programs just strip all control from people. Philosophically, you might define this as "disempowering." But it also cognitively puts a total chill on someone's ability to build confidence and achieve future goals. By making EARN program elements optional, we enabled a sense of control.

We also found an innovative way to actually give people the money and monitor how it's being spent. Essentially, they get a stored-value debit card that allows us to pretty severely limit the kinds of things it can be used for, and actually make a claim to retrieve the money if it's not being used for an appropriate education-related investment. This gives us a chance to 1) make this much more scalable, and 2) to do an experiment. We don't actually believe people are going to abuse this. So far we've been right. In fact, 80 percent of the people who open these accounts get to the point where they start making investments, which is remarkable.

So that's the first focus of EARN. The second focus is EARN's Research Institute, which takes advantage of the fact that we're so close to the end users. There is so much insight that you miss when you're not directly connected to the people you're trying to help. We realized that we have a unique opportunity to directly measure our impact on the population we're trying to affect. The research analysis helps us understand whether what we are doing is working and what the real costs and benefits are.

The third leg of the stool for us is policy, because the history of wealth in the United States is inextricably linked to public policy. We have a long-term vision, which is to build a constituency for this. It's hard to

actually have people who have benefited from the kinds of things that EARN does available to testify to Congress, or get galvanized around a bill that would create tremendous opportunity for people. But EARN is an unbelievably bipartisan idea, and when we talk to policy makers, we talk to Republicans and Democrats. Asset-building for low-income people is one of the very rare instances where there's an authentic overlap in principles between the two parties.

> *"There's something transformational about the simple act of saving. It's a totally future-oriented action. And it's an act of optimism."*

Democrats love the safety net of social services, but they also want to see a path out of the safety net that works. And Republicans are looking for something that aligns with their values a little more clearly, something, for instance, that really rewards effort. And that's what this does. I once met with one of the senior leaders of the California State Senate, who is a very conservative Republican, and he loved what we were doing. He said, half-jokingly, "I love what you're doing because you're making more Republicans."

A lot of my motivation to do this kind of work is personal and has to do with my own experiences with poverty. I grew up with a single mom who sacrificed to give me opportunities. We lived in public housing in Springfield, Massachusetts, until I was about eight, and then we moved to Brooklyn. We were very poor; there is no other way to put it. People have generally not gone to college in my immediate family, and one of the reasons my mom moved us to New York was because she was absolutely committed to me having a different fate. She was totally focused on my education. I was going to go to college. That was the expectation.

But she didn't know anything about financial aid. She assumed I'd go to a state university, so those were the only schools that I applied to. But then I happened to meet someone who had just finished his first year at Vassar and he seemed thunderstruck by what an incredible place it was. I was hungering for an environment where I didn't have to hide the fact that I was interested in ideas. And it sounded amazing. So I begged my mother to let me apply. She very grudgingly said okay. And then I got in, and I received this ginormous financial-aid package. It was really dumb luck.

I've got to say, for a poor kid from Brooklyn, I felt like an immigrant from another country when I arrived at Vassar. I was challenged on so many levels. And it just opened up my world. I graduated in 1992 as a history major and I was offered a job in the admissions department soon after because I had worked there as a student. The director of admissions at the time had a very similar background to mine. So he allowed me to visit all the public schools in New York that normally would not get a visit from a Vassar rep, to talk to kids about the school. That's when I really started to think about this issue of what it meant to have access, the way I did, to a college degree at a place that could be so life-changing. I had all these young people apply, and it was the first time in my career I faced these really tough formative questions about who deserves opportunity and why.

Being poor in the United States is very complicated because there is such a strong mythology about the American Dream. And some of it comes true, but some of it's dangerous, like if you're not making it, it just means you're not working hard enough. The fact is, you've got these enormous structures, which are much bigger than anybody's individual will, that perpetuate wealth and opportunity. Some people are able to break through them and some aren't, through no fault of their own. So there is an enormous amount of shame with being poor in the United States. I personally found it very scarring. It stripped me of my dignity, which is incredibly dehumanizing. A big part of why I work at EARN is to try to redefine the American Dream, and restore integrity to it.

So there is a powerfully redemptive theme around my pursuing this work, absolutely. Redemption for myself, but also trying to pay forward the opportunities that I enjoyed as a result of how hard my mom worked to position me to go to college, and the opportunities that serendipitously emerged for me. Becoming a parent myself has also given me a new sense of urgency to succeed, to give my son even greater opportunities than I had, so that he doesn't ever know poverty the way I did.

"We are really doing exactly what we were doing in 1996, just at a much vaster scale, and much more deliberately, thoughtfully, and strategically. But it's still a desk in the clinic waiting room with a Health Leads sign that says, 'Do you need help with food, housing, heating, employment?'"

Rebecca Onie

Co-Founder and CEO, Health Leads

Rebecca Onie was still an undergrad when she dared to believe that she had an idea that could significantly impact the health of low-income families in her community. Encouraged by her mentors, Onie channeled her willful confidence and early experiences into mobilizing student volunteers, and building a grassroots advocacy organization based on the philosophy that to heal the illnesses of the poor one must look beyond just a medical cure. Health Leads, which is now in six cities across the country, enables doctors to "prescribe" their patients an assortment of social services and resources, including housing, food, and employment assistance. Of the 9,000 patients Health Leads assisted in 2011, more than half resolved at least one critical need within ninety days of receiving their "prescription."

I am the child of two teachers. My mom teaches sixth grade, my father college. The defining aspect of my upbringing was that both of my parents graduated from college in 1968 in the heart of the American civil rights movement and marched and protested in the South. The power of political action to create change was a constant refrain throughout my childhood. We religiously watched the *McNeil / Lehrer News Hour*. My dad drove me utterly insane, perpetually asking me, "When do you think there is going to be the first woman president? Do you think it will be you?" One of my first memories is sitting on his shoulders at a Geraldine Ferraro rally. "That's what it looks like when a woman runs for office."

I drove my parents somewhat insane, asking, "Why?" I guess my approach to the world has always been to question things. To that end, I did a fair amount of journalism. I was editor of my high-school newspaper and also a reporter for WBZ News, here in Boston. They had a radio show run by kids. I had a press pass to the Democratic National Convention in 1994. Interviewing folks like Mario Cuomo at age fourteen was a defining experience.

At Harvard, my concentration was the history of science, and I focused on the convergence of biology and twentieth-century American history. My senior thesis was around physician participation in the American civil rights movement. Doctors from the North initially came to the South to provide medical care to civil-rights workers, who were being denied treatment. As they spent time in those institutions, the physicians became dismayed with the quality of care being provided to African Americans. That was the literal genesis of community health centers in this country.

During my time at Harvard, I had a life-changing conversation with a faculty member, Alan Brandt. He said, "The thing about bioethics is that it's conceptual. History is where decisions are made. Every day as a society we make choices that resolve ethical dilemmas, at least for the moment." That's what really got me interested in history. Ultimately, Health Leads came from my dissatisfaction with certain historical decisions. I believed we could make better choices.

My freshman year of college I thought I wanted to be a lawyer, and so I signed up for an internship in the housing unit of Greater Boston Legal Services. I showed up ready to make photocopies and coffee. Instead I was assigned to this righteous, inspired lawyer named Jeff Purcell, who basically thrust me onto the front lines my very first day.

Over the course of nine months, I had dozens and dozens of

Rebecca Onie in Washington, D.C.

conversations with low-income families in Boston who would come into the clinic presenting with housing problems. When I scratched the surface, there were always underlying health issues. For instance, one client came in about to be evicted because he hadn't paid his rent. He hadn't paid his rent because he was paying for his HIV medication. Or a mom would come in because her daughter had asthma and woke up covered in cockroaches every morning. One of our litigation strategies was for me to go into these homes, collect the cockroaches, and hot glue them to poster board, which we would bring to court. We would inevitably win because the judge was so profoundly grossed out. That was, frankly, more effective than anything I learned in law school. I grew very frustrated that we were intervening so far downstream from the problem. By the time the clients came to us they were always in crisis.

At the end of my freshman year, I read about Barry Zuckerman, who was chair of pediatrics at what was then Boston City Hospital. Barry's first hire was a legal-services attorney to represent his patients, which I thought was a stroke of genius. I cold-called Barry and, with his blessing, spent six months wandering around the hospital asking doctors, "If you had unlimited resources, what would you give your patients?" I kept hearing the same story. "Every day we have kids who come into the clinic with an ear infection or asthma exacerbation and I prescribe antibiotics or an inhaler, but the real issue is there is no food at home or the family is living in a car. I don't ask about those issues because there's nothing I can do. I wasn't trained to help with that." Health Leads was really born out of those conversations.

The challenge was that there were very basic resources needed, which were well understood by everybody involved—the patients, the doctors, and everyone else—to have a significant impact on the health of the patients. But the clinic simply lacked the capacity to address those needs. So, the question became, "How do we create a scalable, cost-effective way for the clinic to address these simple necessities?"

There are 330,000 college students in the Boston area. They have a lot of time on their hands. Couldn't we deploy this otherwise untapped workforce to be able to create those resource connections for patients? I thought so.

When I realized that I needed to leave my job at legal services to focus on the burgeoning idea of Health Leads, I remember being very nervous to tell Jeff Purcell. I said, "Jeff, I think we can mobilize college students to address patients' real health needs." He said, "Rebecca, when you have a vision, you have an obligation to realize it." All I really wanted was a blessing; I wasn't looking for a mandate. But, it literally changed my life. I ended up recruiting an initial group of ten volunteers from campus. We started with a card table in the clinic waiting room with a construction paper sign.

I remember thinking, "Why would anyone ever come talk to us?" But from the first moment, we were inundated with patients who wanted help connecting to resources, and with physicians, nurses, and social workers needing help with their patients.

The first step was mapping the resources available in the community. We started with what was already available to families in these communities. For example, there were food pantries, soup kitchens, one-dollar-a-grocery-bag programs, food stamps. The barrier was the fact that the families often didn't know the resources existed or that they were eligible. Or perhaps they didn't speak the language, didn't have any transportation, or their application had been lost in the bureaucracy and they didn't know how to advocate for themselves. So, we worked side by side with the families to help them access these services and resources. Our advocacy could include anything from making calls, to completing an application for them, to the classic example of a Spanish-speaking mom working two jobs who is running out of food at the end of the month and needs a food pantry within walking distance of her home because she doesn't have a car, and it needs to be open after 8 P.M., with a Spanish speaker on staff.

This is still pretty much what Health Leads does today. In some cases, the resource needed simply does not exist. In the case of affordable housing, that resource is a fixed set. There are limited affordable units. What we do in that situation is to connect that family to all of the other resources for which they are eligible, so that they have more disposable income available to spend on rent.

I graduated in 1997 and actually ran Health Leads for three years.

I had been deferring the entire time from Harvard Law, so in 2000, I co-chaired Health Leads' board of directors and left the organization to pursue my law degree. I stayed on as chairman of the board and then became a member for five years. In the meantime, I clerked for a federal judge out in Chicago and then worked at a civil rights and community economic-development law firm. Then in January of 2006, I returned full-time to Health Leads and have been with the organization ever since.

I came back because I hated being a lawyer. For so long I had thought that the law would be the tool I'd use to fight for affordable housing and access to health care. Ultimately, I realized the notion of using an adversarial process to create systemic change was not something I felt comfortable with. Our model at Health Leads is fundamentally collaborative.

> *"Our growth strategy is partly about replicating the Health Leads model, but more fundamentally about creating a compelling case for what the health-care system looks like when it is designed to address resource needs."*

Part of the reason I left the organization was a belief that the work we were doing was important enough that it should be done by folks who had real experience. I was just twenty-three years old. But, with some time away, I understood that it's not just about experience. It's about leadership. I think there are some distinct advantages coming to these larger systems from outside. When you are deep within them, it is inevitably and understandably hard to pull back and have perspective. Being younger or just being newer to the sector often leads you to ask questions that aren't being asked. My successor/predecessor did an excellent job of institutionalizing our work in my absence, everything from securing our nonprofit status to creating our first audited financial statements. The board was excited to have a solid foundation to really chase an audacious vision. That's where I could add value.

Our growth strategy is partly about replicating the Health Leads model, but more fundamentally about creating a compelling case for what the health-care system looks like when it is designed to address resource needs. The fastest way to get to a different model of health-care delivery is by demonstrating the economic value of connecting patients to these resources. We are working to prove to health-care institutions, hospitals, and health centers that they should pay for the work of connecting patients to resources because it's cost effective.

Health Leads' goal is to raise a significant amount of philanthropic dollars at the outset and use those dollars to deliver this infrastructure. The dollars that we're raising are intended to do two things. One is to allow us to deliver the infrastructure at scale, meaning in each of our clinical sites we have at least one full-time staff person whose job it is to ensure that our team of college student advocates are well trained, well supervised, and effective in connecting patients to resources. In addition, those dollars enable us to have technology systems to do the kind of analytics that then allow us to create a case around the economic value of connecting patients to resources.

In 1996, we started off with ten volunteers. Today we have a thousand college students in six cities. We're in Boston, Providence, New York, Baltimore, D.C., and Chicago, serving about nine thousand patients and their families annually. The operating budget is about $7 million. We are really doing exactly what we were doing in 1996, just at a much vaster scale, and much more deliberately, thoughtfully, and strategically. But it's still a desk in the clinic waiting room with a Health Leads sign that says, "Do you need help with food, housing, heating, employment?"

I can imagine no work more challenging or more inspiring. There is a perspective that comes from having left the organization for five years that really allows me to see how successful it can be without me. There is no lost passion or tenacity or depth of commitment, but there is a sense of responsibility about making the greatest contribution, rather than feeling that if you don't do something, it won't get done. Balance is more achievable than we all think. It's partly about understanding your own place in the world.

"Dance is a great teacher—unlike other art forms, you don't need a paintbrush or an instrument. It is completely inside of you."

Catherine Oppenheimer

Co-Founder, National Dance Institute of New Mexico

America's collapsing education system has long been a very public blight on our greatest-nation-in-the-world persona. Among developing countries, our students rank average at best in most every category of aptitude and skill. The solution to this epic failing continues be among the most elusive and hotly debated social and political issues out there. For Catherine Oppenheimer, the answer is as out-of-the-box as it gets: Make 'em dance. For almost twenty years, Oppenheimer, a former professional ballet dancer, has used the discipline, rigors, and joy of music and movement as a portal to instilling the strongest foundational qualities for achievement there are: self-confidence, discipline, pride, and passion. Her groundbreaking program, The National Dance Institute of New Mexico (NDI-NM), transforms the futures of thousands of school-age children every year. Have your doubts that dance might just be the Rosetta Stone of educational reform? Studies show the percentage of NDI-NM participants who are proficient in math and reading is nearly double that of district averages. The proof is in the stats.

Catherine Oppenheimer in rehearsal with a group of young NDI-NM members in New Mexico.

was born and raised in New York City. I was taken with ballet from a very young age, and I was accepted at the School of American Ballet (SAB) when I was eight. SAB was not a touchy-feely place—it was a very intense environment. They didn't recognize other companies or other forms of dance. There was no social or emotional support. As you grew older, it became increasingly competitive, with a smaller and smaller percentage of girls being asked back each year.

My parents were the antithesis of stage parents. To be honest, they weren't that interested or involved in my dancing. It was a different age of child rearing, I guess, and they took the "let your kids grow and sprout on their own" approach. I think growing up in a pretty chaotic environment at home, where there was a lot of turmoil going on, was confusing. But when I'd go to ballet class, the rules were very clear. You put your left hand on the bar, and the music started, and you did your *pliés*. That structure for me was lifesaving in the end.

I left high school early and was accepted by Columbia University at sixteen. I was still dancing at SAB every day while I was in college. When I got into the New York City Ballet Company, I was eighteen, so I dropped out of school and started dancing professionally full-time. I was one of the last two dancers that Balanchine picked for the company before he died. I was so lucky. I think people were afraid of him because he was just this unbelievable genius—even some of his principal dancers couldn't breathe when they got into the elevator with him. He was really quite old at that point, and I was just very drawn to him. We developed this sweet relationship where we'd just sit together and he'd talk to me about growing up in Russia. He'd tell me about his hunger, when he was starving as a kid.

Balanchine died shortly after I joined the company, and I stayed on for almost four more years. When Twyla Tharpe came in to do a piece with Jerome Robbins, I thought, "Wow, here is an artist—someone who is really working with her dancers to create something new." She was starting another company, which was made up of both modern dancers and ballet dancers. She invited me to join. I did that for about two and a half years, touring all over the place. It was an entirely different way of moving, which was challenging, but also really interesting.

Throughout this time, and for many years before, I'd been struggling with bulimia. I was so young, and coming out of this crazy household, I had all sorts of emotional turbulence going on. When it came time to sign a new contract with Twyla, the whole thing with the bulimia became overwhelming. My weight would go up and down and I just struggled terribly with it. I thought, "Okay, if I can stop dancing and gain weight, then I can figure this out." Well, talk about going through hell. I had no idea who I was anymore or what I was going to do. The truth is there is no magical pill. It was the beginning of a very long journey to get healthy.

I became very depressed and lost for a time. I went to hear the Philharmonic in the park one night and I really thought I was going to kill myself. It started to pour and the concert got rained out. As I was running out of the park I got soaked through, and I had this very clear moment of feeling, "I want to live. I don't know what's in store for me, but I want to stay here." Two days later I checked myself into a rehab for three months. I spent all of my life savings because I didn't have insurance. But I was ready to get healthy.

Years earlier, on my way to company class every morning, I used to see the dancer Jacques d'Amboise (who founded the National Dance Institute in New York City in 1976) working in his studio with kids of all different shapes, sizes, and colors. And at the time I thought, "Oh my God, what is he doing?" The ballet world that I knew was so elitist and everyone's body had to look a certain way. It was a very traditional model of dancers standing there as the clay for the choreographer to mold. So I was instantly intrigued with what Jacques was doing and I went to talk to him. He said to me, "No, you're dancing now, this isn't the time. But when you stop, call me."

Eight or nine years later, when I got out of rehab, I called him. And I spent the next three years teaching for Jacques, learning how to eat and be healthy, and rebuilding my life. The work was very personal and very therapeutic for me. By helping these children, who'd just been through so much hardship in their lives, I was healing myself too.

When I turned thirty I said to myself, "I'm not dancing anymore—I need to finish college. It's time." I'd never lived outside of Manhattan my entire life, never lived in a real house, never seen the stars at night! So, in 1994, I moved to Santa Fe. It was a multicultural place and I could live an

outdoor life. I started teaching while I went back to school, and Jacques said, "Why don't you start your own NDI program out there?"

So I did. I incorporated as a nonprofit in 1995 and began with one hundred kids. In 2012, we worked with about seven thousand young people all over the state. I had no idea that it would grow to be so big. I taught myself how to write a grant, what a board of directors is, how to do financials, how to market. I was accumulating an array of new skills, which I really enjoyed. I also loved the teaching. It was still very powerful for me to see transformation in children and help make a difference in their lives.

The primary focus of the main core program is to use dance as a catalyst to build character in children and, through that experience, to change lives. There are four basic tenets that we call the Core Four, which are Work Hard, Do Your Best, Never Give Up, and Be Fit. I believe—and I live this way—that if you really do those four things, you're going to have a pretty successful life. The tools that we use are dance and music, which are incredibly seductive. Dance simply has this ability to capture kids, and their eyes start to sparkle, and they're just full of energy and smiles.

> *"You can't just say to a kid, 'Here's a platter full of self-esteem. Eat it up.' Feeling your own power as an individual is a process."*

In a typical program in New Mexico, one of our dance teachers goes into a school and works with a whole grade level for the entire school year. So, in any particular class, you have kids with varying degrees of ability or disability, physical and emotional. After eight weeks of classes, you start to see a number of kids who are really turned on by it. Often these are not the students who are the best academically, but are the kinesthetic learners who have finally found something in school that they're really good at. You invite those children to come after school for a special program with the purpose of continuing and expanding on the classroom experience. At the end of the year, evaluations are always,

"I've never worked so hard in my life, and I've never had so much fun." That's the marriage we're working toward. We've found it's a very cathartic experience, one that causes the kids to ask themselves, "Wow, what can I become? How do I apply this in my life?"

New Mexico has a 63 percent drop-out rate. It's constantly voted the worst place to raise a child. It has all these issues with isolation, poverty, and drug addiction. So, this is such a positive program. It's like joining a great tribe and it lays out a real path for them to follow to construct a different life outcome. You can't just say to a kid, "Here's a platter full of self-esteem. Eat it up." Feeling your own power as an individual is a process. Kids learn that when you work hard, do your best, and don't give up, you do get better at whatever you're putting your attention to. They realize they can make different choices from those they've seen around them. And they've learned all this through dance, which is such a great teacher because, unlike other art forms, you don't even need a paintbrush or an instrument. It is completely inside of you. It's you, controlling your body in time and space.

I got married after starting NDI-NM, and we had two sons. When my kids were eight and six, about four years ago, I was working endless hours, and started feeling as though I wasn't spending enough time with them. I wanted to change my role and step back a bit. Thankfully, over a period of years I was able to do that. I became chairman of the board for two years and then last July stepped down and I am just on the board now.

In the meantime, I started another project. It took us three years to get the legislation passed, but last year the very first public high school devoted to the arts in New Mexico was born. Admission is based only on passion and aptitude for the art form, and has nothing to do with previous academic performance. This year we had two hundred kids. Our first senior class had a 100 percent graduation rate. The kids come from many different worlds—financial, geographic, cultural. It's a melting pot. Often projects like this are focused on particular groups, like Hispanics, or African Americans. But in our school it's a mosaic. And it is beautiful. It's so important to me to walk down the hall and just see kids of different colors and shapes and sizes, all talking to each other. You know, that's another thing the arts can do. It really works.

"We're working in countries where the majority of the population is making its livelihood from agriculture. Their relationship to the land, how secure or insecure it is, how adequate, how remunerative, is absolutely crucial. We refer to it as the ladder out of poverty."

Roy Prosterman

Founder and Chairman Emeritus, Landesa

Since 1967, Roy Prosterman and his organization, Landesa (formerly know as The Rural Development Institute), have helped secure land rights for more than 105 million families—representing more than 400 million people—in forty-five developing countries throughout the world. The impact is staggering. This conversion—from landlessness to land ownership—has pumped billions of dollars into the global economy and transformed the lives of the land rights beneficiaries—leading to a 60 percent increase in agricultural production, a 150 percent increase in annual family income, and improved health, nutrition, and educational achievement. Prosterman, now seventy-seven years old and a two-time Nobel Peace Prize nominee, remains the world's leading expert on democratic land reform and a fierce advocate for the rights of the rural poor.

I grew up in Chicago. My father was a small-business owner and my mother was an extremely bright woman who dedicated herself to raising me. My mother used to tell me stories of my grandmother, who would scrape together money and give gifts to the very poor for Christmas. I remember thinking that that was something one should do. I'm eternally grateful to them for spending so much time and energy in helping me be more dutiful to the world.

I graduated from Harvard Law School in 1958. Some of the overseas litigation work I did helped to create a readiness for my work on land reform. One of our clients was a manufacturer in Puerto Rico. I was peripherally aware that one of the things Puerto Rico had done very successfully was provide house and garden plots for landless laborers, and that it had a major role in reducing poverty. I also got to spend several months in remote Liberia. It gave me a sense of how deep rural poverty was in significantly large areas of the world.

A few months after I started teaching at the University of Washington Law School, in the fall of 1965, one of my students gave me a copy of a law review article titled "Land Reform in Latin America: The Uses of Confiscation." The author was a law professor who urged that legal theories might be used to trace land ownership back to indigenous people, to justify taking back the land from large landowners without compensation. My immediate reaction was that land tenure is a really important issue, but if you try resolving it this way, you'll end up with civil war.

I wrote a responding article in which I argued that we had to approach land reform in an "eminent domain" spirit of mind. For example, if we need land for a highway that we have to acquire from a farmer, we don't do it by saying, "You're a bad guy and we're going to confiscate your land." We say, "We're sorry, but we need this for a higher social purpose and we'll pay full market value and you can use that money any way you want to."

My article was titled "Land Reform in Latin America: How to Have a Revolution without a Revolution." Dean Tunks, at the law school, passed it along to a faculty friend at Northwestern, who did consulting for USAID (The United States Agency for International Development). USAID called me and said, "We liked your article, have you thought about land reform in South Vietnam?" I was actually in the midst of writing a follow-up article on the need for land reform in South Vietnam, but hadn't done any field research. They asked me to be the land law consultant for a Stanford Research Institute team that was headed to South Vietnam to look at the land-tenure issue. That gave me the opening to draft a land-reform law

Roy Prosterman at Landesa's headquarters in Seattle, WA.

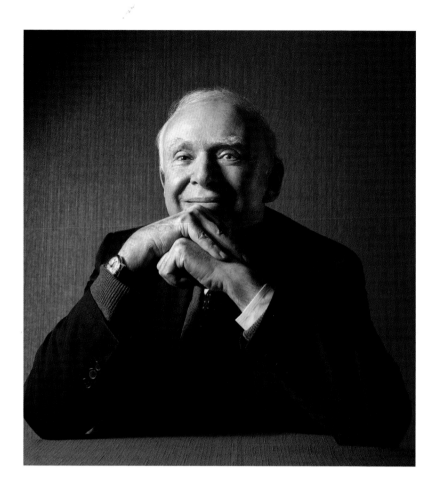

"One of my favorite quotations is from George Bernard Shaw, when he was in his eighties and was still continuing to write: 'I want to be thoroughly used up when I die, for the harder I work the more I live.'"

that was promoted by President Nixon and President Thieu when they had their first meeting on Midway in June of 1969 after Nixon's election.

The concept had floated during the presidential campaign and received support on both the Democratic and Republican side of the aisle. I was off and running. The implementation of the land-reform law in South Vietnam had two interesting results. Rice production went up by 30 percent and indigenous Viet Cong recruitment went down by 80 percent.

Some years later, the government in Hanoi invited me back to look at their de-collectivization of agriculture because they had seen the family farms in the South become far more productive than the collective farms in the North. We saw that family farming, and not collective farming, was now the prevalent model throughout the country.

As I was working on land reform in South Vietnam, some small foundations began to make modest grants for the work to be extended to additional countries. In the late sixties and early seventies, I did fieldwork in at least a dozen countries, including Brazil, Pakistan, and Indonesia.

We always start our work in any given country with rural fieldwork, in which we talk to the prospective beneficiaries of land tenure reform programs and see what their current situations, needs, and desires

are. The four categories of non-land owning, insecure households are: tenant farmers who have private landowners; agricultural laborers who work on small farms or plantations; state farm workers; and squatters on public land. The squatters may have been there for generations, but can't make investments in the land and may feel aggrieved because of their insecurity.

We also talk to other stakeholders, including landowners, government officials, and local NGOs. We pick countries on the basis of two qualifying criteria: 1) that they have a large population of landless rural poor; and 2) that they have a government that, if not yet committed to the idea of giving land rights and security to those families, is at least willing to listen and has interest in the issues.

One crucial feature of the work has been the recognition that these are very large programs, often involving hundreds of thousands—or in places like India, tens of millions—of families. If the land is privately owned, it needs to be paid for at a fair price, typically market value, and only government is really in a position to carry that out. So, in virtually all cases, a crucial role will have to be played by government.

A lot depends on the spirit in which you go in and present what you're doing. I think it's important not to take credit, to let the government or other leaders have ownership of the reform programs. We're in the business of giving away these ideas. People appreciate and recognize that we're providing advice that can ultimately help them out of poverty and that we're not doing it for self-aggrandizement.

We usually break down the work Landesa does into four stages. The first is grounded research to understand the situation; the second is formulating recommendations to policy makers in central government

based on that research and against the comparative background of what's worked in almost fifty countries; the third is to help in drafting land tenure reform programs and related measures; and the fourth is to help in the implementation process, including the very important aspect of oversight.

We're working in countries where the majority of the population is making its livelihood from agriculture. Their relationship to the land, how secure or insecure it is, how adequate, how remunerative, is absolutely crucial. We refer to it as the ladder out of poverty.

The impact of land reform throughout history is well documented and profound. For example, the government in Beijing has been carrying out a land-tenure reform that gives secure thirty-year rights to farmers, and it's about 40 percent complete. Our recent 1,700-household sample survey taken in seventeen provinces indicates that incremental investments by farmers who now feel secure on their land produced an additional $60 billion in farm income in 2010. That represents close to 9 percent of total farm income for the year, and it's just the beginning of the process. We expect that number to multiply substantially.

Another interesting case would be India, where we've had major programs to provide families with micro plots of about one-tenth of an acre. An average family that owns that size plot, with both the husband and wife's name on the title, typically produces all of their vegetable needs, most of their fruit needs, and most of their dairy needs, because they'll scrimp to buy one or two cows or water buffaloes. In addition, the plot provides a surplus, which they sell in the market for an average of $200 a year, which is what an agricultural worker would make in the field. So, in effect, they've added another income producing member to the household. The profits from those plots tend to be controlled by the women, so the money goes disproportionately to the benefit of the children and the basic needs of the household. When you ask families what the principal benefits of the plots are, even before income and nutrition, they'll often mention enhanced status in the community. They say that they can now hold their heads up and look other people in the eye. So there's an important element of dignity that comes with land ownership in these communities.

It's taken decades of steady effort for land reform to be fully recognized and accepted around the world. When I started this work, there was a huge amount of resistance. Right after World War II, the United States successfully supported democratic land reform in Japan, Taiwan, and South Korea. In each of those cases, land reform gave ownership to mostly tenant farm families. Those reforms helped lay the groundwork for the subsequent economic miracles in each of those three settings, but then there were a couple of interfering factors. One was the way Joe McCarthy attacked land-tenure reformers in a very unreasonable way. Also, the term "land reform" was adopted by some of the Marxist movements in Latin America, who had something very different in mind, something that was outside the law, and which was confiscatory rather than compensatory. And they were often violent in their efforts. I can remember doing fieldwork in Nicaragua in 1979, when the Sandinistas had just taken over. Although there was a junta that was more moderate in leadership and agreed to let the farmers decide how they wanted to farm, in the end, the Sandinista directorate, who unfortunately had the guns, said the only thing they would accept is forced collectivization. It turned out to be disastrous.

So it's taken time for the alternative of democratic land reform—which is within the law, pays full market price, involves a willing buyer and a willing seller, and of course lets the farmers and beneficiaries decide how they want to farm—to be adopted.

In the 70 to 100 days a year that I travel, I do a little bit of village fieldwork, but we have many talented young energetic people on board for that now. Most of my time outside of Seattle is spent giving a range of Landesa presentations, interacting with local staff, and meeting government officials. Increasingly we have more and more staff members who can interact with cabinet ministers and other senior policy makers, but sometimes, especially for an introductory meeting, it helps to have someone with gray hair like me to be present.

I will do this work as long as the good Lord gives me breath. I'm not tired at all. In fact, it energizes me. One of my favorite quotations is from George Bernard Shaw, when he was in his eighties and was still continuing to write: "I want to be thoroughly used up when I die, for the harder I work the more I live."

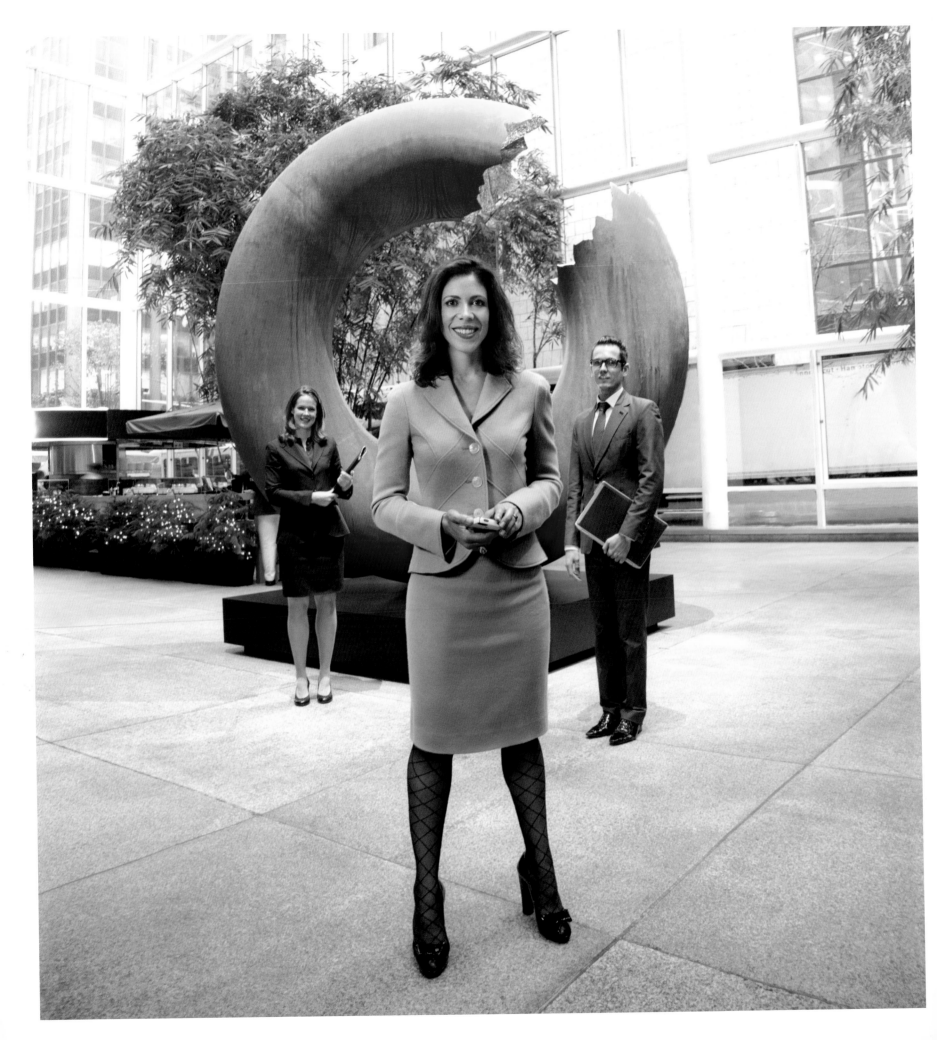

> *"I saw there was a real opportunity to take that DNA of American entrepreneurship and create an ecosystem that can marry entrepreneurship and resources in other parts of the world."*

Linda Rottenberg

Co-Founder and CEO, Endeavor

An Ivy League law school grad who never went into practice, Linda Rottenberg likes to joke that she just took a very early retirement. In fact, Rottenberg was bitten by the entrepreneurial bug in her early twenties, and as so many successful entrepreneurs will tell you, that was the end of any traditional career aspirations (much to her parents' chagrin). Rottenberg encountered a wall of resistance when she first proposed the idea for Endeavor in 1997—a nonprofit that provides resources, mentorship, and funding for high-impact entrepreneurs in emerging market countries. Investors, foundations, and VCs all doubted that, outside of microfinancing, a culture of entrepreneurship could thrive in the developing world. In the past decade and a half, Rottenberg has silenced the skeptics and become a role model for social innovation. Despite her unequivocal success, until very recently her parents still held out hope they'd have a lawyer in the family someday. "I finally convinced them to stop paying my annual bar association dues two years ago," laughs Rottenberg.

The kernel of the idea for Endeavor came when I was living in Buenos Aires in my mid-twenties. I'd gone straight through from Harvard to Yale Law School, and after seven straight years in an intense academic setting, I needed a break and I wanted to get as far away as possible. So, I ended up spending a couple of years living in Argentina and traveling around Latin America.

By that time, I was already a convert to entrepreneurship and I had the zeal of a convert. I couldn't understand why so many young people in Buenos Aires wanted government jobs, and I kept saying, "Why don't any of you want to be entrepreneurs?" Everyone I knew back at home wanted to be an entrepreneur, and I would mention the story of Apple and Steve Jobs, and people would say, "Well that's nice, but that doesn't really apply to my life—plus, I don't even have a garage." The feeling was that no one was going to give them any support to start whatever their crazy idea might be.

I learned that a lot of the development efforts in Argentina were focused on microfinance at the very base of the pyramid—and yet all of the money that was going into private equity and the capital markets was going to the same ten companies that were owned by the same ten families. So I thought, "Why isn't there any organization to help the high-impact entrepreneurs in the middle of the pyramid—the people who can really change the course of these economies?" I felt strongly that, regardless of where you're born, if you have a great idea and you can create jobs, change lives, and innovate industries, you should be able to get the backing and mentorship that you need to get started. But fifteen years ago, there wasn't even a word in Spanish or Portuguese or Arabic or Turkish for "entrepreneurship." Now there's one in every language. There wasn't this ingrained rags-to-riches story we have here in the United States, where each generation can prove itself, and where risk—and even failure—is considered a mark of experience. Even today, in some countries you can be disowned, or even jailed, if you bankrupt your company. So, I saw there was a real opportunity to take that DNA of American entrepreneurship and create an ecosystem that can marry entrepreneurship and resources in other parts of the world.

When I got back to the United States, I got in touch with a young guy named Peter Kellner, who had been in Eastern Europe talking to entrepreneurs in emerging markets. He and I got together and founded

Linda Rottenberg with two members of her staff in New York City.

Endeavor. We decided that we were going to bridge the gap between microfinance and private equity in these markets. We were going to find the best entrepreneurs and try to help them and tell their stories. We believed that if we created this success-story effect, then the venture capitalists would come, and governments would call us to change policies, and the media would want to write about them, and the schools would want to do case studies on them. Everyone thought we were out of our minds, including my parents. I was referred to as *la chica loca*, literally. That was my name for a long time. When I told my parents that I was going to become a social entrepreneur and create this new organization—but it wasn't even a company, it was a nonprofit—they thought their daughter was nuts, and what had I done with all this education they'd given me? So what I always tell entrepreneurs is, "If people don't think you're crazy at the beginning, then maybe you're not thinking big enough."

Eventually, we realized that our model was not going to work unless we started with local support. Instead of saying, "You have a problem in your country and here's the solution," it had to be structured as a partnership built on a sharing of ideas and resources. So, we created this criteria, which we still use today, that before we would go into any country, we had to raise $3 million up front through the top local business leaders, who would agree to form a local board and hire a local management team. And we built this methodology for screening entrepreneurs. Five times a year we have "international selection panels," or ISPs, half made up of U.S. venture capitalists and entrepreneurs, and half made up of local business leaders, and they spend two days interviewing pre-screened candidates (Endeavor also develops a mini-prospectus on each company for panelists to review). After a four-hour deliberation session, the panel has to unanimously select the Endeavor entrepreneurs. It's like *Twelve Angry Men*, where one juror can sway everybody or hold out. It gets very dramatic. It means that by the time entrepreneurs go through this vetting process, they have a whole network of people who are willing to make contacts for them and they have the Endeavor seal of approval—which really means something to venture capitalists. We've been able to screen thirty thousand companies and select 650 entrepreneurs so far.

So many high-growth, high-impact, job-creating companies are not in "sexy" fields, and therefore we don't typically view them as entrepreneurial. We have to broaden our definition of entrepreneurs beyond that of twenty-year-olds creating the next Facebook. Stanford Business School and the World Economic Forum did a survey of 380,000 companies globally and found that 5 percent of the companies created two-thirds of the jobs and 70 percent of the revenues—which means that start-ups are great, but you have to assume that many will fail or be small. So in terms of public policy toward job creation, we have to be honest about which companies we're really targeting. If you want to focus on jobs, you have to look at the more-traditional businesses, as well as the consumer internet startups.

Endeavor is still one of few organizations working in this high-impact space. We're trying to encourage and foster venture capitalists and banks to take risks on these entrepreneurs. We are waving the banner of high-impact entrepreneurship and saying that if you want to move the needle, you have to accept that it's not just about supporting the start-up phase. You have to also support the growth of more established businesses that are going to create a lot of jobs and be able to really scale.

"We have to broaden our definition of entrepreneurs beyond that of twenty-year-olds creating the next Facebook."

We have a number of entrepreneurs who are running wonderful lifestyle businesses, but who's to say they can't be pushed to think bigger? For example, we had a company that manufactured hair-care products in Brazil that was founded by two women. They saw there were no products that catered to curly hair, which is common in the Afro-Brazilian population, so they concocted a new product and suddenly had four-hour waits, and then eight-hour waits, outside their salon. We helped them with franchising and management, and today, they employ 1,500 people and generate $75 million in revenues. You don't hear about a lot of the fast-growing companies—like that one—that aren't in Silicon Valley.

Another company we work with in Brazil started as a fast-food pas-

ta chain worth $18 million at selection. We helped them take over other restaurant chains and now they're a 200-million-dollar company with five thousand employees. They are incredible. They basically took the Starbucks model and replicated it.

Or there's the wonderful example of Bedriye Hulya, a Turkish woman who created B-Fit, the first women-only gym in the Middle East. She went from 10 gyms to 195 gyms with Endeavor's assistance. She employs four hundred women, and two hundred more women have become franchisees—and entrepreneurs as well.

We do very detailed data analysis, so we know that 95 percent of Endeavor-approved companies are still operating. In 2011, our entrepreneurs generated $5 billion in revenues and created 180,000 jobs, most of which pay between five to ten times the national minimum wage. We know that two-thirds of those revenues and 80 percent of the jobs were created after Endeavor selected them.

Now the entrepreneurs are actually giving back a percentage of equity and cash with the idea of supporting their local Endeavor office. For a lot of entrepreneurs today, it's not just about getting rich quick. It's really about doing something that is going to make a positive impact. Twenty years ago, it was an oxymoron to be doing good while doing business, but this new generation wants to combine both. They want to give back. Endeavor is raising a 50-million-dollar passive co-investment fund called Endeavor Catalyst, so that, for the first time, we are investing in some of the entrepreneurs ourselves. I've always said I want an organization of, by, and for entrepreneurs, and that's what's starting to happen. Our first company co-invested in by Endeavor Catalyst is planning on going public on the NYSE next year.

Like I said, when we began this organization, people thought we were crazy, they didn't understand what we were doing outside the United States. But in the last couple of years, there really has been a growing number of people who understand that, even as Americans, we have to learn how to do business with the world. There are many more U.S. venture capitalists today looking to invest abroad and there are American companies looking to make acquisitions abroad.

Fifteen years later, shockingly, Peter's and my original idea, scribbled on a napkin, has really come true. Governments now call Endeavor for help with local public policies regarding entrepreneurship; the business schools are using our clients as case studies; and the venture-capital community is now looking at these markets for the first time. We have a number of entrepreneurs who have even set up offices in the United States and are creating jobs here, too.

> *"Fifteen years ago, there wasn't even a word in Spanish or Portuguese or Arabic or Turkish for 'entrepreneurship.' Now there's one in every language."*

Endeavor's goal is to be in twenty-five countries by 2015. We want our entrepreneurs to be contributing at least 1 percent of the GDP in their respective countries in the next decade. There are very few self-sustaining nonprofit organizations, and I hope to be fully sustainable, primarily due to the success of the entrepreneurs, so that there's full alignment. I'd also like to figure out how to take some of the lessons that I've learned around the world and apply them back in the United States.

I love the work I do, but I've learned that to be the best leader I can be, I also need balance. I'm the mother of six-and-a-half-year-old identical twin girls, and they made something very clear to me when they were four: "You can be an entrepreneur for a short time, but you are a mommy forever." Which I thought was excellent advice. So, despite the fact that my work covers such an international arena, I travel as little as possible and always try to take very short trips. Four years ago, my husband was diagnosed with bone cancer, and thank goodness, he's doing very well now—but that was another real lesson to me. I always thought that—being an American woman CEO dealing in this global business world—I had to show strength and independence, but when Bruce got sick, I had no choice but to be vulnerable and let people in. I was struck by not only how everybody stepped up, but also by how much more connected I felt to them and how showing my emotional side enhanced my leadership rather than detracted from it.

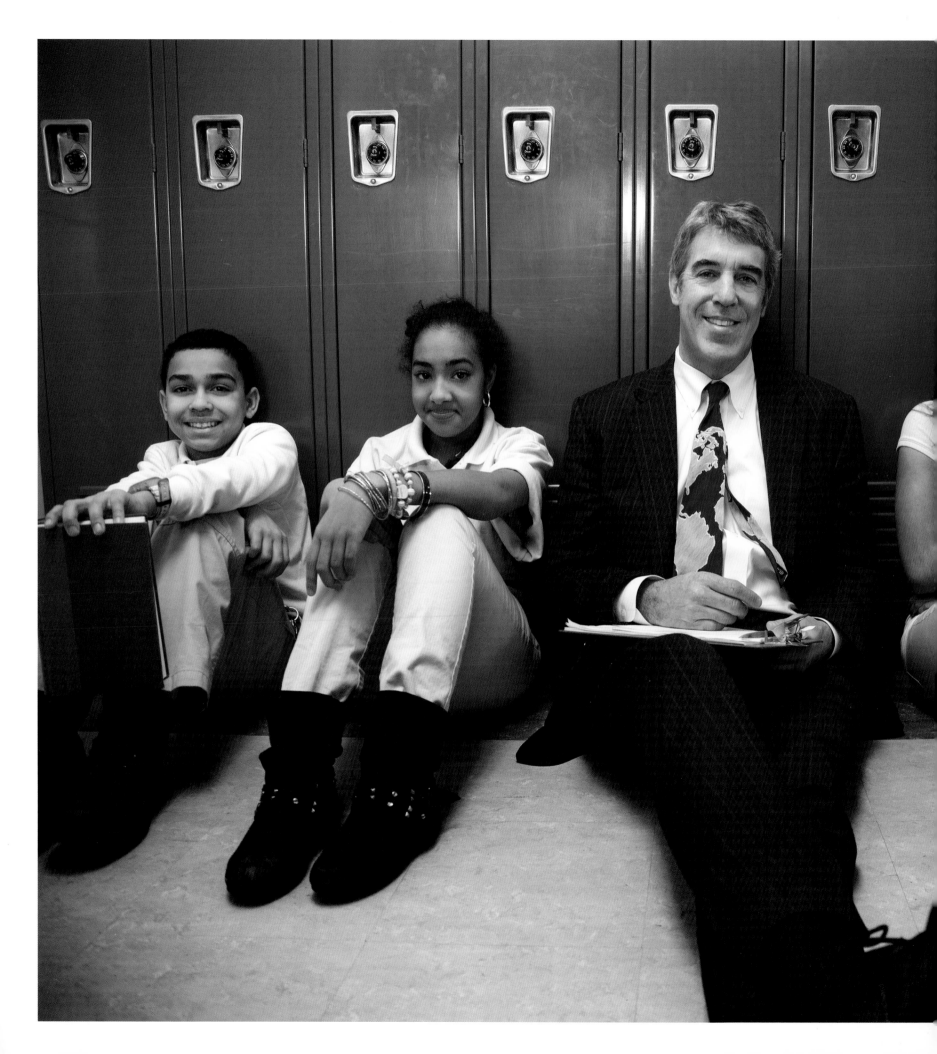

"I knew there must be millions of other people like me who would really love to connect with kids, but didn't want to become full-time teachers."

Eric Schwarz

Co-Founder and CEO, Citizen Schools

For seventeen years, Eric Schwarz has been fighting to level the playing field in American education. The disparity between a lower and upper income child's access to extracurricular activities and mentorship compelled Schwarz to develop Citizen Schools—an unconventional educational program that extends the middle-school day with hands-on teaching and personal tutoring. A combination of community volunteers and trained AmeriCorps Fellows make up this "second shift" of citizen teachers, who engage students in a variety of creative learning opportunities, including apprenticeships taught by accomplished professionals—such as chefs, jewelers, engineers, architects, writers, and doctors—who share their expertise and real-life experiences with students an afternoon a week.

I've been interested in education my whole life. I grew up in Manhattan and my mother was a freshman English teacher—and I think a really great one—in East Harlem. She involved the kids in the community and created amazing experiences for learning while holding them to very high standards. It inspired me a great deal. At the same time, I personally had a very tough time academically when I was young. I bounced around to a couple of different high schools, and barely graduated. Fortunately, I had an incredibly supportive, close-knit community and extended family, to which I owe a lot of my ultimate success. I think in many ways, the idea for Citizen Schools was borne out of that desire my mom instilled in me to connect with kids, but also the recognition that I didn't want to become a full-time teacher.

I finally hit my stride in college. I got the chance to edit my college

Eric Schwarz with a group of students at one of the Citizen Schools in Boston, MA.

newspaper at the University of Vermont and it was an incredible experience to lead a team of fifty people to put out a forty-page newspaper every week. Then I worked on Gary Hart's senate campaign in 1980 and then his presidential campaign in 1983 and 1984. My job was to organize and mobilize student volunteers by the thousands. That was just an amazing leadership experience for me, in which I was able to see the power of ideas and of young people to make a difference.

I went on to work as a newspaper journalist for five years, both as an investigative reporter and as a political columnist. I became frustrated with essentially tearing things down and finding fault in things that weren't working. I really missed collaborating with a team to build something up. So, I made a career shift in my late twenties to join two friends of mine who had started City Year, a very successful national service program.

Initially, I thought it would just be a one-year sabbatical from journalism, but I was bitten by the social entrepreneurship bug, and it became a calling. I was their thirteenth hire and ended up becoming the first vice president and then the executive director of our efforts in Boston when we started to expand nationally. After four years, in 1994, I decided to go off on my own.

Many of the young people who did a year of service in City Year had never graduated high school. Invariably, they had tuned out in middle school even though they didn't drop out until tenth or eleventh grade. Middle school is when the brain is changing very quickly. It is the forgotten link in the educational reform chain. It made me realize how important that time is in a child's development, and how important it had been for me. I was a pretty good athlete and had some great experiences in summer camps and after-school programs. So, those adolescent years weren't a total wasteland. But, a lot of my fuel came from my experiences outside of school.

Kids are only in school for about 20 percent of their waking hours. It seems crazy that we are putting all these resources into changing that 20 percent while giving almost no thought to how to organize that other 80 percent differently for low-income kids, and zero thought to how to really provide these kids with all the experiences that I took for granted growing up—for instance, having someone there to help with homework and being

around successful adults, or having the chance to participate in the arts, sports, music, internships, science fairs. I knew there must be millions of other people like me who would really love to connect with kids, and who wanted to make a difference in their communities, but didn't want to become full-time teachers. The idea that evolved was to build an organization that allowed successful professionals to share their knowledge and talents with kids in an extracurricular setting, through a variety of apprenticeships.

I got the first concept paper together for Citizen Schools and recruited a team to co-found it with me. The first apprenticeship was a journalism class where I worked with ten kids to publish a newspaper. Every kid got a chance to write several articles, we had comics and editorials, and we raised $400 by selling advertisements. The last week, I rented a van and we drove to a printer in Chelsea, MA, and the kids got to see their newspaper come flying off the press. They were so proud. They took that paper back to their school and handed it out. It was transformative for them and for me. I became totally hooked. The next semester, we started recruiting for a full-fledged pilot program. We were off to the races. Seventeen years later, we've grown from a $100,000 budget to a $30 million budget.

We're living in a world where everything is changing very quickly. Companies like Google, which didn't even exist ten years ago, are leading the world. But old paradigms die hard. In education, hardly anything has changed. We still have kids sitting in chairs for six hours a day, listening as the teacher talks in front of a chalkboard. That is crazy. It's very difficult for people to think of valuable learning taking place outside of school, and of kids being taught by anyone other than teachers. So, our model is counterintuitive, a disruptive innovation. We're letting kids learn by doing and by producing things for the community. We also give kids practice on the academic basics, building their proficiency in math and English. The good news is, we're delivering great outcomes. We've got a couple external multiyear studies that show huge results in erasing and reversing achievement gaps. We're helping kids go on to four-year colleges and to careers in science and engineering.

We've had 25,000 volunteers so far, and there are millions more like them. They're lawyers, architects, chefs, web designers, engineers. They're graduate students and retirees and people in the middle of their

careers. We ask them to take a couple hours, one afternoon a week, to work with a team of kids to create an amazing project. We work with the volunteers to design the courses and we now have a databank of more than one hundred that have really worked. We want each volunteer to bring their own special sauce and expertise to it, but we also provide them with a template, which dramatically increases their chances of being successful.

We're always adding new courses as well. In our second year, we had an undertaker suggest that she teach a class. We were a little worried it might upset the parents and freak out the kids. But she persisted. "We're in the grief business," she said. "We're good at dealing with bereaved adults. But we're not very good with the kids. We'd love to work with your kids to design a set of activities that we do with young people when they've lost someone." That was a perfect Citizen Schools apprenticeship: middle-school kids working with a talented adult to do something important for the community that would otherwise be outside their experience set.

"Middle school is when the brain is changing very quickly. It is the forgotten link in the educational reform chain."

Our other key pillar, besides apprenticeships, is the hundreds of really talented AmeriCorps teaching fellows who join us for a two-year full-time commitment right after college. These are the best and the brightest, and they are so dedicated to changing the world that they are willing to work for starvation wages. They help kids academically, talking to teachers in the morning and to parents at night, knitting together the worlds of the regular school, the extended day, the home, and the community. They help kids with their homework, bring them on field trips to college campuses, and support the volunteer Citizen teachers. Citizen Schools adds three hours to the school day, four to five days a week, all through middle school. The apprenticeships are two afternoons a week. Then every day, there's some time to practice academic skills.

There are so many great stories about the kids we've worked with over the years, but one kid I especially remember, John, was a special-needs student, getting Ds and Fs. It seemed like he wouldn't finish high school and was on his way to becoming a depressing statistic. But he happened to love animals. He'd even nursed a bat back to health once in a shoebox. He took an apprenticeship, "Drugs on the Brain," with a postdoctoral researcher at Harvard University. He got to hold a human brain in his hands and take little pieces of tissue from a sheep's brain and study them. All of a sudden, the light went on and he saw the connection between animals and biology and math and science and the future. Because of that one experience, he got out of special education and became a B student in science and math.

Another kid, named Francisco, took an apprenticeship in carpentry with a teacher named Joel Bennett. The project was for every kid to make a really high quality toolbox. On the side of his toolbox, in big letters, Francisco wrote, "Miguel." Joel asked him, "Who's Miguel?" Francisco said, "Miguel is an older gentleman in my community and he took me out to a baseball game. He always takes me out for ice cream. I've never had anything to give him." This kid was finally able to give something back to a caring adult.

What we're doing isn't supplemental to education reform: it *is* education reform. I think what we've got in America is a broken, industrial-era, agricultural-schedule model for education that's not working. Thirty percent of our kids aren't even graduating from high school. The United States has moved from first in the world to twelfth in the world educationally, because school is not connected enough to the real world. It's not preparing kids for college or the workforce. And truthfully, it's not very interesting.

Citizen Schools is a new model for education that supports teachers and allows schools to truly reinvent themselves in much more successful ways. The ideas behind our program need to become commonplace as opposed to the exception. Our goal is not only to grow and extend our own reach, but also to see other organizations replicate our model and partner with local school districts all over the country. Regardless of the delivery method, the central idea is to provide kids with more time for more relevant learning, and more exposure to successful adults. When you do that in middle school, it sets them up for success in high school, college, and beyond.

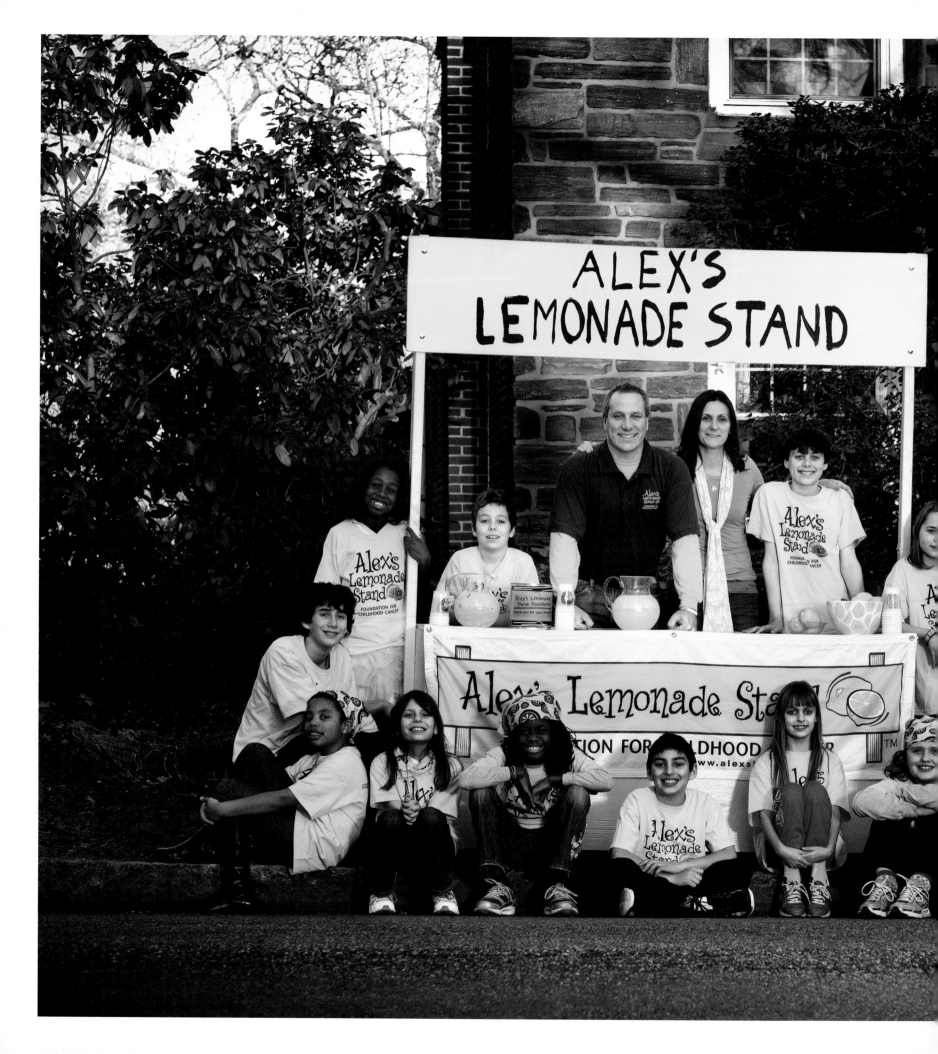

"I feel like Alex set us up for success. She knew what she was doing. Our job is just to channel her energy."

Jay Scott

Co-Executive Director, Alex's Lemonade Stand Foundation

By the time eight-year-old Alexandra "Alex" Scott lost her life to cancer in 2004, she had already touched the lives of millions. Her humble idea to raise money for a cure through a front-yard lemonade stand captured the world's heart and launched a movement to end childhood cancer. When Alex passed away, she had surpassed her seemingly impossible goal of one million dollars. Her parents, Liz and Jay Scott, carried their daughter's legacy forward by starting a foundation in her name that has raised more than $55 million since Alex set up her very first lemonade stand twelve years ago.

Our daughter Alex was diagnosed with cancer two days before her first birthday, in January 1997. She had been unwell since Halloween of the previous year, and we'd taken her to the doctor at least once or twice a week during that whole time, but they could not find anything wrong with her. She was very cranky, crying all the time. She wouldn't sleep for more than an hour at a time. She wanted to be held constantly. She sweat a lot. The doctor just told us to give her Tylenol when she was fussy. Even up until the week she was diagnosed, they told my wife, Liz, that she was imagining her illness.

One Sunday, we drove Alex to the emergency room at the Children's Hospital and told them we wouldn't leave until they'd figured out what was wrong. We told them that both grandmothers, with fifteen kids between them, said that she wasn't acting normal. We were in our twenties and they didn't really believe us, but they believed the opinion of the grandparents. They brought in a neurologist, who ordered an MRI that showed a tumor wrapped around her spine. The next day she underwent a sixteen-hour surgery.

Jay and Liz Scott with a group of young volunteers at a lemonade stand in front of their home in Wynnewood, PA.

167

When they took out the main tumor, they accidentally cut off the blood supply to her spine and she was paralyzed from the chest down. Her first birthday present was paralysis. But the pain was gone and she was happy. They told us she would probably take around three weeks to recover in the hospital. Within seven or eight days, she was ready to go home.

The doctors said to us, "If Alex survives this cancer, she's never going to walk." We were stubborn and didn't believe them. A few weeks after we got home, I was getting her ready for bed and I told her to kick her leg. She didn't move, but I saw a little flicker in the muscle, and I got so excited that I called the doctor at 10 P.M. and told him that she was trying to move her leg. He said, "That's just a spasm. Don't get your hopes up." But we kept doing it, and a few weeks later we showed him and he agreed we might be right. Over the next couple of years, Alex had intensive physical therapy with braces. The braces got smaller as she got stronger. The orthopedic surgeon said one day, "Alex, I don't know why you're using these." We got home and she threw those braces in the back of her closet and never put them on again. In second grade, she walked into the first day of school. That was a very proud day.

Throughout this time, she was undergoing treatment for cancer. She started with traditional chemotherapy for neuroblastoma, which is a tumor that starts in the sympathetic nervous system. The chemotherapy was very toxic because it is an aggressive cancer. It seemed like it was working, but then it stopped. So, they switched her to another treatment, which also worked for a little while. Every time a treatment stopped working, they would switch her to a different one. Two years from the time she was diagnosed, toward the end of 1999, all the doctors finally agreed: there was no other possible treatment left to give Alex. They said we should just take her home and let her spend her last days away from the hospital.

We were shocked. One doctor pulled me aside and told me that there was a specialist in Philadelphia who might be able to help, but he didn't want his colleagues to know that he was referring us to another practice. Liz called the doctor and he said, "We probably won't cure her, but we could help." Alex was now in so much pain that she was on morphine twenty-four hours a day.

The treatment they gave her was called MIBG, and it's basically radioactive iodine that is injected into an IV. Alex got the highest dose ever given to a human. She had to go into a lead room and behind a lead shield that was covered in plastic. She couldn't take anything out that she brought in. We got duplicates of every toy she loved. At the time, her favorite was Stacy, Barbie's little sister. We took turns staying with her, because you couldn't be exposed too long. She got out after three days. She had no pain anymore. She said to my wife, "That treatment worked. I can tell by the way I feel." She was a couple of months shy of four.

> *"My wife called the police and said, 'There might be a traffic problem. My daughter is having a lemonade stand.' They thought she was crazy. In the pouring rain, Alex raised $18,000."*

Before this, she was supposed to get a stem cell transplant, but they had called it off because her disease had spread from bone in her foot to her neck, and she didn't have MRD—minimal residual disease—which was required. The iodine treatment worked so well, they rescheduled the transplant. They gave her very toxic drugs as part of the transplant protocol. One of the drugs caused sores on the whole inside of her mouth, throat, esophagus, and stomach. She couldn't talk for a couple of days. One of the first things she said when she was able to speak again was, "When I get out of the hospital, I want to set up a lemonade stand."

At first, she mentioned it once a month, then once a week, and then every day. Finally, Liz asked her, "What is it with this lemonade stand? Do you want to buy something? If you want a toy, we'll just buy it for you." Alex looked at her like she was crazy and said, "I'm not keeping the money, I'm giving it to my hospital so they can help other kids the way they've helped me." We thought it was cute: "You're going to set up a lemonade stand and give the hospital ten dollars?" Alex said, "I don't care. I want to do it anyways."

She was still recovering from that transplant, so she tired easily, but

she was so excited about this lemonade stand that she laid out her outfit the night before. She called it her "lemonade clothes." We bought a couple of canisters of powdered lemonade and she had a little plastic table. It was July 4th weekend, 2000. People started coming—it was unbelievable. I must have made six trips to the grocery store to get more lemonade for her. She raised $2,000.

In the meantime, she'd received two more MIBG treatments. The doctors in Philadelphia had told us they'd have better options for Alex if she could spend more time at the hospital. But the drive was as long as fourteen hours with traffic from our home in Connecticut. In March 2001, we decided to move our family to Philadelphia so that we could be closer to the hospital. She went on a new treatment when we moved, which she ended up staying on for the next year and a half. At that point, she had less disease than she'd ever had in her life. Her hair was starting to grow back. It was a great time for our family.

Our first summer in Philadelphia, Alex started asking to do another lemonade stand. We didn't know anybody in Philadelphia, so we put her off and told her the stand had to wait until the fall, when we'd met some people and school was back in session. Her second lemonade stand happened at the end of October. She had mittens and her winter hat on. She made about $800. She was not happy with us.

Next year comes around, the weather starts getting warm, and she says, "I want to set up the lemonade stand again." One of the parents from school called a Philadelphia newspaper and they ran a full-page article about Alex and her stand. Before she even opened for business, she had already broken the $2,000 mark. By the end of that day, she had raised $12,000.

The next year, my wife and I were thinking, "She can't beat twelve thousand dollars." But word got out. My wife called the police and said, "There might be a traffic problem. My daughter is having a lemonade stand." They thought she was crazy. In the pouring rain, she raised $18,000. Our yard was ruined from all the trampling, but to see her so excited and happy was amazing. Later that night, the police stopped by and said, "Hey, next time she has a lemonade stand, let us know so we can send somebody to direct traffic."

People started sending Alex letters and checks from all over the world. Some of them were holding their own lemonade stands, some of them were just donating money. Letters would be addressed to things like, "The Lemonade Girl, United States." I had no idea how, but the post office found us. Eventually, she was getting thousands of envelopes.

When 2004 came around, Alex was probably sicker than she had ever been. We knew that she was dying. We had her eighth birthday in January, knowing full well that it was going to be her last. Alex was really a grown-up, smart eight. She would get calls all the time for interviews. She was pretty savvy and she would say "yes" if she recognized the name of the newspaper or the magazine calling. My wife heard Alex tell one interviewer, "In 2003, I raised a hundred thousand dollars. This year, I'm going to raise one million." When she hung up the phone, Liz asked her how she was going to do that. Alex said, "If everyone has lemonade stands and sends their money in, we can do it."

Up until that point, our only contribution was to buy the lemonade and take out the garbage. This time, when people asked what they could do to help, we said, "You can set up a lemonade stand on the same day that Alex does." It worked. There was a lemonade stand in every state and many foreign countries. We had to move Alex's stand to her elementary school because it had grown so much. Thousands of people came. Over the next couple of weeks, she reached $700,000. Then she got a call from Volvo. They were big fans. They said, "Tell Alex we will take her over the one-million-dollar mark. We'll fund-raise in all of our dealerships." She stopped playing spider solitaire and clapped a few times because she was happy.

She died just a couple weeks later, on August 1, 2004. We kind of think that she was holding out to hit that million dollars before she was willing to go.

After she died, we assumed that what she started would go away. But people said, "You've got to keep this going. We're behind you." We talked to friends who ran nonprofits and decided that we could help a lot of kids with cancer. We could also teach kids what it means to give back.

Now we're one of the largest childhood cancer charities in the country. We've funded around 225 research projects looking into causes and cures for childhood cancer. Last year we raised over $10 million. I feel like Alex set us up for success. She knew what she was doing. Our job is just to channel her energy.

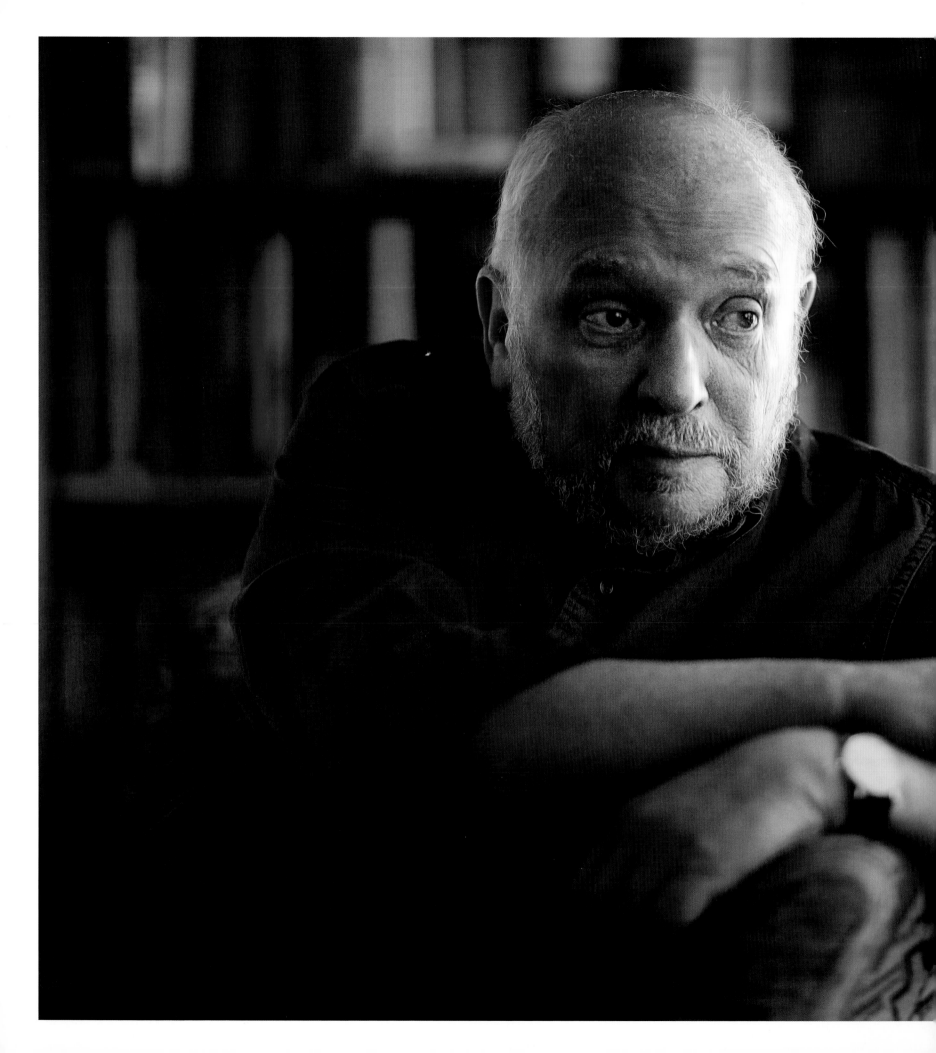

Earl Shorris

Founder, The Clemente Course in the Humanities®

Earl Shorris lived in his mind and through his words in a way that echoes the great philosophers and writers he so loved to teach. It was this steadfast belief in the power of knowledge that led him to create the Clemente Course, a program that offers the humanities at the university level to the multicultural poor. Now in its seventeenth year, the Clemente Course has more than ten thousand graduates and more than sixty sites operating around the world. The nonprofit earned Shorris the National Humanities Medal in 2000. Shorris passed away on May 27, 2012, but his revolutionary cure for poverty will undoubtedly continue to save lives for many generations to come. A short time ago, Shorris wrote in *Harper's* magazine, in an article examining his own life and proximity to death, "I have wished for many years to be a physician to my beloved country. The means to care for it is clear. I was revived by love and ethics. And I am not unique: no man, no woman is a metaphor; that is the place of gods."

I'm afraid you could say that I was a prodigy. When I was three years old, some little girls in the building where we lived taught me to read so that I could play Monopoly with them, and by the time I was four I was reading books from the library. My parents were encouraging—they thought that reading was a good thing. We didn't have television then, and we didn't listen to a lot of programs on the radio. I didn't decide that I wanted to be a writer until I was nine. That's when I began writing stories, probably better than the ones I write now.

I had a strange academic career, skipping a lot of grades when I was young. I was just eleven when I started high school. The University of Chicago, in connection with the Ford Foundation, had a program known as the

Earl Shorris in his apartment in New York City.

Hutchins Plan, and they took students into the college after two years of high school. There was a long acceptance exam and then a long scholarship exam that followed, and I was admitted with a full scholarship when I was thirteen.

I never graduated college—I finished all but the last two courses and then I was booted out—I'm not gonna tell you why, though. So, I joined the Air Force. This was early 1953. After the service, I went back to Chicago for a while before returning to West Texas, near where I'd grown up. I worked on a newspaper, wrote novels—didn't publish any of them— and then the best thing that ever happened to me occurred. My wife, Sylvia, came to visit somebody there and we got along very well. We knew each other for five days and decided to get married. Soon it will be fifty-six years. Everyone we knew said it wouldn't last, and now they're all divorced many times. I can't imagine what life would have been like if we hadn't met.

Sylvia raised the children and went to work for Random House and Putnam, while I continued to write and work in advertising to pay the bills. I published my first novel in 1966, and next came *The Boots of the Virgin*, which was a comic novel.

I'd always been interested in questions of poverty—I think it's a serious issue in this country, and politically, I suppose I'm quite far to the left. I wanted to write a book about the poor and my editor at Norton said, "If you can't think about anything positive to say about changing the lives of the poor, don't show it to me." I began traveling around the country asking people why they were poor. I learned something about why people are poor, and the place of violence in the lives of the poor, but the answer to the question of what can be done eluded me.

I went up to the Bedford Hills prison in New York to talk to some of the inmates there. We were sitting in a circle discussing family violence and I asked the woman next to me, whose name was Niecie Walker, "Why are people poor?" And she said, "Because we don't have the things that people have downtown. We don't have plays, we don't have concerts, we don't have lectures." And I said, "Oh, you mean the humanities." And she looked at me as if I were an idiot and said, "Yeah, Earl, the humanities." And when I left prison that day—it's always nice to leave a maximum-security prison—I started thinking about my own education at the University of Chicago. That was really the beginning of the idea for the Clemente Course.

I asked a friend, Jaime Inclan, who is the director of the Roberto Clemente Family Guidance Center and a brilliant family therapist, what he thought of the idea. Jaime looked at me and said, "Well, you want to do it here? I'll give you the walls," meaning that I had a classroom. Then I asked some friends who I played poker with to be the faculty. And so, we started teaching. We had someone to lead each of the five disciplines: art history, history, literature, philosophy, and logic. I taught moral philosophy and then, because our history professor didn't work out, I taught American history, too. We recruited students, and Sylvia was the den mother. Then we had to try to raise money for it, and when I told people I wanted to teach the humanities at the university level to poor people, they said I was nuts: "Impossible. You can't teach the poor." Nobody would give us funding, so we did it on a shoestring.

We started out with about thirty-one students, and we lost some almost immediately. The work was hard and the hours were bad, so we quickly came down to twenty-two or twenty-three. They were largely people of color; many were single mothers. I remember when all the kids came in that first day—they looked so tough. They looked like thugs, but instead they were wonderful students. They'd stand out in the snow and ice after class, still arguing about questions of logic, and they were just grand, absolutely grand. Seventeen of the original twenty-three students earned certificates and fourteen earned transferable credits from Bard College. And of the fourteen, most went on to get their undergraduate degrees at some point. We have, out of that group, which is extraordinary: two dentists, a nurse, a Ph.D. in philosophy, a Ph.D. in literature, a woman who graduated from the Fashion Institute of Technology, and a woman who I'd fished out of a drug rehab program who is now a counselor in that same program. We've

had a lot of good years since then, but that first class was spectacular.

What we did that really worked is what I think should be done in every college-level course—we taught from primary sources: we didn't use textbooks. So, our students read Aristotle and Kant and Hume; they read the Declaration of Independence and they learned about it as a philosophical document, not just as a separation document.

The only students we really can't teach are illiterates. We used to ask applicants to read a page from the *Daily News* to show us that they could read, but we lowered the entrance requirements—now we ask them to read a page from Plato, which is a lot clearer.

The reason we teach the humanities is that we're interested in creating a person who understands the world, understands beauty, understands thinking, and knows how to seek wisdom. While the sciences and math are very important, the foundation of society and of democracy is in the humanities, and it's certainly the way to freedom. The humanities free people, they allow them to think, they teach them to be beginners. I was just in Puerto Rico explaining to the faculty there the notion that what we want is to teach people to think about the humanities differently every time they encounter them. Let me give you an example. To see a Botticelli in the morning light is to see one painting; to see a Botticelli in the afternoon light is to see another painting. It reflects a different color: the morning light is blue, the afternoon light is red. Or to see that same painting on a day when you have a headache, and then to see it on a day when you awaken feeling wonderful, is again to see the Botticelli differently, because *you're* different. So, every time you encounter the Botticelli you become a beginner again and you have to think about things anew. If you read a Blake poem, every time you read that poem, you read a slightly different poem, just because of who you are, what's happened to you, how you've changed.

So, if we learn through the humanities to want to seek freedom, to be beginners, if we learn to live a life not of reaction but of reflection, then we're prepared to go on to do wonderful things and to have a good life. If, for instance, we move on to study law or medicine or science, all of which are dependent to a large extent upon repetition, we are prepared to see things differently because of our education in the humanities. We're free in ways that other people are not, so the person who knows the humanities has a greater chance to invent some new kind of mathematical solution, some new kind of answer to the law, some new sort of business.

It's complex when you're building an international organization like this, but I really try to avoid creating any kind of bureaucracy. We don't have a central office; we don't have any stationery; we don't have any business cards; we have no office expenses—whatever it is, I pick it up. We're unlike any other organization—we're essentially a worldwide University of the Poor. Our faculty for the most part is made up of tenured professors: almost all have terminal degrees in their fields, so we're a pretty classy outfit. I'd say we're as good or better than most faculties in the country. Our teachers come from Harvard, the University of Chicago, the University of Texas, the University of Khartoum; they come from the Women's University of Korea, the Grand University in Argentina, the National Autonomous University of Mexico—we're pretty good! And we're competitive—we pay people, we raise the money somehow, and we pay our faculty—so it's not a charity, it's an education. And the other nice thing about paying the professors is that if they don't do the work, we fire them.

I've learned from the Clemente Course not to be an imperialist. In the beginning, I really was like an 18th-century British professor: I wanted everyone to be based in the Greeks and to follow Western civilization exactly, and I thought those were the humanities, as I'd learned them, and I was terribly wrong. I soon realized—slowly realized—that the humanities exist in all cultures, and that when we teach the humanities in Mayan, we must teach the Mayan humanities, and when we teach the humanities in Spanish, we use Spanish literature more than English literature, although we still use translations of the Greeks. The Koreans and I really bumped heads because they thought that I was going to teach this imperialistic course and get rid of everything Asian, and of course there are Asian humanities, just as there are Western humanities—literature, history, art history—it's all there, but it's in Korean. What I've learned about this great democracy of the humanities is that nothing is more democratic than to know that the humanities exist in all of these different languages and they are all equally valid, and some teach us about the world as we can't know it in our own language. And the experience of meeting wise people in many cultures has for me been just glorious—it's been a terrific ride.

"People say, 'Architects design pretty things,' when, in fact, designing is just 5 percent of the entire process. In a way, we're more like developers of humanity, but no one would ever donate if we called ourselves that."

Cameron Sinclair

Co-Founder and Chief Eternal Optimist, Architecture for Humanity

When Cameron Sinclair was twenty-four years old, he founded Architecture for Humanity to bring designers and architects together to collaborate on humanitarian projects. Sinclair believes that where resources and expertise are scarce, innovative and sustainable design can change people's lives. Since 1999, the organization has built or developed 2,250 projects around the world in which 2,130,000 people now live, work, heal, study, or play. With fifty-two local chapters in thirteen countries, this global network of design and construction professionals transforms communities where the need is greatest. "When you design," says Sinclair, "you either improve or you create a detriment to the community in which you're designing in. So you're not just doing a building for the residents or for the people who are going to use it, but for the community as a whole."

I was six when I first knew I wanted to be an architect. I grew up in a rough neighborhood in South London, very violent, and I used to visit other neighborhoods and see the difference in the way those communities were built. It had an effect on me. I would go back home and play with LEGOs, and unlike regular kids who would build spaceships, I would redesign my entire neighborhood to make it much more community focused, so there were places where people could play and have access to hospitals and schools. Unlike a lot of architects who go into the field because they have seen an exquisite cathedral or a museum, I was inspired by bad architecture.

My parents moved to the United States for work when I was eleven and I was sent to live with my grandmother in Bath, which was a bit of a culture shock and quite a step up from where I'd been raised. My parents felt I would receive a much better education for architecture if I remained in England. What was interesting about that experience is that when I was eleven, my grandmother was definitely looking after me, but by the time I got to seventeen or eighteen, I was really looking after her. She was growing older and needed more care. She had been an artist, a set designer, and a sculptor since she was fifteen years old. She had an incredible work ethic and she passed that on to me. She showed me that you could be artistic and have a successful career. She once told me the only difference between stubborn and visionary is that no one's discovered you yet.

Being poor, we basically always had to struggle. It's like having the hustle gene. I'm always hustling, even now when I don't have to anymore, it's so deeply rooted. I worked forty hours a week to put myself through college. Had I not been so focused, had I just given in and designed fancy houses, all this would never have happened. I'm proud of it. When you have to pay for your own education and have no cushion to fall back on, you don't have the easy option of giving up.

Everything I did was driven by how I could marry social justice with architecture. No matter what assignment was given to me, I would add in some humanitarian or social element. My postgraduate thesis focused on sustainable transitional housing for New York City's homeless. At the time, there were between forty thousand and sixty thousand homeless people in New York City. The temporary housing structures I designed would have blocked the view of the Statue of Liberty for most people. The idea was that when the city took responsibility for its homeless and provided them with rehabilitation, it would have its view of the Statue of Liberty back again.

During that project, I spent a lot of time with the homeless in New York. I was dating a girl whose father owned a bunch of coffee shops

Cameron Sinclair at the Architecture for Humanity headquarters in San Francisco, CA.

around the city. Each night, when she closed out the shops, we would deliver hot coffee to the homeless. I ended up speaking to them about my work. I realized that the homeless knew a lot more about what I was trying to do than my professors. So, I moved to New York. If I wanted to focus in on these issues, I had to be where the work was.

I worked at a couple of boutique firms and one of the first projects I did was restoring Brancusi monuments in Romania. It was during that time that I began really paying attention to what was happening in Kosovo. NATO and the United States were bombing villages there to stop the aggression of the Serbs. As someone who builds things for a living, it didn't make sense to me that you would be bombing the place that you needed to repair. I called the U.N. and asked to speak to whoever was in charge of refugees. We started talking about transitional shelters based on my thesis idea. Before I knew it, I was standing in front of U.N. officials presenting this idea. That really was the birth of Architecture For Humanity (AFH).

It wasn't like anyone was going to pay me for this work. I spent five years pro bono. I worked on AFH by night, and as a commercial architect by day—I wouldn't call it "soul-destroying" but it was corporate work, not my passion.

AFH's first work was building mobile HIV/AIDS testing centers in South Africa. I had been in South Africa looking at low-cost projects, and my co-founder was a journalist doing a story on the rape crisis that had led to the HIV/AIDS crisis there. We began looking at the lack of medical facilities in rural communities, which to me was a design problem. Rather than expecting people to walk twenty kilometers for what was then a two-week AIDS test, we thought, let's have the doctors go to them. A lot of the work we do is common sense.

To start a project, there have to be three things in place: funding or the potential of funding; a community that understands our process and has a strong need for a building or a rebuilding; and, most important, an architect that not only has the skills and the passion, but the determination to see a project all the way through. A lot of architects can design something, but that doesn't change the world. What changes the world is implementation.

We adapt to almost every project. Everyone in the nonprofit world

"*A lot of architects can design something, but that doesn't change the world. What changes the world is implementation.*"

always thinks and talks about scale. But, scale can only be achieved through patience. Each disaster presents very, very specific needs. After Katrina, the definite need was for permanent housing; whereas in Haiti, a full, across-the-board reconstruction effort is what's required: schools, health clinics, housing. And in Japan, they need reconstruction of small businesses, which are the lifeblood of many of the villages.

We don't see the community as a recipient of our aid. It's a partner. So, it's vital that our architects and engineers live in the towns and villages they're helping to rebuild. By working in and with the community we're serving, we often realize during the development stage that their needs are greater than or different from what we set out to address. For example, we might have gone in to erect a school, but discover there's no food resource for the students. So we have to build a bakery or some social enterprise to make sure that the kids are getting fed. We're not just

doing construction, we're doing systemic, low-cost development.

Even if it's a tiny project, we always have a local partner. We always have a local architect or engineer, to make sure our buildings adhere to building codes. We also share everything—the construction documentation, the construction photographs. We are known for our collaboration and our ability to work with many, many partners who are stakeholders. We're brought in to collect those stakeholders. In Haiti, for example, we're working on projects of upwards of three thousand homes with multiple organizations to implement. We are the biggest floozies out there!

I think our biggest downfall is our inability to communicate the depth in which we are working across the development field. People say, "Architects design pretty things," when, in fact, designing is just 5 percent of the entire process. In a way, we're more like developers of humanity, but no one would ever donate if we called ourselves that.

Need doesn't have a nationality or a color. There is need everywhere. Whether it's responding to tornados and earthquakes in the States or to the lack of access to education in Central Africa, there's a similar level of input that's required from a design and construction context. We've worked in most inner cities in the United States as a design partner—everything from community gardens in Oakland to rethinking disused facilities in New York City to repurposing abandoned military bases.

I'm not the lead designer on a single project. Early on in the organization, I realized that had I been the principal architect, no one would have joined us. It wouldn't have scaled the way it has. Right now, we're doing eighty projects in twenty-two countries. We're about to open regional offices in Latin America; New York and Chicago are probably next.

In 2006, I won the TED prize. Recipients are granted one wish to change the world. Members of the TED community voluntarily contribute to granting the wish, by offering their resources and talent. Our wish: to build on our success creating opportunities for architects to help communities in crisis. We envisioned a truly collaborative online community and gathering place for those dedicated to improving the built environment. It led us to ask ourselves the question, "What if we could galvanize the entire building industry to work in partnership globally?" So, we built a website, Open Architecture Network, which is now called "WorldChanging."

I met Dean Ornish, the well-known author-physician, at the Ted conference and he was just ecstatic about AFH. He came up to me and said, "I love what you do. I have nothing to do with architecture, but I just like your energy." It was such a West Coast thing to say! He said, "I know a lot of people are giving resources to your organization. I can give you something that's very architectural, but has nothing to do with expertise, which is space. I'll give you a year's free rent if you move to Sausalito." When we moved to the Bay Area, there were four of us. Six years later, there are 120 of us. I started this for $700 by myself. Thirteen years later, we're close to a 10-million-dollar organization.

I like San Francisco a lot, but I don't feel at home anywhere. Home is wherever we're doing our good work. I travel quite a lot. Last year I logged 300,000 miles. I definitely still have a personal life, I just mix it with my business life—and I don't sleep much. Tomorrow, I'm taking the red-eye to New York to have two meetings—one with a donor and one with a potential client. In the evening, I'm helping a friend with a fund-raiser for some artists. Then, at 11 P.M., I have to attend an after-party with another group of people that we're looking to help. At 7 A.M. the following morning, I have a meeting with a Brooklyn foundation. At midday, I have another meeting about working in Japan, and then I come back to San Francisco. I also have a daughter and I'm raising her. She's often my date. She's five.

Taking time off in the position I'm in right now would be like complaining about the color of the cherry on the cupcake. Most of the people I grew up with are struggling to get by. The way I look at it, we're each of us on our own roller coaster. My roller coaster happens to be massive at the moment. Eventually it's going to stop, and then I can get off of it. Until then, this is the ride I'm on. I'm a big believer in just going with the flow, no matter how fast the rapids are going.

It's hard enough to explain what architects do, it's even harder to explain the value of architects within the humanitarian space. We're working in refugee camps in Haiti, where the family that we're trying to build a house for has cooked me dinner with what very little money they have. It's a reality check. I don't make as much money as most of the people I know, but I have a cultural and social wealth that most rich people would love to have.

"When I'm in Uganda, I look into the faces of the kids there and I see my own kids. And I think, why should that child have any less access to better health or a better life than mine does?"

Chuck Slaughter

Founder and CEO, Living Goods

Chuck Slaughter has two driving passions: global travel and solving social problems. At twenty-eight, he started TravelSmith, a 100-million-dollar travel-wear catalog. His latest venture, Living Goods—which aims to be the "Avon" of rural health in Africa—empowers entrepreneurs to deliver life-changing products to the doorsteps of the poor. Slaughter's goal is to make Living Goods a completely self-sustaining enterprise that "fights poverty and disease with profitability."

One day after college, I opened the *New York Times* and read about Glen and Millie Leet—a married couple in their seventies who had started a nonprofit called Trickle Up. Trickle Up took its inspiration from Grameen Bank, the now famous microfinance organization. In 1985, no one knew what the heck microfinance was. Trickle Up would go to the island of Dominica and give a $50 grant to five people, who would write a one-page business plan and agree to work together. If three months later, they showed they were still progressing, they got another $50. The Leets wrote the checks directly from their own personal bank account. When I read their story, I literally picked up the phone and said, "This sounds brilliantly simple, do you need any help?"

When I started working for the Leets, Trickle Up was in fifteen countries, but the whole operation was still run out of their apartment on Riverside Drive in New York City. I first volunteered and then I went on salary. Glenn became a mentor to me. He was a restlessly creative, terminally optimistic guy. He encouraged me to go back to school and get a business degree, so I could be of even more help. While I was there, I wrote a business plan as an academic exercise, for a catalog that would

Chuck Slaughter in San Francisco, CA, where Living Goods is headquartered.

market handcrafts from the entrepreneurs that Trickle Up supported. It seemed like the perfect synthesis of doing well and doing good. The fundamental problem was that the idea needed scale to be profitable, but any scale would quickly outstrip the capacity of these little entrepreneurs and it would lose its very purpose.

After graduation, like many of my classmates, I took a job in management consulting to sock away a little money. I was not terribly enamored of my boss and asked myself, "What would I rather be doing?" and I started thinking about these threads in my life—like how much I loved traveling, my early entrepreneurial efforts as a paper boy and bike repairman, and the bit I learned about direct marketing in business school. I thought why not create a catalog for travelers? There was nothing of the sort at the time, so at twenty-eight I quit and launched TravelSmith.

We put our first catalog out in spring, 1992. Over the next twelve years, we built TravelSmith into a highly profitable business with over $100 million in sales. But I grew restless and knew I wanted to eventually get back into the social sector. So, in 2004, I sold the business and my wife and I welcomed our first child at about the same time—which can't be cosmically irrelevant. My grand plan was to do nothing for two years, just enjoy my new family and let inspiration come.

My hiatus was to be short lived. Within a few months, I was introduced to a program in Kenya called Child and Family Wellness Shops—a lousy name for a really great idea. It was a network of franchised clinics and drug shops in Kenya whose purpose was to improve access to essential medicines and to become financially sustainable. My wife and I became donors and then I was asked to join the board. I went to Kenya to see it for myself and found that this brilliant program was being run into the ground. It was broken organizationally, financially, and managerially. The board asked if I would help them rescue it, which I did pro bono.

That experience became the inspiration for Living Goods. The shops were mostly run by women. There were busy parts of their day, but a lot of time was spent waiting for sick people to walk in the door. This was inefficient and biased toward treatment rather than health promotion. The local manager came up with the idea of getting employees to promote health in local schools and by going door to door. This mobile socially-

networked strategy worked beautifully—profits grew and so did impact. And I'm like, hold the phone, isn't there a business model out there that is exactly that—i.e., Avon, Amway, Tupperware?

I did a little research and learned that Avon started well over 125 years ago in rural agricultural communities with poor access to quality products. Women needed a source of income, but there was no employment economy, plus they had families and farms to take care of. It was remarkably quite similar to sub-Saharan Africa today. Another important parallel is the reliance on very tight social connections. Avon is very profitable and it operates successfully in incredibly diverse settings without having to change very much, including the products. So, to learn the model from the inside, I became an Avon Lady. I bought into the business to learn more. I did not set any records in lipstick sales, but Living Goods has stolen shamelessly and proudly from many of the strategies that I learned from the turbo-charged microenterprise system of Avon.

If you think about microfinance, it's a highly successful model—there are 500 million people benefiting from microfinance across the globe. Living Goods really takes its cue from that whole movement—it's a touchstone for us. Nobel laureate Muhammad Yunus had the idea for a simple lending product to help very poor people start small businesses to improve their livelihoods. It started as an experiment by nonprofits, like Grameen and Trickle Up, but what made it take off was that it became profitable. You had organizations that started as money-losing NGOs become registered banks. In the last few years, there have been IPOs of microfinance institutions. This profitability has enabled microfinance to scale, because it can use private debt and equity—a massively greater source of capital than charity. Our vision for Living Goods is very similar: to be extremely high-impact and commercially viable in order to achieve game-changing scale.

There are 150 million microfinance borrowers in the world, 70 percent of them run one of a few basic businesses that meet the essential needs of the poor—small trade, food production, tailoring. But these 150 million borrowers are all working independently. There's almost no structure for sharing learning or combining buying power. Franchising, one

way or another, is the future of microfinance—it lowers risk and increases profit for small entrepreneurs, franchisors, and lendors. It enables microfinanciers to lend to people who might not have been creditworthy otherwise, because they now have a business in a box. It lowers the risk. It's really microfinance 2.0.

Here's a fun fact. The average independent start-up has a one-in-three chance of reaching its fifth birthday, but if you buy a Subway franchise, your chances are more like 85 percent. You're part of a company that's figured out what people want and how to lower the cost of goods and run a shop profitably. This should have happened in microfinance years ago. We're trying to create these microenterprise franchise opportunities in ways that benefit not just the entrepreneur, but also the customer. For every entrepreneur, you have hundreds or thousands of customers, so that's enormous leverage.

We want to see a thousand flowers bloom. If you look at the microfinance field today, you see nonprofits, social enterprises, banks, publicly traded companies—all adapting and thriving. That arc with microfinance took forty years. We'd like to see the same thing happen with applying franchising to the needs of the poor in a space of five to ten years. Ultimately, Living Goods is not just about health care. What we're really trying to do is use the principles of direct selling and franchising to build a high-impact, financially sustainable distribution platform for products that make a difference in the lives of the poor.

Our first products were in the health-care field because that's where the greatest potential for marginal improvement in life exists. Both the treatment and preventive products are cheap, so there's high impact and low cost. Malaria, diarrheal disease, respiratory infection, neonatal/pregnancy and newborn care, and micro-nutrition collectively represent 70 percent of the under-age-five mortality rate and can be treated and prevented very cheaply. Treating a case of diarrhea or respiratory infection costs fifteen to twenty cents. And there's a whole set of preventive products, like bed nets, condoms, and nutritional supplements. We're trying to get the biggest bang for a buck.

We also have a group of fast-moving consumer products that bring daily velocity to the model. You buy a bed net every two or three years and

"Our vision for Living Goods is to be extremely high-impact and commercially viable in order to achieve game-changing scale."

need a malaria treatment every two months. That isn't enough to make the model sustainable. So we brought in feminine pads, diapers, soap, fortified foods, iodized salt—things that people buy every day. That way, the agent is also in the homes more often and has a greater opportunity to spot and treat sick kids early.

One of our most potent areas for driving profit and impact are simple money saving health technologies like clean cook stoves and solar lights. Indoor air pollution from inefficient stoves contributes to one million under-age-five deaths a year. Our stoves save the average household in the areas we work about $1 a week in charcoal. Not only is the health of the children better, but we've also raised the family's effective income by 15 percent. Triple win, because now you're not cutting down a tree, and you reduce the emissions of black carbon in the atmosphere by half.

This year we're opening a Living Goods development advisory business, which will make money by helping companies and NGOs replicate our model. I would love this to be the business that launches a thousand businesses. Because even if Living Goods becomes a billion dollar business, that's still a rounding error compared to the size of the problems we're trying to address.

I told myself a little lie when I sold TravelSmith, which was that I didn't really want to start another business. I didn't make a Google-esque fortune, but I made just enough money not to have to worry about money. I said to myself, why go do that again? What I wanted to do was pursue my passion in the social space, but of course that led to starting a nonprofit, which takes just as much care and nurturing as a business start-up, if not more. That said, I've consciously tried to strike a real balance. I work from home part of the time and all I have to do in the morning is look at the faces of my kids to get inspiration. And when I'm in Uganda, I look into the faces of the kids there and I see my own kids. And I think, why should that child have any less access to better health or a better life than mine does?

The Reverend Stan J. Sloan

CEO, Chicago House and Social Service Agency

When Chicago House was founded in 1985, its mission was to provide dignity and shelter to those who were dying of AIDS. As the prognosis for survival of the disease improved dramatically in the late 1990s with the advent of antiretroviral treatments, the organization had to reconsider its purpose. When The Reverend Stan J. Sloan joined Chicago House in 2000 as their new CEO, he shepherded their transition from providing end of life care for the homeless, HIV-positive community to improving their quality of life. Since then, helping clients achieve economic independence through employment assistance programs and social services has become Chicago House's central focus.

I was raised in Amarillo, Texas. There's a book called *Landscapes of the Sacred* that says we get some of our personality from the places we're from, and Amarillo's part of the Great Plains—it's just flat as a tabletop, as far as the eye can see.

I was raised in a loving household that was strongly Roman Catholic and I've always had a natural prayer life. In college, I was president of the inter-fraternity council and was one of the top five graduates. I went to mass every day.

I was ordained in 1991 as a Roman Catholic priest. And then I attended Weston School of Theology in Cambridge, Massachusetts, where I received my post-graduate degree in spiritual counseling and direction. I went to work for the diocese at Tulsa, Oklahoma, for four years. As time went by, I felt very positive about what I was doing; but I also felt progressively negative about the Roman Catholic Church. I was fine as a celibate, but I was bothered by the Church's treatment of women and their position on sex and sexuality. I had been openly gay before I was a Catholic priest, and these issues continued to mount and weigh heavily on me.

John the XXIII, the Pope during the Second Vatican Council, said that it's time to open the windows of the Vatican and let some fresh air in. He moved mass into the vernacular and had priests face the people instead of having their backs to them. The Church went through a more liberal phase and I entered seminary right at the tail end of that. Then Pope John Paul led it to a much more conservative place and Pope Benedict XVI has taken it even further, back to the days before the Second Vatican Council.

I felt increasingly compromised by being a Catholic priest and I sought advice from a great eighty-year-old Jesuit priest. He said, "My stomach is in the same knot as yours, only I'm not in my twenties." The Jesuits are a much more progressive and forward-thinking Catholic order, and that made it pretty clear to me that I just needed to leave.

That's when I became affiliated with the Episcopal Church here in Chicago. Christianity is at its best when it's prophetic and a voice crying out for those who need help, and I feel the Episcopal Church does that. We've taken courageous steps forward for human rights, such as ordaining women and gays as bishops. We're out there asking the right questions and really doing what the Gospels challenge us to do.

Episcopalian Bishop Frank Griswold in Chicago plugged me into a place called Saint Leonard's House, which works with homeless people who've just gotten out of prison. I'd always been a privileged white kid who didn't interact with anyone who was homeless. It was love at first sight. I felt immediately drawn to the ministry and have worked in homeless services ever since.

One of my friends, the chair of the board at Chicago House said

The Reverend Stan J. Sloan outside Chicago House in Chicago, IL.

to me one day, "We need you to apply for a position. Our programs are designed for gay men who are dying of AIDS, but our houses are filled with homeless people who are living because of great medications. We don't know how to help them move forward with life." While the gay community had always been important to me, there were already a lot of smart people working for gay causes. I never felt like I had to be on the front lines for gay rights. But the homeless needed voices speaking up for them, since their voices are just not heard. Chicago House was founded, and is still largely supported, by the gay community, no matter who we're serving. I've been here twelve years now.

"*I was fine as a celibate, but I was bothered by the Church's treatment of women and their position on sex and sexuality. I had been openly gay before I was a Catholic priest, and these issues continued to mount and weigh heavily on me.*"

At the time of its founding in 1985, Chicago House was the only AIDS housing provider in the Midwest. There was much hysteria around AIDS because its transmission was mysterious, so people suffering from it weren't even allowed to be in hospitals at times. Doctors were terrified, and landlords would just evict people because of their HIV-positive status. Five members of the gay community got together over drinks and said, "We've got to do something." In 1985, they bought a little house where people could come to die with dignity. By the time I got here, in 2000, Chicago House had a budget of $1.8 million and four housing facilities.

Right before I joined Chicago House, it closed its hospice. Our program director and I have worked really hard over the last twelve years to build programs that help people live fulfilling lives, instead of just dying with grace. For example, we have about fifty children who live with us. Twelve years ago, all the high-school kids were dropouts, criminals, and

drug abusers and dealers. Over the last five years, we've not had one kid who hasn't graduated from high school and gone on to college.

We've grown from a $1.8 million to a $5.2 million agency. In 2005, Senator Dick Durbin, now U.S. Senate Whip, visited us and said, "What else do you need?" And I said, "Well, I'm used to working in regular homeless services where people move from the street to an overnight shelter, to transitional housing, to permanent housing, to having that baggage-handling position at American Airlines that eventually helps liberate them from any type of subsidy. There are more than fifty thousand new infections every year in the United States, and increasingly, those infections are in very, very poor and homeless communities. We've got to start an employment program specifically focused on people with HIV and AIDS, to help create that same flow to the system that exists in homeless services." He gave us a $200,000 grant to start up what is the nation's only metropolitan-wide employment program for people with HIV and AIDS.

We've had close to seven hundred people go through the program, with over a 40 percent job placement rate, which is twice the national average for people with disabilities. It's changing the face of AIDS services in Chicago. It's a four-week training course that works on basic employment issues. We have groups of lawyers who come in and talk about benefits and rights in the workplace and medication adherence. People With Disabilities leads sessions on the ADA and we put all those pieces together. The program moves from the south to the west to the north side of the city in order to make sure that we're serving everyone who needs our help.

Most clients are both formerly homeless and infected with HIV and AIDS. There are many different avenues they can take, according to their skill set and their barriers. There are some people who need a GED to get hired, so that's one track in the program. We've got tons of people with mental illness diagnoses or who are in recovery from substance abuse. Many have felonies. So, there are a lot of barriers beyond just HIV and AIDS that people need to overcome as we work with them to help them find employment. Seven years ago, nobody was reaching this population, because people with HIV and AIDS would not have accessed mainstream employment programs. There's just too much that's particular to their disease that leads to fear and anxiety.

To provide transitional jobs, we had a bakery called Sweet Miss Giving's Bakery. We just recently closed the bakery because a national baker is taking over our internship program and marketing our biscotti nationwide. This will expand the six-month internship program and offer a great many more people that first job experience. Plus it keeps me from getting calls in the middle of the night because the ovens are broken!

We've had five transgender women go through the bakery program and it's been a huge learning curve for us. We had no idea how big the gaps in service were for the transgender community. We have a building that we're turning into transgender-exclusive housing and we're developing an employment program that mirrors our HIV and AIDS employment program. I think that we can do things that nobody in the nation is doing for the transgender community. I think we can comprehensively wrap our arms around that forgotten population.

> *"I've realized over the years that I have to figure out how to be fair to myself, even as I give myself away so fully to my work. One of my favorite quotes is, 'The graveyards are full of indispensable people.'"*

Everybody always talks about LGBT issues, but the bisexual and transgender people really don't get much attention. And a bisexual person can walk down the street and be indistinguishable; but a transgender person, however, can find it very difficult to "pass." Discrimination in everything from housing to employment to getting kicked out of your house as a teenager is commonplace. Rates of transgender homelessness are five times that of the general population. Over 50 percent of transgender people of color have engaged in the sex trades because that's the only avenue of employment open to them. So, their HIV and incarceration rates are huge. Hauntingly, almost half of all transgender people have tried to take their life at one point. I don't think there's another community in the United States that's as in need as our transgender brothers and sisters.

Every day for me involves working with three amazing groups. First, our clients: formerly homeless people with HIV and AIDS. People think that must be depressing, but it's far from it. Their lives open up and I get to see them courageously move forward. Today, I had a visitor from Northern Trust Bank. He was talking to Gerald, who lives in one our residences, and Gerald started talking about hearing voices like you or I would talk about having coffee. He said, "Everybody always told me I was crazy. I got to Chicago House last year and I told a case manager, 'I'm crazy.' And he said, 'You're not crazy. You've got a mental illness.' For the first time it clicked that if I'm sick, I can get well. But if I'm crazy, I'm just crazy." Now Gerald's on medications and barely ever hears voices.

Second, I work with an amazing staff that tirelessly does great things for very little money. And third, I get to work with people who have all the money you could ever want, and who don't have to care about the less-fortunate, but do. I'm having dinner with one of those donors tonight. Every day is different, but involves some combination of those three groups of people.

I've been comfortably out since I moved to Chicago. But leaving the Catholic priesthood was like a real divorce, and I remained celibate for two years afterward because I needed time to process. Then, one night my parents were on a road trip and were hit by a drunk driver. My mom woke up in the hospital after a week and her first question to me was, "Is your father alive?" Seeing how their love pulled each other through, I realized there's no reason why I can't have that anymore. But nobody told me how hideous dating would be! Eventually, I met my wonderful partner, Derrick, and we live together with our three dogs and have a very normal life. It's what I saw with my parents.

Is my call to the people of Chicago House, the poor, and the homeless, greater than my call to Derrick and our relationship? I think at the end of the day, hopefully, for all of us, our relationships enhance our lives and give us the energy to do what we do better and with more passion. I've realized over the years that I have to figure out how to be fair to myself, even as I give myself away so fully to my work. One of my favorite quotes is: "The graveyards are full of indispensable people."

"I decided to focus on designing something new for reducing violent behavior. This is what we did at World Health. We designed new interventions. And I wanted to do it in Chicago because Chicago is to violence what Uganda was for AIDS—ground zero."

Gary Slutkin, M.D.

Founder and CEO, CeaseFire

Gary Slutkin has spent his entire career at the intersection of science and social injustice. Trained as a physician and infectious disease specialist, Slutkin was on the front lines in the U.S. and abroad fighting pandemics like TB, AIDS, and cholera for more than a decade, before turning his attention to a killer of a very different sort: violence. As an epidemiologist for the World Health Organization, Slutkin's experience taught him that to "cure" infectious disease, you must ultimately change social norms, but that first you must minimize transmission—quell the eruption of new cases. He posits that the exact same scientific methodology can be applied to the fight against violent behavior. His unorthodox approach of training local members of America's most crime-ridden urban areas to use their street credibility to interrupt the violent impulses of fellow residents before they are acted upon, while simultaneously providing social outreach and educational resources within the communities, is the foundation of his organization CeaseFire. Since its implementation in various Chicago neighborhoods, (the nonprofit is headquartered at the University of Illinois School of Public Health), incidents of shootings have fallen as much as 40 to 70 percent, and retaliation homicides have decreased as much as 100 percent. That's what you'd call a "significant relative risk reduction" in medical-research speak; but I'd call it the science of saving lives.

M y mother was a bookkeeper. She's about numbers—as well as social justice. My father was a research chemist. I've always looked at the world through a scientific lens.

I grew up in Chicago. We lived in a one-bedroom apartment until I was ten. My brother and I slept in the dining room. Both my parents worked, so I never thought about what we had or didn't have. I started working myself when I was ten or eleven, and I've always had a job since. I read constantly when I was a kid. I was particularly interested in learning how things worked, especially the human body, plants, animals, the earth—anything to do with the natural world and humanity. I was also reading a lot about individual historical heroes, like Edison, Einstein, Jefferson, and Lincoln. I was really inspired by them. Then, when I was nine, we took a trip to the United Nations in New York, and I remember being heavily affected by the idea that people from countries around the world came together to try to figure things out. I still have a U.N. flag from that trip in my office.

I was pre med in college and then went on to medical school at the University of Chicago, but I never imagined myself as a general practitioner. I loved the challenge of working with patients, but I ultimately preferred more of an academic research world where there's a constant exchange of ideas. I moved to San Francisco to do my internship and residency at UCSF, and they asked me to be chief resident at San Francisco General. But, I'd already decided to take a year off and go to Africa first. It seemed like the most distant place I could go, an adventure. A couple of other doctors and I got a group together and basically drove a truck across Africa. We entered at Tunis, then drove across the Sahara desert, turned left and went through Cameroon. We drove through the jungles of Zaire, and camped our way out to Mombasa. It took about nine months. Administering medical care was inescapable, but it wasn't the principal purpose of the trip. It was more about survival, sleeping under the stars, and meeting all these different people. It's the kind of thing that if you don't do in your twenties, you really should not do.

Gary Slutkin, M.D., in Chicago, IL.

That's when I made the decision to focus on infectious disease, because it was the worst problem that I saw in the developing world. I went back to the States and SF General designed a special two-year program for me to study infectious diseases. While being the Chief Resident at SFGH I also went to work at San Francisco's tuberculosis clinic and when the director there resigned, I was asked to run the program. It was right in the midst of a TB epidemic in San Francisco, so it was a fantastic learning opportunity, because I was thrown right into how an urban environment controls and rapidly decreases the spread of an infectious disease. We had more than five hundred new cases and they were mostly Cambodian and Vietnamese immigrants. They understandably didn't trust doctors or anyone besides their own relatives. So I had to hire people they trusted so they would reliably do what was needed to control the disease, which was to take their medicine. Over the next four years we reversed the epidemic.

"We saw results very, very fast. The gun violence stopped rapidly. We went from forty-three shootings to fourteen in the first year."

Friends and close colleagues of mine at the time began to do refugee work in East Africa, and asked me to help. So I started to travel regularly to Mogadishu to treat TB there, and set up a system for controlling TB. Eventually I moved full time to Somalia, where soon a cholera epidemic had encompassed the entire northern half of the country. I stayed for three years, helping to build a health-care system and treating cholera and various diseases. I left in 1987, and was picked up by the World Health Organization (WHO) which was looking for an epidemiologist who had experience in Africa.

WHO was just beginning the global program on AIDS. I was one of the first six physicians recruited and I got assigned to the epicenter—Central and East Africa. My assignment was to help build the national AIDS programs of Uganda, Rwanda, Zaire, Cameroon, Kenya, Tanzania, Ethiopia, Malawi, and other countries. I also was given the task of developing the system for measuring the progress of HIV/AIDS. About a quarter of my time was focused on Uganda, which was the worst off. What we learned was that we had to change behavioral norms, and once again, this required a tremendous amount of community-level activity. Through a massive grassroots public education effort, we succeeded in getting local groups to question what is "normal." It was previously common there, for instance, to have five or six concurrent sexual partners. With good guidance, the local communities and villages were able to reconsider this as the norm. That program made Uganda the first country in Africa to have a reversal of HIV/AIDS infection rates, which dropped by about two-thirds between 1987 and 1995. Unfortunately, it wasn't as widely replicated as it could have been, because the global community bought into the concept of using biological solutions over preventive ones. Even though the Uganda experience was out there, the world was still betting on vaccines and treatments. It was—and still is—an enormous missed opportunity.

I spent seven years at the World Health Organization. I left for two big reasons. One was I didn't like the way that the global program was going. We had lost a lot of momentum. The other was I had been overseas for ten years straight and I really wanted to come home. But these large-scale epidemics that I'd been working on didn't exist in the United States, so I spent a couple of years figuring out what to do first.

It seems I am addicted to working on problems. When people started to tell me about kids shooting each other with guns in the U.S., I was very interested. It seemed to me that the experts working on this had no chance of affecting change the way they were approaching it, based on the scientific understanding of behavior. Punishment is not the main driver of behavior. And the other solutions that were being recommended were way too nonspecific. The feeling at the time was that to fix the violence issue, you had to solve this whole list of social problems—broken communities, bad schools, absent fathers. It's what I call the "everything" approach, which didn't seem like a feasible strategy. It seemed like a complaint list, which validates the notion that there's an intractable problem. In other words there was the "punishment" myth, and the "everything" myth—and there was little progress being made.

I was aware of other problems that had been "stuck" like violence was. Malaria had been stuck. Diarrhea had been stuck. HIV had been stuck.

I saw this great need and in an area that appeared to be intellectually very challenging. So I decided to focus on designing something new for reducing violent behavior. This is what we did at WHO. We designed new interventions. And I wanted to do it in Chicago because Chicago is to violence what Uganda was for AIDS—ground zero.

We began simultaneously designing strategy, looking for financial support and infrastructure, and trying to develop some allies. The model we developed was based on community outreach to the people who were responsible for the violence. It was essentially patterned after the TB program and AIDS work that I'd been involved with before. The outreach workers needed to be people from within the neighborhoods who already had credibility and trust. Then there was a major public education effort backed up with lawn signs, leaflets, and flyers. That was basically the outline of it.

Those first five years were all about design, and it was an extraordinarily hard period. I was way out of my World Health element. Besides, I'm white. It was all, "Who does this guy think he is? What does he want?" I'm trained in very linear thinking from medicine and epidemic control. But these communities are very disorganized, aggressive, and often depressed. Violence doesn't exist in a vacuum. It exists in a sea of hostility, competitiveness, and individualism, which is unfortunately common in America now.

I finally found support with the state senator, who is now the state's attorney general, Lisa Madigan. She believed enough in the idea to get us the money to implement the program in the most violent neighborhood in Chicago at the time. We put it on the street in 2000 and the CeaseFire Intervention program was officially launched. We saw results very, very fast. The gun violence stopped rapidly. We went from forty-three shootings to fourteen in the first year.

In 2004, we added a new category of worker, the interrupter. There was a tension that had developed in the outreach workers' job. Between working late nights to prevent shootings and working days to provide social support, like helping them with résumés, or getting them mental health services—it was too much. So, we separated these responsibilities into two different positions: the outreach workers and interrupters.

Since then, we've had external and independent evaluations of our work, and of this new strategy for reducing violence—which the *Economist* called "the approach that will come to prominence." We're now working in fifteen other cities and five countries. The program is being promoted by the National League of Cities, the National Governors Association, the World Bank, and is supported by the U.S. State Department. However, a major challenge to scaling this work is the static mindset in some parts of the United States that these are "bad" people committing these violent acts, who need "more" punishment. Actually, this behavior, we are now learning, is unconsciously modeled or copied—and peer pressure perpetuates it. So that violence, in fact, acts like a contagious brain process. Whereas the old thinking is that you need to punish these people and "teach them a lesson," the modern approach, which follows the science, is that you must interrupt events, change behaviors, and change norms. We now have enough social, psychological, and brain research to know this works. But the money and the efforts in some places are still stuck in old solutions like prisons and the criminal justice system. Yet there are signs that a transition is finally coming. The new approach is spreading from city to city and country to country. Through science, we can begin to put the problem of violence behind us.

"I always say there are two kinds of spinal-cord people out there. Those who carry their own baggage and those who have their baggage carried for them. Mike Utley carries his own baggage."

Mike Utley

President, The Mike Utley Foundation

On November 17th, 1991, an unlucky fall on the football field left former Detroit Lions offensive lineman, Mike Utley, paralyzed from his chest down. As Utley was carried from the field, he famously gave the crowd a "thumbs-up" sign, a gesture of courage and hope that went down in sports history. Almost twenty-one years later, Utley is still unable to walk, but his will is as determined as ever. His belief that a cure for paralysis is within the grasp of science is one of the driving forces behind the founding of The Mike Utley Foundation, which provides financial support for research, rehabilitation, and education for spinal cord-related injuries. Guided by a strict moral compass, Utley's straight-talking, take-me-or-leave-me outlook on life offers no allowances for self-pity or defeatism. Frequently referring to himself in the first person, his inimitable style may not exactly be PC by modern standards, but beneath that rough exterior beats a heart of pure gold.

There are three important things that came from Mom and Dad: God, family, and football. Dad was always a very straight shooter, but he was also the biggest kid. If I had one thing to say about my folks, it would be that they were true role models. They have been married fifty years and I think Mom is going for sainthood, but that's just my two cents.

I started playing ball when I was seven years old. Mike Utley was not the greatest athlete. He wasn't the fastest. He wasn't the strongest. But what I did have was more tenacity, and more vigor in my giddy-up than most anyone. I absolutely thrived on the action of collision. My best talent was my short fuse.

Mike Utley at Ford Field in Detroit, MI.

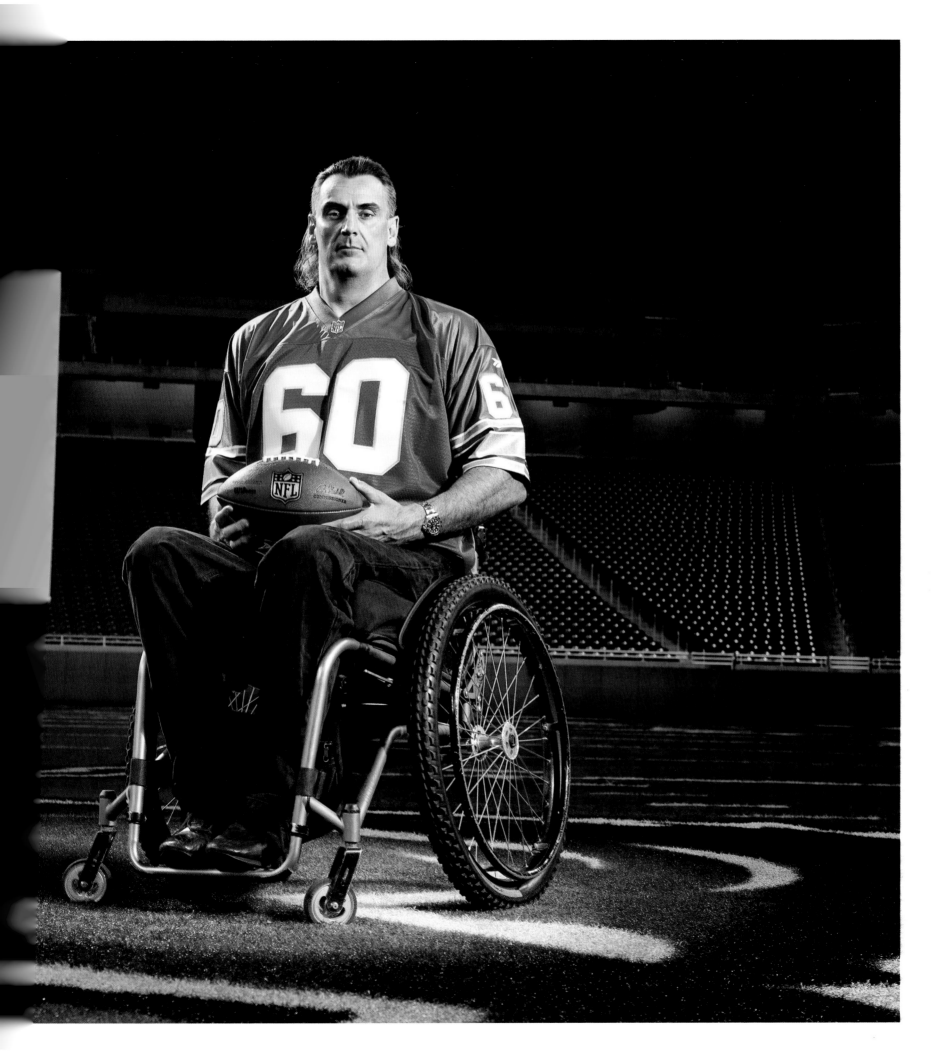

When I got to the major leagues, I experienced a lot of injuries. I played for the Detroit Lions. The fifth game of my first season, in 1989, I broke my leg. My second season, I broke my ribs, separated my shoulder, and separated my hip. By the eleventh game of my third year, I was finally feeling healthy. I was 315 pounds. I was strong and I was doing great, up until the big "oops" on that first play of the fourth quarter.

The first thing I remember is Coach Fontes touching on me and asking, "Son, can you feel this?" "No, sir, I can't." That was it. I had a burning sensation from the middle of my chest all the way down. It was like being in molten lava. As I was carried out, the crowd cheered their best wishes. That's when I gave the thumbs-up sign. All I wanted was for people to know that Mike Utley would be back. A man walks onto the field of battle. A man walks off. All I could think was, "I broke a promise to myself and I got carried off the football field."

That was my temperament at the time. I was angry. In the following weeks, I had a couple surgeries. The game of football is a violent sport, a semi-controlled fight for a few seconds. I'd been hurt many times before, but this particular time I lost muscle strength. I never had that happen before. So I knew I was in serious trouble.

When the doctor came in and said, "Son, you'll never walk again," I just said, "Get out of my room, don't tell me I can't do something." I loved my doctors, but I needed information I could use. I was in the ICU for twelve days and they moved me out just before the big Thanksgiving Day game. My brothers and some friends snuck in some pizza and we watched it on television. The nurses kept scolding me to settle down and not get so riled up. Later that night I threw two blood clots. I had my last rites and my brothers were called. I should have died right then and there, but I pulled through somehow.

On December 19th, they moved me to Craig Hospital in Englewood, Colorado, for rehab. I was still at Craig during the Super Bowl that season. Now, as a man watches a Super Bowl, he likes to partake in a cold one. I hadn't ever left the hospital up to this point, but I wasn't going to let that get in my way. I had no use of my hands, wrists, or fingers, but I wanted something to drink. I managed to get about four blocks but, as I was trying to cross the street, I got stuck on the curb. I couldn't grip the wheels so I

couldn't rock myself loose. This gentleman saw that I was stuck and gave me a little boost. Then I continued up the hill to the store and bought myself a forty-ouncer. When I got back to the hospital I sat in the TV room and it took me an hour and a half to open up that bottle. I wouldn't let anybody help me because, damn it, I'm a man. I earned the right to pour myself a Dixie cup full. I had a cold, well, lukewarm beer for the Super Bowl in 1992. Best darn beer I've ever had in my entire life.

For three and a half months I was in the hospital doing my rehab. Then I got an apartment in Denver, about twelve miles away. I had a nurse for six hours in the morning and then I had a nurse for six hours at night. Over the years, I kept cutting back, pushing for more independence. I was going to live or die on my own volition, absolutely. The wife came up with this statement: "Athletes measure success not in time, but in goals achieved." That's a great way to articulate it.

In 1998, I flew up and met my dad in Seattle and moved into my own house. Back in my first year in the NFL when I broke my leg, my dad was doing a lot of my finances and he saw me hobbling, and he asked, "Was it worth it?" I said, "Absolutely, Dad. As long as I have twenty bucks to buy a beer and a burger, this game has been worth it to me." So, eight years later, I am completely on my own. I have left the nurses in Colorado. We're driving to my new house. All of a sudden he goes, "Boy, you got twenty bucks in your pocket?" I said, "Yes, sir." We pulled off the road and we got a beer and a burger. My dad has never said a word about this injury to me, not one word.

When you get hurt, you must take personal responsibility. I couldn't do anything bowel, bladder, or skin-related by myself until 1998. But I've been independent ever since. I will never be a burden on anybody. I always say there are two kinds of spinal-cord people out there. Those who carry their own baggage and those who have their baggage carried for them. Mike Utley carries his own baggage. He always has and he always will.

No injury can change you unless you allow it to. If you say, "I'm not in control," you're a victim and dependant. If you're addicted to cigarettes, knock it off. If you're addicted to alcohol, knock it off. If you're addicted to overeating, knock it off. Say no to everything that makes you less than you can be. If you choose to get married, take care of your wife. If you

choose to have kids, take care of your kids. Stand on your own two feet. This is my two cents.

Before I was injured, there was a third of the gals who would not go out with Mike Utley because I looked so big or because I had long, bleached hair and wore earrings. Then there was a third of the girls who were curious. I had a great time with them. Then there was a third of the girls I took home to Momma. When I got hurt, there was a third of the girls who wouldn't go out with me because I was a crippled dude. Then there was a third of the girls who were curious. And there was a third of the girls I took home to Mom. Nothing changes unless you allow it to.

One day I went into Gold's Gym in Wenatchee, WA, to train with the owner. He was working with Dani when I got there. I could see she had the eye for me. I'll be honest with you, I kept asking her out and she didn't say no, but damn it, she didn't say yes either. So, what I did was I asked her if she wanted to come to my house and play on my boat. I made her Top Ramen prime rib burritos and she thought that was the greatest thing in the world. Dani's a medic, and she's a lot smarter than I am. She's above the evolution line. But she saw me in plaid and tie-dye and said, "There is a project for me. I'm going to change this boy's life forever."

The Mike Utley Foundation was started in 1992 with the help of my agent and attorney. The original mission was to help direct an injured person to a spinal cord rehab center. After you understand the p's and q's of spinal cord injuries, you can go home and cry all you want. But first, you've got to get yourself the right care and learn the rules. That's exactly what I did for three and a half months at Craig Hospital.

Then, over time, the number-one purpose of the foundation became finding a cure for paralysis. I tell spinal cord injury centers that my job is to put them out of business. Period.

When Dani and I started dating, a couple things happened. I was finally ready to do more than just try to survive and I started noticing little things weren't being handled very well. I also realized that when people called the foundation, they were often looking for information. They had questions about bowel, bladder, and skin control, or what type of wheelchair they should have. But there was no education piece in place. Dani noticed those things too. We had this epiphany together that we should take this organization to the next level.

I flew down to Scottsdale, AZ, wheeled into the office, packed everything up, closed it down, and moved it all to Washington state where I could initiate a hands-on approach for operations. Now Dani deals with people. She believes through the foundation everybody deserves a chance to hear the right information the first time. God bless our doctors, but 99.99 percent of them are not athletes. They tell people to limit water intake because they don't want you to go out in public and wet yourself. I still drink a gallon of water a day because your system needs to function at its highest level for you to be productive. You only have so many heartbeats. I don't care if you're in a wheelchair.

The focus of the foundation is now research, education, and rehabilitation. We give grants to fund adult stem-cell research. I absolutely believe we will find a cure for spinal injuries in my lifetime. I wouldn't waste my time with it otherwise. We're also proud of the Mike Utley Fitness Scholarship that we have at the Rehabilitation Institute of Michigan. You get weight lifting, conditioning, nutrition, biofeedback, and a boot in your butt for four weeks, 24/7. We're also building the Mike Utley Terrain Parks, which are training environments for people learning to use a wheelchair. They include curbs, steps, ramps, door frames, cobblestone paving, grassy areas. We funded these because there is no place for spinal cord folks to go in private to learn wheelchair skills. People are afraid to fall on escalators in public places, which are not designed for educational purposes.

I had a guy tell me once, "I want to walk again." The first thing I asked was, "What's the most important thing in the whole world?" He said, "I have to walk again." I said, "Okay, let me ask you again. With your wife and kids and everything else around you, what's most important?" He said, "I got to walk again." Finally I said, "When was the last time you initiated a hug with your wife or kids?" He goes, "Before my injury." "Let me ask one more time, you clown, what's the most important thing to you?" "I have to walk again." That guy will never be a productive part of society. He doesn't realize that the most important thing is to hug and kiss his wife however he can. He needs to stand up and take care of her first. This injury has nothing to do with your legs. This has to do with what kind of a man or woman you are.

"We have a motto around our place that we're not responsible for saving the world, we're just responsible for loving the person in front of us."

David Vanderpool, M.D.

Founder and CEO, Mobile Medical Disaster Relief

Dr. David Vanderpool has spent a lifetime donating medical assistance and infrastructure to communities in developing nations. His nonprofit, Mobile Medical Disaster Relief (MMDR), serves fourteen countries around the world. He and his wife, Laurie, travel overseas every month for a week or two at a time, taking along twenty to forty trained volunteers, to deliver aid to those in need. Last year alone they provided free health care to more than 10,000 patients, as well as many other support services. This year they'll break ground on a twenty-three-acre permanent campus in Haiti, which will house a fully operational hospital, an orphanage, a school, a demonstration farm, and handicapped housing.

I was born and raised in Dallas, Texas. I grew up very privileged, went to the best schools, and ended up becoming a vascular surgeon just like my father. Because of my upbringing, I didn't really come into contact with people who were disadvantaged until I was older. When I realized how many people out there are in dire straits and living on the edge, I felt I needed to use the gifts and the talents I'd been given for their benefit.

So my wife, Laurie, and I started doing volunteer medical work about twenty years ago, providing free health care in third-world countries that had suffered either a natural or man-made disaster. We continued to build that effort throughout our adult lives, and in 2005, we formally founded Mobile Medical Disaster Relief (MMDR).

A lot of the medical services we provide are very simple, but it's the simple things that will kill you in the Third World. Something like appendici-

Dr. David Vanderpool, M.D. (standing second from right), and his two sons, David Stallings and John Mark, administering to an injured woman and her sons in Port-au-Prince, Haiti.

194

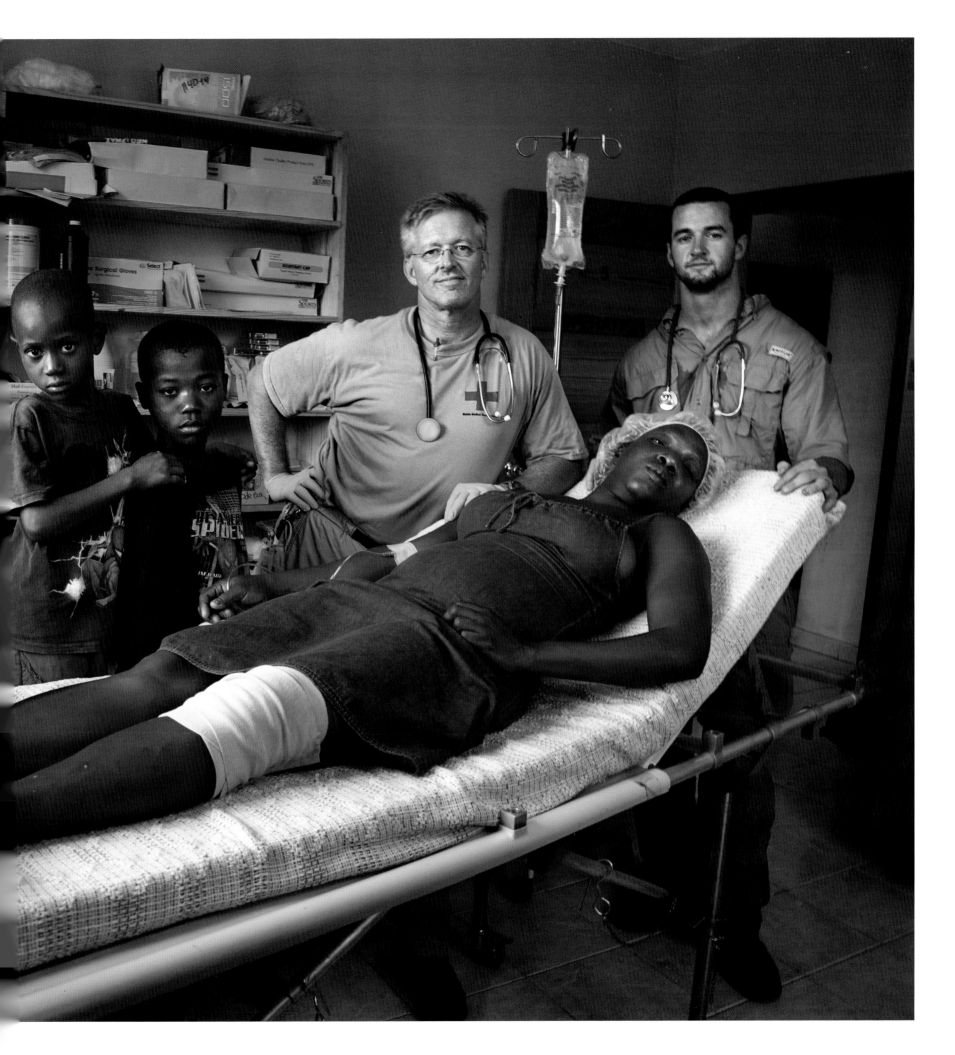

tis is an inconvenience here in America, and it's lethal over there. We'll go in and provide primary care to the local people. They may have diabetes; they may have high blood pressure. Most of them have infections, like malaria—that's the number one killer in developing countries. I'll perform surgical procedures in some of these areas as well.

We've branched out now beyond the medical care. It's still the backbone of our organization, but we also work to supply clean drinking water and provide microfinancing to small businesses. We want to add sustainable agriculture to our model as well. In fact, my oldest son is getting his master's in that subject at Texas A&M. When he graduates, he wants to join us and implement a sustainable agriculture program in the countries that we're working in. If you can go into an area and provide those four basic things—clean water, a food supply, adequate medical care, and business growth—that community can thrive.

We intentionally go to the worst places we can find, the places that need us the most. For instance, we work in Central Ghana, where child slave trafficking is a big issue, and we've found that we can use our health and clean water initiatives to leverage the children out of slavery. So we're not just a disaster organization that goes in, spends a few weeks, and then leaves. We stay. And we try to build infrastructure. We develop relationships with the people. And, they not only come to trust us, but they become our friends.

We work in Haiti quite a bit. We're about to make our twenty-third trip. The first time we were there, just two days after the earthquake, we helped set up a large hospital on the Dominican border, where I had to perform a number of amputations. I was the first doctor on the scene. We had a couple of nurses and a thousand patients, so it was just an overwhelming situation.

Unfortunately, it's very difficult to get adequate pain medicines into a country right after a disaster because most are narcotics, and because the narcotic drug trade is a huge issue in many of these countries, the laws are very restrictive. Therefore, a lot of the surgical cases we have are insufficiently treated for pain. It's an unbelievably difficult situation, as a doctor, when you have to perform a procedure like an amputation without pain management, especially when the patient is a child.

Sadly, we had a lot of children injured in the Haitian earthquake. The quake hit just a little bit before 5:00 P.M. and it was naptime; so, many of the children were at home. Anyone inside a structure was very likely injured, because the walls collapsed.

The first amputee patient that I saw was an eight-year-old girl. Her leg was just absolutely pulverized. Her parents were both there, and of course, they didn't want her to lose her leg. We just had no choice whatsoever, she was dying in front of us. Through some long discussions, they finally consented to the operation. So we went ahead, and the little girl did fine. We fitted her with a prosthetic limb, and her parents were extremely grateful. I sort of lost track of her over the ensuing months, until about a year later, when we were back in Haiti on another relief mission. We were going into a little church that we attended there, and on the front steps were the little girl and her dad, waiting for us. They had heard that we were going to be at the church, and had really sacrificed—traveled hours—to see us and thank us. That was just an amazingly touching moment for me.

"A lot of the medical services we provide are very simple, but it's the simple things that will kill you in the Third World."

A big part of our work is trying to get Westerners to see that there are people whose lives we can save with very little money and very little effort. I think if more people realized that, we would change the world. In the places we go to, the people are living on maybe a dollar a day, and we spend more than that here for a small latté. We live in a country that's very materialistic, but you go to Mozambique or Ghana or Haiti, and the people are very spiritual. They don't care how you look or how you drive or how many letters you have after your name. I have a hard time with reverse culture shock whenever I come back home. I'll pull up to a stop sign and there will be three hundred thousand dollars' worth of vehicles lined up in front of me, and I'll think, "I could build two hospitals with 300K, that would serve hundreds of thousands of people who don't have medical

care." And I'll just think, "My goodness, can't you drive a ten-year-old car and save the lives of some people who are dying because they can't get a vaccine or clean water?"

My kids have been traveling with us since they were little, so they don't see it as unusual; they think it's fairly normal, which I think is hilarious. Our little girl, she's our baby and she's a senior in high school now, I think her first trip to Africa was when she was ten. So she's grown up playing with tribal African children and she just loves it. It's interesting, they're very different from other kids because of these experiences. They're not materialistic, all of them are focused on getting degrees and educations that will help them help people in the developing world. It's fun for an old dad to see his kids further his vision. I hope they continue it. It's so fulfilling to be a small part of helping people who are at the other end of the socioeconomic scale.

People ask me all the time, especially in relationship to Haiti, with all the problems over there, "Why do you do it? I mean, it's hopeless." Well, it's only hopeless if you don't go. We have a motto around our place that we're not responsible for saving the world, we're just responsible for loving the person in front of us. And when you look at it that way, it's so easy to solve these huge problems. You wake up one day and you realize, "You know, we've made a little impact on our corner of the world."

One of the experiences that just rocked me was in Northern Mozambique, where the people are excruciatingly poor, in absolutely heartbreaking situations. The average life span of a woman is thirty-four years, and 60 percent of kids die before age five. I was treating a woman who had been badly beaten. The men over there are very aggressive toward women, and the women are impoverished and destitute. It was just breaking my heart. I was sewing up this woman's face and she spoke a tribal language that I didn't speak, so we could only communicate by smiles and gestures. And it just hit me hard that I could be in her situation. She could have what I have—the great education, the degrees, the fantastic upbringing, and I could have been born in Mozambique. Bono (social activist and lead singer of the Irish rock band U2) calls it the "accident of latitude." I don't think it's an accident, but it's just mind-boggling to me that the roles could be reversed just as easily as not.

I would certainly want people to come over and try to give me a leg up if I were in that situation.

Hurricane Katrina was one of the first large-scale disasters we participated in, and it allowed us to see how we could be really effective in doing mobile clinics. We went down probably fifteen times, with a pickup truck loaded with medications, and worked with the Red Cross. The hospitals were completely shut down because they had no electricity. The residents had tremendous medical problems and there was no one to take care of them. It absolutely blew my mind that I was in the United States. You expect things like this in Africa . . . but here? It was heartbreaking. They didn't have cars, they didn't have money, they didn't have shoes. The rich people had all gotten out; it was the poor who were left behind. We went through the truckful of medicines in a heartbeat.

My oldest was probably about sixteen at the time. Right before we left for New Orleans the first time, he asked to go with us. I said no; I knew there would be a lot of body recovery and I didn't want him to see that at that age. And then the night before we were making another trip down there, he said, "You know, Dad, here you're spending all this money and time and taking off work to go help these people—why didn't they just get out, why didn't they just get in their cars and leave? They knew that the hurricane was coming." So I said, "Pack your stuff, buddy, you're coming with us." Our first stop was in Biloxi and there was a fella who had been bitten by an alligator and lost a good portion of his leg. We actually had to operate on him in the back of our truck, and we got him fixed up. We put him back in his house and we'd visit him twice a day and change his dressing. But as we were initially taking care of this guy that first day, my son, who had questioned why we needed to even go before, said, "Dad, this is terrible, people need to come down and help these poor folks." He had made a 180-degree change in just a few minutes, and it was gratifying because I knew he got it, he got the vision.

I truly believe every person—whether you live in Africa or Texas—is equally valuable; and that we're put on this earth to help people who are not able to help themselves. We live very simply, Laurie and I, so that we can do this work, and we love doing it. I feel I have the best job in the world right now.

"The ultimate vision is that one day every kid in America will have access to safe, healthy play every day. And it really feels doable to me."

Jill Vialet

Founder and CEO, Playworks

"We don't stop playing because we grow old; we grow old because we stop playing," George Bernard Shaw once said. Jill Vialet's career personifies this maxim. In her role as the leader and founder of Playworks, a nonprofit dedicated to transforming recess into a valuable and nurturing part of the school day, Vialet's life is filled with play. In the 2011– 12 academic year, Playworks helped insure safe and healthy recreational time for 130,000 kids in three hundred schools in twenty-three cities across the United States, through their direct service program. Vialet has been honored as a social innovator at the Clinton Global Initiative and was recently named as one of the Forbes Impact 30—a highly select list of leading social entrepreneurs worldwide.

I've been working with young people for my whole career. My first job, right out of college, was teaching Eskimo kids in Alaska how to swim. It was extremely fun. Everyone else was going off to these jobs with Morgan Stanley and all these big banking companies, and the only job interview I could motivate myself to go on was for the Boys and Girls Club of America. When it was over, I ended up in Berkeley on my college roommate's parents' couch and

Jill Vialet with a group of Playworks students at the Peabody Elementary School in San Francisco, CA.

198

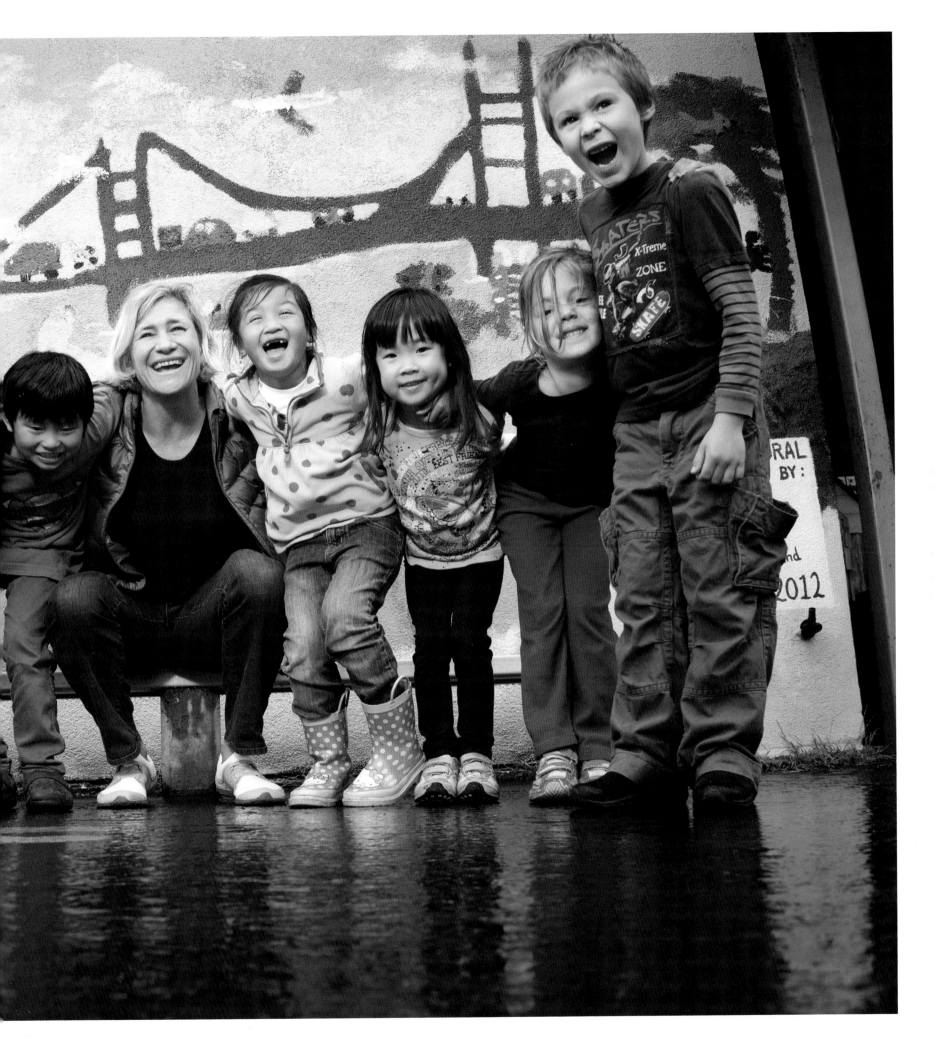

I never left. I mean, I left the couch, but I fell in love with the Bay Area and decided to stay.

In 1988, I started the Museum of Children's Art (MOCHA). I got the idea for Playworks during a visit to an elementary school where MOCHA had an artist-in-residence program. I was waiting in the principal's office, and she was dealing with these little boys who had gotten in trouble roughhousing during recess for the third time that week. After they left, she went off about how recess was hell, and couldn't I do with recess what I was doing with the arts? It did resonate with what I'd seen in the schoolyards. It wasn't the kind of warm, fuzzy chaos that I remembered from my childhood; there was an uneasiness to it.

In that moment, I was reminded that when I was a kid, there was this guy named Clarence who was the recreation coordinator for my school playground. He made sure that whatever activity was going on, I got involved. He wasn't super-didactic, but he was a strong presence, which made it possible for everybody to play comfortably. It occurred to me that every kid should have a Clarence-like person in their life.

I decided to try a little experiment. I sent a friend of mine, who I'd played basketball with in college, into two neighborhood schools to oversee lunchtime recess. And it was an amazing success. She was able to really transform the dynamic of their playtime by organizing games and including all the kids. I had all these relationships through MOCHA with principals around the area, and when they heard I was running a pilot program to make recess a positive part of the school day, my phone started ringing off the hook. So, we went from two schools that first year to seven schools the next year, and fourteen schools the third year. It just exploded.

It was a little bit of "build the plane as you fly it." I've always had the good sense to work with people who are smarter than I am in a lot of different ways. So, my terrific team built a program around creating the best possible recess, based on five core elements.

The first component is recess time itself. We provide trained coaches to help the kids engage in constructive and inclusive playtime, which includes a roster of games and excercises that we've developed to encourage participation and teach important values, like good sportsmanship and self-reliance. The second component has to do with developing classroom game time, where we have teachers bring kids outside in smaller groups to introduce them to play-based physical activity.

The third core element is our Junior Coach program, in which we identify older kids from the school to assist at recess. Thinking back to that early exchange with the principal who sparked the original idea for Playworks, I recognized that those three little boys who were getting in trouble all the time were natural leaders. They were just using their superpowers for evil, not for good. Playworks gives kids like them the opportunity to redirect that energy toward being positive leaders. We end up working with kids who are obvious classic leaders, as well as kids who are a little on the ne'er-do-well side. We bring them back into the fold, and it's amazing, the extent to which play is an untapped resource for kids to become more engaged.

"When local principals heard I was running a pilot program to make recess a positive part of the school day, my phone started ringing off the hook. It just exploded."

The fourth component is before- and after-school monitored recess for the kids of working parents. And then the fifth part is interscholastic sports leagues. That's our way of introducing competition and engaging families. The different Playworks schools will compete against one another. Many of the schools we're working in can't afford an organized athletics program, so we are it.

The ultimate vision is that one day every kid in America will have access to safe, healthy play every day. And it really feels doable to me. Schools have to pay for about half the cost of the program, which is about $25,000 right now. We're in more than three hundred schools and there are about three hundred different ways they come up with the money. A lot of them use Title I federal funding or school-improvement grants. Some are raising money through PTAs, and others receive district support. The schools can find the money, but we have a limited capacity to raise the balance, so

biggest districts in this country, we'll be serving 25 percent of all students.

We've been very explicit and disciplined about executing this three-phase path to scale. The first phase, by design, was to establish a gold standard for recess in twenty-seven cities. The second phase is building up the training business so we can reach a greater number and wider variety of schools. At that point, we will have demonstrated that it isn't an issue that affects just one demographic, and we can make the case that this is something that everybody benefits from. That's how you build a foundation for a really viable movement. The third part is really working to build that movement. How do you empower families who you'll never even meet to be advocates for play and recess as a critical piece of the school day?

I got into this business because I believe that all kids deserve and need to play every day. But along the way, the motivation of the young adults who work for us, and the transformative experience they have of being out there every day and being rock stars in these kids' lives, has become a powerful piece of all this. Believing in the idea that everyone can be an everyday hero is essential to our future as a society. And it's the "everyday-ness" of it that's more important than the heroism.

> *"Believing in the idea that everyone can be an everyday hero is essential to our future as a society. And it's the everyday-ness of it that's more important than the heroism."*

Launching Playworks has been so hopeful. Overwhelmingly, people want to help. Everybody seems so negative and miserable about education reform, but my experience is the exact opposite. I'm out in poor, hard-hit schools every day, and I see kids who want to learn, families who care desperately about their children's education, and teachers who are really giving their all. There are some problems, but it's not that the system is broken. It's that we, as individuals, really need to marshal our collective will to make change.

there's a waiting list. Our focus is on low-income, urban, public elementary schools where the need is the greatest. We also offer a lighter, less-expensive training option that makes our program accessible to any school that wishes to create a safe and inviting recess for its students. Through training, we're able to serve more mixed-income schools as well, such as those in more-affluent and rural communities.

I think that the challenge for most nonprofits is that they have great ideas, but the system is set up with this magical thinking around how ideas actually get to scale. It's almost the exact opposite of what happens in the for-profit sector, where it's the companies that best execute scaling that are successful, not necessarily the ones with the best ideas. I mean this very lovingly toward Subway Sandwiches, but I don't think you'd give me much of an argument if I said that it's not the best sandwich anyone's ever had, but they've rolled out like nobody's business. I spend a lot of time thinking about how Playworks is going to scale enough to change the system.

There are sixty thousand public elementary schools out there, and by the 2015–2016 school year, we want to be in seven hundred. That's 1 percent. And we want to be training two thousand schools every year. You break it down into bite-sized chunks. When we get into the one hundred

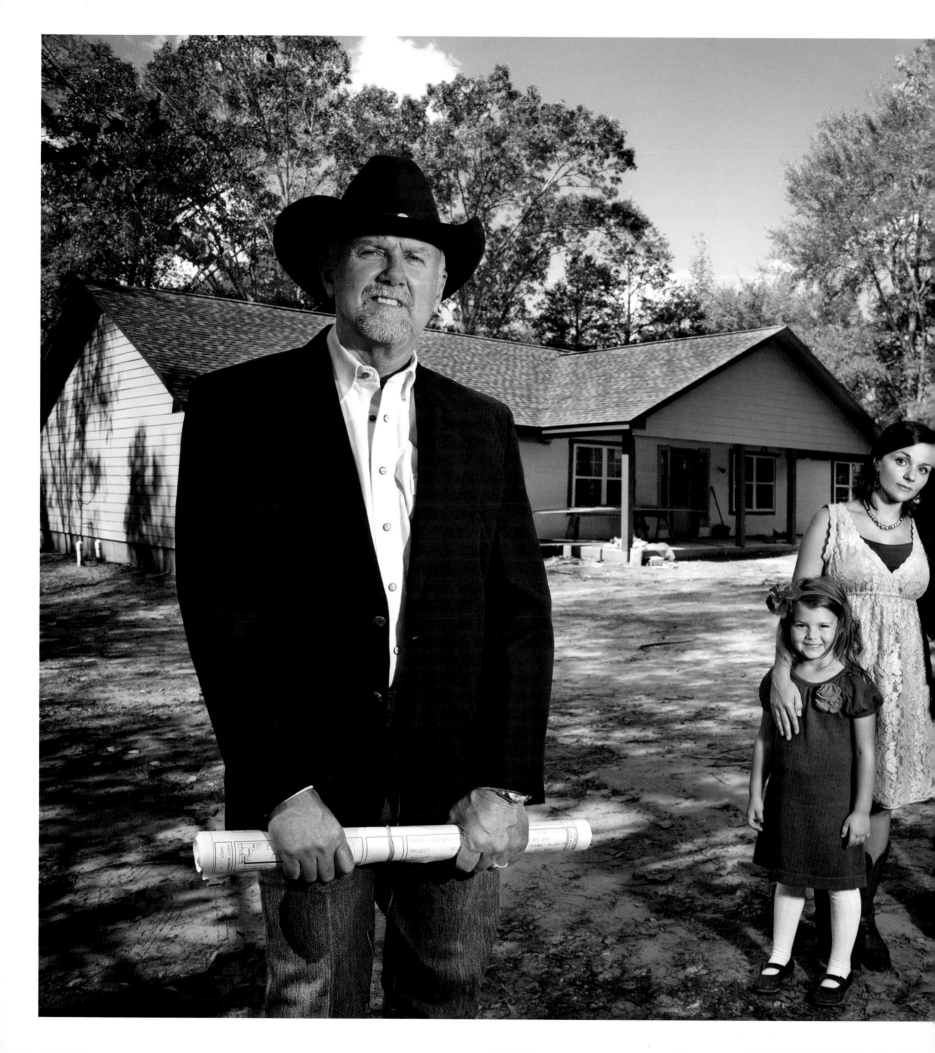

> *"When we hand them the title, we say we're giving them a new start, they've paid for it already on the battlefield."*

Dan Wallrath

Founder and President, Operation FINALLY HOME

When Dan Wallrath started building homes for injured veterans, he had no previous experience in the nonprofit world. He was just a big-hearted Texan who had spent his life as a builder, rancher, and church-going family man. But, when he saw a need that his experience in construction made him uniquely suited to fill, he responded without hesitation. His organization, Operation FINALLY HOME, has erected thirty-two new houses in the past six years, and Wallrath expects to double that number in 2013 alone. Soon, he says, they will exceed one hundred homes a year.

Back in 2005, a friend contacted me about his son, Steven, a Marine who had suffered severe head injuries from a roadside bomb in Iraq. They had to do some remodeling on their house to bring this young man home in a wheelchair. At the time, I was building custom homes and they asked me if I'd come over and look at the project. He told me what he and his wife were up against. They were going to be full-time caregivers to their adult son for the rest of his life. He showed me pictures of Steven before his injuries and after. It just touched my heart and I thought, "We need to do something about this." That's how we got started.

I was a builder for thirty years, so I have a lot of industry contacts all over the United States. Everything required to build these homes is donated—materials and labor. There's no cost to the family at all, it's mortgage free, no strings attached. When we hand them the title, we say we're giving them a new start, they've paid for it already on the battlefield. We continue to support them after they move into their new home by helping them pay their taxes and insurance, and assisting them with job placement or continuing their education.

I've retired, so I volunteer all my time now and I don't take any compensation for it. To go from a builder to a fund-raiser to being the spokesperson for the organization has been quite a challenge. But, knowing that these homes are actually changing lives makes it all worth it. These young men and women who place themselves in harm's way for us are my heroes. They inspire me. Every time we do this, it doesn't get any less emotional.

Dan Wallrath with Captain Jason Vest and his family in front of their new home in Centerville, TX.

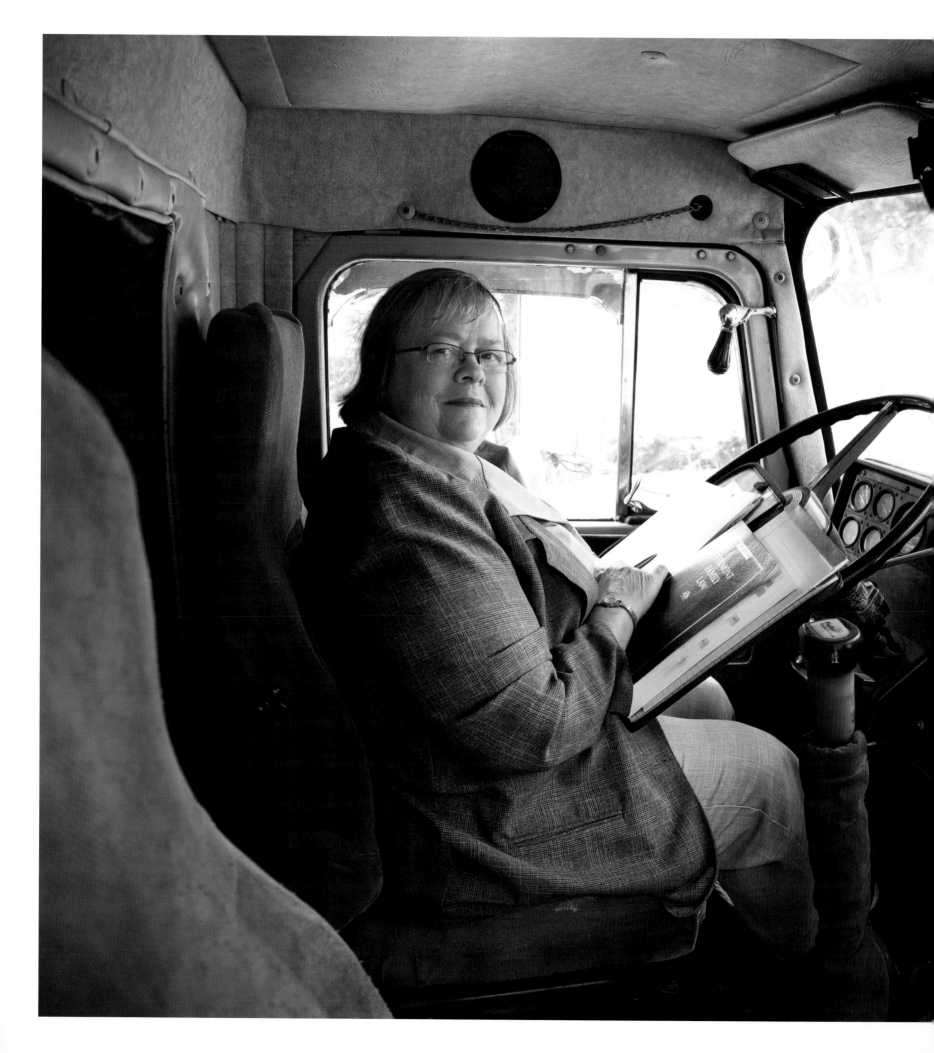

Wynona Ward

Founder and Executive Director, Have Justice–Will Travel

When most of us think of Vermont, we picture the abundance of nature: the snow-covered pines, the rolling hills of farmland, the leaf-strewn winding roads, the charming red barns and B & Bs. Wynona Ward knows a very different Vermont, one that is littered with dark secrets, often kept for generations, where winding roads lead only to hidden suffering and imprisonment. Ward knows this because she grew up on one of those back roads in a home filled with violence and neglect. Unlike so many others in her situation, she escaped the abuses of her childhood, and then returned to try and save others like her. Ward started her nonprofit legal practice, Have Justice—Will Travel, in 1998, the year she graduated law school at the age of forty-seven. Her mission was clear: to represent Vermont's forgotten battered women and children, and prosecute their abusers.

It's hard not to wonder if there was some special reason that Ward was able to rise out of her nightmarish beginnings to achieve so much with so little. Perhaps one piece of the explanation is the man she's been married to for forty-two years. Ward started going steady with Harold in the eighth grade, and they married at eighteen. For sixteen years they drove a truck together, hauling everything from Cirque du Soleil set pieces to Disney on Ice, back and forth across the country, before Ward decided to pursue her legal career. Driving a big rig with your old man may not have the most romantic ring to it, but somehow when Ward describes it, you get a glimpse of the genuine love, humor, and closeness the couple share. Sometimes all it takes is one person to change the trajectory of a life. Perhaps Harold was that one for Ward. And now Ward is that one for thousands.

Wynona Ward in her truck in Vershire, VT.

We were very poor growing up outside of a very small town in Vermont. My mother worked as a school lunch cook. My father worked in the quarries and copper mines. He was an alcoholic and he sexually and physically abused my mother, my three sisters, my brother, and me. He married my mother when she was only fifteen and pregnant. As he became older he was unable to walk due to a repeated leg injury and eventually had to have both his legs amputated, which confined him to a wheelchair in the last years of his life. Despite the abuse, my mother never left him.

I was considered the "smart" one of my five siblings by my father. And that's how the whole family came to view me. So, when there were family problems, even with my parents, whether it was finances or some other issue, everyone came to me to help solve it. This was true even when we were all older and living on our own. So in 1990, when my brother was accused of abusing a child, it was no surprise that I was the one my two younger sisters called for help.

That was really the first time that we all sat down and discussed the fact that we had been abused by our father. I did some research and found that the sexual and physical abuse of spouses and children went back five generations in my family. I just thought, "This has to stop."

My mother, father, and older sister sided with my brother, in that classic way that incestuous families often try to cover up the abuse; but my two younger sisters and I simply refused to do that. It really divided our family. I offered to step in and advocate for the child who had been assaulted and her parents. I had no formal training in social work or law at that point. In fact, I had dropped out of college when I was twenty-five because I couldn't afford it and had been on the road working with my husband, who drove a truck, for some years. But I felt I needed to try and help, so I sort of acted as a medium between the family and court system. I was with the victim during depositions and my sister and I made sure that she was in therapy. The family actually lived with me for a while. They were very poor.

My brother was eventually convicted of aggravated sexual assault of a minor under ten. I knew prison was the only place where Vermont offered free therapy or treatment and I asked him to get help. At first he refused and kept denying what he had done. Then he asked for a medical

parole because he had failing kidneys and was on dialysis. I protested that along with my younger sisters and his parole was denied. After he lost his appeal, my father died. He had been the one who always told my brother to deny what he'd done, no matter what. Once my father was gone, he finally admitted what he had done and started treatment. As part of that, he had to make a list of all those he had abused, and he had two dozen or more. We actually corresponded while he was incarcerated and I visited him for a while. We talked about the abuse that both of us had suffered in our childhood. But he ended up passing away in prison because he had heart problems as well as kidney problems.

"*Vermont is a largely rural state, so I spend a lot of time on the road, traveling to very remote areas to reach women who have really been isolated by their abusers. It's essential for those women to know that there is help out there for them, and that's really what Have Justice—Will Travel is all about.*"

Going through the whole experience of my brother's trial made me realize that I wanted to help other children who had been victimized, and the best way to do that was through the law. So I decided to return to college and get my degree. I went to Vermont College of Norwich University, which was an adult degree program. I could do the course work in the truck and then mail it in. I studied child development, adult development, and abnormalities in family psychology. I learned a lot about what was happening in my family. I graduated in 1995 and enrolled at Vermont Law School the following fall.

I got off the road when I started law school and a year later my husband decided to stop trucking as well, and switched to plumbing and heating work to be closer to home. In my third year, I realized, "Gee, I'm going to have

almost seventy thousand dollars' worth of loans to pay off. Who's going to hire a little old lady with no experience?" So, I applied for some fellowships and received one from the Equal Justice Foundation, a national organization that helps law-school graduates who want to go into public service law but need help paying their loans. It paid about half of my debt.

It was through that fellowship proposal that I first came up with the idea of Have Justice–Will Travel. While in law school I had already been researching domestic violence in my community. As part of that, I'd sat down at the local county courthouse and read all the affidavits for one year. There were more than two hundred submitted by women and men—and some on behalf of children—that sought restraining orders against their abusers.

I was shocked to realize that women were still being hit, kicked, beaten, and strangled the same way my mother had been forty years before. Many of these women didn't even have a high-school education and they were extremely poor. Because it was usually their abuser that held the purse strings, they had no way of affording an attorney. So they were being forced to stand up in court by themselves, with their abuser sitting a few feet away, and try to litigate for their own safety and their children's safety against an experienced lawyer. I began thinking about what could be done about this. And I thought, "Well, number one, they need a way to get back and forth to court. And they need someone to represent them in the courtroom." And it just popped into my head: "I'll start my own legal service and call it Have Justice–Will Travel."

In 2000, I got a three-year fellowship and that allowed me to formally incorporate and become a 501c3 nonprofit. One of the problems I first faced when I started Have Justice was that I had forty clients almost instantly. You can't easily represent forty clients on your own and do a good job. And the most important thing was to have a quality reputation. So, I started offering consulting services as an alternative to some people to help them represent themselves in divorce, child custody, child support, and visitation. That program has now evolved into what we call LEAP, the Legal Empowerment Assistance Program. We help people represent themselves by giving advice and guidance over the phone from the beginning to the end of their case.

Once I could afford it, I hired other attorneys to work with me and was able to start paying myself as well. We depend on individual donors

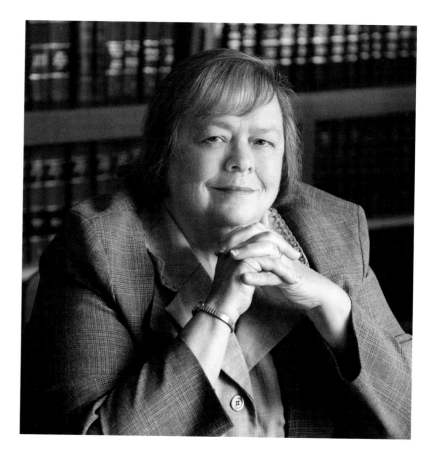

for support, as well as grants from private foundations. I pay my attorneys and I pay my employees, but all the services we provide for people are free. We have three offices throughout the State of Vermont now, and part of my strategic plan is to expand throughout the state with a couple more locations and then replicate the practice in other states. It's a great model for rural services. I'm very proud of the fact that 90 percent of the people we have worked with do not return to their abusers or go on to other abusive situations.

Part of the way we've achieved that percentage is through establishing our Women in Transition Life Skills and Mentoring Group. Each session includes eight meetings dedicated to supporting and educating women about domestic violence, the legal system, parenting issues, health care, and financial and job planning. The most wonderful thing is that the women mentor one another and develop friendships.

Vermont is a largely rural state, so I spend a lot of time on the road, traveling to very remote areas to reach women who have really been isolated by their abusers. It's essential for those women to know that there is help out there for them, and that's really what Have Justice–Will Travel is all about. We provide for those that don't have the access or resources to provide for themselves. We let them know they're not alone.

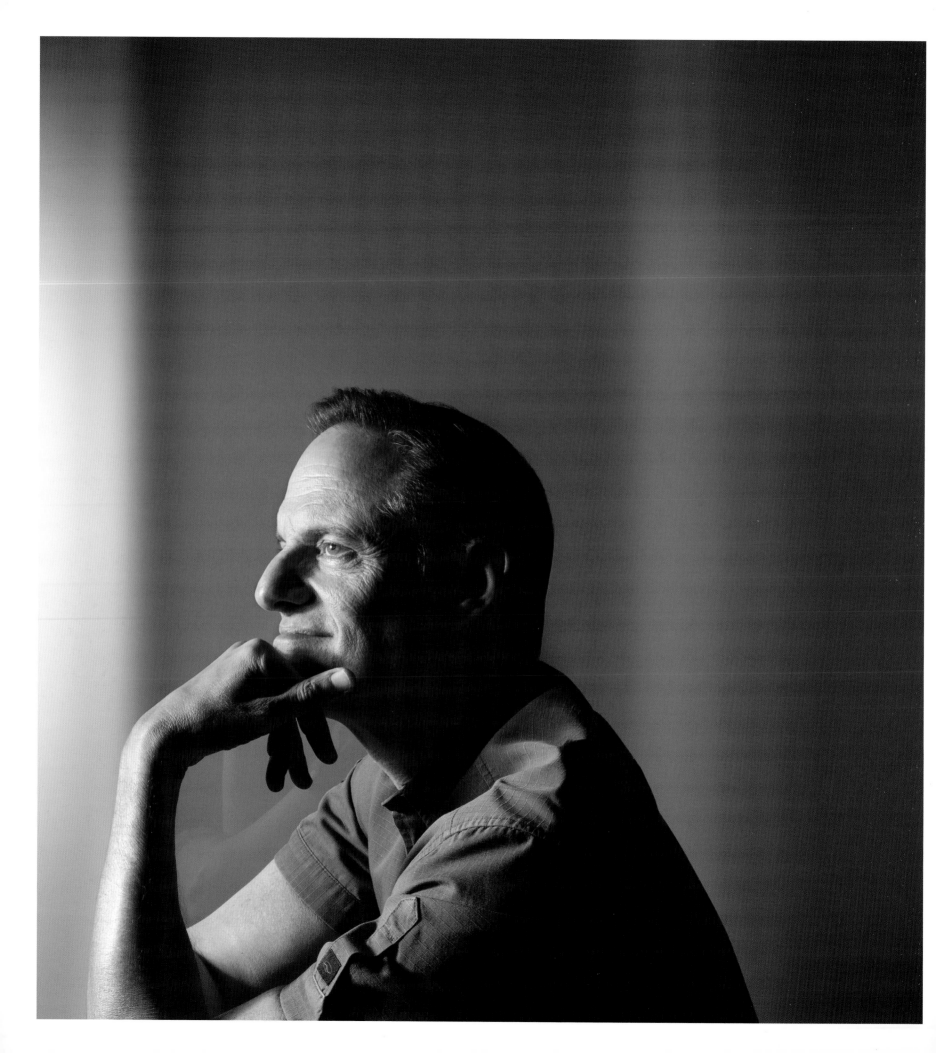

"When AIDS appeared, we needed people who were tough enough to really deal with what was happening. There were bombs exploding everywhere and you had to just figure out how to clear a path through it. It was brutal. I didn't even know that I was tough enough, but it turned out I was."

Michael Weinstein

Co-Founder and President, AIDS Healthcare Foundation

Michael Weinstein's rebellious streak started in his teenage years and is still going strong. A lifelong activist, Weinstein took up the gauntlet for a number of causes before he found his true calling as an advocate for people with HIV/AIDS. In 1986, as AIDS was decimating the gay community in Los Angeles, Weinstein joined a small group of activists who committed themselves to "fight for the living, and care for the dying." Soon after, he co-founded the AIDS Healthcare Foundation (AHF) with a mission "to provide cutting-edge medicine and advocacy, regardless of ability to pay." Today, AHF is the largest nonprofit global HIV/AIDS organization and cares for 175,000 patients in twenty-four countries. Under Weinstein's leadership, AHF has also become fully self-sustaining through a number of social enterprises—an epic feat when you consider their annual budget is half a billion dollars. As the face of AIDS has changed throughout the years, Weinstein has remained a fixture on the front lines. Reflecting back on thirty years of the virus last year, Weinstein wrote, "As much as things have changed, the essential elements are the same—love, compassion, and fighting for what's right—and always believing that this battle can be won."

I t's sort of an apocryphal story, but it happens to be true that I started out building this organization by going around with a clipboard and a coffee can to meetings. I met with every person who I thought would be interested in AIDS in Los Angeles. I asked if they would grant me a few minutes—people in the gay community, people in health agencies. I operated out of my house. I tell that story a lot to grassroots nonprofits because they often feel very beleaguered. We now have fifteen hundred employees worldwide and an annual budget of over $500 million. In the not too distant future, that will exceed a billion dollars. We're celebrating the twenty-fifth anniversary of AHF.

So far this year, I've traveled sixty thousand miles. I did a tour of eight countries in twenty-one days. Just in the last ten days, I've been in four states. I joked recently that AHF's agenda has finally caught up to my ADD. There's nothing I enjoy doing more than working. I don't feel like I'm sacrificing anything. I was an army of one at the beginning. And now, I get to delegate to all these talented people, and it's fabulous.

I was born and bred in Brooklyn. My family was financially humble.

My father sold potato chips and pretzels to movie theaters. I had a fairly sheltered childhood. I always hated school. I was bored out of my mind and I was a rebellious kid. By the time I was in high school, I was very engaged in grassroots politics. I went to the High School of Art and Design in Manhattan. It was extremely diverse and free-spirited. And also, it was very gay, which was something that I was not aware I was yet. I was socially awkward. I remember feeling like the only virgin in the school. This was 1968, and I was really active in civil rights and the anti-war movement.

My parents were generally supportive of anything I wanted to do, but one time I was at a sit-in at the Housing Authority with a group that was primarily African American. I was the only white person there and I wanted to show that I was as fierce as they were and I was going to sleep over. My parents demanded that I come home. We had a big fight about that one. I ended up dropping out of high school when I was sixteen.

I became involved in an activist group that sent me to California to liaison with other organizations in 1972. In LA, I got involved with what is now called the LA Gay and Lesbian Center. I hadn't come out yet and I did

Michael Weinstein at the AIDS Healthcare Foundation office in Los Angeles, CA.

the proverbial walking around the block a couple times before I screwed up the courage to go in. It was a revelation to be in that environment.

After a few years, I moved back to New York and worked a bunch of odd jobs. It's like that line from *Office Space*: "Bob, it's not that I'm lazy. It's that I don't care." Work was just a way to pay the rent. I'd gotten my GED some years earlier, and I finally decided to go college when I was twenty-eight. I was studying architecture, but I knew that it was a heartbreaking career and people should only do it if they absolutely had to, and I realized I didn't have to.

By 1986, I had moved back to LA. Prop 64 was on the ballot in California to quarantine people who were HIV positive. My friends persuaded me to get involved. We organized a march on the headquarters of Lyndon LaRouche, who was sponsoring the initiative. We got Patty Duke, who was the head of the Screen Actors Guild at the time, to endorse it, as well as politicians and religious leaders. We handed out 65,000 flyers on windshields and in bars and restaurants.

We had no idea what the response would be. We rented a hall that could fit five hundred and four thousand showed up. That initiative was defeated. We had stopped something terrible from happening but people were still dying in the hallways of county hospitals and on the streets of Los Angeles. The average life expectancy if you had AIDS was thirteen months.

"The organization as a whole is extremely diverse on all levels. We've come from providing end-of-life care to having a vision of global AIDS control, which we think is feasible, if there's the political will."

We felt the least we could do is give people a dignified death. So, we created the AIDS Hospice Foundation. We didn't intend to provide direct services, just to be an advocacy organization and to harangue the county. The chair of the Board of Supervisors at the time thought the best way to deal with AIDS was for gays to turn straight. People were terrified of AIDS and there was not a lot of common knowledge about it.

I got a call one day from a supporter who said, "There's this hospital near downtown LA on twenty-six acres. We want to turn it into an AIDS hospital and hospice." It was gorgeous.

We decided to open up a residential hospice. That was complicated by the fact that we had to get a law passed in order to get the license for it. We found a private donor to fund us and then we went to the city to help complete the construction. Eventually, we convinced the county to give us the money to run it. We named it after the co-founder of the organization, Chris Brownlie, who was my best friend, and he had AIDS. Chris was very much of a persuader and heartfelt speaker. He was the front man and I was behind the scenes. His struggle with AIDS formed a lot of what we did. He only lived for about a year after we opened.

In 1990, we decided to grow from hospice care to opening clinics. The life expectancy started to improve. There were treatments available for the various related infections. We changed our name to the AIDS Healthcare Foundation.

Then came the advent of the cocktail in December of 1995. We were operating three twenty-five–bed facilities. We were ecstatic about the fact that people were living. All of a sudden, we were administering these drugs and people were going home and doing well. No one had ever left before. We felt we had a moral obligation to give the cocktail to our patients, but we had no means to pay for it. The state didn't start subsidizing it until the following July. We were very close to bankruptcy. Once we survived that financial crisis, we realized we needed to bring as many into the lifeboat of care as we possibly could. We went national.

In 2000, I decided to attend the International AIDS Conference in Durban, South Africa. I'd never been to Africa before and I was fairly ignorant. I had bought the line that there wasn't enough infrastructure to treat people in the developing world. It was really an eye opener, talking to activists there. I was approached by a local AIDS organization there that desperately needed help. We agreed to open up a clinic in a large township just outside of Durban, which is the epicenter of AIDS in the world. It's

the furthest distance that you can go from Los Angeles without starting on your way back. I then received an invitation to meet with the president of Uganda, who was waging a war against AIDS and had brought down infection numbers there. So, we started a clinic there, as well. That was the beginning of our global program.

> *"When you've seen countless people die, of course the question in your mind is 'Why not me?' If I were a more spiritual person, I suppose I would believe that it's because I had another purpose. But I don't dwell on those kinds of things a lot. I'm always asking the question, 'What's next?'"*

The biggest issue we had was the price of the drugs. The cost of medication per patient was $5,000 a year. We were in weak financial shape, but we decided that we would treat 100 patients in South Africa and 100 patients in Uganda. We knew there was no way that this could be expanded without bringing costs down. So, we sued the drug maker, GlaxoSmithKline, and spearheaded a huge international advocacy effort. We won. Now we pay as little as $64 a year for a regimen of antiretrovirals. We went on to set up bureaus in Africa, Eastern Europe, Asia, and Latin America. Today, we have about 166,000 patients worldwide. Advocacy has always been at the core of what we do, and it still is.

About twelve years ago, I decided that begging for government grants and donations was not the way to go. We started focusing on developing social enterprises that would allow us to fulfill our mission and be sustainable. We have since opened twenty pharmacies, which represent the lion's share of our budget. We also have a chain of Out of the Closet thrift stores. We went from grants being virtually 100 percent of our budget to being less than 5 percent. The organization as a whole is extremely diverse on all levels. We've come from providing end-of-life care to having a vision of global AIDS control, which we think is feasible, if there's the political will.

We have our mission statement: cutting-edge medicine and advocacy regardless of ability to pay. Behind that is something I call an organization's article of faith. I'm not saying that in a religious sense per se. But the value that we hold dearest is protecting the public health and raising people's awareness about the ability of the world to fight diseases. Our legacy is elevating global public health into the pantheon of important issues, like women's rights, the environment, poverty, democracy.

Around the time that we launched this global program, I had the realization that this was my life's work. I had this audience with the president of Uganda and this voice in my head was saying, "You're just a kid from Brooklyn. You've got a helluva nerve telling the president of Uganda how to deal with AIDS in his country." And then another voice, saying, "Shut up. You've done well." When we started to roll out globally, seeing that impact reinforced to me the singularity of the contribution we could make.

AIDS from a personal point of view is a nightmare without end on the one hand and a miraculous opportunity on the other. If this had not come along, would I ever have really explored these dimensions of myself? When AIDS appeared, we needed people who were tough enough to really deal with what was happening. There were bombs exploding everywhere and you had to just figure out how to clear a path through it. It was brutal. I didn't even know that I was tough enough, but it turned out I was.

People don't do a lot of things if they think they can't or that the world won't allow them to. When actually, if you get out there and start doing it, you realize that doing the right thing does matter. You realize that there is such a thing as moral authority, that you will attract to yourself the people who you need to help you in order to accomplish these things. And that people will want to do the right thing, they just don't know how or where to go to do it.

When you've seen countless people die, of course the question in your mind is, "Why not me?" If I were a more spiritual person, I suppose I would believe that it's because I had another purpose. But I don't dwell on those kinds of things a lot. I'm always asking the question, "What's next?"

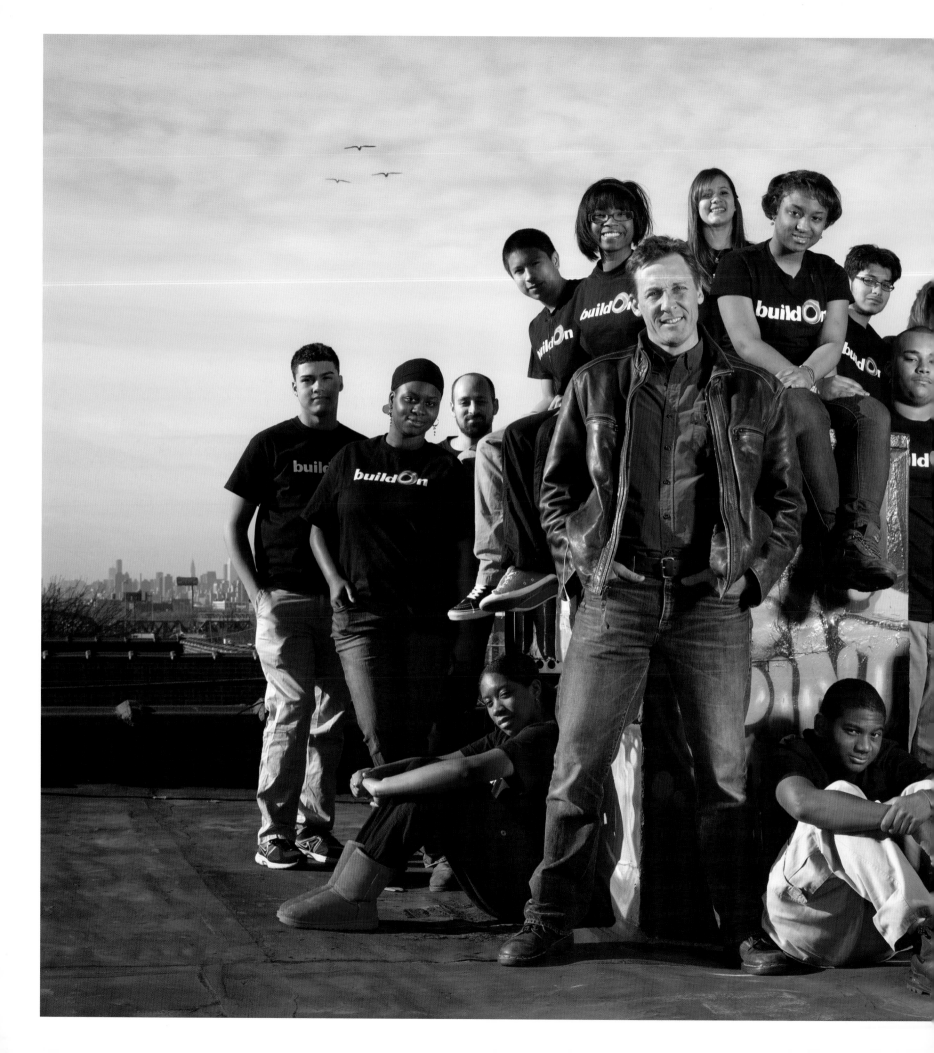

*"Why do I believe these kids can change
the world and change their communities?
Because I see them do it every day."*

Jim Ziolkowski

Founder and CEO, buildOn

**How does a small-town boy from Michigan make it his life's work
to take students from the roughest urban neighborhoods in America
to build schools in the poorest communities in Africa? In Jim
Ziolkowski's case, it took a mix of curiosity, courage, and the opti-
mism of youth. He was only twenty-three years old himself when
he began mobilizing America's inner city kids to transform their own
neighborhoods and the world. Working simultaneously on opposite
sides of the globe, Ziolkowski's nonprofit, buildOn, engages at-risk
high school students in social activism, while partnering with remote
villages in developing countries to build schools.**

I went to Michigan State University and majored in finance. I worked
hard in college, and when I graduated in 1989, I had a great job offer
from GE. But I decided to take off a year to travel, and I backpacked,
mostly alone, through Europe, Australia, New Zealand, Thailand, India,
Nepal, China, Mongolia, and Siberia.

During these travels, the most profound experience occurred during
a twenty-seven-day hike in the Himalayas in Nepal. Soaking wet from the
rain, I stopped in a village to dry off, and the community was in the midst
of a two-day celebration for the opening of a school. For the last several
months, in some of the poorest countries in the world, I had seen suffering
unlike I had ever imagined—beggars without legs holding out their tin
cups in quiet desperation; men with leprosy baring their ghastly abrasions
beneath the hot sun; children scavenging for food on top of mountains of
waste. But in this village I saw something different. I saw the hope and
courage of a community, and it all revolved around education.

When I got back to the United States, I began my job at GE. The

Jim Ziolkowski with students from a buildOn school in the Bronx, NY.

work was challenging—everything I hoped it would be—but I could not shake those memories from abroad, those images of extreme poverty. They struck a deep spiritual chord.

My parents were devout Catholics, and my father had introduced me to liberation theology, which interprets the goal of Christ as the liberation from unjust social conditions. I thought of Christ as a nonviolent revolutionary who gravitated to the "outcasts." The poor. The hungry. The homeless. Christ's job was to lift them up, and I realized that I wanted to try and do the same. I wanted to live my faith, so I quit GE after fourteen months and my younger brother Dave and I started a nonprofit organization with a clear mission: to break the cycle of poverty, illiteracy, and low expectations through education and service. We wanted to build schools in developing countries while also running after-school programs in America's toughest inner cities.

It was a crazy idea. Neither Dave nor I had any relevant experience, and most friends and family were certain we would fail. There were many times I had my doubts, too. Every potential donor said no. Seven months after I had quit GE, we still couldn't break ground on our first school, even though we had talked to hundreds of high-school kids about joining us. They wanted to improve their neighborhoods through community service; we just couldn't find investors who felt the same way. Then, I received a fax from an organization we had partnered with to identify an African village—Misomali in Malawi—where we could build one of our first schools.

Our partners announced to the village that we were coming . . . and the villagers broke out in song and dance. Dave and I were sinking. We had not raised a penny. The last line in the fax said, "Needless to say, if you fail, they will be equally disappointed."

We were doomed, but what I've learned over the years is that even at your lowest point—and this was one of my lowest—there is always a way. We held a last-ditch fundraiser and somehow scraped enough dollars together to keep going, and we've never stopped.

We went to Misomali to build our first school in Africa. At the time, the HIV/ AIDS infection rates were between 30 and 50 percent nationally. Malaria was taking even more lives. Malnutrition killed many others. The dictator had just been overthrown, and the government was in chaos. In Misomali itself, one of the leaders, seeking political gain, had turned much of the village against us. Then I almost lost my life to malaria. But by the grace of God, my brother was there to drag my unconscious body to one of only two hospitals in the whole country. The doctor explained that if I had waited another two hours to come in, they wouldn't have been able to save me.

Walking back into the village alone a week later, I realized that when these people get these illnesses, especially the kids, they don't make it. We had dedicated ourselves to living in mud huts and working side by side with the community to build schools. We'd felt like we were walking in their shoes.

But that was an illusion. They could not afford to make it to a hospital or get urgent medical treatment. I felt strongly that education was the first step out of extreme poverty. We had to finish building the school in Misomali, despite the challenges. My best friend there was a farmer named Steven, who was with me on the worksite every single day. His daughter Ruthie was newly born, and when I saw Steven holding her in his arms, I knew what was at stake. We finished the school.

In many ways, Misomali was the turning point, because the experience helped us develop the methodology on how to build schools going forward. To construct any buildOn school takes two to three thousand volunteer workdays. Villagers contribute all the unskilled labor. They form leadership committees of six women and six men. They spearhead the project. We provide all the materials, an engineer, and a small team of skilled laborers that works with them in the village, but they do the real work.

By the time we were done building the first round of schools, I'd spent three years living in Africa, Asia, and South America. In 1997, I came back to work with high school students in a more meaningful and effective way. I didn't feel qualified to run programs for inner-city kids because I came from a small town in Michigan, so I moved to Harlem into a half-boarded-up brownstone. I spent three years in what the New York Times called the worst drug trafficking neighborhood in the city.

What I learned by living there is that these youths have lost a sense of control over their own lives, but they have not given up. They don't want to escape; they want to transform their communities. When they're

empowered, there is nothing that can stop them. We're working in more than one hundred urban high schools in America, from the South Bronx to Detroit to Oakland, to cities in between. We implement a service curriculum and work closely with the administration and teachers. In schools where only 50 percent graduate in four years, 95 percent of the seniors we work with not only graduate but they also go to college.

They map out their own community service and decide what issues are most important to focus on. They work with elders, homeless people, younger children, veterans, and folks with disabilities. They plant gardens, paint murals, and tackle environmental and food-security issues. They also build schools in developing countries. They have contributed more than one million hours of service, and they've touched the lives of 1.8 million people.

I emphasize to our students—we are not a charity. We are a movement, and our goal is to help others help themselves.

We just finished building our 500th school worldwide, and we currently construct schools in Haiti, Nicaragua, Nepal, Senegal, Malawi, and Mali. There are 73,000 children, parents, and grandparents attending these schools every day.

I recently visited Malawi. I was with a team of sixteen kids from

the South Bronx, the poorest congressional district in the United States. We rolled into this village, and hundreds of children started singing and dancing and swarming us. Half of our students were in tears. The first thing we did was sit down and have the entire community sign a covenant that outlines the villagers' contribution to building the school and their promise to send their daughters to school in equal numbers as their sons. It's a huge cornerstone of our methodology. Very few people in the village could even sign their own names, so they used thumbprints.

One of the kids from the Bronx was a sixteen-year-old named Gimy (pronounced "Jimmy"). He had joined a gang when he was just nine. One of his role models was currently in jail for murder; the other was murdered. His mom had recently died from leukemia. This was a kid who could really go either way—he was at a crossroads. And now there he was, in Africa building a school for children who were even more impoverished than he was. One of the elders in the village introduced Gimy to a boy who had also lost his mother. Gimy embraced this kid and said, "We got to finish this school. Our mothers are watching us right now. We got to make them proud." He was so emphatic, so earnest, when he said this. That's what this program is about. Why do I believe these kids can change the world and change their communities? Because I see them do it every day.

While I was in Malawi, I returned to Misomali, where we built our school twenty years ago. Since then, the village has constructed four more schools on their own. Now, instead of 150 kids, there are more than 1,000 kids attending school: 533 of them are girls, and four of the five chiefs from that region are women. This is unheard of. They have clean water. Some homes are built out of concrete, not mud. Electrical wires have also been hung. Seeing this was mind-blowing, but the highlight was seeing Steven, still fit and in good spirits. Then he introduced me to Ruthie, now a beautiful young lady. She attended our original school, plus the other four schools in the village, and then she went to secondary school. She is now a teacher, and Steven is a proud father. "I'm an illiterate man," he told me, "but my daughter will lift up our family name for generations."

Heroes among us? Steven is the hero. And Ruthie. And all the kids we work with—in this country and abroad—who overcome great odds to help other people. They're the heroes.

> *"My relationship with my mother changed and deepened as I spent more and more time caring for her. There is something about laboring for someone, attending to their needs, that fosters closeness, love, and compassion."*

Irene Zola

Founder and CEO, Lifeforce in Later Years (LiLY)

Irene Zola's organization Lifeforce in Later Years (LiLY) reaches out to people whose voices are weakened with age. Some are isolated, some require help with home or health-care management, some are simply lonely and starved for companionship. LiLY helps connect seniors to these services and reminds them they are not alone. Zola became aware of the neglected needs of this often forgotten population as she began caring for her aging mother, Faye, in the final years of her life. When Faye passed away in a nursing home, Zola was moved to found LiLY, which provides the support seniors need to continue living at home. Her first program, Morningside Village, pairs elders with local volunteers in her Upper West Side neighborhood of New York City.

When my mother was in her nineties, it was clear that she needed help. She was living in a suburb of New York City next door to two of my sisters, who were looking after her. She started having a fall every year or two. She would only go out at night with her walker because she was embarrassed to be seen using it. When I heard that, I went out and got a secondhand car the next day so I could drive out to see her and walk with her.

Through Mom, I found out the amount of shame that our seniors feel about being old. The walker is viewed as the crowning glory of dependence and a symbol of the decline. People often don't like it known that they're living alone or that their family isn't helping them. And those who do have family don't want to be a burden to their loved ones. There is also fear that the family will have them put in a nursing home if they're struggling.

My mother and I walked together for two years. And that time together brought us closer. We would confide in each other in ways that we hadn't over the many years. Later, when she was bedridden, I would jump into bed with her and we would tell jokes. My relationship with her did change and deepen as I spent more and more time caring for her. There is something about laboring for someone, attending to their needs, that fosters closeness, love, and compassion.

When Mom had a stroke, we felt we had to put her in a nursing home. Half of her body was paralyzed, and she wasn't swallowing or speaking. We didn't know how to take care of her. When I went back the evening after she'd been admitted, my husband and I found her in urine-soaked clothing. It took nearly an hour for an aide to come in and change the bedding. After that, I was at the nursing home every day.

Because I spent so much time there, I could see what the other patients went through as well. It was quite obvious that many of the residents were there because there was no care at home, not because they needed medical care. Many of them were on psychotropic medication to control agitation and depression, which increases in nursing homes. There was a study done in Florida nursing homes, which revealed that 70 percent of residents were given psychotropic medication within three months of admission.

I also learned that one caregiver was responsible for eleven patients. So, every morning, one aide would have to go around and wake up eleven patients, groom them, and get them into the dining room. Which meant putting them in a wheelchair, and lining them up in a hall, one at a time, until breakfast was ready. The first patient they'd work on would have to sit there waiting for an hour or two until everyone was

Irene Zola with one of the members of Morningside Village on the Upper West Side in New York City, near where the organization is located.

in line. It would often happen that my mother would finally get into the dining room, but her teeth wouldn't be in, her glasses wouldn't be on, and she'd be left three feet away from the table with nobody to feed her. The family started taking turns at mealtime when we realized what we were up against.

Every day, I would find new things to become upset about and I was treated as if I was interfering. It was maddening.

It was the rare patient that got even a weekly visit from a family member. I remember one day, I saw a woman say good-bye to a visitor in the lobby, and then turn her wheelchair to the wall and start sobbing. I asked if she needed help and she said, "No." Obviously, she was crying because her visitor left her in the institution to face the daily drudge. It was just heartbreaking.

My mom had been in four different traditional nursing homes before this for short stays in her later years. She'd broken her arm, her leg, her shoulder, her rib. Each injury required a few weeks of residential rehab. When she fractured her shoulder, she couldn't hold on to the walker to support herself, but her feet and legs were fine. Nobody was available to help her walk, so she was a prisoner in her bed. She had all this energy and interest in keeping her body vital and wanted physical activity. She succeeded one night in getting herself out of bed and she was found on the floor. Their solution was to tie her in a chair in front of the nurses' office so she wouldn't try it again. I got there at 6:30 the next morning because her roommate called to tell me my mom had been screaming all night. That was just inhumane and unconscionable. The next day my sister and I took her home and spent the money on a home health aide.

The last time I checked, the average turnover of personnel in a typical nursing home was 78 percent per year. Many aides don't even read the charts. They work in twelve-hour shifts and are paid very low wages. They're given too much to do. You put those things together and you're going to have poor care.

In the last home, there were a lot of aides from Ghana. I got to know one of them and I remember her telling me, "We don't have nursing homes in Ghana. When someone gets sick, the family arranges to take care of them in shifts." And then I talked to aides from Puerto Rico, Chile, and China who all said the same thing. I realized this is very much an American convention: to send an old person to a traditional nursing home, where the family thinks they're doing the right thing, especially when they live far away and aren't there to see what's really going on.

I had decided that I would like to find some way to have my mother with me at home during her last three months of life. She had started being able to swallow and eat again. We had a room readied for her with a bathroom connected. I tried to get Medicare and Medicaid to help with a live-in health aide. I was told by Social Services that I would be lucky if I could get twelve hours a day of care. She died before the paperwork process was finished.

After she died, I thought a lot about what went wrong for my mom. And, by extension, what went wrong for all those other people I'd met in her nursing home. Before I began caring for my mother, if an elderly person was in front of me at the supermarket, picking pennies out of an old-fashioned wallet, I would have thought, "I wish they would hurry up." But those people started looking like my mom to me. They became visible. I'd never noticed seniors on the street, and suddenly I started to see them everywhere. So, seeing is really the first step.

I wanted to do something to change eldercare. My initial ideas for an organization were out of anger at the condition of many American nursing homes, like a rating system. But I realized that wasn't coming from a very positive place. I was sitting with my friend Wendy Darby one day, and she said, "Why don't you do something where we care for people in their own neighborhood?" I researched elder villages and found that they all used a membership plan where seniors had to pay for services. It just struck me as wrong philosophically that we would charge money to help seniors with their small needs—like going to the market or reading a book, when they had helped us learn to read and write, to pick up a knife and fork, to play the piano. So I decided to create a new nonprofit model that was completely free of charge.

We settled on the name Lifeforce in Later Years (LiLY) for the organization, and Morningside Village was what we called the first community program. The idea was to build a neighborhood network of volunteers to help people age in their own homes comfortably.

I borrowed a portable table from my block association and sat out on the street handing out fliers I'd made with help from a friend who is a graphics person. I just kept asking people to be involved. I started talking a blue streak about the Village and LiLY, morning, noon, and night.

A local church gave us some space to hold our first volunteer meeting, in June 2009, and only seven people showed up. Instead of filling up the room, we filled a table. I knew we couldn't solicit for seniors unless we had volunteers to help them. We spent that summer practicing with seniors in a local nursing home and getting really geared up for another meeting in September. This time, we had a much better turnout—thirty people attended. That was the beginning. We were able to take in our first group of seniors, each of whom recommended three others who needed help. Word of mouth spread like wildfire.

"It just struck me as wrong philosophically that we would charge money to help seniors with their small needs—like going to the market or reading a book, when they had helped us learn to read and write, to pick up a knife and fork, to play the piano. So I decided to create a new nonprofit model."

Starting Morningside Village has meant a new 2-A.M. bedtime and being on the go from the minute I wake up. There are so many different aspects to consider. Coordinating the village requires a lot of hands-on day-to-day administration. We have about eighty-five volunteers and sixty-seven seniors now. Most of our seniors get one visit a week but some get several, depending on what their needs are. One of our seniors, for example, had a fall. She was extremely anxious about living alone but she didn't want to move from her home. She was in a state: she couldn't go out by herself because she needed an arm to hold. Since she's been with us, she's had a different volunteer seven days a week. The volunteer visits, has tea, and goes shopping with her. Sometimes they go to a doctor's appointment. Another one of our seniors contacted me *while* she was having a heart attack. One of our volunteers was there to talk to the EMS team when it arrived on the scene and to hold the patient's hand. Then, the volunteer accompanied the senior in the ambulance and through the intake at the E.R. Later that evening my husband and I visited her in the hospital, talking to her for an hour until she fell into a peaceful sleep. The next day, when her daughter arrived from hundreds of miles away, we were able to fill her in, and later to provide follow-up visits once she'd fully recovered.

Since we started, we've had requests from all over the nation from people who want to start eldercare villages of their own, or whose aging parents are in need. The high volume of people contacting us has made things a bit hectic; so, we've created village-building guidelines and posted them on our website. We refer people to those free of charge, and also mail out information to those who don't have computers. We don't have the personnel or the resources right now to provide oversight, but I'd love to be able to do that eventually.

What really gets me going in the morning these days is the idea of LiLY's visibility campaign. We've been working with a wonderful photographer who's taking stunning portraits of seniors with and without their caregivers. We hope to just plaster the city with these images to raise awareness. I'd love to see a National Nonagenarian Day, on which Americans honor ninety-year-olds.

I lost one mother, but now I have dozens of women who are very maternal toward me. One of them makes me homemade applesauce, another cooks me dinner. If I mention I'm going to a wedding, they'll call and ask me what I'm wearing. So, my family has expanded exponentially. It is serendipitous that I benefit personally from the relationships that I formed. Between the seniors and the volunteers, I almost have too many friends right now! When I walk down Broadway, sometimes I get stopped so many times that I choose to take the back way to get somewhere.

Our village is an idea, more than a geographical parameter, but we do have parameters. And, we're growing each year. Each year, a larger patch.

Afterword Paul Mobley

The heroes in this book have a different kind of a heart than some of us. In 2008, when I came off the life-changing experience of my first book, *American Farmer*, I felt I knew where all the "good people" were. But, if farmers are heroes (and they are), in *Everyday Heroes* we are talking about a different kind. Farmers keep to themselves. They're hard working. They've got a great sense of family. They're pure and honest as can be, but they take care of their own. In the case of these people, these heroes, as everyday and normal as they are, there is something about their heart and soul which is different. They want to help other people, and they have committed themselves to reaching out and trying to make a difference.

One of the first people I photographed was Dr. David Vanderpool in Haiti. It was not too long after the earthquake. I was concerned, to be honest, about going. My family was a little worried. I kept thinking of all of the vaccinations, all the preparation, knowing I was going to be sleeping on a concrete roof with no mattress, a mosquito net wrapped around me, and no clean water. Did I really want to go and do that? I remember speaking to my publisher about it and she said, "If you look back in a couple of years, are you going to feel regret that you didn't go?" I got on the plane.

I was a nervous wreck by the time I arrived until I saw what Dr. Vanderpool was doing in that clinic every day. There were all of these people— especially the children—lined up three, four, five hundred in a row, waiting patiently, and cooperatively, and respectfully. They had nothing; I mean half of them were naked . . . standing in the line, *naked*. I'm sitting there thinking, "You had better not complain about anything in your life again." And, then, my next thought was, "Man, if you thought *American Farmer* was a life changing experience, this book is going to shake you to your core."

I think that I'm a nice person. I think I'm reasonably giving. I don't feel I'm too terribly selfish—at least my mother doesn't think so. But, after getting to the house in Port-au-Prince—a shelter is a better way to describe it—where Dr. Vanderpool slept, I remember he said to me, "You know Paul, everybody does what they want with their life. I could have three big cars in the driveway. I could have a super big house and a couple of boats, but this is the work that I've chosen to do and it's what I feel is my purpose."

That really set the whole tone for this book. I wish the whole world could have seen what I saw, and heard what I heard, because we'd all be in a better place. Now, when my daughter acts a little too big for her britches I say, "Let's take a trip down to Haiti, you'll be straightened out in a weekend."

So the journey began. After *American Farmer* I was in a certain place in my mind, but now, it's all about gratitude. I walk the streets and do my work and feel very lucky that I am able to harness that gratitude. I have clothes and I can eat. But, there are a lot of people that I've learned about doing this book, who don't have anything close to that.

> *"Now it's all about gratitude. I walk the streets and do my work and feel very lucky that I am able to harness that gratitude. I have clothes and I can eat. There are a lot of people that I've learned about doing this book, who don't have anything close to that."*

There wasn't one person that I sensed was in it for the money or to be popular or famous. When they started talking about their core issue, you really felt like they just wanted to be doing the work. Adam Lowy just wanted to not let all that food from his moving business go to waste (no one shipped food to their next home). Taryn Davis, of the American Widow Project, had lost her husband, but felt compelled to carry on and help other

widows. Any person reading her story would be brought to tears—such a sad and tragic, tragic story. They were high school sweethearts. He went off to serve his country and she lost the love of her life. As soon as I met her, I could see it in her eyes, in her behavior, in her mannerisms. So sad, but there was such an optimism and a spirit to her. I remember arriving, crabby, to this remote part of Texas to photograph her and meeting her straightened me right out, as you can imagine. I had to remind myself very quickly, "No complaining." It was just a delayed airline flight. It wasn't the death of a loved one.

My greatest hope for this book is that it inspires people to pay attention to the work these heroes are doing. And, when I say pay attention, I don't just mean give money. I mean take the time to really look more deeply at what these people and organizations are accomplishing. It almost leaves you speechless.

I was awed by how committed they were, how dedicated and devoted. This wasn't like, "Oh, I'm going to do this for a year and if it doesn't work out . . . " No, it was, "This is it. I'm all in." Doc Hendley, whose organization, Wine to Water, is based in Boone, NC, was a guy who ran a nightclub and owned a bar, and then he was hit by the reality that so many people can't even get a glass of clean water. He told me that, in some of the countries he was working in, his life was threatened many times because he was trying to change things that were so cemented into that society. It seems to me that when most people's lives are threatened they might quit. Not him.

Like Doc, so many of the nonprofit leaders I photographed are incredibly young and ambitious. Their resourcefulness and imagination are refreshing and goes to prove that there are truly as many ways to give back as there are people in the world

Catherine Oppenheimer in Santa Fe has helped so many kids. The photograph I did of her was with almost one hundred children and they behaved for her like nothing I'd ever seen. "Children, it's time to be quiet now. Mr. Mobley is going to take the picture." You could have heard a pin drop. And she spoke to the kids in such a sweet, kind way. Young kids nowadays . . . they are a little different with their parents, but these kids clearly honored and admired her. And I thought to myself, "She must be doing something,

to turn that whole town around and to have all of those kids and parents love her the way they did."

And another thing . . . everything they touch turns to gold. Failure is not an option for them. Brahm Ahmadi from People's Grocery went from creating one nonprofit to another. He was just the sweetest man and all he did was talk about how he started this thing with one person, and how it grew and grew. Instead of telling me, "Paul, I just broke my back, I worked my whole life," he said, "It was no work at all Paul, because I loved it. I loved doing it—getting to water that flower every day and see it grow. It kept me going. It wasn't work for me. It was just what I wanted to do." The same was true of Jessica Jackley. They both went from one goal to another, because the next one was just a logical extension of the first.

"I wish the whole world could have seen what I saw, and heard what I heard because we'd all be in a better place. Now, when my daughter acts a little too big for her britches I say, "let's take a trip down to Haiti, you'll be straightened out in a weekend."

It would have been a mistake—a sad, terrible mistake—if I hadn't gone to Haiti. It helped me add another layer of compassion to the way I see the world and want to treat people. And, I don't think the photographs in this book would have looked the same if I hadn't gone. I looked through the camera in a different way after that experience.

What did I learn?

One person can really make a difference. You really, *really* can make a difference. If you're compassionate—and passionate about something—it will hopefully silence some of the fear you may have in giving it a try. If an idea is started and seen through, maybe it can grow into something amazing, as it has for the people in this book.

Everyday Heroes Nonprofit Directory

A New Way of Life Reentry Project
P.O. Box 875288
Los Angeles, CA 90087
323.563.3575
anewwayoflife.org

Academy for Global Citizenship
4647 West 47th Street
Chicago, IL 60632
773.582.1100
agcchicago.org

AIDS Healthcare Foundation
6255 Sunset Blvd., 21st Floor
Los Angeles, CA 90028
323.860.5200
aidshealth.org

Alex's Lemonade Stand Foundation
333 East Lancaster Avenue, #414
Wynnewood, PA 19096
866.333.1213
alexslemonade.org

American Widow Project
P.O. Box 1573
Buda, TX 78610
877.297.9436
americanwidowproject.org

Architecture for Humanity
848 Folsom Street
San Francisco, CA 94107
415.963.3511
architectureforhumanity.org

Back on My Feet
100 South Broad Street, Suite 1400
Philadelphia, PA 19110
215.772.1080
backonmyfeet.org

**Attn: Dr. Robert D. Bullard, Dean
Barbara Jordan–Mickey Leland School
of Public Affairs
Texas Southern University**
3100 Cleburne Avenue
Houston, TX 77004
713.313.6849
tsu.edu

Birthing Project USA
Attn: Kathryn Hall-Trujillo
2270 Wyoming Blvd., NE, Suite D-331
Albuquerque, NM 87112
504.482.6388
birthingprojectusa.org

Bright Pink
670 North Clark, Suite 2
Chicago, IL 60654
312.787.4412
brightpink.org

buildOn
P.O. Box 16741
Stamford, CT 06905
203.585.5390
buildon.org

Capuchin Soup Kitchen
1820 Mt. Elliott
Detroit, MI 48207
Volunteering: 313.579.2100 ext.213
or 313.822.8606 ext.10
Donations of clothing, food, furniture, etc.
313.925.1370 ext.100
Donations of money: 313.579.2100 ext.185
cskdetroit.org

CeaseFire
1603 West Taylor Street, MC 923
Chicago, IL 60612
312.996.8775
ceasefirechicago.org

charity: water
200 Varick Street, Suite 201
New York, NY 10014
646.688.2323
charitywater.org

Chicago House and Social Service Agency
1925 North Clybourn, Suite 401
Chicago, IL 60614
773.248.5200 ext.000
chicagohouse.org

Citizen Schools
308 Congress Street, Floor 5
Boston, MA 02210
617.695.2300 ext.1172
citizenschools.org

D.C. Central Kitchen and Campus Kitchens Project
425 2nd Street, NW
Washington, DC 20001
202.234.0707
dccentralkitchen.org

DonorsChoose.org
213 West 35th Street, 2nd Floor East
New York, NY 10001
212.239.3615
donorschoose.org

DoSomething.org
19 West 21st Street, 8th Floor
New York, NY 10010
212.254.2390
dosomething.org

Dr. Susan Love Research Foundation
2811 Wilshire Blvd., Suite 500
Santa Monica, CA 90403
866.569.0388
dslrf.org
armyofwomen.org

EARN
235 Montgomery Street, Suite 470
San Francisco, CA 94104
415.240.4477
earn.org

Endeavor
900 Broadway, Suite 301
New York, NY 10003
212.352.3200
endeavor.org

**FIRST (For Inspiration and Recognition
of Science and Technology)**
200 Bedford Street
Manchester, NH 03101
800.871.8326
usfirst.org

Getting Out and Staying Out
91 East 116th Street
New York, NY 10029
212.831.5020
gosonyc.org

Global Citizen Year
1625 Clay Street
Oakland, CA 94612
415.963.9293
globalcitizenyear.org

Harlem Children's Zone
35 East 125th Street
New York, NY 10035
212.360.3255
hcz.org

Have Justice—Will Travel
9580 Vermont Route 113
Vershire, VT 05079
802.685.7809
havejusticewilltravel.org

Health Leads
Two Oliver Street, 10th Floor
Boston, MA 02109
617.391.3633
healthleadsusa.org

KaBOOM!
4301 Connecticut Avenue, NW, Suite ML-1
Washington, DC 20008
202.659.0215
kaboom.org

Kiva Microfunds
875 Howard Street, Suite 340
San Francisco, CA 94103
828.479.5482
kiva.org

Landesa
1424 4th Avenue, Suite 300
Seattle, WA 98101
206.528.5880
landesa.org

Lifeforce in Later Years (LiLY)
PO Box 250402
New York, NY 10025
917.775.1199
lifeforce-in-later-years.org

Living Goods
220 Halleck Street, Suite 200, The Presidio
San Francisco, CA 94129
415.430.3575
livinggoods.org

Meals On Wheels Association of America
203 South Union Street
Alexandria, VA 22314
703.548.5558
mowaa.org

Mobile Medical Disaster Relief
5409 Maryland Way, Suite 119
Brentwood, TN 37027
615.221.1191
mmdr.org

Move For Hunger
Attn: Adam Lowy
1930 Heck Avenue Bldg. 1, Suite 1
Neptune, NJ 07753
732.774.0521
moveforhunger.org

National Dance Institute of New Mexico
1140 Alto Street
Santa Fe, NM 87501
505.983.7646
ndi-nm.org

One Day's Wages
541.402.1487
onedayswages.org

100 People Foundation
15 West 26th Street, #914
New York, NY 10010
212.252.8402
100people.org

Operation FINALLY HOME
1659 State Highway 46 West, Suite 115-606
New Braunfels, TX 78132
830.214.4224
babasupport.org

Pencils of Promise
37 West 28th Street, 3rd Floor
New York, NY 10001
212.777.3170
pencilsofpromise.org

People's Grocery
909 7th Street
Oakland, CA 94607
510.652.7607
peoplesgrocery.org

Playworks
380 Washington Street
Oakland, CA 94607
510.893.4180
playworks.org

Roots of Change
300 Broadway, Suite 20
San Francisco, CA 94133
415.391.0545
rootsofchange.org

The Clemente Course in the Humanities®, Inc.
7 Kingman Road
Amherst, MA 01002
clementecourse.org

The Harold P. Freeman Patient Navigation Institute
55 Exchange Place, Suite 405
New York, NY 10005-3304
646.380.4060
hpfreemanpni.org

The Mike Utley Foundation
P.O. Box 458
Orondo, WA 98843
800.294.4683
mikeutley.org

The Ray of Hope Project
1354 Ruan Street
Philadelphia, PA 19121
215.744.1039
rayofhopeproject.org

The Trevor Project
8704 Santa Monica Blvd., Suite 200
West Hollywood, CA 90069
Los Angeles Office: 310.271.8845
New York Office: 212.509.0072
If you are a youth who is feeling alone, confused
or in crisis, please call The Trevor Lifeline at
866.488.7386 for immediate help.
800.4.U.TREVOR
thetrevorproject.org

Upaya Zen Center
1404 Cerro Gordo Road
Santa Fe, NM 87501
505.986.8518
upaya.org

Wine to Water
P.O. Box 2567
Boone, NC 28607
828.355.9655
winetowater.org

Youth Villages Operations Center
3320 Brother Blvd.
Bartlett, TN 38133
901.251.5000
youthvillages.org

Acknowledgments

FOR MY TWO PRECIOUS DAUGHTERS, CAMDEN AND PAIGE.

Paul & Vivian Diamond — This book would not have been possible without you. Thanks for your gracious hospitality, friendship, and constant support. The best friends a person could ever have.

Lessandra MacHamer — My favorite producer. Since we met at NBC, your friendship has meant the world to me. I look forward to our exciting projects together.

Walter Farynk — My mentor. I know you're looking down on me saying, "Good isn't good enough." I've used your lessons to guide my career, and will continue till the day I put my camera down. I was lucky to have learned from you.

Richy Ferrell — The retouching work is exquisite. It was a true pleasure working with you.

The entire team at Welcome Books — Katrina Fried: for making my subjects "come to life" with your gift for words and brilliance for storytelling; Lena Tabori for believing in me since Day One; Emily Green for being the best point person I could ever ask for. Thanks for coordinating my insane schedule seamlessly, and smiling all the way thru! And finally, my designer Gregory Wakabayashi, whose amazing talent continues to astonish me every day. Your vision and support has been one of the highlights of my career. I am so grateful to have worked with you.

For their guidance, support, friendship, and advice along the way, I would like to thank the following: The Bruley Family, Andrew Kopietz, Rich & Julie Tiller, Carolyn Somlo, Jennifer Kilberg, Jay Schlott, Robert Bortnick, Denise Walton (for my first break, which I will never forget), Steven Rimar, Joe Kovar, John "Shrek" Drake, Peter Kazor, Charlie Grover, John Cueter Jr., Dan Lawrence, Madelon Ward, Sid & Michelle Monroe, Steven and Corey at Hidden Light, Titan Photo, and Nelson the Shar-Pei (for his unconditional love!).

For all their continued support, I thank my Mom, Dad, Shawn, and Todd.

And to my wife Suzanne. I am still amazed how lucky I am to have such kind, gracious, and strong partner. I could not have this life without you. You have championed me always, and are truly a hero to me every single day.

Lastly, I want to thank all my "heroes." You are a constant reminder of how the world can be a better place, and exemplify the power of human kindness. I've been truly inspired by the examples you've shown me.

— P.M.

A HUGE THANKS TO:

All the heroes, who shared their stories with openness, honesty, and eloquence;

Paul Mobley, whose exquisite portraits bring these heroes to life;

Sal Giambanco, whose excellent advice, early guidance, and generous introductions were instrumental in the making of this book;

Gregory Wakabayashi for his always-elegant art direction and design, not to mention ad hoc proofreading skills;

Emily Green, my right hand, for all her extremely hard work and relentless positivity;

Christopher Measom for stepping in to help with layout;

Marissa Guggiana for her invaluable editorial assistance;

Frank Rehor for being a final set of eyes;

Lena Tabori and Natasha Fried for being there when I needed you, every single time — I'm so grateful to you both;

Christian, Hopi, and Gianni for their constant support and patience during the many months and long hours this project entailed — I love you and thank you.

— K.F.